"If everybody in the U.S.A
Could come with us to Californ-i-a
We could take 'em to a place out west
Where the good sun shines everyday."

CALIF

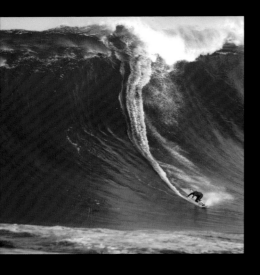
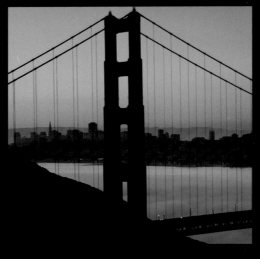

California.... A Great Place to Live.
ISBN 0-9749780-1-9
Published by Rhino Media Works, LLC
P.O. Box 3084, Portland, OR 97209
www.rhinomediaworks.net

Book Design: Loren Weeks
Narrative: Jackson Quast, Tim Leigh
Production: Beverly Warren-Leigh

ORNIA

A Great Place to Live

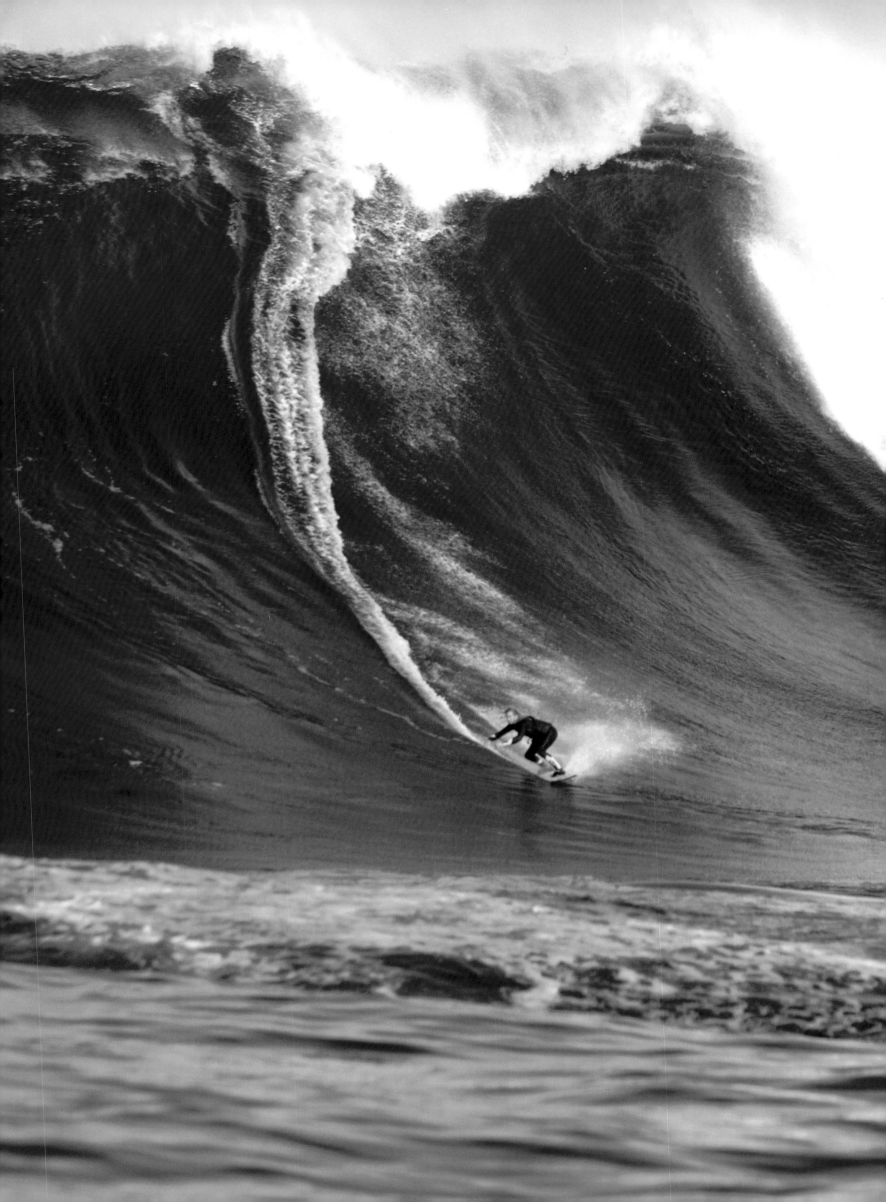

Ron Wilks
Rhino Media Works

A NOTE FROM THE PUBLISHER:

California! Like the explorers and adventurers of eras gone by, the name itself always generates in me feelings of excitement, new beginnings, hope, and opportunity.

The amazing diversity of its geography provides residences and visitors alike a never ending panorama of beauty and wonder. California's vast natural features – from the fertile central valley to the majestic mountains and high lakes, scorching deserts to the hundreds of miles of a cool coastline – lures all of us to its borders.

This book project has been a homecoming for me. I actually got my start in publishing in the Bay Area in the crazy but (stimulating) exciting sixties. Now, forty years later I am blessed with the chance to travel the state and present my findings in beautiful color. And I have come to the conclusion that the gold in California is the natural wonders, the unique living experiences and, by far, the people.

In this book celebrating California, my goal is to not only showcase the state's beauty but inspire you to think about your next vacation, leisure time, or perhaps a long awaited dream home. So, sit back, relax, and come find California with us.

OPPOSITE: Chris Brown at Shark Point
PHOTOGRAPHY: ©Greg Huglin

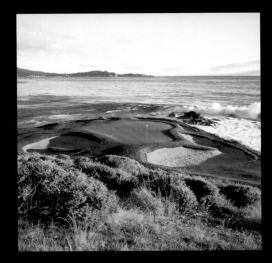

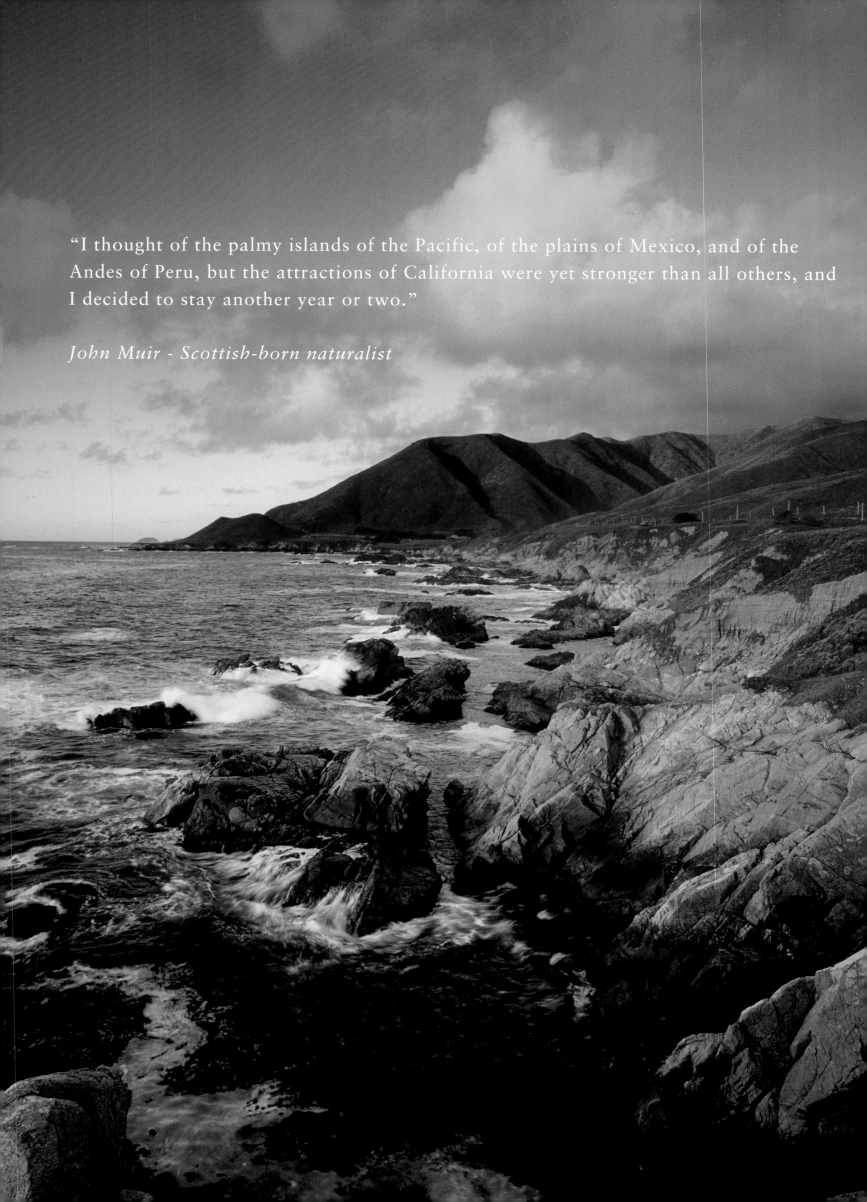

"I thought of the palmy islands of the Pacific, of the plains of Mexico, and of the Andes of Peru, but the attractions of California were yet stronger than all others, and I decided to stay another year or two."

John Muir - Scottish-born naturalist

come find
CALIFORNIA

"KNOW YE THAT ON THE RIGHT HAND OF THE INDIES THERE IS AN ISLAND CALLED CALIFORNIA..."
THIS FIRST MENTION OF CALIFORNIA IN LITERATURE IS FROM A 16TH-CENTURY SPANISH NOVEL
DESCRIBING A MYTHICAL ISLAND WHERE GOLD WAS PLENTIFUL. WHEN FICTION LEADS TO FACT IT CAN
SPUR THE IMAGINATION TO DREAM EVEN BIGGER DREAMS AND WITH THE DISCOVERY OF GOLD IN 1848
THE STATE WAS FOREVER CHALLENGED BY FUTURE VISION AND INNOVATION. FROM ITS MAGNIFICENT
SHORES TO ITS DRAMATIC SNOWCAPPED PEAKS, TO ITS MYSTICAL DESERTS AND RICH PRODUCTIVE
VALLEYS, THE GOLD TODAY IN CALIFORNIA IS THE UNLIMITED NATURAL BEAUTY OF THE LANDSCAPE,
THE EXCITING CITIES, THE DIVERSITY OF THE PEOPLE AND THE INFINITE EXPERIENCES WAITING FOR
THOSE WHO DREAM. COVERED WITH GOLDEN GRASSES AND FIELDS OF WILD GOLDEN POPPIES, IT IS
APROPOS THAT "THE GOLDEN STATE" WAS DESIGNATED THE OFFICIAL STATE NICKNAME.

Opposite page photo: ©Scott Campbell

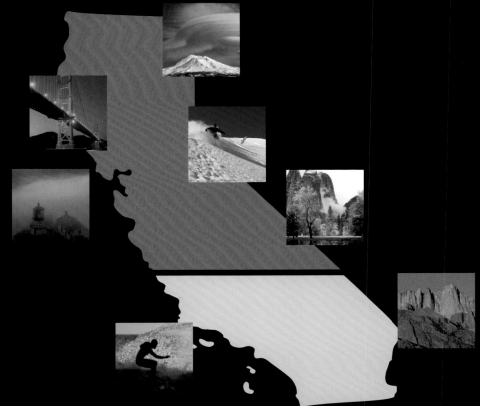

From the north

With its rich mixture of cultures, natural resources, and varied landscapes, California is a cornucopia of topographic and cultural diversity. From remote wilderness to metropolis enchantment, California is where you will find a little piece of everywhere. Geographically, the northern part of the state includes the regions of Shasta Cascade, the North Coast, Gold Country, the High Sierra, San Francisco and the Bay Area, down to the North Central Valley.

San Francisco
Oakland
Palo Alto
Carmel-by-the-Sea

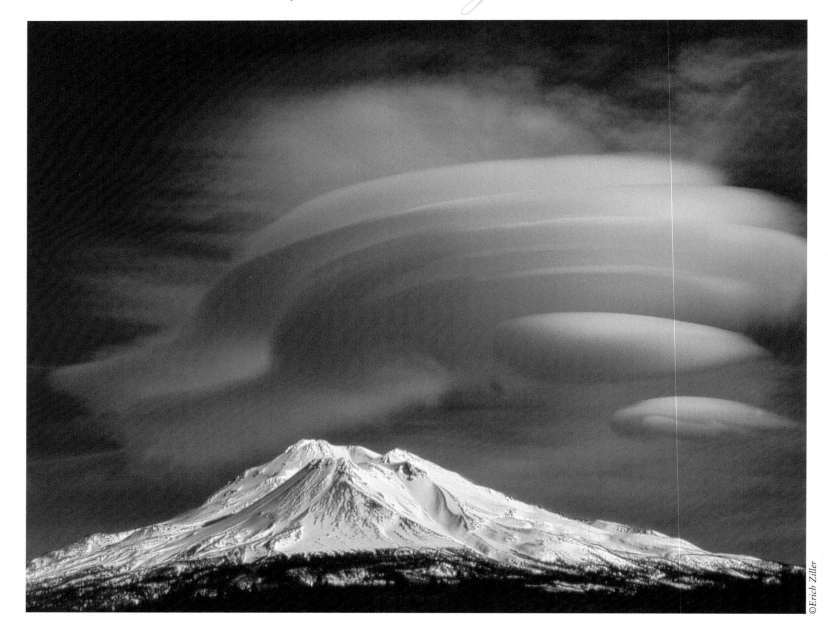

©Erich Ziller

SHASTA CASCADE

Big physically as well as in spirit, the Shasta Cascade region is the great outdoors at its vigorous best—a land of dense conifer forests and volcanic landscapes. The dominating feature, the snowy volcano Mt. Shasta, in Syskiyou County is one of North America's biggest mountains. Mt. Shasta reaches a height of 14,162 feet .

NORTH COAST

This spectacular region stretches over some 400 miles of rugged coastline from north of San Francisco to the primeval redwood forests below the Oregon border. The region reaches 40 miles inland to lush vineyards, pastoral farms and quaint villages. Built in 1856, The Battery Point Lighthouse in Crescent City is the oldest working lighthouse in the state.

GOLD COUNTRY

Cradled between the High Sierra and the Central Valley, this region offers remnants of the 1849's wild days and one of the biggest gold rushes of all time. With rustic towns and picturesque scenery, plenty of recreational and cultural activities, this historic area is filled with "golden" opportunities. The Empire Mine State Historic Park in Grass Valley is California's richest hard-rock gold mine.

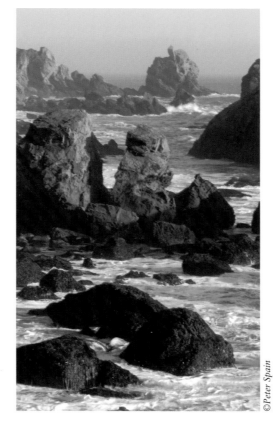

©Peter Spain

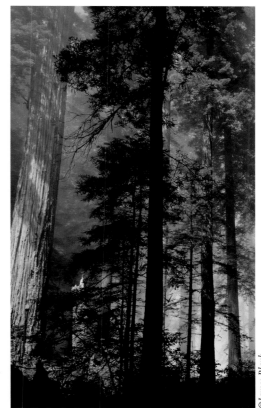

©James Blank

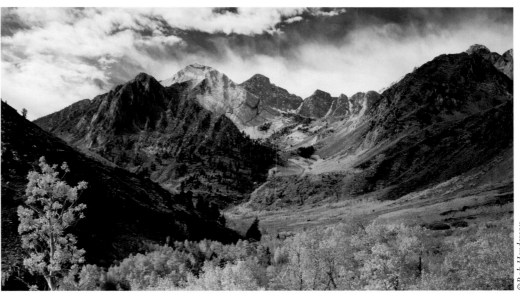

©Rob Henderson

©Rodney Lough

©Rodney Lough

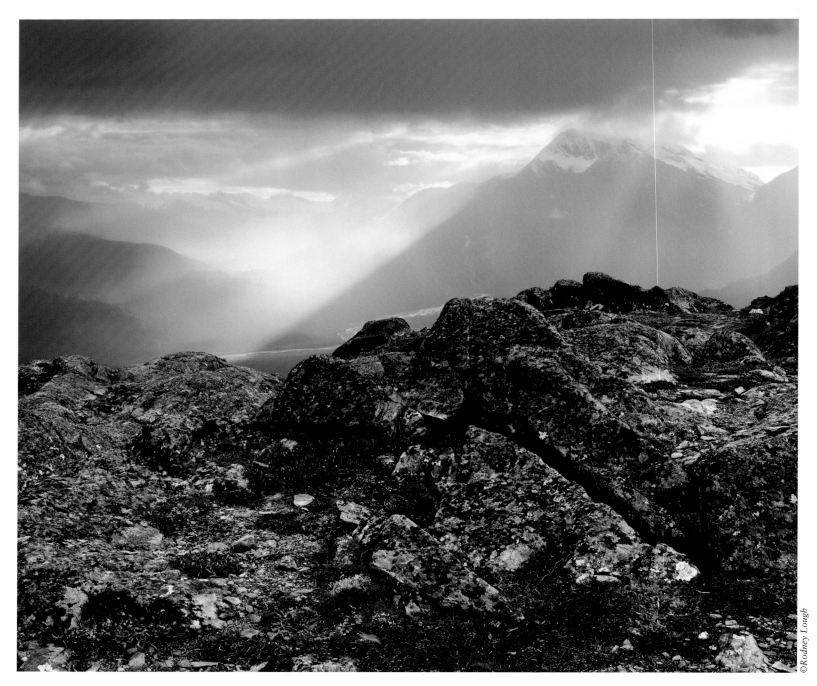

©Rodney Lough

HIGH SIERRA

The magnificent Sierra Nevada mountain range serves as the backbone to the spectacular High Sierra region. Here you will find three of the nation's most treasured National Parks. Mt. Whitney in Sequoia National Park is the highest point in the United States outside of Alaska and rises to a majestic 14,495 feet above sea level. Lake Tahoe in the Tahoe National Forest is a natural wonder and year round resort. Glacier Point in Yosemite National Park is opened seasonally with a glorious view of Yosemite Valley and the high country.

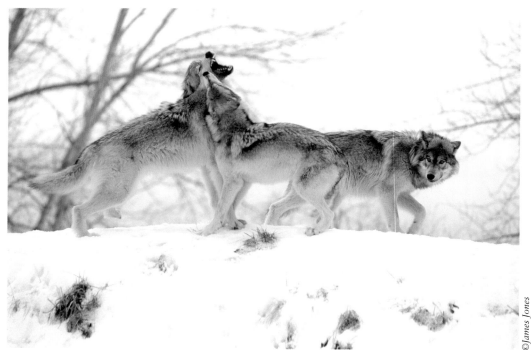

©James Jones

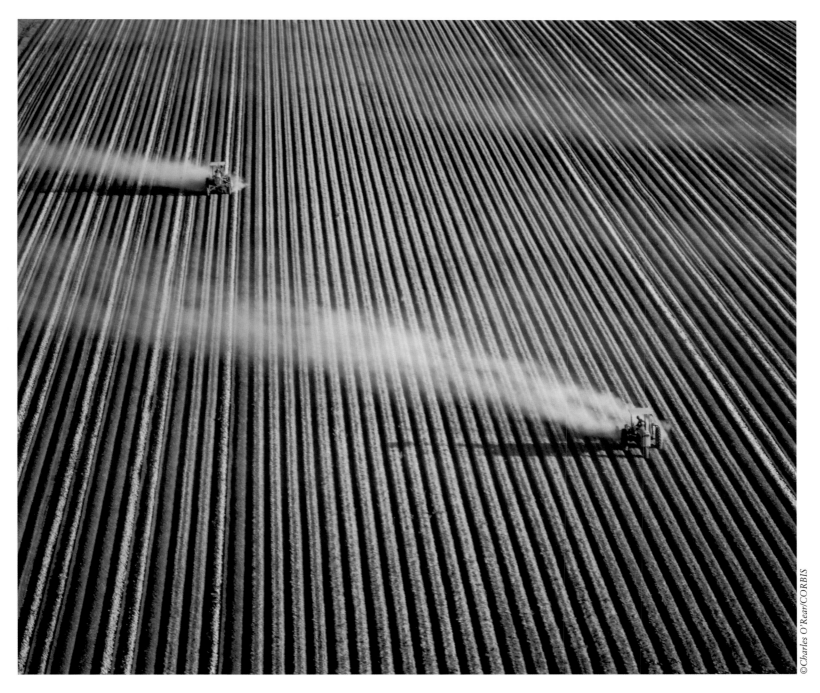

THE NORTH CENTRAL VALLEY

California's agricultural bounty flows from the Central Valley, one of the most productive farming areas in the world. This thriving region includes a wealth of culturally diverse communities, commerce, and historic sights. The Sacramento National Wildlife Refuge covers nearly 35,000 acres and six national wildlife refuges.

EUREKA

Founded in 1856 and located 280 miles north of San Francisco, Eureka is bordered on one side by beautiful Humboldt Bay and on the other by mountains lush with redwoods that offer a reminder of the area's rich logging heritage. The city serves as the County seat for Humboldt County and offers an excellent quality of life. Housing is very affordable by California standards and includes a wealth of attractive Victorian homes.

Eureka is home to the College of the Redwoods and Humboldt State University. A variety of cultural opportunities are available, including active artisan, arts, and theater groups. Outdoor recreation is abundant with activities such as boating, sport fishing, hunting and backpacking all available close by.

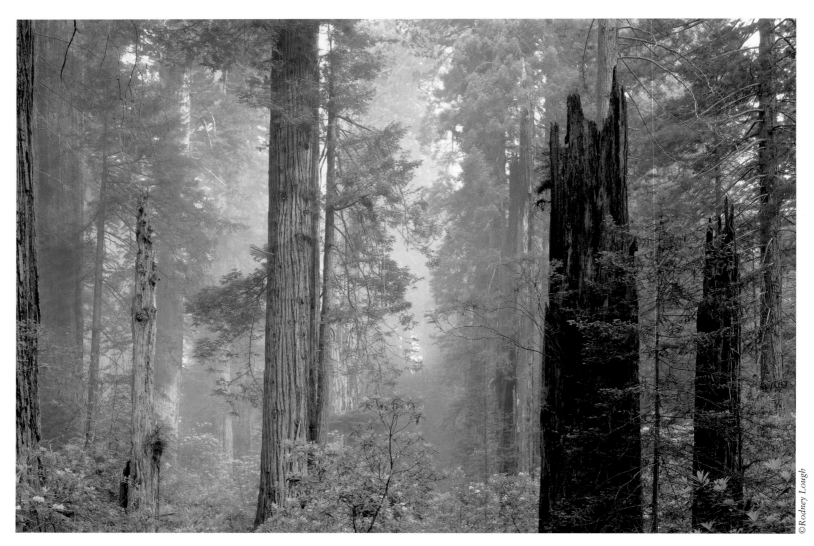

©Rodney Lough

REDDING

Nestled in the north end of the Sacramento Valley, Redding is the county seat of Shasta County. Money magazine rated Redding as one of the nation's 20 best places for starting, relocating, or expanding a small business. With towering mountains, dense forests, volcanoes, glaciers, lakes, waterfalls, winding rivers, and whitewater rapids, this is one of the most scenic areas in all of California.

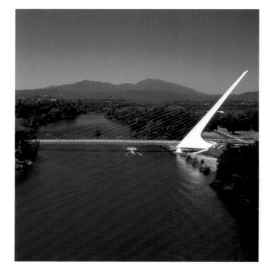

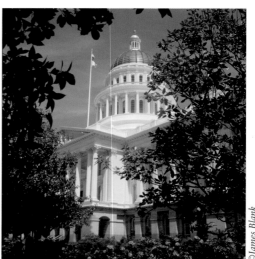

©James Blank

SACRAMENTO

Located in a valley of scenic rivers and favored with a great climate, Sacramento is the capital of California.

The discovery of gold at Sutter's Mill in 1848, started the greatest human migration in American history. Thousands of hopeful pioneers headed towards Mexican California on the Oregon Trail in search of prosperity. From the settlement town of Old Sacramento, to the supply center and trade post of Sutter's Fort, the region is rich in Gold Rush History.

Sacramento has emerged into a cosmopolitan city that still retains its unique Gold Rush history. Today you can still find richness here – in the area's family-friendly attractions, museums, and parks and gardens. It's there for the taking at four-star restaurants and first-class hotels.

Sacramento is a modern blend of tall, gleaming buildings, hearty Victorians, and a vibrant arts scene.

NAPA VALLEY

This world-renowned valley runs through more than 30 miles of agricultural land speckled with hundreds of wineries and is internationally renowned as one of the world's great wine regions. 50 miles north of San Francisco, the Valleys major towns include Calistoga, St. Helena, Oakville/Rutherford , Yountville, and Napa. In 1850, Napa became one of the original counties of California. The Napa, Sonoma and Mendocino region is in the North Coast area. With its rolling hills and warm, sunny climate the state revails its European counterparts and draws visitors by the millions each year to tour and taste vintages which are world-famous. Located between the rugged coast on the west and rolling hills and mountains on the east, Sonoma County offers a grand landscape of beautiful valleys and winding roads to explore. Nearly 40 wineries are located in Mendocino County. The City of Napa is the business and economic center for Napa Valley.

SAUSALITO

Just north of the Golden Gate Bridge, Sausalito sits on the southeastern tip of Marin County. With its magnificent views and sublime climate, Sausalito has an international reputation for charm and character. Named by 18th century Spanish explorers for the "little willow" trees (Saucelito) which were found in abundance on the banks of its streams, Sausalito covers a mere two and one half miles. People who live here work hard to preserve its architecture and historical past.

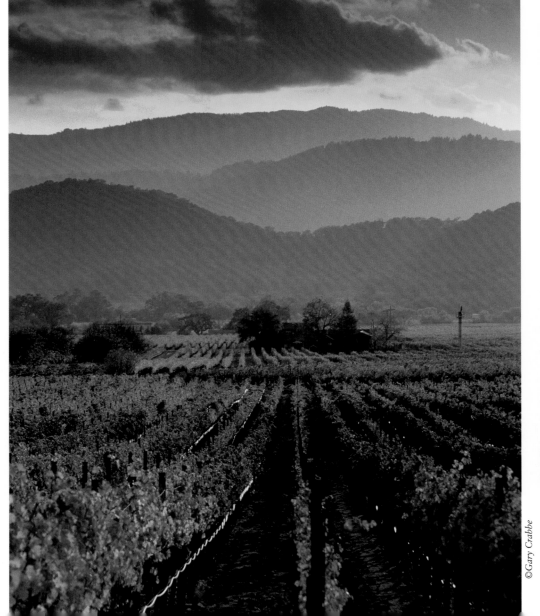

©Gary Crabbe

©Peter Spain

Scoma's Restaurant - Sausalito

©Peter Spain

Only in
SAN FRANCISCO

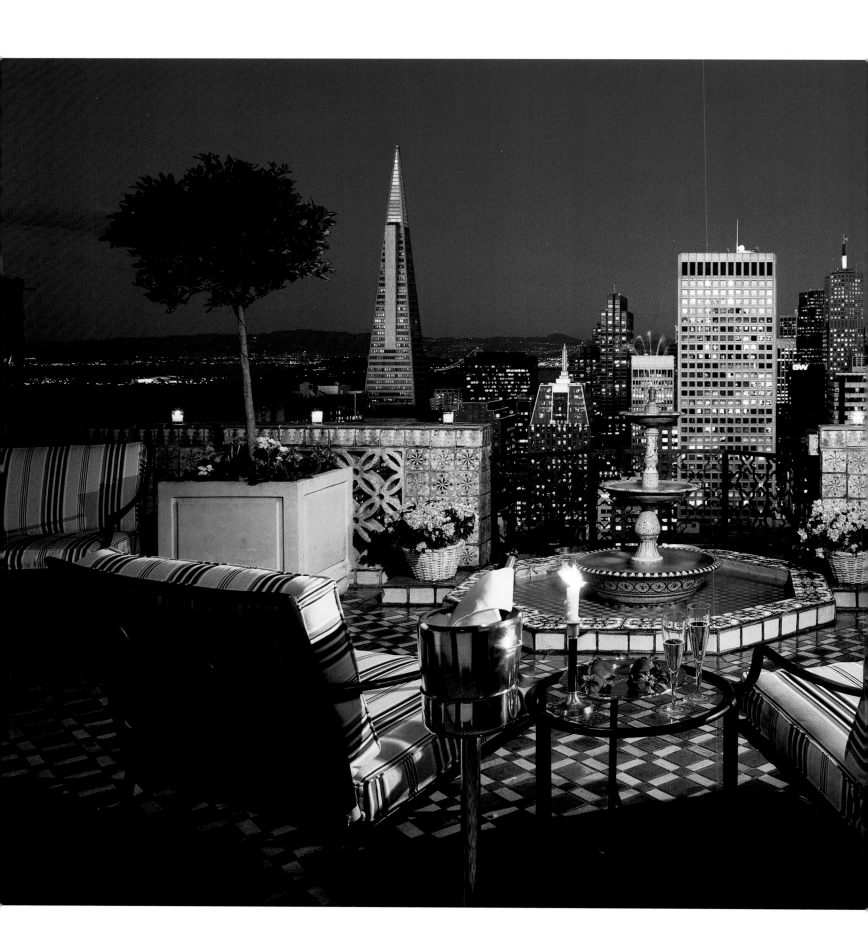

For atmosphere and ambiance, San Francisco is a unique and breathtaking metropolis. The City is situated on a 46.6 square-mile peninsula bounded on the west by the Pacific Ocean, on the north by the Golden Gate strait and from north to east by San Francisco Bay. Views of the Pacific Ocean and San Francisco Bay are often laced with fog, creating a romantic mood in this most European of American cities.

San Francisco is not only one of the most scenic cities in the world, it is one of the most compact. A stroll of the City's streets can lead to Union Square, the Italian-flavored North Beach, Fisherman's Wharf, the Castro, Chinatown and the Mission District, with intriguing neighborhoods to explore at every turn. "I don't know of any other city where you can walk through so many culturally diverse neighborhoods, and you're never out of sight of the wild hills. Nature is very close here." (Gary Snyder, Pulitzer prize-winning poet and essayist)

San Francisco is often called "Everybody's Favorite City," a title earned by its scenic beauty, cultural attractions, diverse communities, and world-class cuisine. The cultural influences, proximity of the freshest ingredients and competitive creativity of the chefs result in unforgettable dining experiences throughout the City.

©Natalie Tepper

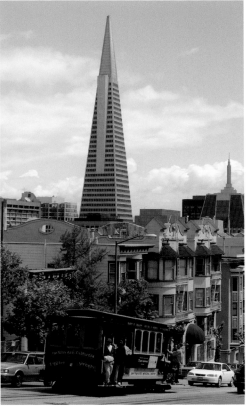

©Alan Weintraub

Forming a panoramic view of the City and the Bay from high atop The Fairmont San Francisco and Nob Hill, the lighted towers of the Financial District and the waterfront gleam under a clear sky, showcasing the Transamerica Pyramid and downtown skyscrapers. The tallest building in San Francisco at 835 feet, the Transamerica Pyramid marks the edge of the financial district and the beginning of North Beach.

©Alan Weintraub

In San Francisco, magical moments abound, like the rejuvenation of the soul upon crossing the Golden Gate Bridge, and the splendor and elegance of a boat cruise on San Francisco Bay.

To the west of San Francisco sits the Pacific Ocean and due east through the strait of the Golden Gate lies the bay. The bay is home to some of the most famous and magnificent bridges ever built

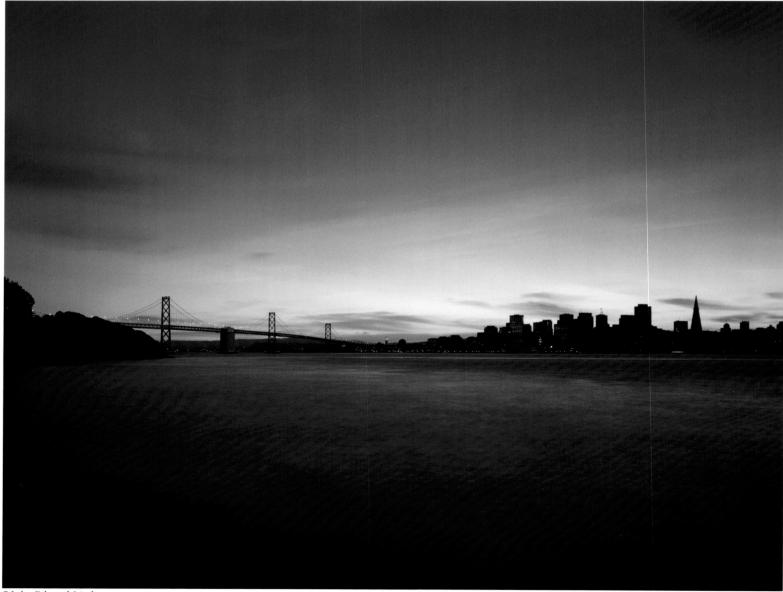

©John Edward Linden

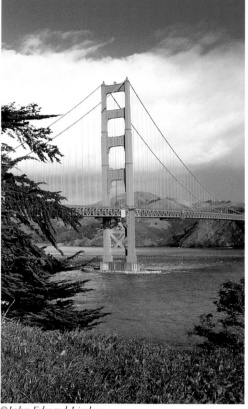

-- the Golden Gate Bridge, San Francisco-Oakland Bay Bridge, Richmond-San Rafael Bridge, Hayward-San Mateo Bridge and the Dumbarton Bridge. Collectively, these five bridges represent a gamut of engineering structures and designs. The Golden Gate Bridge was officially opened in 1937 with a total length of 1.7 miles. "I Left My Heart in San Francisco," is the official city song and it's been said that, if you drive onto

©John Edward Linden

the Bridge at the start of the song and go the speed limit, you'll exit as the songs ends.

The Golden Gate Bridge, steep streets lined with Victorian era houses, and a great turquoise bay surrounded by low mountains, all make San Francisco one of the most picturesque cities in the world.

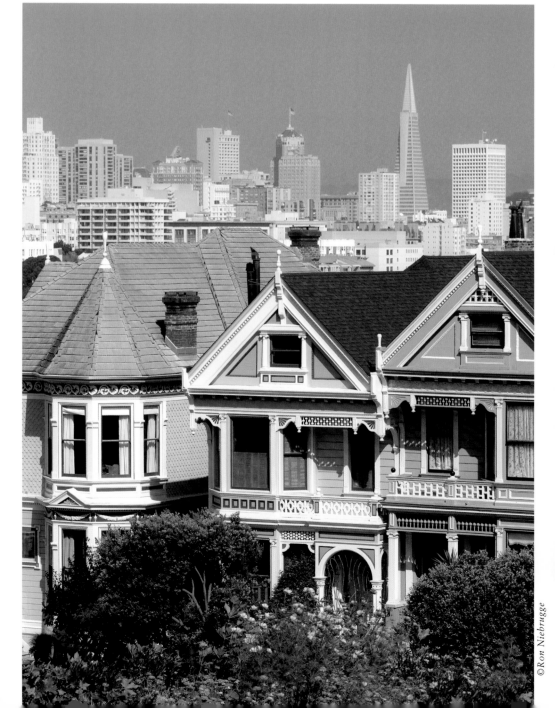

©Ron Niebrugge

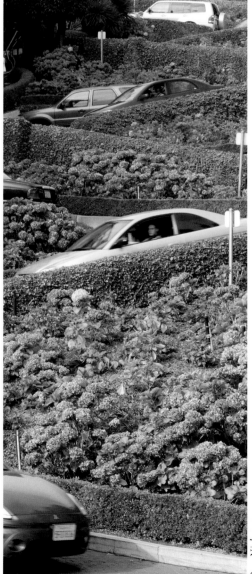

©Ron Niebrugge

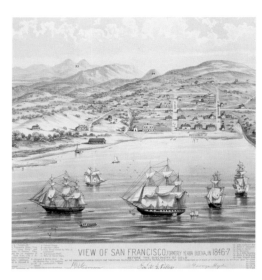

©Ron Niebrugge

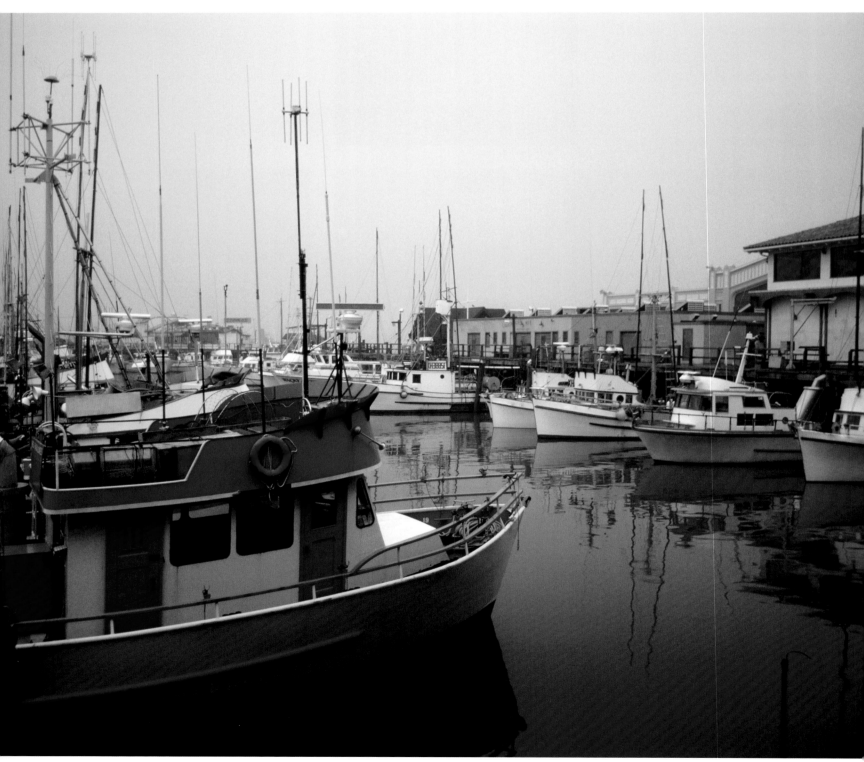

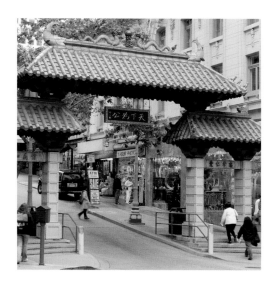

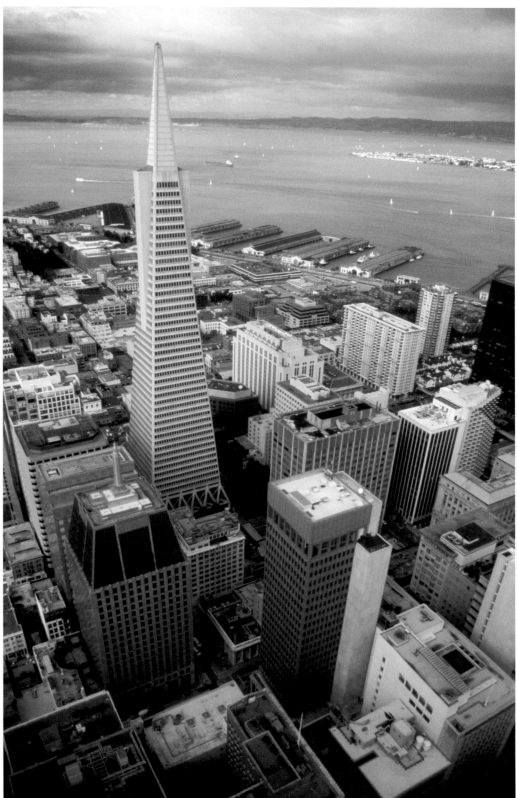

According to the city archivist, San Francisco has 42 hills ranging upward from 200 to 938 feet. But for those whose favorite sport is scaring friends from the flatlands, only five really count. The city's 10 steepest through streets (open to vehicles) are conveniently confined to Russian and Nob Hills and Pacific, Dolores and Buena Vista Heights. Most of these eccentric arteries are marked at the point where they vanish into space with yellow "Hill" or "Grade" signs. What this means is "Don't try it unless you've had your brakes checked recently." Brakes and gearboxes aside, the views are smashing.

Home to the largest concentration of Chinese outside of China, San Francisco's Chinatown crams exotic shops, restaurants, produce markets, herbalists and temples into its 24 square blocks of teeming activity in the midst of downtown. Every year in February the neighborhood explodes in a riot of color and festivity for the Chinese New Year celebrations.

©Ron Niebrugge

19

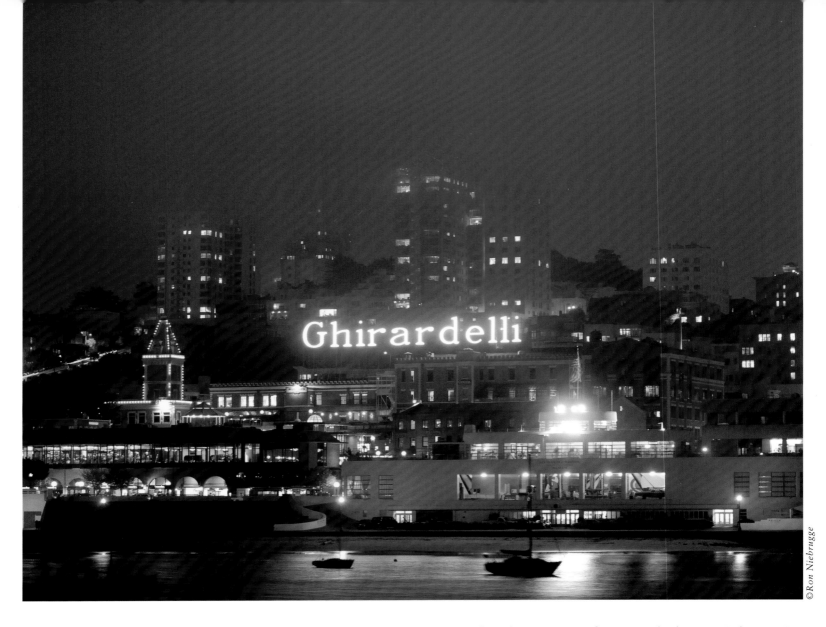

©Ron Niebrugge

The City has a colorful past with a mixture of Spanish colonialism and rowdy American romanticism. The Yankees came en masse following the discovery of gold at Sutter's Mill, changing the landscape from a small village to a major city as a result of the 1849 Gold Rush.

After the 1989 Loma Prieta earthquake, San Francisco's Embarcadero Freeway was removed and is now lined with shops, restaurants and tourist attractions including several piers that have been converted to specialty shopping malls.

Most famous is the historic Fisherman's Wharf that still hosts a fleet of working fishing vessels as well as fish markets, seafood restaurants and gift shops.

©Peter Spain

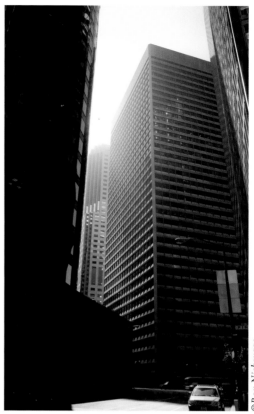

The Coit Tower on Telegraph Hill was completed in 1933 and named after Lillie Hitchcock Coit, philanthropist and admirerer of the fire fighters at the 1906 earthquake fire.

Once the chilling home of maximum-security convicts, Alcatraz now sees more tourists per year than the total number of prisoners in its 29-year life as a federal penitentiary.

After crumbling for over 50 years, the Palace of Fine Arts was rebuilt in 1966. The lagoon, rotunda and elegant colonnade evoke a sense of joy and timeless beauty.

The nation's only moving national historic landmarks, the cable cars still run on 8.8 miles of track along three of their original hundred-year-old routes.

©Ron Niebrugge

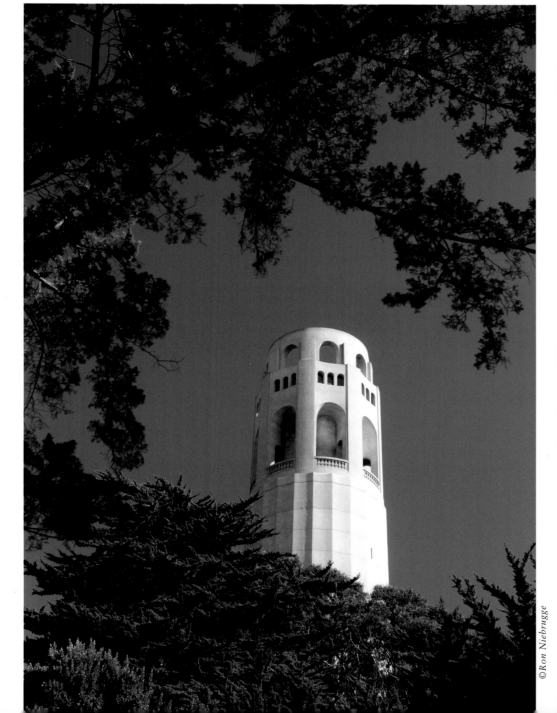

©Ron Niebrugge

©Peter Spain

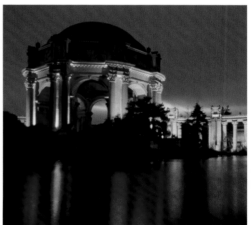

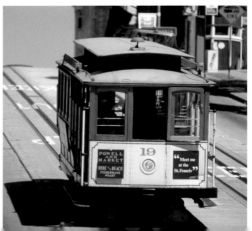

BERKELEY

At the geographic midpoint of the Greater Bay Area, Berkeley is 12 miles from San Francisco. Nestled between the Berkeley hills and the San Francisco Bay, the community is internationally renowned for research, education and culture. Berkeley is home to the University of California, which lends an academic air to the entire city. Its wealth of culture and social diversity, dining, favorable shopping, and recreational pursuits are many and varied. If you can dream it up, you can probably find it here! They've got dinosaurs, ice-skating, sidewalk cafes, dog parks, wind surfing, outdoor markets, rock-climbing, fabulous shopping, outdoor concerts, world-class theater, art museums and galleries, movie theaters galore, and every type of ethnic food imaginable.

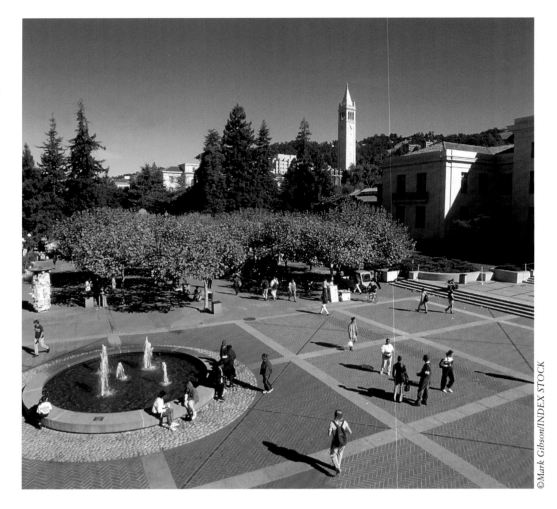

©Mark Gibson/INDEX STOCK

OAKLAND

On the east side of San Francisco Bay, Oakland offers 19 miles of coastline to the west and magnificent rolling hills to the east that afford one of the most beautiful views in the world—the crystal clear bay, the Golden Gate and Oakland Bay bridges and the majestic Pacific Ocean. Oakland's hills and downtown high-rises appear to cast long shadows on the quiet dignity of historical buildings and establishments.

Tucked between the waters of San Francisco Bay and the green coastal hills, Oakland represents the Bay Area's true temperate zone—temperatures in the gentle 50s and 60s in winter and spring, and 70s throughout summer and fall. The city has an abundance of intriguing, enlightening fun things to see and do. Topping your list of must-sees are the spectacular Chabot Space and Science

Center, lively Jack London Square, and beautiful Lake Merritt. A stroll through Chinatown or Old Oakland brings the city's rich cultural history to life. Home to a proud, prosperous and ethnically diverse people, the residential

neighborhoods, thriving commercial districts, world-class sports teams, and significant architectural landmarks all create the fabric that is Oakland.

©Vladpans/eSTOCK

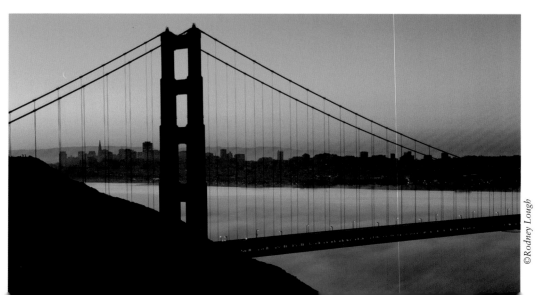

©Rodney Lough

PALO ALTO

Located 35 miles south of San Francisco and 14 miles north of San Jose, Palo Alto is named for a majestic 250 year-old coastal redwood tree along San Francisquito Creek, where early Spanish explorers settled.

The blend of business and residential areas anchored by a vibrant downtown defines Palo Alto's unique character. A charming mixture of old and new, Tree-lined streets and historic buildings reflect its California heritage. At the same time, Palo Alto is recognized worldwide as a leader in cutting-edge technological development. This exciting mix of tradition and innovation makes Palo Alto an extraordinary place in which to operate a business.

Complementing its innovative business community, Palo Alto's residents are highly educated, politically aware and culturally sophisticated. Proximity to Stanford University with its cultural and educational offerings adds to the vibrancy, innate charm and beauty. Distinctive in every way, Palo Alto offers its business community a diverse and exciting environment in which to work and live.

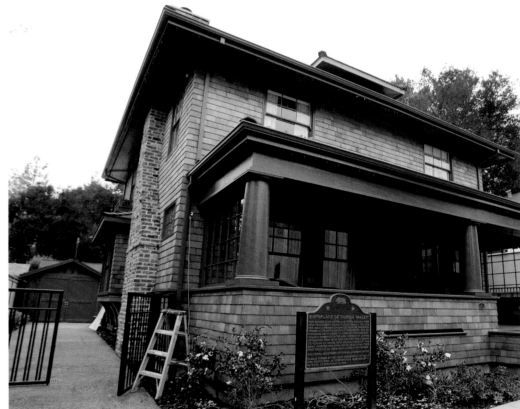

©Kimberly White/CORBIS

SAN JOSE

The third most populous city in the state after Los Angeles and San Diego, San Jose is located at the south end of the San Francisco Bay within the informal boundaries of Silicon Valley. San Jose offers a wide variety of exciting cultural, recreational, educational and entertainment opportunities. The city has the nation's best public safety record of any metropolitan area, a marvelous ethnic diversity and a beautiful climate.

San Jose was the first town in the Spanish colony of Nueva California founded in 1777 as a farming community to provide food for the military installations. It served as the first capital of California after statehood was granted in 1850.

Like most of the Bay Area, San Jose has a Mediterranean climate tempered by the Bay. Protected on three sides by mountains, this shelters the city from rain and makes it more of a semiarid, near-desert area with an annual rainfall of only 14.4 inches. With this light rainfall, San Jose experiences over 300 days of full sunshine each year.

Since San Jose is the unofficial "Capital of Silicon Valley," the economy rises and falls with high-tech employment in the Bay Area. The city lists 25 companies with 1,000 employees or more, including the headquarters of Adobe Systems, BEA Systems, Cisco, and eBay, as well as major facilities for Flextronics, Hewlett-Packard, IBM, Hitachi and Lockheed Martin.

The garage where Bill Packard and Dave Hewlett started in 1938 is a state landmark designated as "The Birthplace of Silicon Valley."

wildlife habitat. Spectators are generally discouraged, as access is limited.

Residents of Half Moon Bay live a lifestyle that many think no longer exists in California. Neighbors care about each other, schools are important, and there is a sense of real community here.

HALF MOON BAY

Half Moon Bay rests on the Pacific Coast between forested hills and some of the most beautiful coastlines that California has to offer. It is approximately 28 miles south of San Francisco and lies within the westernmost portion of San Mateo County. The City and coast are home to numerous nurseries and farms and roadside stands that sell locally grown artichokes, greens, root vegetables, beans and herbs. You cannot top the fresh seafood available in restaurants or to take home. The Pumpkin Festival held in October draws people to the coast to enjoy the panoramic vistas, fine cuisine, arts, crafts and genuine hospitality. The "big waves" of the world famous surfing spot known as Mavericks Break are about 1 mile off shore in Princeton-by-the Sea, a small community about 4 miles north of Half Moon Bay. The viewing area, however, is very isolated and is a sensitive

©JupiterImages/COMSTOCK

©George Lepp

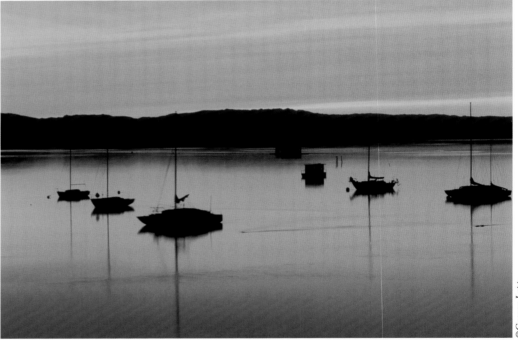

©George Lepp

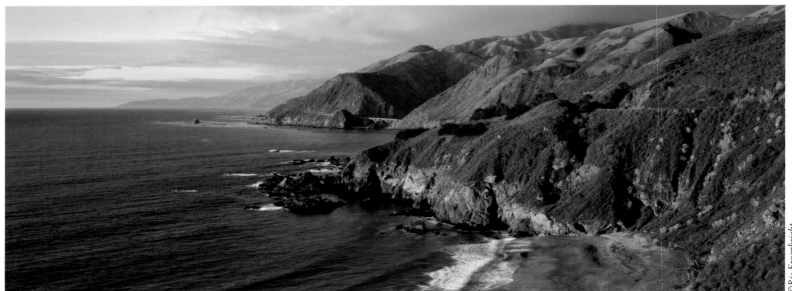

©Ric Ergenbright

SANTA CRUZ

The City of Santa Cruz is located on the northern part of Monterey Bay about 74 miles south of San Francisco and 30 miles from San Jose. The climate is mild with an average high temperature of 69 degrees Fahrenheit and an average low temperature of 44 degrees Fahrenheit. Rainfall averages 32 inches per year. Santa Cruz is the quintessential beach town. It was here that Hawaiian royalty first introduced surfing to the mainland--and locals and visitors alike have been riding the waves ever since. A few blocks from the beach is Santa Cruz's newly renovated downtown, a year-round destination with over 300 days of sunshine per year.

In 1769, the Spanish explorer Don Gaspar de Portola discovered and named the land area that is now known as the Santa Cruz, which means holy cross.

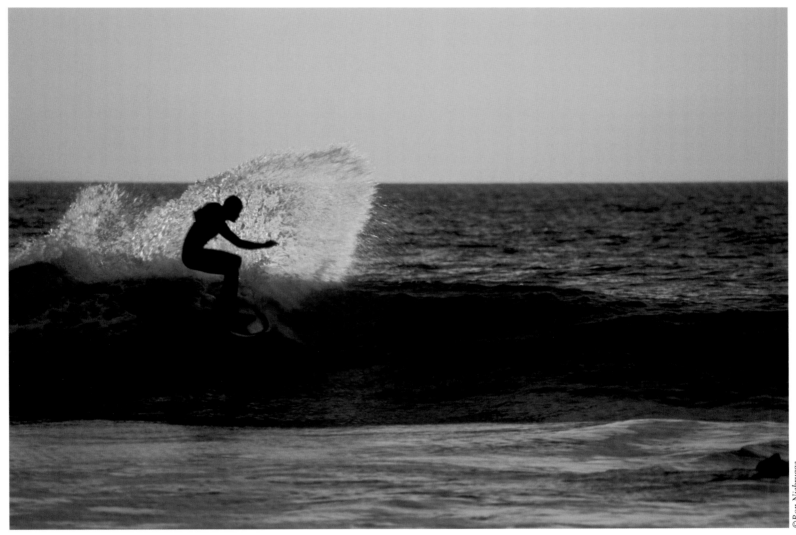

©*Ron Niebrugge*

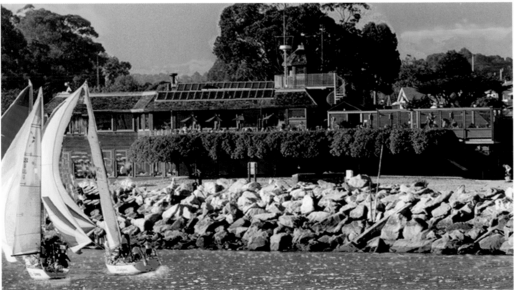

The Crow's Nest, Santa Cruz

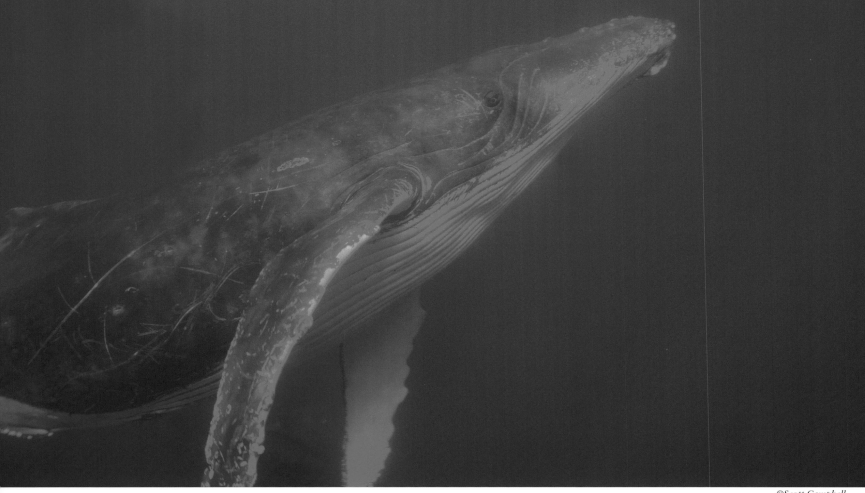

©Scott Campbell

MONTEREY PENINSULA

The magnificent Monterey Peninsula has been called the greatest meeting of land, sea and sky ever presented on mother earth. Set along a 90-mile crescent of coastline, the cities of Carmel, Pacific Grove, Monterey, Pebble Beach, Point Lobos, and Big Sur offer an abundance of scenic beauty, cultural activities and an endless variety of recreational invitations. The rich history of the Peninsula combined with 17 world-class golf courses, the world's best aquarium, a unique variety of shops and galleries and a spectacular assortment of parks and natural areas provide a truly unrivaled place.

Blessed with maritime bounty and cultural diversity, Monterey Bay is the setting for both high-tech marine habitats and luxurious resorts.

MONTEREY

Monterey is world-famous for its majestic beauty, magnificent coastline and its golf and recreation facilities. Situated on the southern end of the Monterey Bay, the Monterey Peninsula is surrounded by the Pacific Ocean, Carmel Bay, and the Monterey Bay. 125 miles south of San Francisco, Monterey enjoys a unique weather pattern. In summer, fog is prevalent; in spring and fall, clear days are the norm. Average yearly rainfall, occurring primarily between November and April, is a low 15 inches. Average summer highs are 68°F; winter lows average 61°F.

The town of Monterey was California's first capital and the Carmel Mission was the headquarters for California's mission system. John Steinbeck's novels immortalized the area in *Cannery Row,* and Robert Louis Stevenson strolled its streets, gathering inspiration for *Treasure Island.*

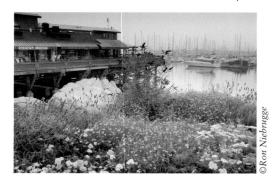

©Ron Niebrugge

©Ron Niebrugge

CARMEL-BY-THE-SEA

Located in the forests of Monterey County, is a little city with great weather, clean air and one of the best places in the world to live. Father Junipero Serra established the Mission San Carlos Bor-romeo in 1770. Later, writers and artists helped put Carmel on the map. Robert Louis Stevenson lived in nearby Monterey and often visited. At the turn of the century, poets came because of cheap land and great scenery. Carmel's greatest poet arrived in 1914; soon thereafter he built the famous tower named for him, Robinson Jeffers. By the 1920s, vacation homes were popping up. Carmel has since become home to many more writers, directors, and folks that enjoy a relaxed atmosphere, great food and especially the arts.

©Douglas Peebles/CORBIS

Nepenthe Restaurant, Big Sur

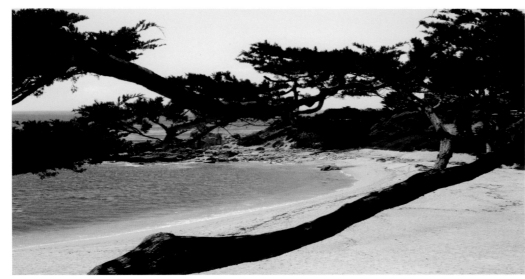

©Kodiak Greenwood/Hawthorne Gallery

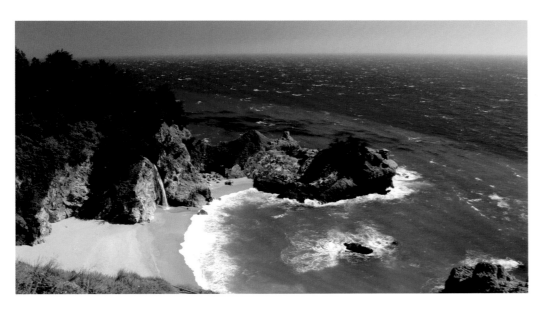

©Ron Niebrugge

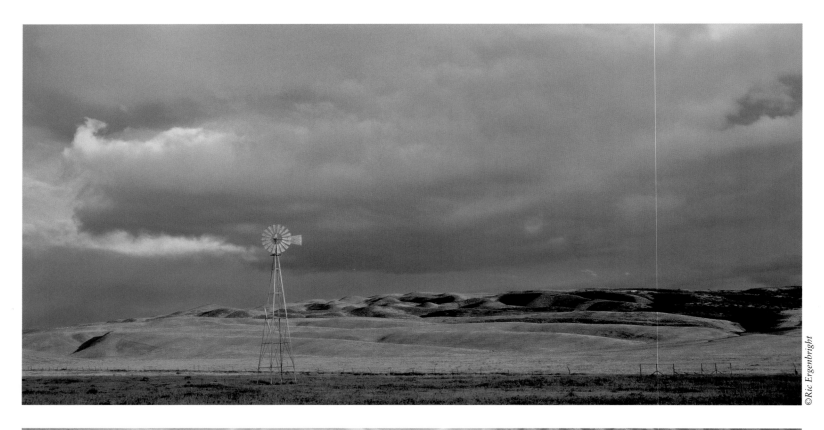
©Ric Ergenbright

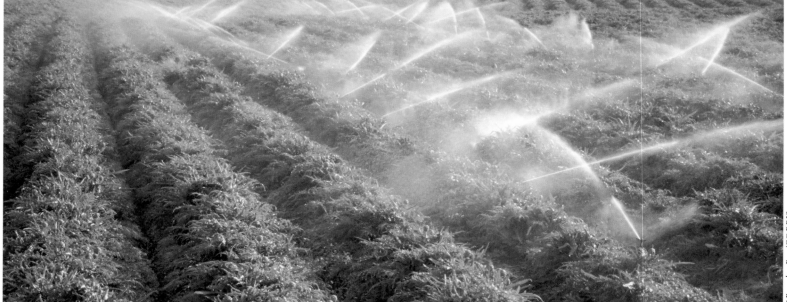
©Royalty-Free/CORBIS

MODESTO

Modesto is located in the heart of one of the greatest agricultural areas of our nation—California's fertile San Joaquin Valley that stretches 300 miles through the center of the state. Modesto is twice blessed with mild weather and some of the world's richest soil. Modesto offers the diversity and facilities of a metropolitan city, but still maintains an atmosphere of old-fashioned hospitality.

West of the valley and over the coastal mountain range lies the San Francisco Bay area, a 90-minute drive from Modesto. Eastward are the foothills that house the famed Mother Lode gold country and lead to the majestic Sierra Nevada mountain range and Yosemite National Park.

©Payne Anderson/INDEX STOCK

Fresno is the Spanish name for "Ash Tree" and is California's sixth largest city. Founded near the center of California's San Joaquin Valley and close to three national parks, national forests and wilderness areas, Fresno County is a diversity of natural beauty and recreational opportunities. The southern entrance to Yosemite National Park is about 65 miles to the north, while the entrance to Sequoia Park and Kings Canyon National Park is about 55 miles to the east. The Coast Range foothills, which form the county's western boundary, reach a height of over 4,000 feet while along the eastern boundary some peaks of the Sierra Nevada Mountains exceed 14,000 feet.

Rich soil, irrigation, and the hard work of farmers who came from all over the world combine to make Fresno County the richest and most productive agricultural county in America. In the year 2000, Fresno County growers grossed over 3.4 billion dollars from the production of more than 200 commercial crops.

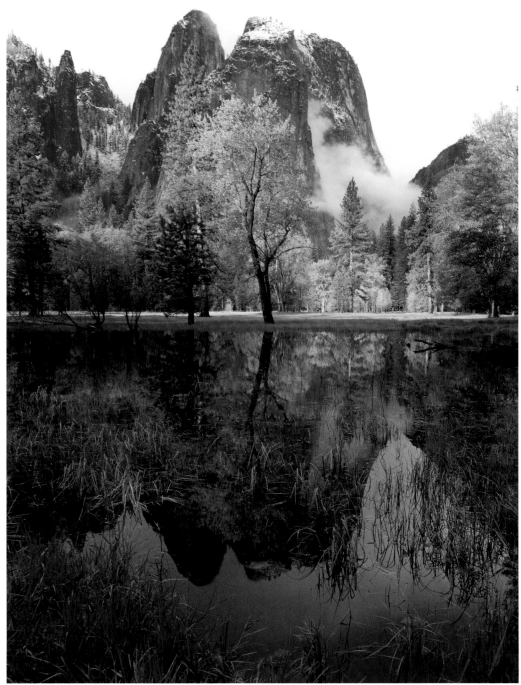

©Rodney Lough

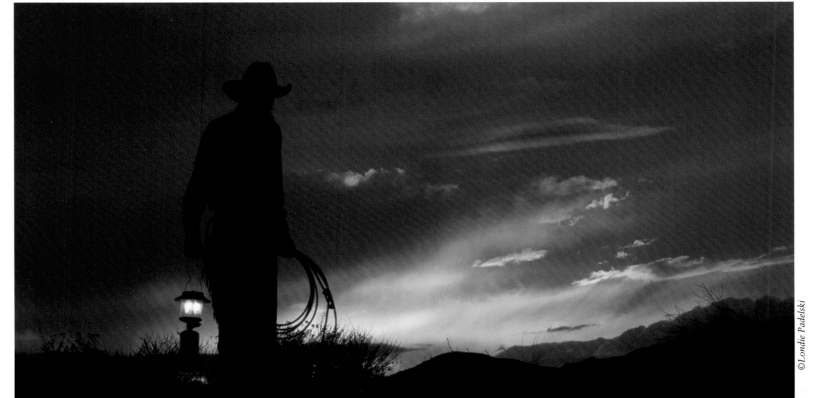

©Londie Padelski

Into the south

With over 1200 miles of ever changing coastline, numerous
rugged mountain ranges, miles of fertile valleys and three different
and imaginative desert regions, it's possible to surf in the Pacific,
enjoy a glass of wine in a rolling Tuscan atmosphere and ski on an
alpine mountain - all in the same day. The culturally rich regions
of the southern part of the state include the South Central Coast,
Los Angeles County, Orange County, San Diego County,
the Inland Empire, and the Deserts.

SOUTH CENTRAL COAST

South Central California is comprised of ten counties starting roughly 70 miles north of Los Angeles and down to the international border with Mexico. The region encompasses half a dozen mountain ranges and more than half of California's 21 historic Jesuit missions. The dramatic seascapes, coastal resorts, pristine mountains and pastoral inland agricultural communities create a unique blend of unspoiled natural beauty in idyllic settings.

The South Central Coast is a realm of small towns, each offering its own brand of inspiration. Oxnard and Ventura are shoreline communities with the Coast Range in their backyards and the Pacific Ocean at their doorsteps. Set against a backdrop of mountains, gardens, and sea, Santa Barbara is renowned worldwide for its charm and beauty and San Luis Obispo presents small-town appeal with wineries and a weekly Farmer's Market.

The Santa Barbara Museum of Natural History offers the largest collection of artifacts from the Chumash Indians, at one time the largest tribe in the Western United States. In Oxnard, The Maritime Museum has marine art dating from the late 1700s, and in San Martin, the Wings of History Air Museum showcases a collection of restored antique aircraft. Nearer to Los Angeles, the Channel Islands National Park is home to over 2,000 species of plants and animals.

©Ron Hughes

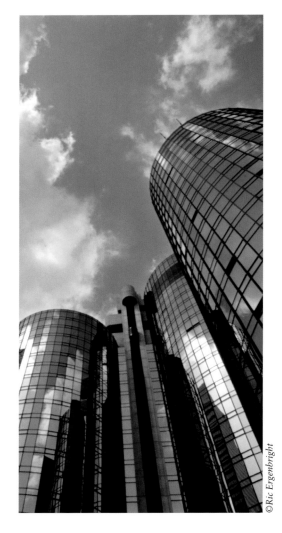

©Ric Ergenbright

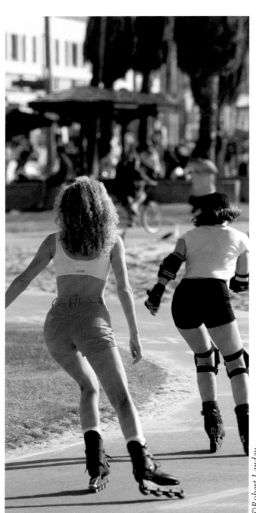

©Robert Landau

©Robert Landau

LOS ANGELES COUNTY

Ever since 1913, when filming began in Los Angeles, the world has been fascinated by movie making and Hollywood. With its entertainment industry, world-class museums, great shopping and miles of parks, recreation areas and sunny coastal fun spots, Los Angeles County is recognized world-wide as a great vacation destination.

There's probably no other city on Earth as complicated and diverse as Los Angeles. Over three and one-half million people live in the 467 square miles of desert basin, mountain canyons, and coastal beaches. Outside the city limits, another 6 million people have found homes in the 80 incorporated cities within the county. Beyond that, another 5 million reside in the region's four other counties, all within the economic shadow of the city. Rich in human diversity and culture, people from 140 countries speak 96 different languages and all call Los Angeles home.

Los Angeles County is afternoons on the beach, touring Hollywood, taking the kids to Disneyland or Knott's Berry Farm and exploring their many museums. The fantastic climate invites a myriad of beach and other water related activities. For snorkelers and scuba divers, The Catalina Islands Underwater Park with its shipwrecks and kelp forests is a perfect setting. The Naples Canals in Long Beach and the aquatic playground at Raging Waters in San Dimas are opportunities to cool down from a hot summer day. For a different approach, leave the beaten track and head to the coast and tide pools at Cabrillo Beach in San Pedro, the seclusion of Malaga Cove near Torrance or the near perfect waves at Surfrider Beach in Malibu.

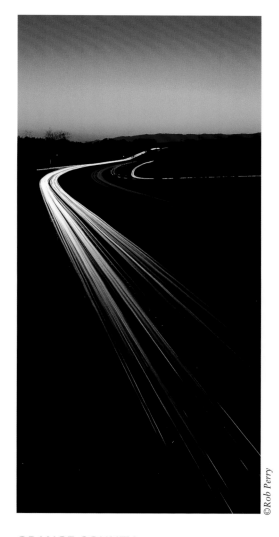

©Rob Perry

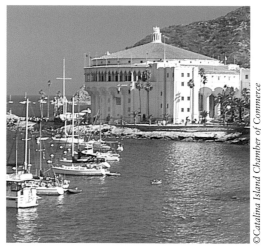

©Catalina Island Chamber of Commerce

©Robert Holmes/CORBIS

Courtesy of NASCAR

ORANGE COUNTY

Orange County is a favorite family destination due to its many theme parks, historic and cultural facilities, mild climate, and great beaches. The county is anchored by Anaheim and Buena Park, Southern California's theme-park heaven. Both residents and visitors alike are drawn to the county's 42 miles of beaches, vast tracts of green space and the picture-postcard coastline that is recognized around the world.

Things began happening on a global scale for Orange County in 1955 when Walt Disney created his Magic Kingdom. Legend has it that Walt looked all over Southern California before deciding on the 75 acres of orange trees in Anaheim for the site of his first amusement park. Although Disneyland made Orange County a household name, it is Knott's Berry Farm in Buena Park that has the distinction of being the nation's oldest themed amusement park, dating back to the 1920s. It's amazing what can happen with a mouse and a jar of jam.

If you are looking for outdoor action, Bell Canyon in San Juan Capistrano has a 4.5 mile bike trail that leads to a lush green valley with gnarled oaks. At Main Beach in Laguna Beach there is always a pick-up volleyball or basketball game and Ortega Falls south of Lake Elsinore is a sublime surprise and just minutes from the Ortega Highway.

Back to the coast, try kayaking Upper Back Bay in Newport Beach or hike and bike from the ocean to the hills along Morro Ridge and Crystal Cove in Laguna Beach. Big Corona, in Corona del Mar State Beach, is a perfect family beach and Surfside Beach is the least crowded patch of sand south of San Louis Obispo.

©James Blank

©James Blank

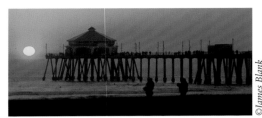
©James Blank

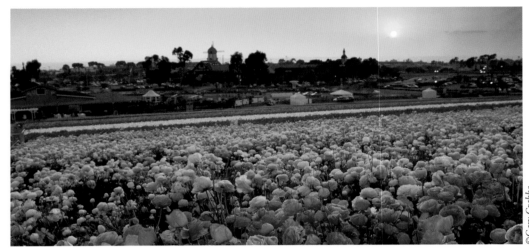
©Gary Crabbe

©James Blank

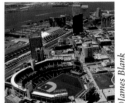
©James Blank

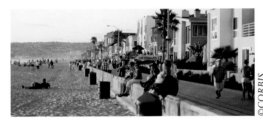
©CORBIS

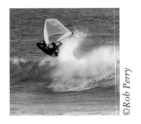
©Rob Perry

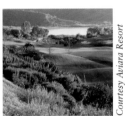
Courtesy Aviara Resort

SAN DIEGO COUNTY

With its rich Hispanic heritage, temperate climate, deep-sea harbors, sandy beaches and a variety of fun-filled attractions, San Diego County maintains its reputation as a world-famous destination. Blessed with an ideal climate, 70 miles of sandy beaches, a deep-sea harbor, a variety of fun-filled attractions, and a rich, distinctive Spanish-Mexican heritage, San Diego County is a paradise. Here you can play golf year-round at a number of scenic courses or surf, dive, sail, fish, water ski, play tennis, ride horses, roller blade, jog–the list of outdoor recreational possibilities here is endless.

There's plenty of spectator entertainment as well. The region boasts the San Diego Zoo, Sea World, the Wild Animal Park and is home to several professional sports teams. The Mission San Luis Rey in Oceanside is known as the "king of the missions" and is the largest and most populous Indian mission in California. The classic Del Mar Racetrack, built by Bing Crosby and Pat O'Brien, opened in 1937. The Hotel de Coronado was built in 1888 and is said to have inspired L. Frank Baum's illustrations in the Wizard of Oz.

For a bit of culture, check out Balboa Park in San Diego, home to the Museum of Art and the Old Globe Theatre. Add to the list the California Center for the Arts in Escondido, the Chicano Park Murals that cover the support structures of the Coronado Bay Bridge and the La Jolla Playhouse, one of the most respected and prestigious theatres in America.

If it's the great outdoors you're looking for, try Azalea Glen in Cuyamaca Rancho State Park with a 3-mile hike through dense stands of coniferous trees and wild azaleas, horseback ride along the surf at Imperial Beach, kayak, water-ski, sail, windsurf at Mission Bay Park, look for California gray whales December through February at Point Loma or take the Tour d' Oceanside, a 6.5-mile scenic biking loop in Oceanside.

©Vern Clevenger

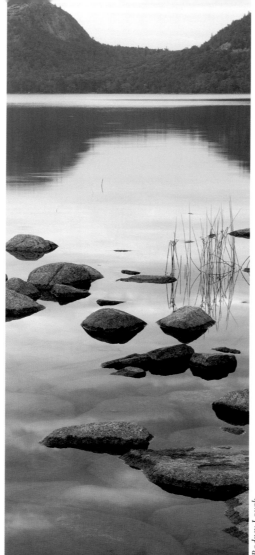
©Rodney Lough

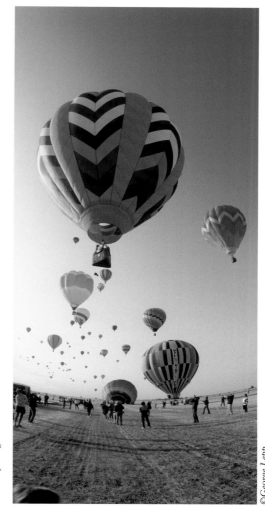
©George Lepp

INLAND EMPIRE

Larger than Rhode Island, Connecticut and Delaware combined, the Inland Empire, encompassing the mountain ranges to the north and sunny farmlands, orchards and vineyards along the lush Santa Ana River Valley, is truly an empire. Here you will find soaring mountains, alpine lakes, winter snow sports, and pine-scented air. The region is also home to hot air balloon festivals, Old West towns, orange groves and wineries.

A trip along the Rim of the World Scenic Highway in the forested San Bernardino Mountains features stunning vistas as well as abundant recreational opportunities. Enjoy the art galleries in Lake Arrowhead and visit Big Bear Lake at an elevation of 7,000 feet. The lakeside resort communities here offer year-round recreation and great living.

Back down to lower ground, there are more than 280 acres of parks, lakes, and recreation areas within the city limits of San Bernardino. The towns of Yucaipa, Oak Glen, and Cherry Valley comprise the region's apple-orchard country, and Temecula is the gateway to the state's youngest wine country.

The Asisencia Mission de San Gabriel in Redlands was built in 1830, Presidents have wed and honeymooned at the Riverside Mission Inn and the San Bernardino County Museum displays an array of historical California figures. The Gilman Ranch Historic Park and Wagon Museum in Banning is where you can view an overland stagecoach, prairie schooner and chuck wagon, and old trains and trolleys operate at the Orange Empire Railway Museum in Perris.

Get your kicks at the Route 66 Territory Gift Shop in La Verne from memorabilia featured in John Steinbeck's *The Grapes of Wrath* and also the popular 60s television series, *Route 66*. This stretch of the famous highway that passes through California extends from the Colorado River near Needles to the Pacific Ocean at Santa Monica.

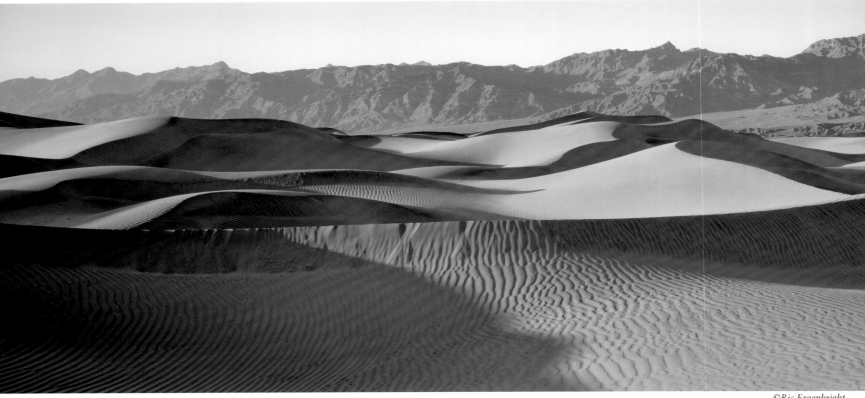

DESERTS

California's deserts are lands of acute contrast. Under the blazing heat of days to the deep chill of nights, jagged rocks, bone-dry basins, and twisted Joshua trees form a landscape unlike any other in the region. Desolate yet surprisingly alive, the desert holds a mystery and beauty for those who venture there.

In the Northeast corner of the state is the Modoc Plateau, a wasteland of former lava flows and part of the Great Basin. The Basin extends out of Nevada into the eastern edge of California and forms Death Valley, the lowest point in North America at 282 feet below sea level. The Mojave Desert in Southern California is a high desert region with an average elevation of 3500 feet, and in the southwestern corner of the state lies the low Colorado Desert.

For explorers, there are a number of outdoor trails where you will find sand dunes, eroded cliffs and golden poppies along with slow moving tortoises and soaring eagles. A hike in Indian Canyons near Palm Springs places you in the middle of a palm oasis on the Agua Caliente Indian Reservation. The Bajada All-Access Nature Trail in Joshua Tree National Park is a 1/4-mile loop designed with features for limited-mobility travelers, and Borrego Palm Canyon in Anza-Borrego Desert State Park is a 3-mile round trip hike in a dreamy oasis with a waterfall flowing from winter to spring. Red Rock Canyon State Park in Cantril is a picture of colorful cliffs and in the Big Morango Canyon Preserve in Yucca Valley you can walk the trails and view 250 bird species and reptiles.

For the culturally inclined, the ancient petroglyphs near Ridgecrest contain one of the largest petroglyph collections in the world and the Aqua Caliente Cultural Museum in Palm Springs exhibits artifacts that explain Cahuilla Indian history and culture.

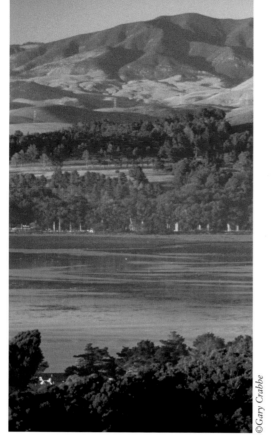
©Gary Crabbe

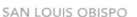

SAN LOUIS OBISPO

San Louis Obispo is located eight miles from the Pacific Ocean, midway between San Francisco and Los Angeles at the junction of Highway 101 and scenic Highway 1.

One of California's oldest communities, it began with the founding of Mission San Luis Obispo de Tolosa in 1772 by Father Junipero Serra as the fifth mission in the California chain of 21 missions. The mission was named after Saint Louis, a 13th Century Bishop of Toulouse, France.

Ideal weather and natural beauty provide numerous opportunities for outdoor recreation. A key feature contributing to the City's great quality of life is the downtown. With its wonderful creekside setting and beautifully restored mission, Mission Plaza is the community's cultural and social center.

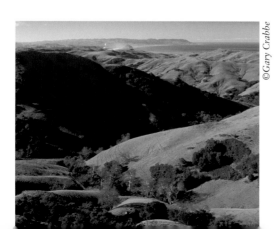
©Gary Crabbe

©Rob Perry

PISMO BEACH

The City of Pismo Beach was founded in 1891 and incorporated in 1946. It's located mid-way between Los Angeles and San Francisco and is a recreation and tourism-oriented town. Visitors enjoy a myriad of activities and miles of beautiful clean beaches where tide pools, coves, and caves are waiting to be explored. The "Butterfly Trees" of Pismo Beach are one of the most beloved attractions. From late October through February, thousands of colorful Monarch butterflies cluster in the limbs of Eucalyptus and Monterey Pines, giving the appearance of yellow and orange leaves.

In Pismo Beach you'll find wonderful accommodations, corporate meeting rooms, restaurants and gorgeous weather. A favorite pastime is to stroll the long white beaches and catch spectacular views of the Pismo Beach sunset.

BAKERSFIELD

Bakersfield was settled in 1858 by a handful of families who had trekked northward through the El Tejon Pass seeking home sites rather than gold. The town was named after Colonel Thomas Baker who invited weary travelers to rest overnight. These travelers would plan to meet and rest in "Colonel Baker's field."

Bakersfield was one of the first cities in the United States to adopt the council-manager form of government. With big city conveniences and advantages, Bakersfield maintains an atmosphere of small town hospitality, friendship and optimism. In 1990, the citizens of Bakersfield received the National Civic League's stamp of approval through the designation of an "All-America City" for proactively dealing with the needs of its citizens.

SANTA BARBARA

Photography by Bill Zeldis

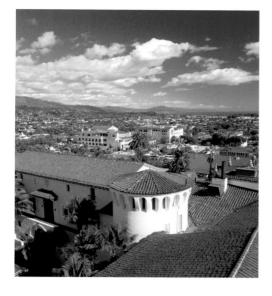

Quietly nestled between the ocean and the mountains along scenic Highway 101, Santa Barbara is one of America's best-kept secrets. This stretch of coast is often referred to as the "American Riviera" because of its Mediterranean climate with temperatures that range from the mid-60s to mid-70s throughout the year. Late summer highs will climb into the 80s with evening temperatures remaining refreshingly cool all year long. Santa Barbara basks in sunshine, natural beauty, creativity, cultural sophistication and an appreciation for taking life at your own pace.

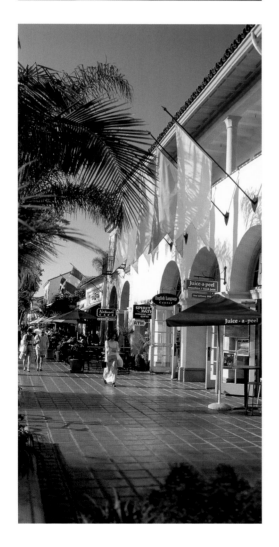

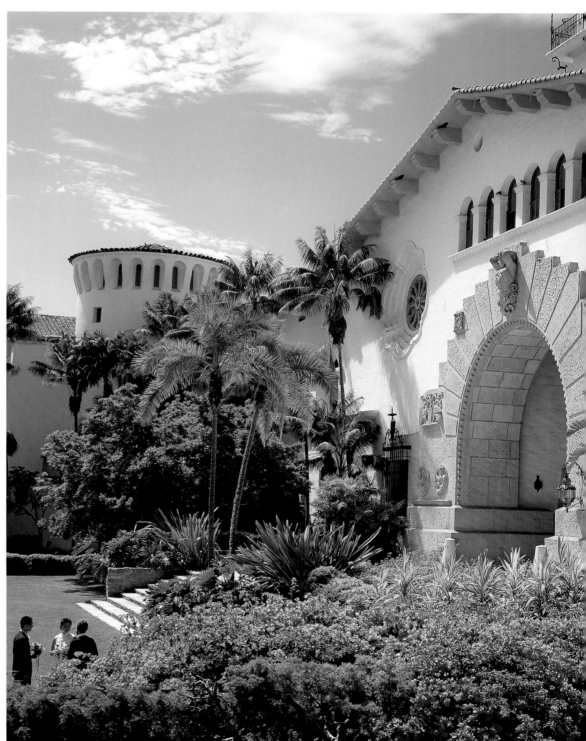

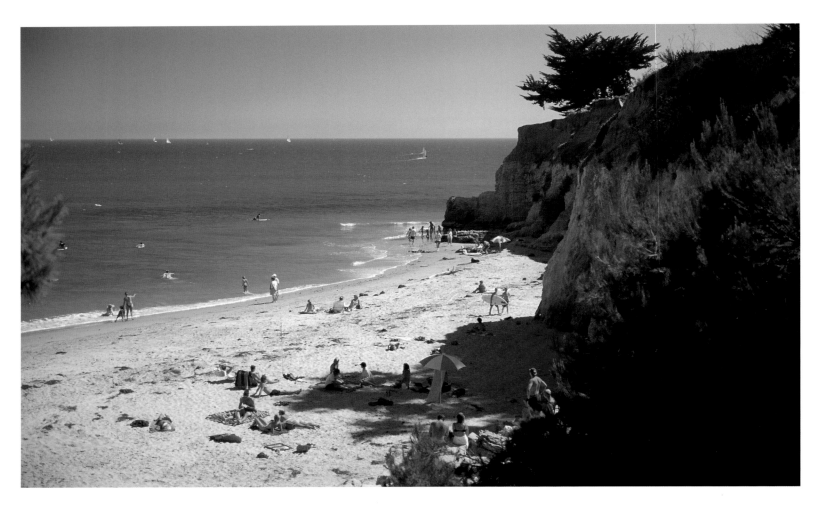

Santa Barbara County encompasses an enormously varied terrain. Nearly one-third of the total acreage is set within Los Padres National Forest, which includes the rugged San Rafael Wilderness Area. The Santa Ynez Mountains rise dramatically behind the city, with several peaks exceeding 4,000 feet. Covered with chaparral and sandstone outcrops, these mountains create the scenic backdrop to the town. The first known people to call Santa Barbara home were the Chumash Indians, sustaining themselves from fish-rich waters of the Pacific and game-tracked mountains behind. In 1542, Portuguese explorer Juan Cabrillo laid claim to the region in the name of Spain and established friendly relations with the Chumash. Sixty years later, Sebastian Vizcaino led his fleet into the channel seeking shelter from a severe storm. The storm passed on Saint Barbara's feast day and, grateful for God's having spared the ships and lives of their crews, a friar on board one of the vessels named the

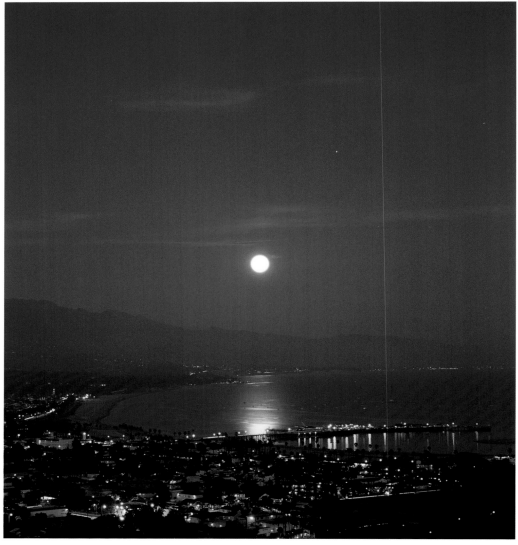

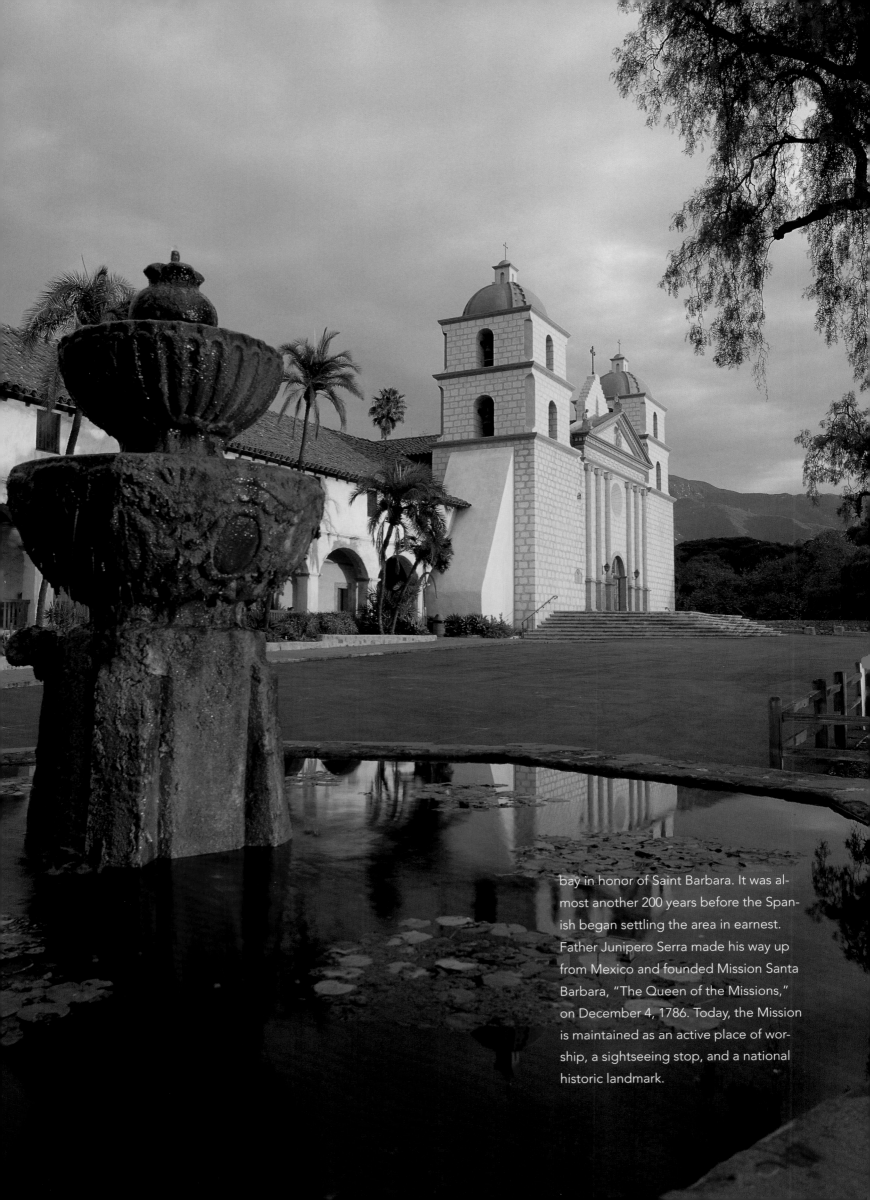

bay in honor of Saint Barbara. It was almost another 200 years before the Spanish began settling the area in earnest. Father Junipero Serra made his way up from Mexico and founded Mission Santa Barbara, "The Queen of the Missions," on December 4, 1786. Today, the Mission is maintained as an active place of worship, a sightseeing stop, and a national historic landmark.

Keeping with its Spanish heritage, the Santa Barbara's architectural style is famous around the world. Spanish, Mediterranean and Moorish/Islamic influences can be found in the gleaming white stucco surfaces, red tile roofs, courtyards, and wrought iron used to ornament windows, light fixtures, staircases, and other accent elements.

With 57 parks totaling nearly 1800 acres and an abundance of 35,000 public trees, the outdoor environment showcases the quality of life in Santa Barbara.

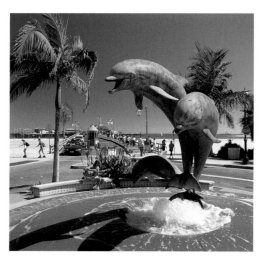

Beautiful beaches, picturesque mountains and colorful culture make the city a premier resort destination. Whether you enjoy hiking, fine-dining, water sports, lazing on the beach, a great nightlife, wine-tasting tours, shopping, beachside hotels or coastal inns, Santa Barbara has something for everyone.

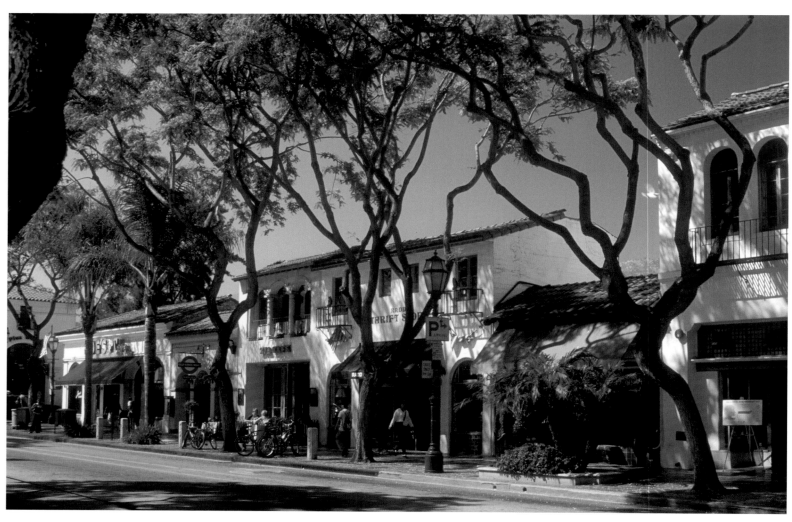

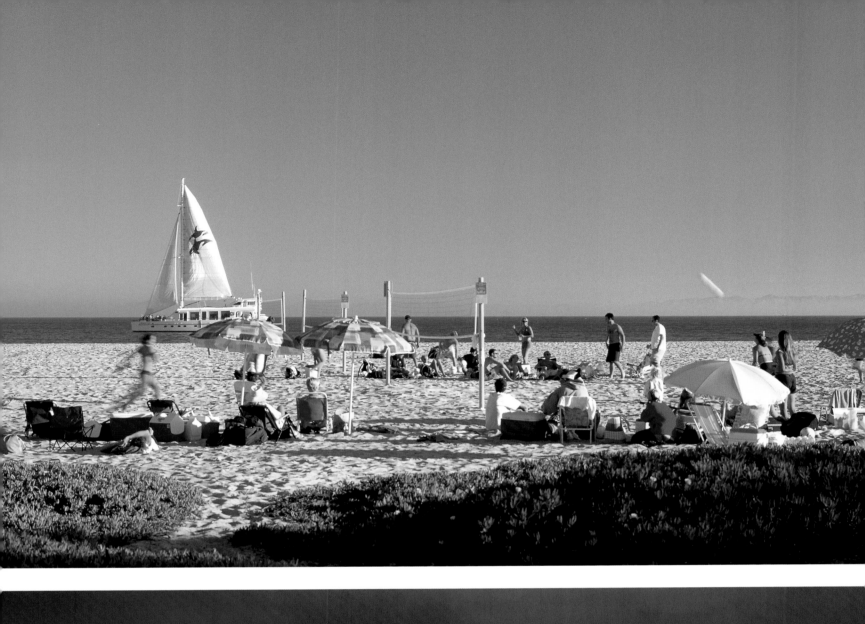

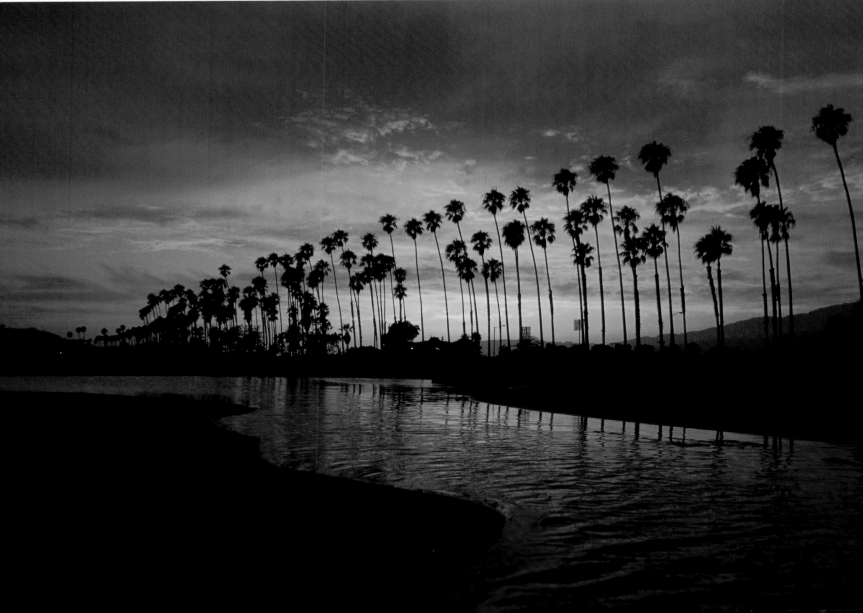

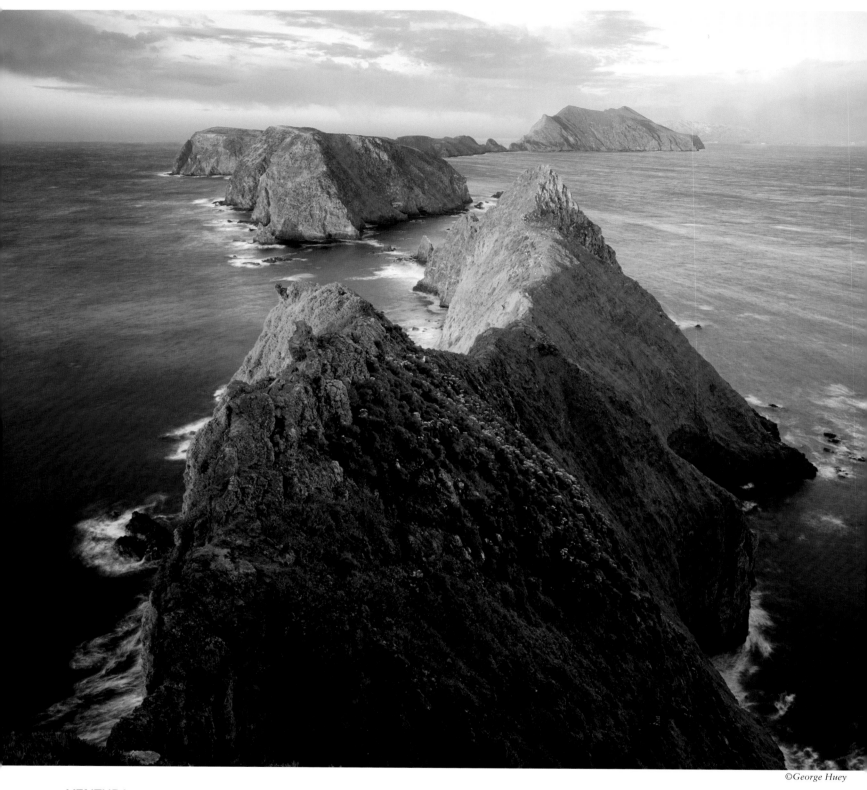

VENTURA

Just a few miles up the coast from Los Angeles, Ventura is light years away in attitude and opportunity. From the pristine beaches to acres of beautiful parks, Ventura offers unrivaled vacation possibilities for those who want to bask in the California sun.

The city is located between two richly endowed valleys, the Ventura River and the Santa Clara River, and soil so rich that citrus grew better here than anywhere else in the state. The growers along these rivers got together and formed Sunkist, the world's largest organization of citrus production.

Ventura is the getaway to the Channel Islands National Park and a classic Southern California beach town. Mission San Buenaventura was the most successful and influential of the California Missions founded by Father Junipero Serra.

MALIBU

Imagine waking up and breathing in fresh ocean air while gazing at the vast horizon of the Pacific. This is Malibu– where people from the four corners of the world live and celebrate each day. The City of Malibu is a 27-mile strip of Pacific coastline, a beachfront community famous for its warm, sandy beaches, and for being the home of countless movie stars and others associated with the Southern California motion picture and recording industries.

 Located in Northwest Los Angeles County, here is where you will find a variety of climates and terrain including beaches, mesas and canyons that create this special environment. Malibu is a closely-knit residential community characterized by its carefully preserved rural atmosphere. Enjoying one of the prime locations anywhere in the world, Malibu embodies good people, beautiful surroundings, and a community that cares about the quality of life.

Duke's Restaurant - Malibu

©Ron Hughes

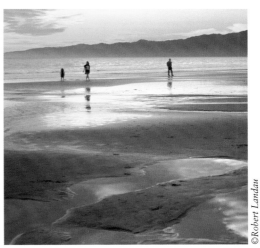

SANTA MONICA

Santa Monica is a city rich in tradition and diversity. The city grew from Spanish roots in the 1600's and blossomed with movie star glamour in the 1920's. Today Santa Monica mixes these eras and influences with a style and attitude unique among the California coastal towns.

Great weather, shopping, restaurants, art galleries, and world-class beaches define Santa Monica. The city has experienced a tremendous economic boom since the late 1980s through the revitalization of its downtown core, significant job growth, and increased tourism.

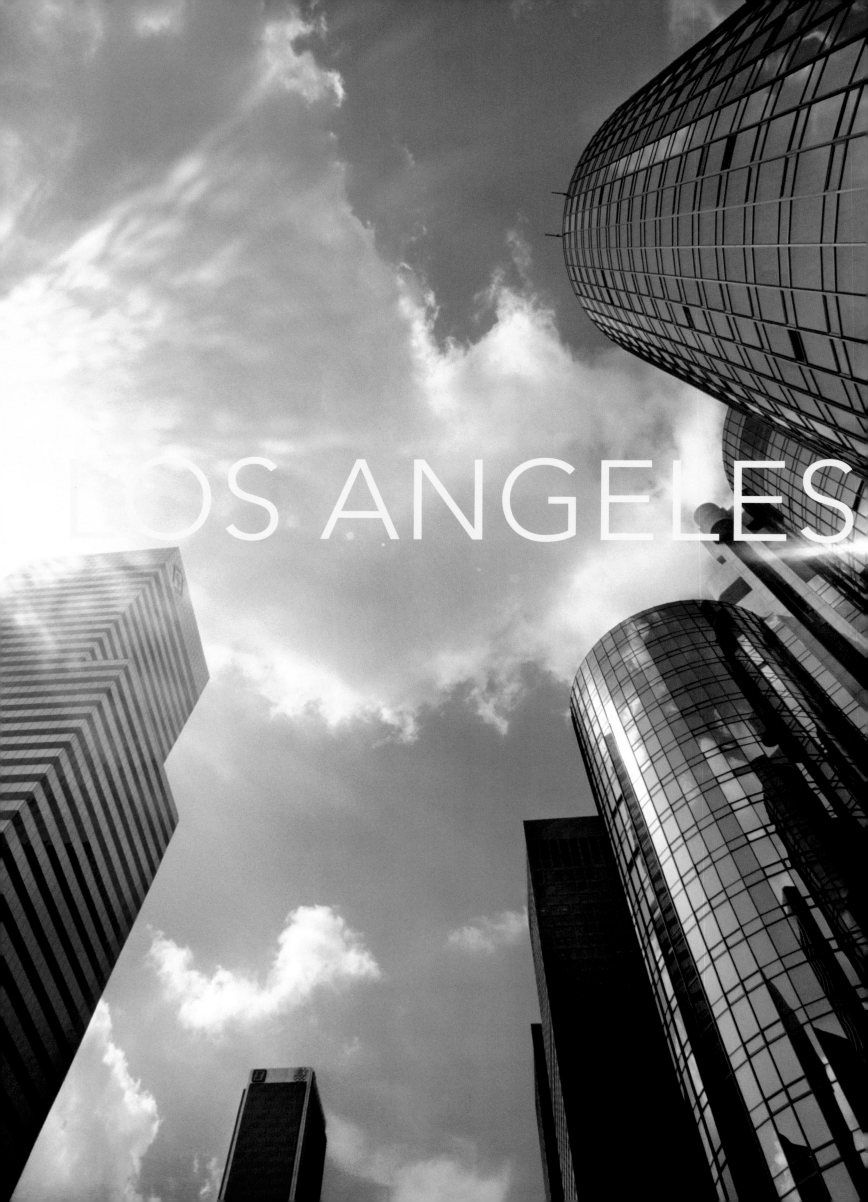

LOS ANGELES

The City of Los Angeles, also known as L.A. or the City of Angels, is the second-largest city in the United States as well as one of the world's most important economic, cultural, and entertainment centers. Los Angeles County has nearly 10 million residents—which represents 30 percent of California's population. With 4,083 square miles, it is larger than 42 states.

Sept. 4, 1781 became the city's official birth-date when 44 village settlers from the Mexican provinces of Sonora and Sinaloa made their home in what is now downtown Los Angeles. The Spanish named the new settlement "El Pueblo de Nuestra Senora la Reina de Los Angeles" or the town of the Queen of the Angels. After the territory changed hands from Spain to Mexico, the town was officially declared a city in 1835. In August of 1846, American soldiers entered Los Angeles and the Stars and Stripes have flown over the city since January 1847.

©Robert Landau

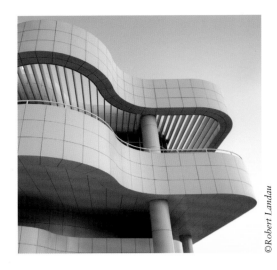

Diversity rules Los Angeles. From architecture, geography, and cultures to lifestyles, restaurants, entertainment and industry, this city is rich in variety.

LA spans a widely diverse geographic area. Primarily a desert basin, the area is surrounded by the San Gabriel Mountain range and divided by the Santa Monica Mountains.

Los Angeles is situated in a Mediterranean climate zone, experiencing mild, wet winters and warm to hot dry summers. Breezes from the Pacific tend to keep the beach communities of the area cool in summer and warm in winter. Best of all, the Los Angeles area averages 329 days of sunshine annually with an average high temperature in January of 66 degrees. Thanks to the unique geography, which ranges from 10,080-foot Mt. San Antonio to 81 miles of picturesque coastline, you can surf, snow ski and explore the desert all in the same day.

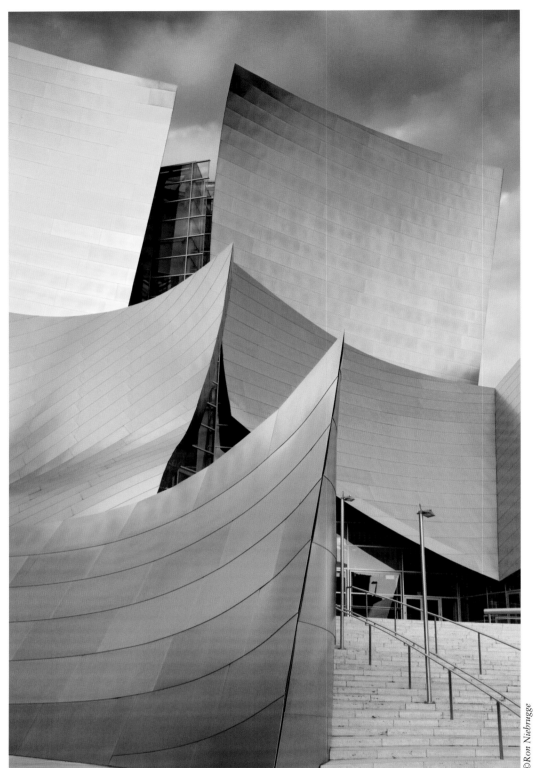

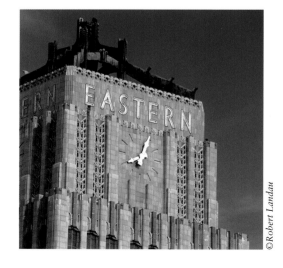

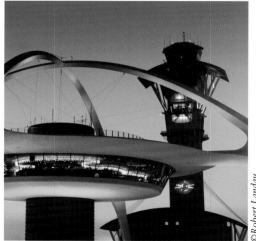

Driven by international trade, entertainment, aerospace, agriculture, petroleum, and tourism, the city is home to major Fortune 500 companies including aerospace contractor Northrop Grumman, energy company Occidental Petroleum Corporation and numerous others. Los Angeles is also on the leading edge of the growth industries. The metropolitan area's "Digital Coast" fills more multimedia jobs than Silicon Valley and New York City combined. If it were a separate country, California would have the fifth largest economy in the world and the L.A. five-county area would be No.10, just behind Brazil and ahead of Mexico.

With more than $146 billion of trading activity in the Los Angeles customs district (including the Port of Los Angeles, Port of Long Beach, LAX and smaller ports), Los Angeles is the No. 1 import/export port in the United States. Major exports include integrated circuits, aircraft and space craft, computers, aircraft parts and parts for office machines. Major imports are computers, passenger vehicles, integrated circuits, and office machine parts.

filmmakers, actors, dancers and musicians living and working in Los Angeles than any other city at any other time in the history of civilization. Creative expression is this region's most prolific natural resource and it shows in the variety of fun activities that abound in the L.A. region. From the Rose Bowl Parade in Pasadena to the Hollywood Christmas Parade, the Kwanzaa festival to the Playboy Jazz Festival—there are a host of activities year-round. Los Angeles has been called the entertainment capital of the world for good reason. There are classic theme parks, thrill rides, movie premieres, beaches, mountains, parks and spectator sports. People have always been attracted to the city for its balmy weather, its vibrant lifestyle, its unique, high-velocity energy, and the opportunity to realize the "American Dream."

All photos this page ©Robert Landau.

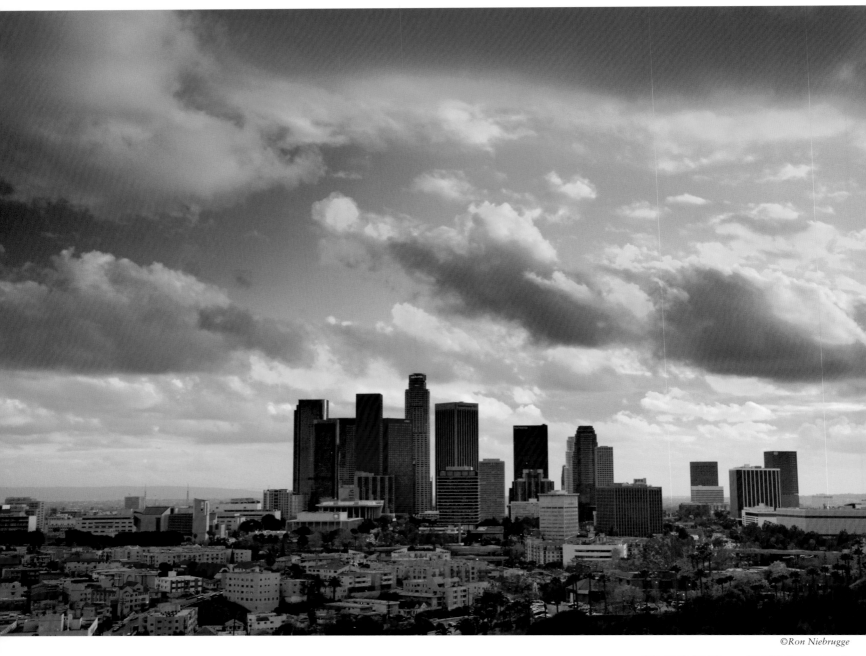

53

The city holds claim to many distinctions; besides boasting more than 300 museums, Los Angeles is the birthplace of the hula hoop, the Barbie doll, the Mazda Miata, the DC-3, Mickey Mouse, the Fender Stratocaster, the chaise lounge and the Space Shuttle and its multi-ethnic population makes it a cultural hub of the Pacific Rim.

If you're looking for an education, Los Angeles County is home to 158 colleges and universities including such prestigious institutions as Pepperdine, Occidental, The University of Southern California (USC) and UCLA.

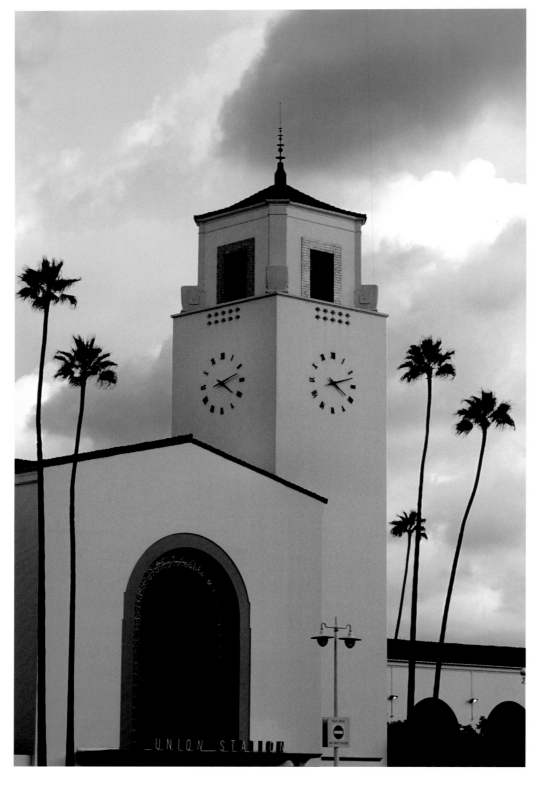

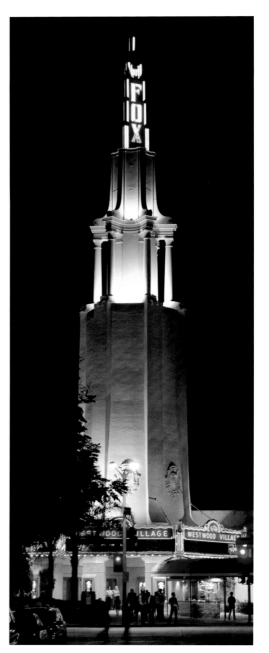

All photos this page ©Robert Landau

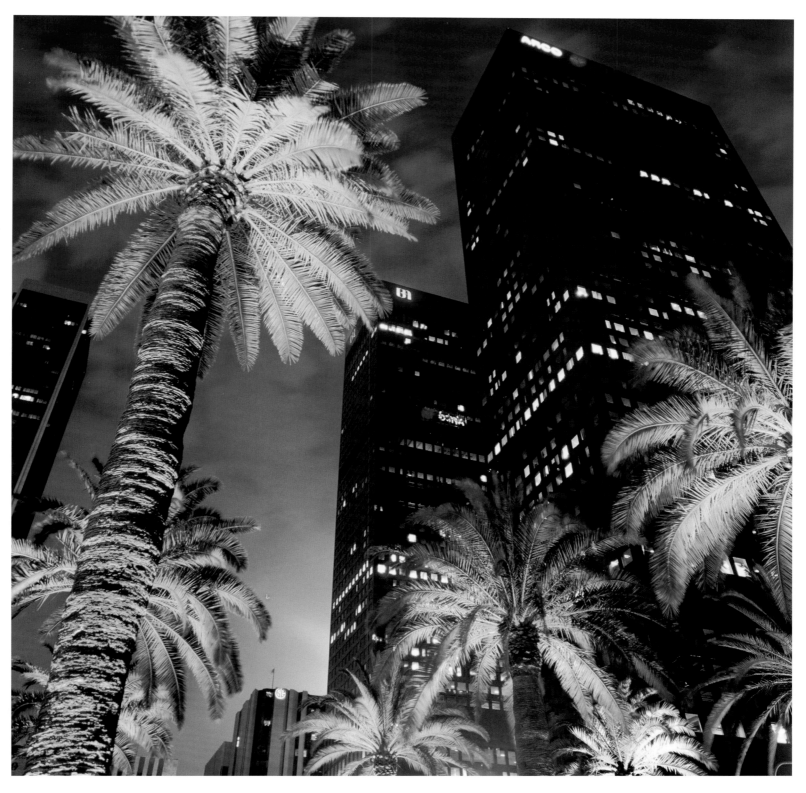

All photos this page ©Robert Landau

Catalina Island

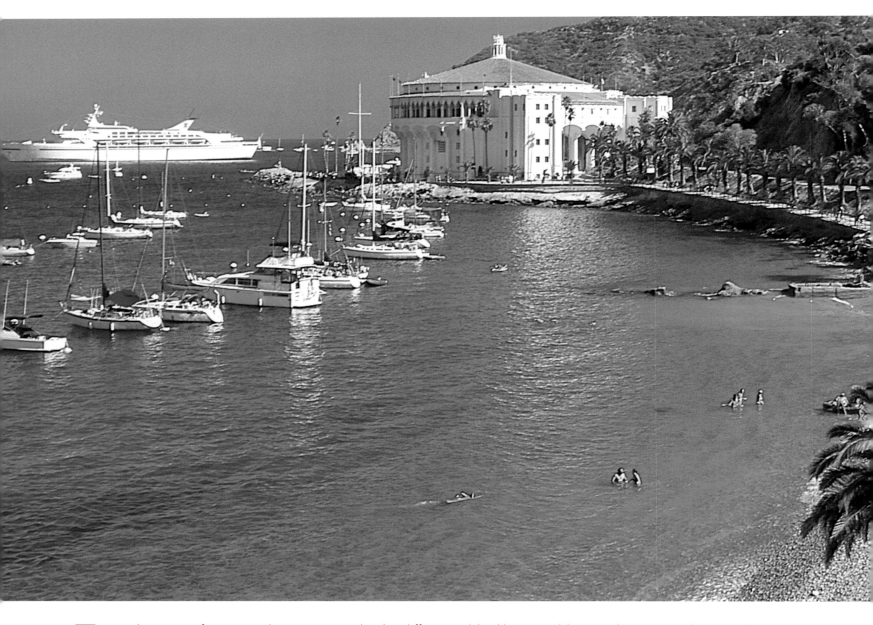

Quotes author J. Ivey from naturalist John Muir's 1888 publication *West of the Rocky Mountains:*

"On no portion of the Pacific Coast is color and beauty in rock and in water so rampant as at Catalina. Caves, fissures and precipices offer endless sources of interest and admiration to those who leisurely pull around its coast, while the sea is a thing of enchantment. In corners under the cliffs it trembles like emeralds liquefied. Its moving wave masses reflect a color seen nowhere else, except on the shores of the Western Atlantic, while to look over your boat as it floats in some, almost motionless, recess of a cliff is to receive a revelation of beauty; for through more than ten fathoms of water your vision of rock or of fish is as clear as though it were the surface."

The Santa Barbara or Channel Islands are a chain of eight rugged islands with many islets extending 150 miles along the Southern California coast. Of all the islands, Santa Catalina (Catalina for short) is the most economically developed. If you have only viewed the cliffs of Avalon from the Pacific Coast Highway, it's time to venture over to Catalina. Keep in mind that the use of motor vehicles is restricted, but not to worry, as most everything

©Gary Crabbe

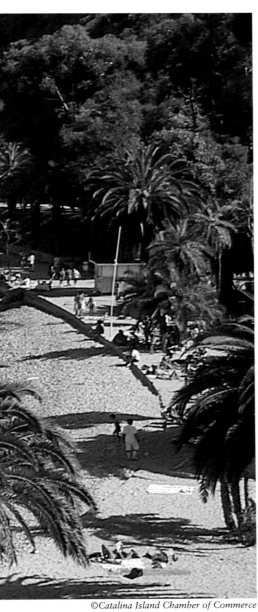
©Catalina Island Chamber of Commerce

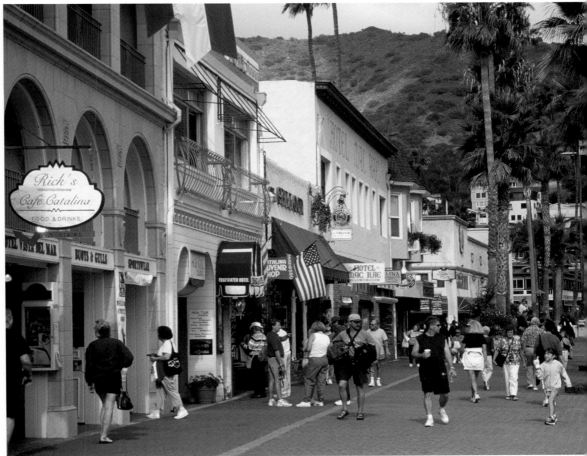
©Gary Crabbe

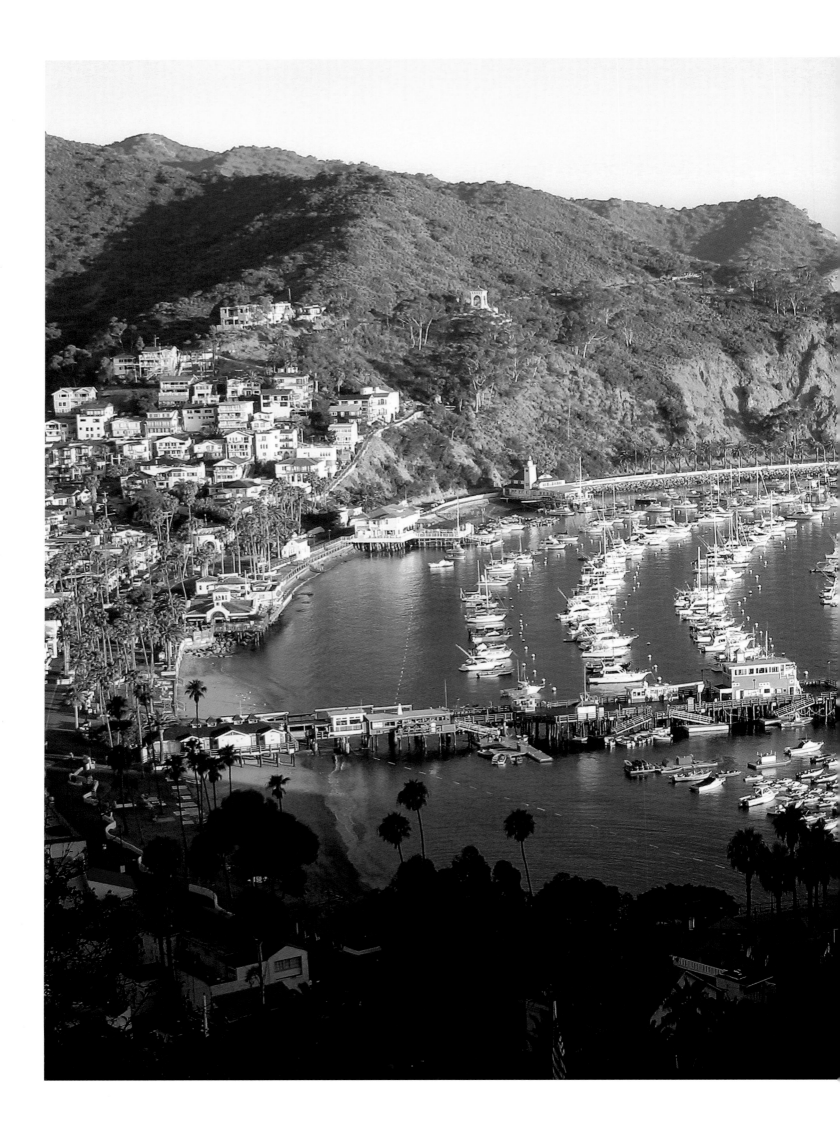

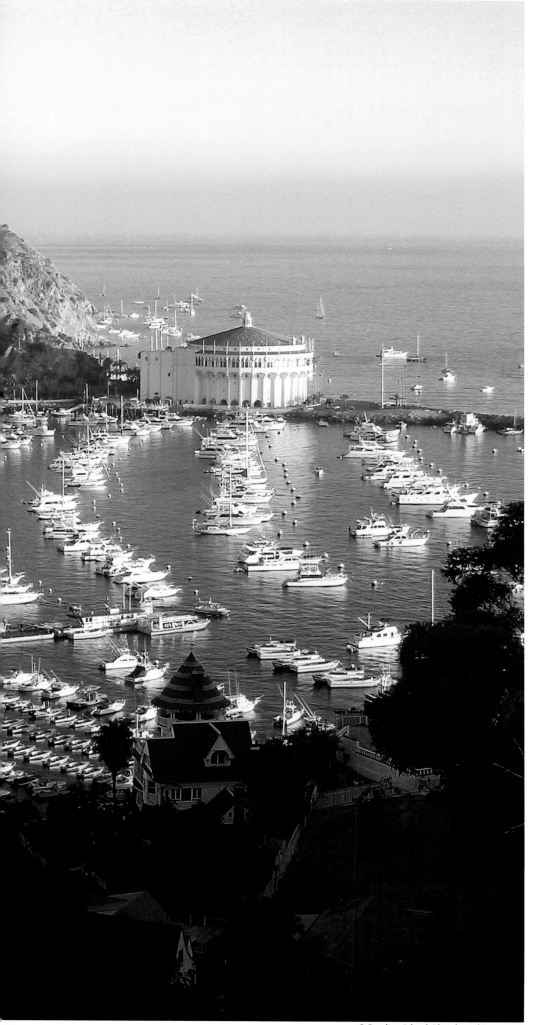

is within walking or biking distance, both premier Island activities.

The Catalina Casino has been the focal point of Catalina Island entertainment and culture since it opened in 1929. Dominating the Avalon landscape from its regal perch along the harbor, the casino exemplifies the style and romance of the island. Restored to its original condition, the Art Deco circular icon is a stunning reminder of Catalina's glorious past. There is, however, no gambling at this facility. Rather, the massive twelve-story building is divided into a spectacular grand ballroom, movie theatre and is also available for events and weddings.

Just one square mile large and filled with a beautiful coastline, shops and points of interest, the city of Avalon is easy to navigate on foot. When deeper exploration beckons bike into the island's interior (permit required) with a mountain bike and some stamina—the summit above Avalon is two-miles uphill.

To get here by water, the Catalina Express provides 25 daily departures. By air, the Island Express Helicopter Service is the fastest and most exhilarating transportation to the Island. The flight often overlooks pods of dolphins and whales, and always offers panoramic coastal views. The Airport in the Sky has a 3,250-foot runway that can accommodate most small planes.

As you stroll along the romantic pedestrian walkway in Avalon, striking views of the harbor, quaint shops and boutiques are everywhere. The crystal blue seas are known worldwide as one of the healthiest marine environments on the planet. With magical kelp forests and plentiful sea life, scuba diving and snorkeling are an experience you will never forget.

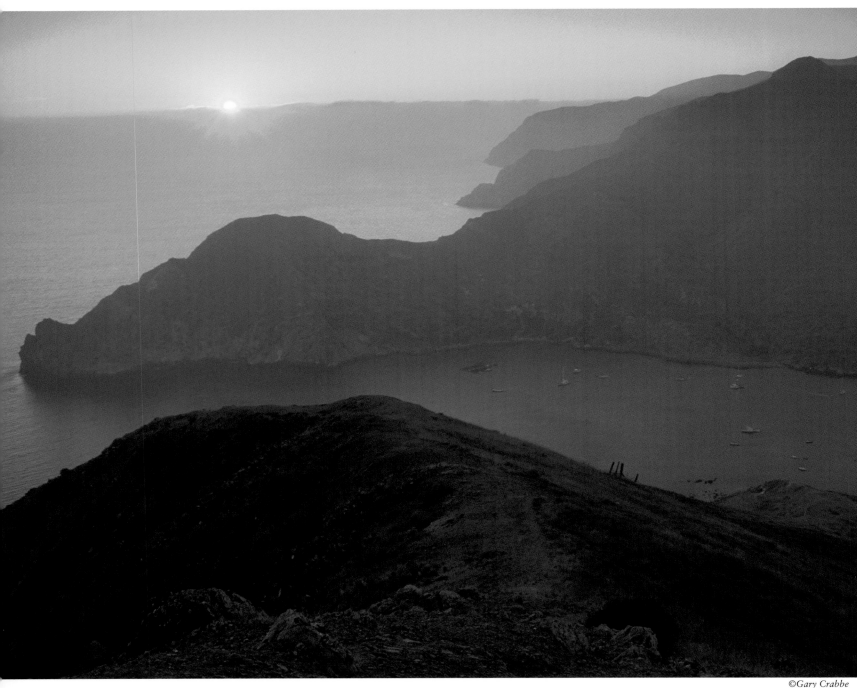

©Gary Crabbe

©Doug Gifford

In 1924, buffalo were turned loose on the Island for use in filming the motion picture, *The Vanishing American*. Today, they are managed by the Santa Catalina Island Conservancy, a non-profit organization dedicated to the conservation and preservation of the Island.

Avalon and Santa Catalina Island are made for exploring. Miles of back roads and trails are available, each offering fabulous views of the rolling hills and endless ocean, ensuring that you will go home with a memory to last a lifetime.

©Doug Gifford

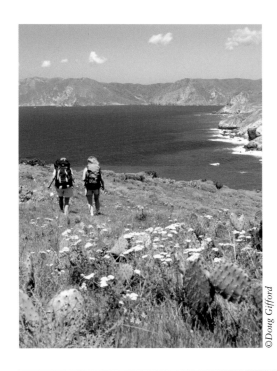
©Doug Gifford

©Doug Gifford

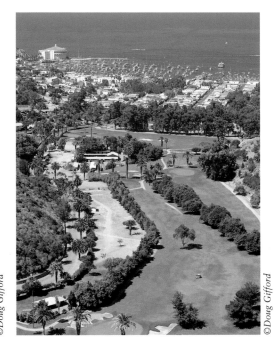
©Doug Gifford

©Doug Gifford

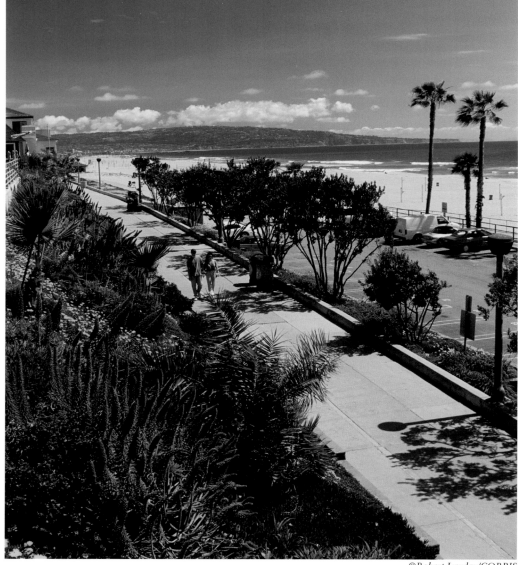

©Robert Landau

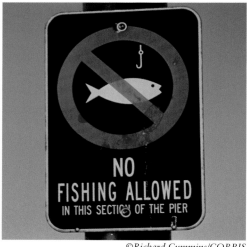

©Robert Landau/CORBIS

©Richard Cummins/CORBIS

MANHATTAN BEACH

Manhattan Beach is located 19 miles southwest of Los Angeles on the southerly end of Manhattan Beach and is one of the three Beach Cities in the South Bay including Hermosa Beach and Redondo Beach. For quality lifestyle, Manhattan Beach is one of the finest cities in California. A great selection of fine dining, excellent shopping and natural beauty help unify the city into a spectacular community. Being close to Hollywood, the city has been the production home to a number of popular television programs. The Manhattan Beach pier is seen as a symbol of the city and the beautiful beaches are popular with volleyball players, surfers, swimmers and sun worshipers. One visit and you will understand why Manhattan Beach lives up to its reputation as being the "jewel by the beach."

HERMOSA BEACH

Hermosa Beach is the essence of the California lifestyle. A sun drenched beach village, Hermosa sits at the edge of the Pacific, where the surf, sand and palms welcomes people year-round. Combining spectacular coastline, wide sandy beach, a century-old pier, rich history, colorful shops and restaurants, and lively festivals, this intimate community has long been a favorite with Californians.

Hermosa Beach is an important center for American beach volleyball competitions. The wide flat beach makes it one of the most popular places to play beach volleyball, from professional to amateur.

In the Spanish language, the word "hermosa" means beautiful and the city **is** true to the word. A beautiful place to live, Hermosa Beach offers a variety

of Southern California options for any lifestyle. There are residences on the Strand, bungalows scattered throughout the town, and multilevel homes in the hills with ocean views. By day and in the evening, Hermosa Beach is a special place, having one of the best beaches in the world and some of the best shops and restaurants in the South Bay.

REDONDO BEACH

Located in the choice coastal edge of Los Angeles County, just twenty miles from downtown Los Angeles and seven miles south of Los Angeles International Airport, Redondo Beach has been a preferred resort destination for more than a century and one of the most desirable areas to live in the country.

The coastline and beaches rival the most beautiful Mediterranean resorts. With

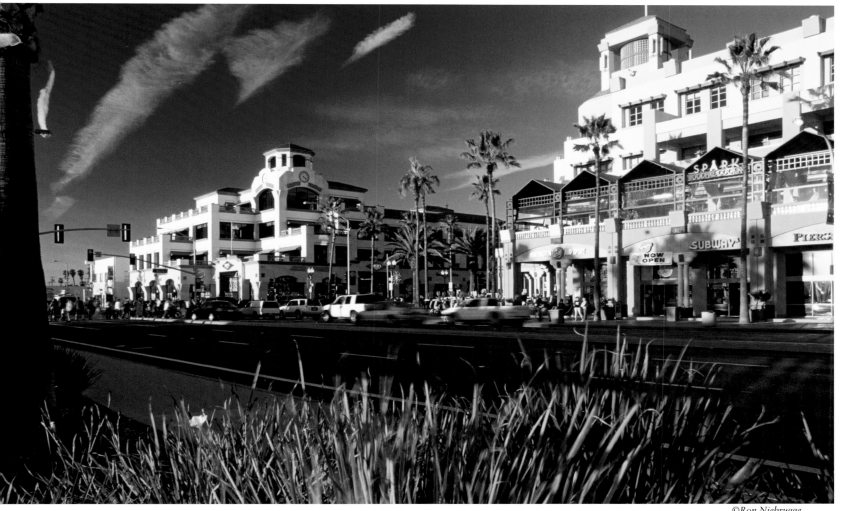

©Ron Niebrugge

a pleasure Pier for strolling, shopping and dining, a sport fishing fleet, a harbor with many seaside restaurants and cafes, Redondo Beach offers a unique and relaxing seaside ambience. With its variety of year-round attractions and events, accommodations to fit every style and budget, and shopping opportunities such as the Riviera Village and the Galleria at South Bay, the City is a fun and easy place to visit and play. The twelve public schools in Redondo Beach are among the finest "distinguished schools" in the country.

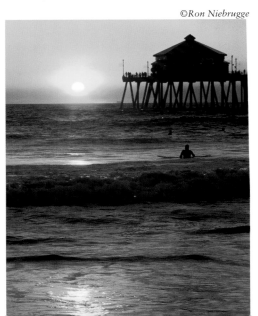

©Ron Niebrugge

HUNTINGTON BEACH

Huntington Beach is located 40 miles south of Los Angeles and provides easy access to Long Beach and all of Orange County. Internationally known as Surf City, Huntington Beach boasts eight miles of scenic, accessible beachfront, the largest stretch of uninterrupted beachfront on the West Coast. The beautiful and spacious beaches attract large crowds to watch professional sporting events as the U.S. Open of Surfing, AVP Pro Beach Volleyball and Van's World Championship of Skateboarding. The quality of life in Huntington Beach is enhanced by its reputation as one of the ten safest cities by City Crime Rankings and the quality of the community services offered to its citizens. The Huntington Beach Art Center and the Huntington Beach Playhouse provide a wide variety of fine arts, and the excellent library

system and numerous museums provide a strong cultural foundation. The Pier is one of Huntington Beach's focal points. With its sunny Mediterranean climate and idyllic setting, tourism remains a vital part of its economy. Today, thousands of visitors stroll along the pier and enjoy a meal at Ruby's Restaurant at the end of the pier.

LONG BEACH

Overlooking San Pedro Bay on the south coast of Los Angeles County, Long Beach is 22 miles south of downtown Los Angeles and 10 miles southwest of Anaheim. The Port of Long Beach is one of the busiest sea ports in the world, as well as one of the largest. Long Beach is California's fifth largest city and offers a unique combination of strategic location, excellent climate, shoreline beauty, and Southern California lifestyle wrapped in one package. From the emphasis on the "three T's" (Trade, Tourism and Technology), to the city's bountiful array of business and residential neighborhoods, it is no wonder Long Beach has become one of the leading regions for business, tourism and community in the west.

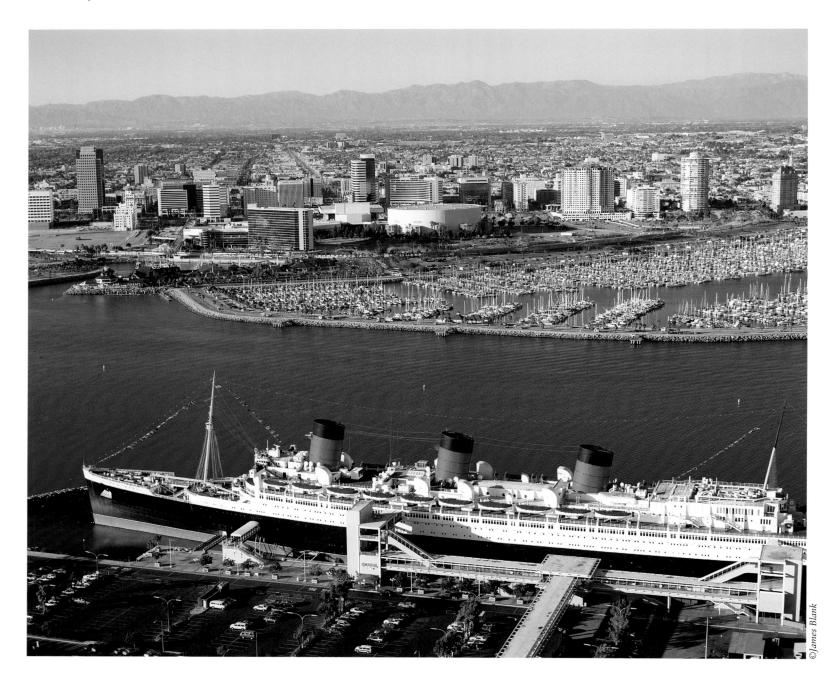

©James Blank

ANAHEIM

Anaheim is the second largest city in Orange County and is known for its amusement parks, sports teams, and fantastic convention center. Founded by fifty German families in 1857 as a colony of farmers and vintners, Anaheim has developed into an industrial center, producing electronics, aircraft parts and canned fruit. Anaheim is a blend of "Ana" after the nearby Santa Ana River, and "heim" a common German place name meaning home. Those early pioneers considered this location their home by the river.

The many attractions in Anaheim include Angel Stadium, Arrowhead Pond, and the largest convention center on the West Coast. Anaheim is also the home of the Disneyland Resort, a grouping of theme parks and hotels that originally opened in 1955.

©Robert Landau

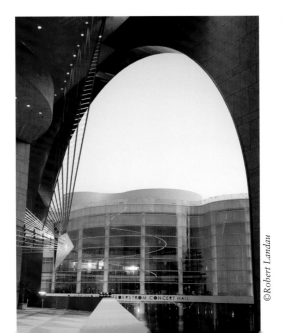

©Robert Landau

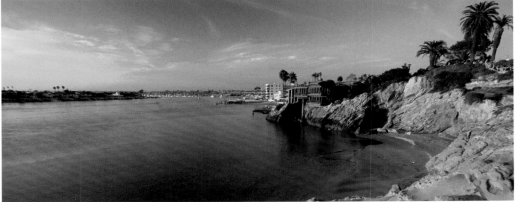

©Ron Niebrugge

LAGUNA BEACH

A very special place in Southern California, the city of Laguna Beach is well known as a unique beach community and artist's colony with seven miles of city beaches running along its nine square miles. During the summer, several million visitors are drawn to the resort environment for its picturesque beaches, art festivals and the Pageant of the Masters. Laguna's village scale shopping district, walkways and tram system create a pedestrian environment and scale that is unique in Southern California. Here is where you explore the tide-pools and enjoy the sunsets over the Pacific—just as the Indians, Spaniards and early artists who recognized Laguna's charm did in times gone by. Laguna's universal allure is best expressed on a famous gate built in 1935 that today stands at the corner of Forest and Park avenues. It reads, "This gate hangs well and hinders none, refresh and rest, then travel on."

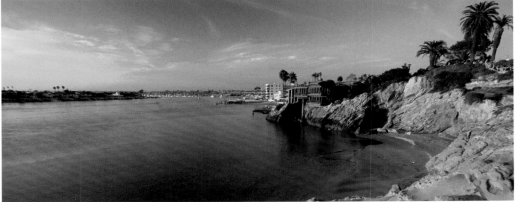

©Ron Niebrugge

Newport Beach is located between Huntington Beach and Laguna Beach and is home to a six-mile strip of sand that lies along the Balboa Peninsula, between Newport Bay and the Pacific. The upscale city boasts some of the most expensive real estate in Southern California.

Many of Newport Beach's activities are centered around the water, much like the city itself. Attractions include great surfing and beach activity, Crystal Cove State Park, and the Catalina Flyer, a giant 500 passenger catamaran, that provides daily transportation from the Balboa Peninsula in Newport Beach to Avalon on Santa Catalina Island. The historic Balboa Pavilion, established in 1906, is Newport Beach's most famous landmark.

The eight-block Cannery Village was once the center of the city's fishing industry. It now hosts restaurants, antique shops, galleries and a popular area called "Montmartre by the Sea," where artists paint and display their works. Newport Harbor is crowded with fishing and tour boats and its streets are busy with shoppers browsing Fashion Island, an open-air mall with more than 200 stores, restaurants and theaters. Catch a boat to Catalina Island, or take a ride around the Balboa Peninsula, which separates Newport Bay from the Pacific. You also can take the ferry over to Balboa Island. The charming community is home to dozens of gift shops, restaurants and the Balboa Fun Zone amusement park. Residents identify closely with their respective villages. Popular neighborhoods include Corona del Mar, West Newport, and Harbor, Lido and Balboa islands.

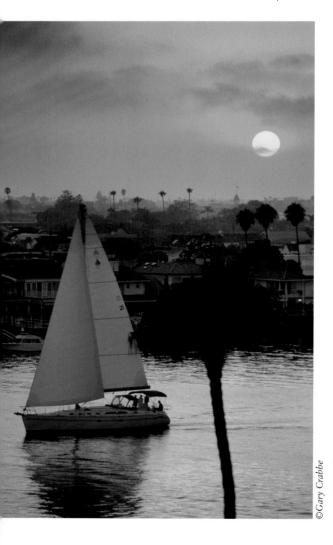

©Gary Crabbe

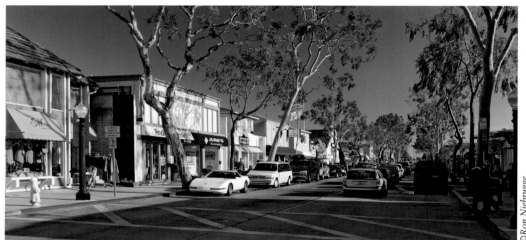

©Ron Niebrugge

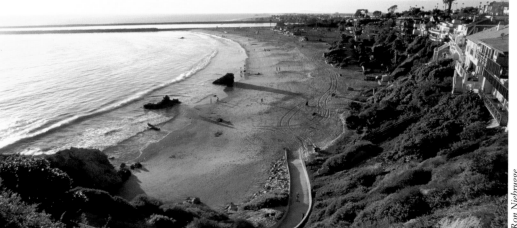

©Ron Niebrugge

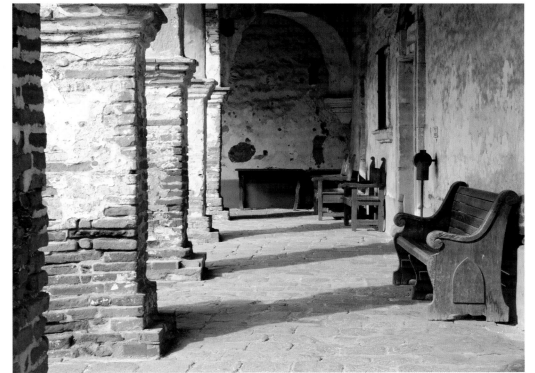

©Ron Niebrugge

Located in a little hilly valley next to the Pacific, the geography of San Juan Capistrano makes for a perfect climate. Settled midway between San Diego and Los Angeles, the city is the site of the mission for which it is named—Mission San Juan Capistrano. Founded in 1776 by Junipero Serra, the Mission is the seventh of the 21 Spanish Missions established in California by the Franciscan Padres. San Juan is also known around the world for its swallows. These protected birds make their annual return migration on or about March 19th of each year, arriving in the spring to nest and have their young, then returning to Argentina in the Autumn. The Swallows Festival or "Fiesta de las Golondrinas" is a two-month long celebration of the return of the swallows and begins in late February.

To live in San Juan Capistrano is to share in a rich historical legacy. Here is where you experience California's multi-cultural diversity of Native American, Spanish, Mexican and European heritage. The historic downtown area features the Mission, the Capistrano Depot railroad station and the beautiful Los Rios Historic District. To walk here is to feel the past in all its trials and successes.

Mission San Juan Capistrano is the third largest visitor attraction in Orange County behind Disneyland and Knott's Berry Farm. Today, the city is a historic cultural center full of art, music and magic, an ideal community in which to live and work. With abundant open space, hillsides, and a unique history, San Juan Capistrano provides its residents with a distinct sense of community.

©Ron Niebrugge

71

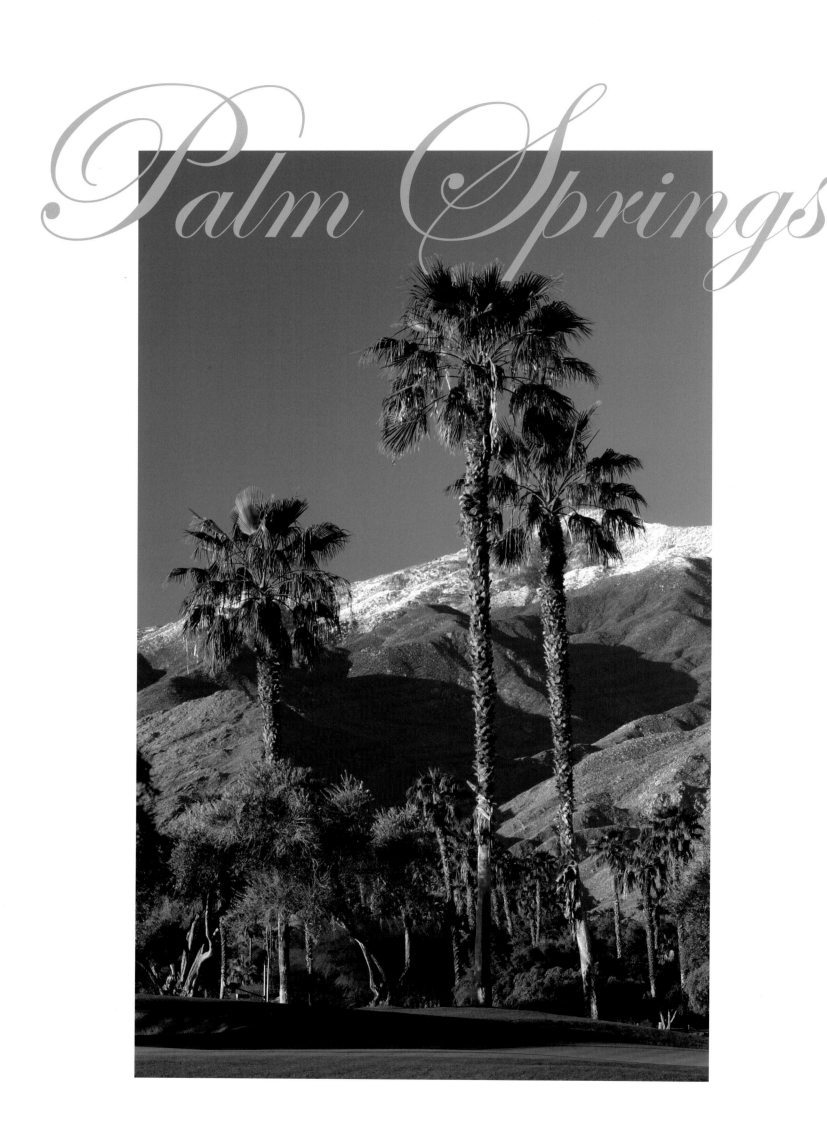

Palm Springs

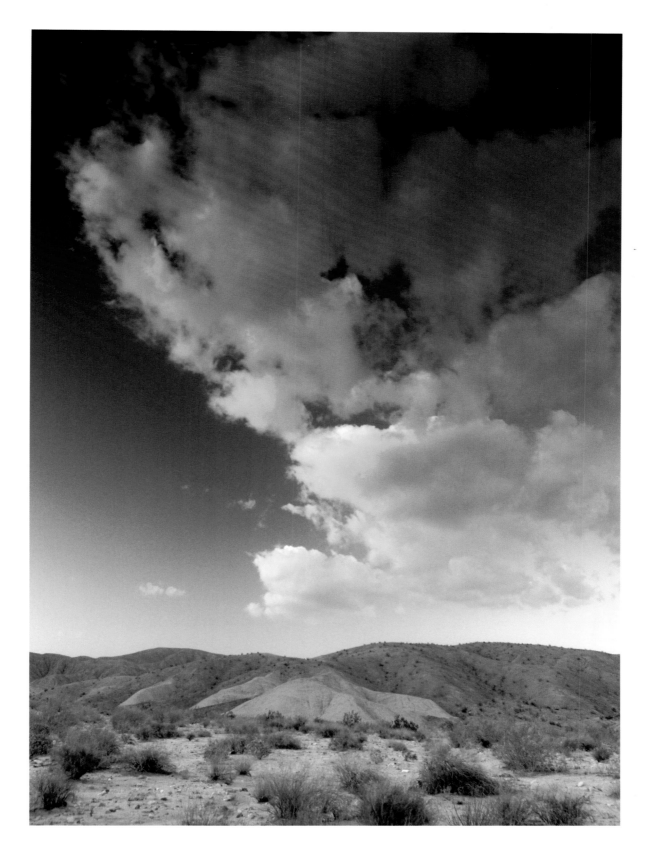

A premier vacation destination and desert resort, the city of Palm Springs is sheltered by the Little San Bernardino Mountains to the north, the Santa Rosa Mountains to the south, and the San Jacinto Mountains to the west. This geography helps give the area its famed warm, dry climate with 354 days of sunshine and less than 6 inches of rain annually. Winter temperatures average in the 70's with nights in the low to mid-40's while the dry desert heat of summer can push the daytime temperatures well above 100°F.

Located at the western end of the Coachella Valley, the Palm Springs area is composed of nine cities: Palm Springs, Desert Hot Springs, Cathedral City, Rancho Mirage, Palm Desert, Indian Wells, La Quinta, Indio, and Coachella. The city of Palm Springs is within the ecological area known as the Colorado Desert and is 487 feet above sea level. Rising behind the downtown is the impressive Mt. San Jacinto with an elevation of 10,831 feet.

Photography by Tom Brewster except where noted.

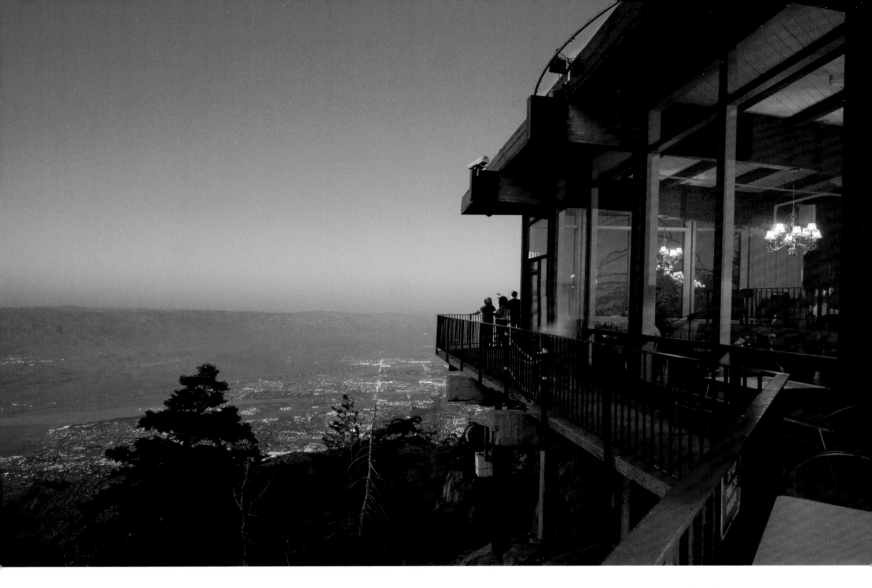

It is not uncommon to be swimming in 80-degree weather while looking up at this majestic snow-covered peak.

The original inhabitants of Palm Springs were the Agua Caliente Band of Cahuilla Indians. They named the area "la palma de la mano de Dios" (the palm of God's hand), while the name "Palm Springs" came from the natural mineral springs the Cahuilla claimed had magical powers. The original springs are now a part of the downtown Spa Resort Hotel, which is owned by the Agua Caliente Band. In fact, they still own half of the land in the city and in 2004 added a luxurious gambling casino across the street.

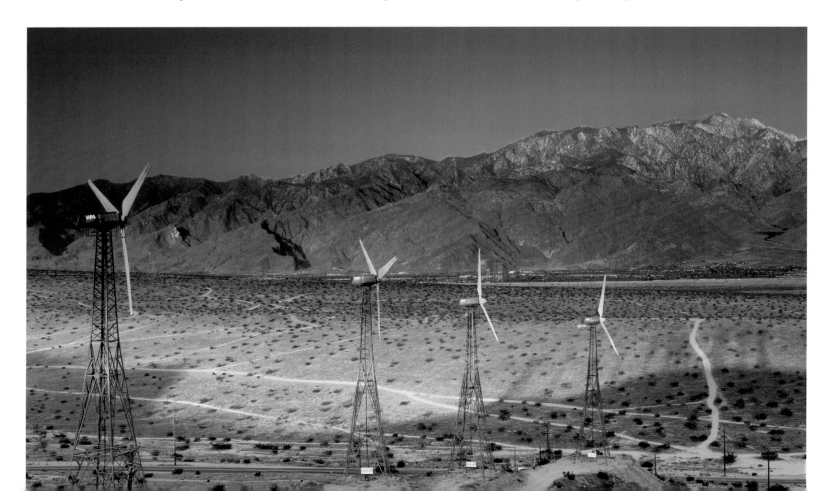

Recently there has been a fascination with mid-century modern architecture, something Palm Springs is proud to have as part of its mix of eclectic design styles. This form of architecture is reflected in the work of Albert Frey (who designed the Palm Springs tram station), and others. Alexander Homes popularized this post-and-beam architectural style in the Coachella Valley by building homes featuring low-pitched roofs, wide eaves, open-beamed ceilings and floor-to-ceiling windows to create an indoor/outdoor ambience suitable for private, poolside living in the desert climate.

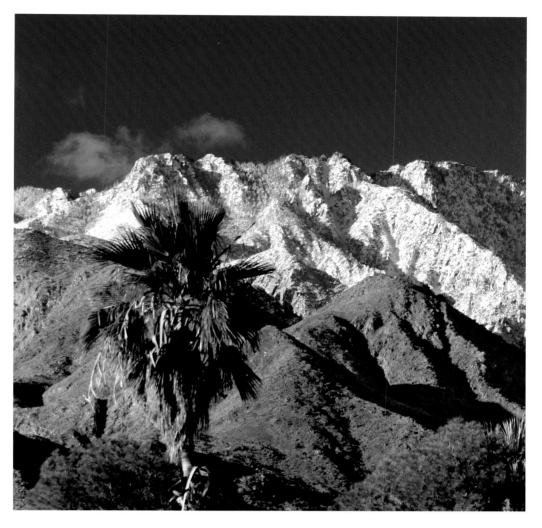

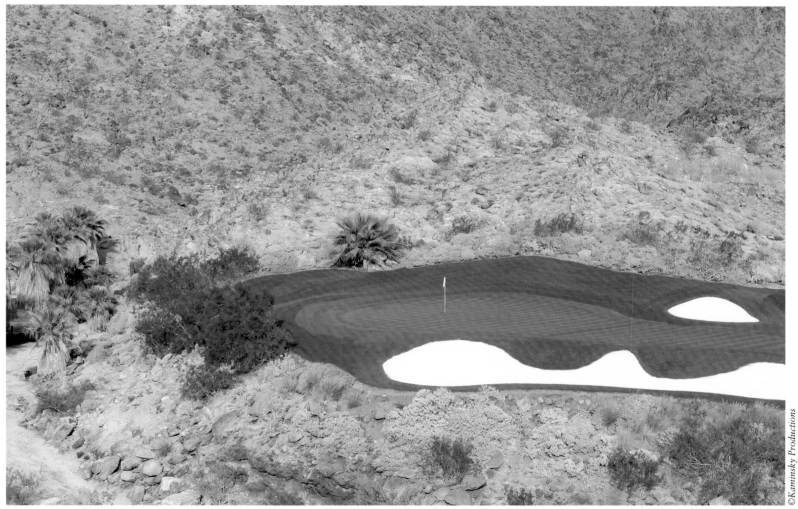

©Kaminsky Productions

Because the sun shines nearly every day, outdoor recreation abounds, including world renown golf, tennis, swimming, hiking and horseback riding. From the desert floor you can travel 8,500 feet up Mt. San Jacinto aboard the Palm Springs Aerial Tramway as it makes the scenic trip to its mountain station, or cruise a few hundred feet above ground in one of the many hot air balloons that hover gracefully over the valley. Spend a day at The Living Desert where you'll see hundreds of small desert dwellers and much bigger species including Big Horn Sheep, leopards and camels.

 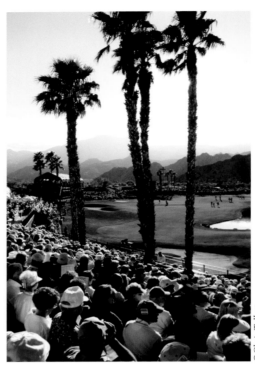 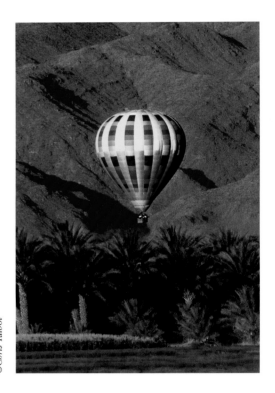

©Chris Talbot

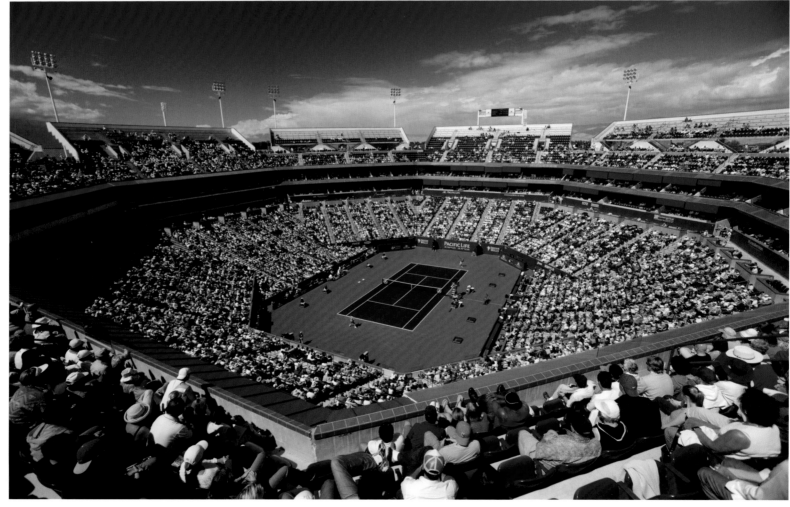

In downtown Palm Springs, the palm trees grow tall and straight along Palm Canyon Drive. Cruise the one-way strip lined with antique shops, art galleries, boutiques, restaurants and night clubs and you'll soon spot something that will catch your eye.

With the tranquility of its desert and mountain setting, and its many year-round outdoor activities and points of interest, Palm Springs attracts the attention of those who want to live in one of the most unusual and appealing resort areas in the country.

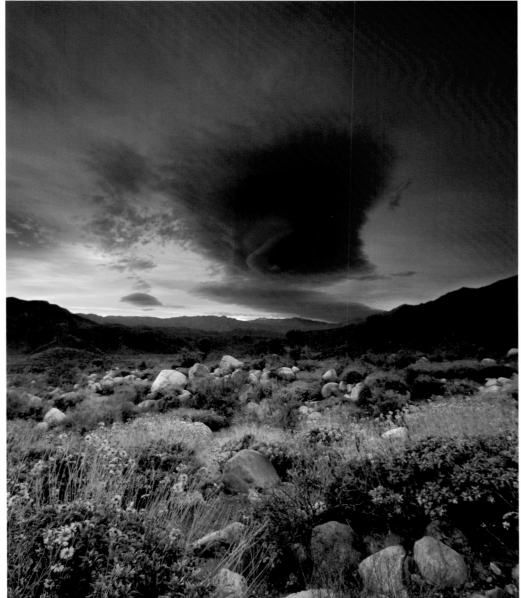

©Kaminsky Productions

77

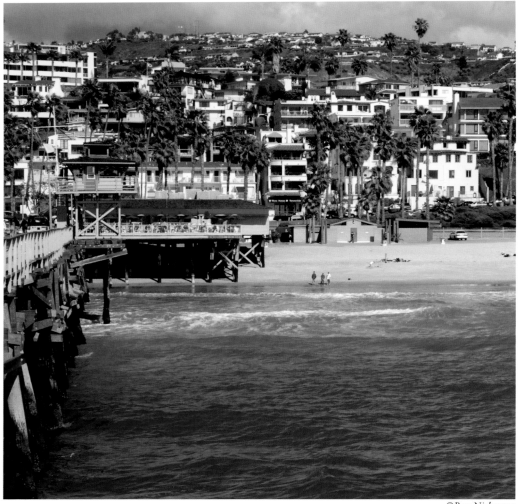

©*Ron Niebrugge*

SAN CLEMENTE

Located halfway between San Diego and Los Angles at the southern tip of Orange County, San Clemente residents often think of their town as paradise, where the sun shines 342 days a year and where the conveniences of metropolitan Southern California are balanced by fresh ocean air and beaches untouched by time. Just 75 years ago, most of the coastal land between Los Angeles and San Diego was no more than barren rolling hills covered with mustard and sagebrush. San Clemente was no exception. Today, the city is known as "The Spanish Village by the Sea" for its magnificent coastline and beautiful Mediterranean lifestyle. The city of San Clemente was founded in 1925 by real estate developer Ole Hanson who named it for San Clemente Island. In an unprecedented move, he had a clause added to the deeds requiring all building plans to be submitted to an architectural review board.

San Clemente is a premier surfing destination, catching swells all year long. The San Clemente State Beach is popular with surfers. Skin diving, body surfing and hiking along the trails on the landscaped bluff are other popular activities.

OCEANSIDE

This is a thriving community that provides all the conveniences of a modern city without the disadvantages. World War II saw Oceanside grow from a sleepy little town to a modern city. With the construction of the nation's largest Marine Corps Base, Camp Pendleton on her border, the demand for housing and municipal services exceeded supply. Centrally located in the heart of the beautiful Southern California coastline, Oceanside is among the region's best places to escape the hustle and bustle of the crowded cities. Located just 35 miles north of San Diego and 83 miles south of Los Angeles gives the city a unique location on California's main highway, Interstate 5. Oceanside enjoys proximity to all major Southern California destinations, while at the same time maintaining its coastal beauty and autonomy. Being a classic Southern California community, and recognized as a mecca for water sports, there are plenty of activities in Oceanside. With over 3.5 miles of spectacular white sandy beaches, this is the ultimate place for sunning, surfing, playing and relaxing. Sports fishing, whale watching, kayaking and jet skiing are available along with bike riding, rollerblading, skate boarding, bird watching and historical tours. Steeped in history and just minutes away is Mission San Luis Rey de Francia, the "King of Missions." Behind the Mission is Heritage Park Village and Museum with an idyllic main street lined with many of Oceanside's historic buildings. A quaint beachfront community, Oceanside is quintessential California.

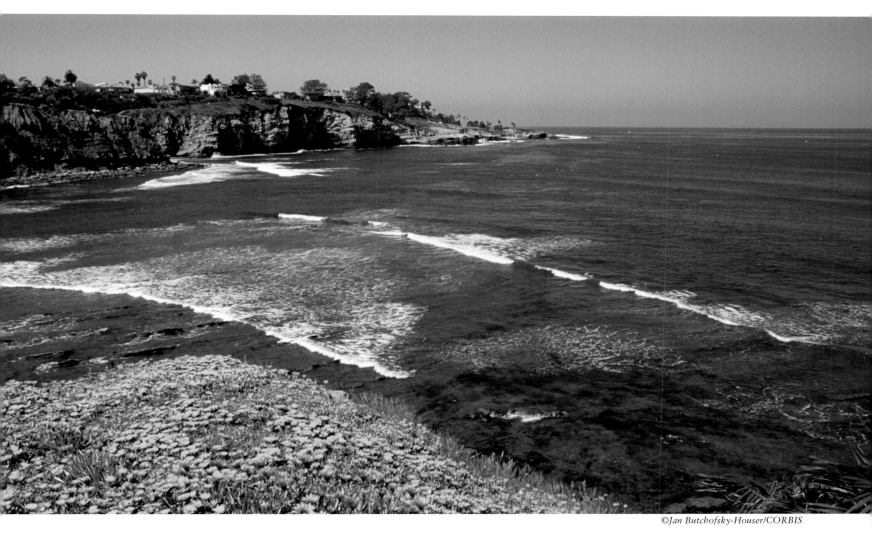

LA JOLLA

Located 15 minutes from downtown San Diego, La Jolla has long been a favorite vacation destination. Here you will find a majestic coastline, ideal weather, wonderful beaches, cultural activities and renowned institutions such as the Scripps Institution of Oceanography, the Stephen Birch Aquarium & Museum and the University of California, San Diego. And just to the east, the famous Del Mar Racetrack.

The exact origin of the name La Jolla remains somewhat of a mystery. Some claim it means "the jewel" from the Spanish word La Joya while others say it comes from an Indian term "Woholle" …meaning "hole in the mountains." What is clear however, are the soft sand beaches and the watercolor sunsets. While La Jolla is known to be one of the most affluent communities in the U.S., it's a unpretentious community proud of its natural beauty and coastal spirit.

Del Mar Racetrack

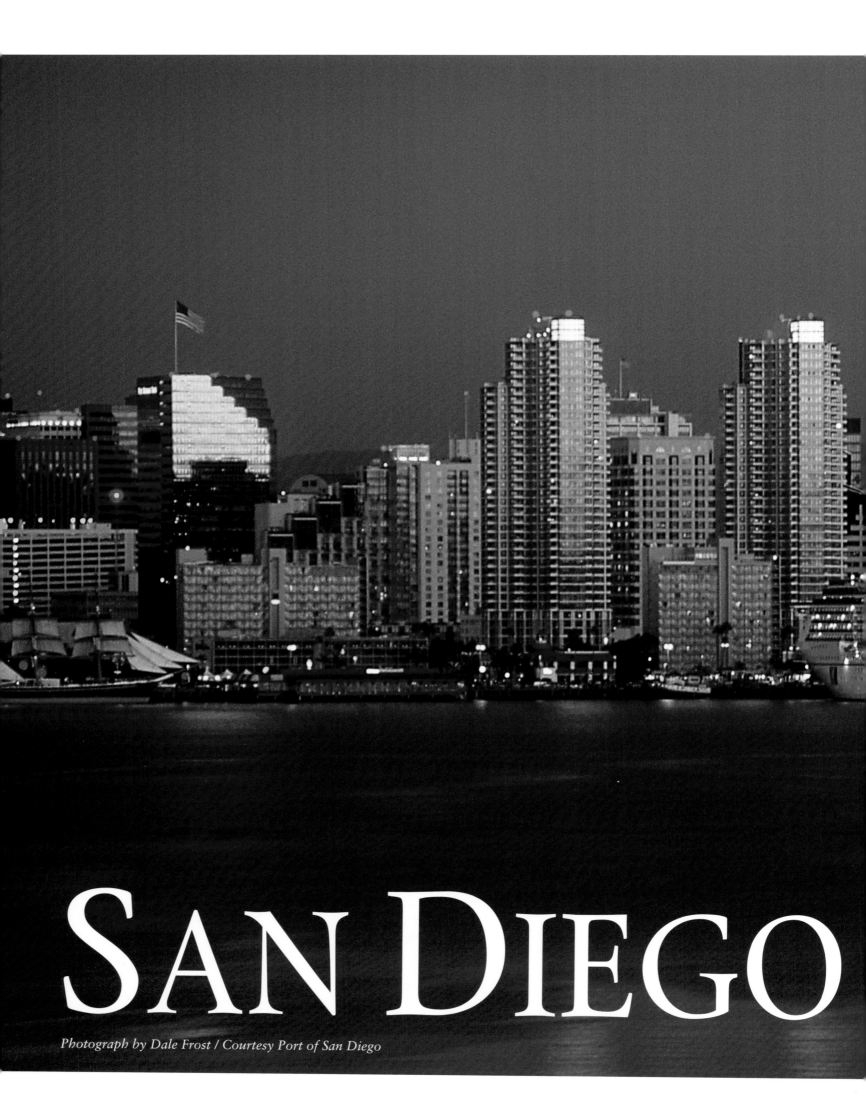

SAN DIEGO

Photograph by Dale Frost / Courtesy Port of San Diego

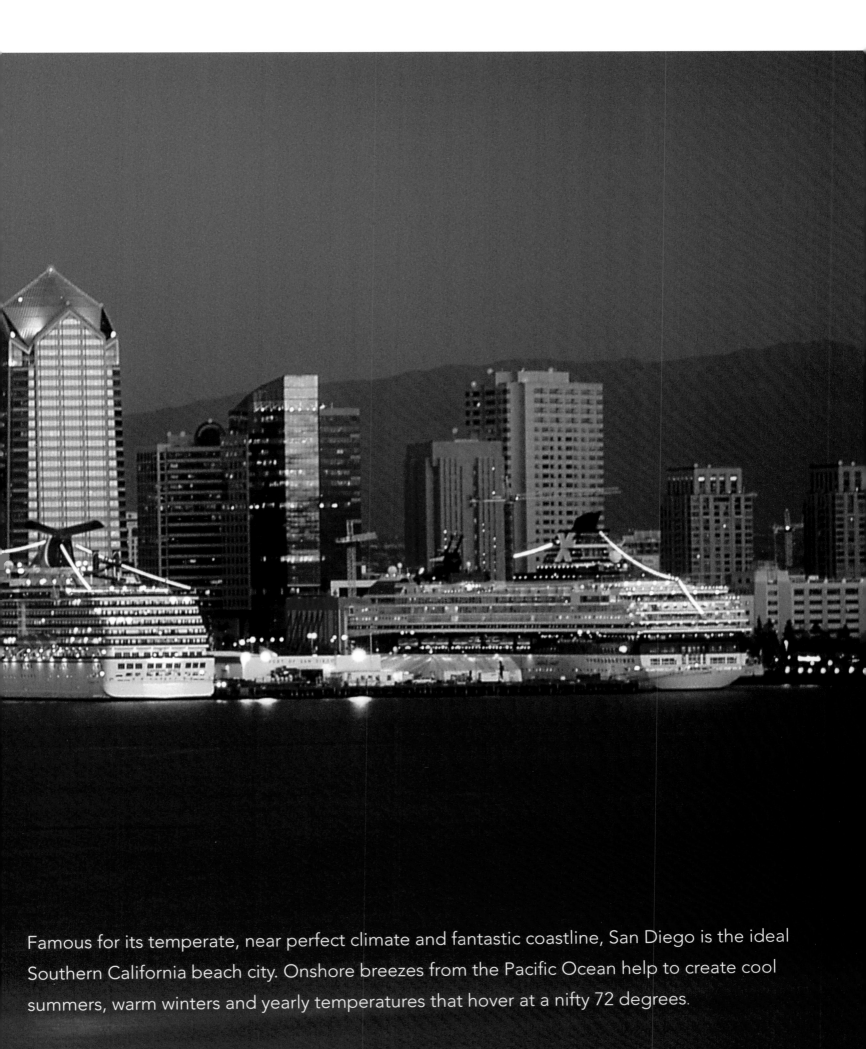

Famous for its temperate, near perfect climate and fantastic coastline, San Diego is the ideal Southern California beach city. Onshore breezes from the Pacific Ocean help to create cool summers, warm winters and yearly temperatures that hover at a nifty 72 degrees.

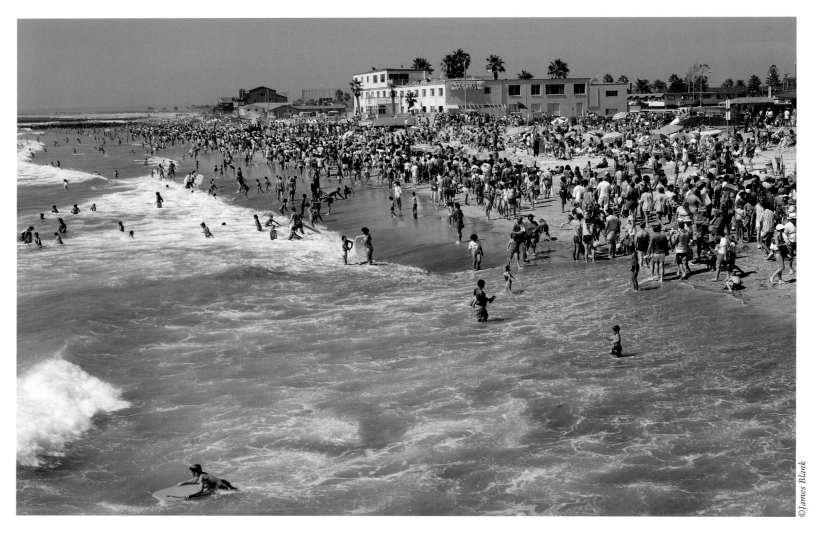

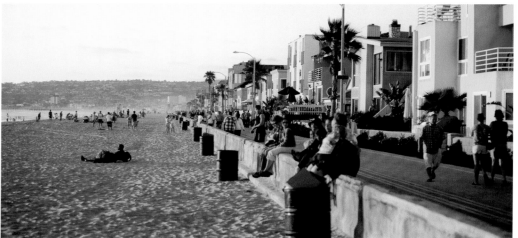

San Diego is home to many U.S. military facilities, including Marine Corps bases and Coast Guard stations, and is the homeport of the largest naval fleet in the world. With its great weather, miles of sandy beaches, major attractions and borders with Mexico, the Pacific Ocean, the Anza-Borrego Desert and the Laguna Mountains, San Diego is known worldwide as one of the best tourist destinations.

The birthplace of California may have started as a sleepy mission town, but the city of San Diego is now home to more than 2.7 million people and is a great spot to enjoy the history of southern California. Steeped in Mexican and Spanish heritage, the area's museums and attractions bring its history to life, and have created a rich and vibrant cultural center of information. With its ethnic and cultural mix, the city is well known

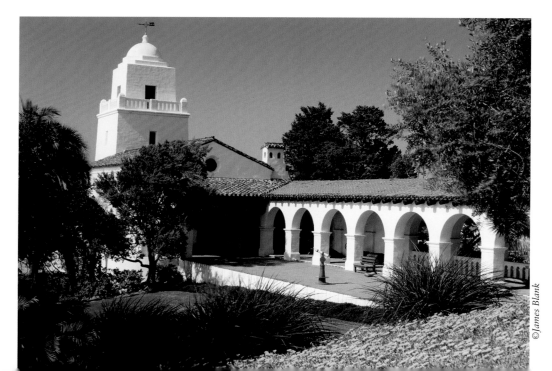

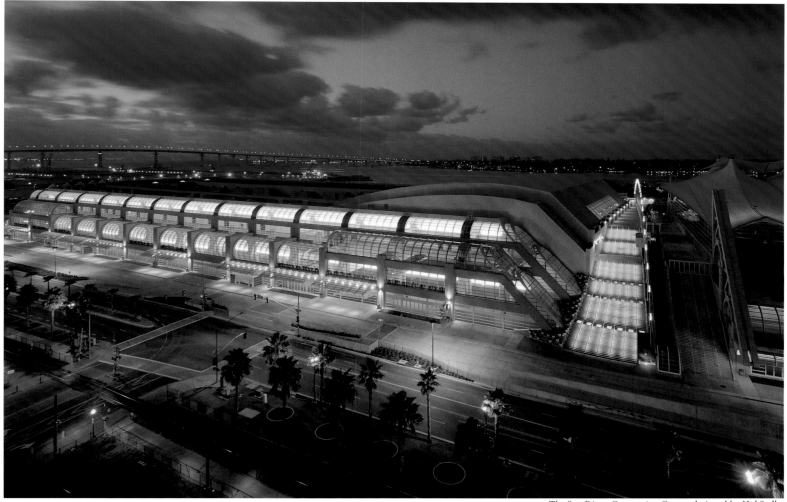

The San Diego Convention Center, designed by Hal Sadler

for a myriad of fine dining experiences. Mexican, Italian, Greek, Latin, Asian, Middle Eastern and Pacific Islander restaurants abound throughout with several of the finest dining choices found in the Gaslamp Quarter, Little Italy, La Jolla and Old Town.

Here, entrepreneurs are building one of the great technology regions of the twenty-first century. Fueled by research

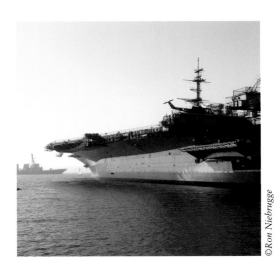

©Ron Niebrugge

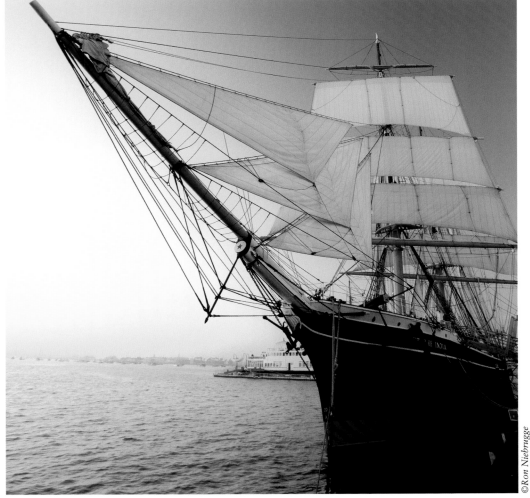

©Ron Niebrugge

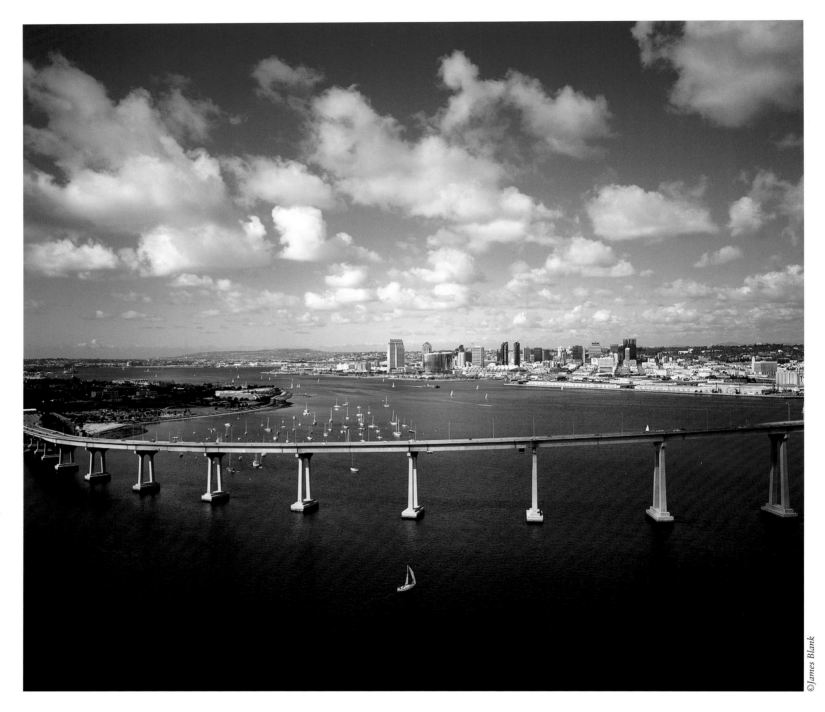

©James Blank

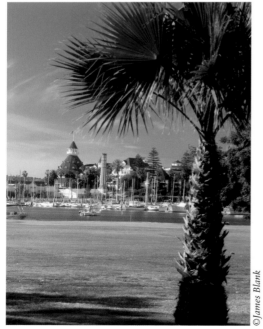

©James Blank

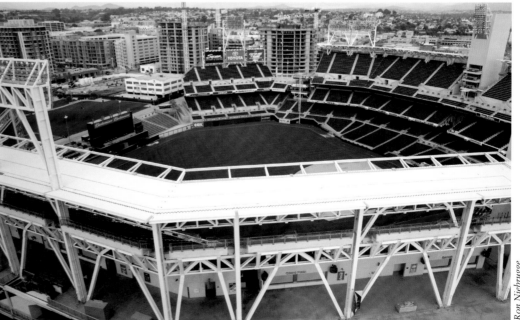

©Ron Niebrugge

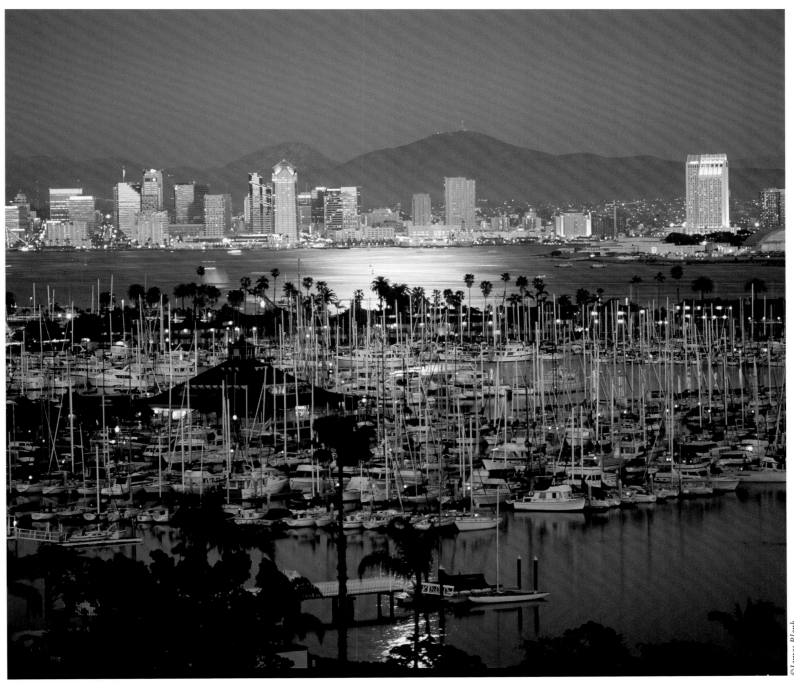

©James Blank

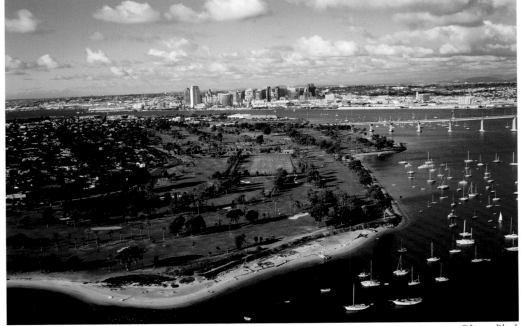

©James Blank

being done at San Diego's world-class universities and institutes, and supported by a business-friendly public sector, the region is a hotbed for new companies.

Next to its long-standing defense and military-based economy, high technology and medical technology have come into the forefront as major areas of economic growth. The biotechnology community is the third largest in the country, and the local communications industry has earned the title of "wireless communications capital of the world."

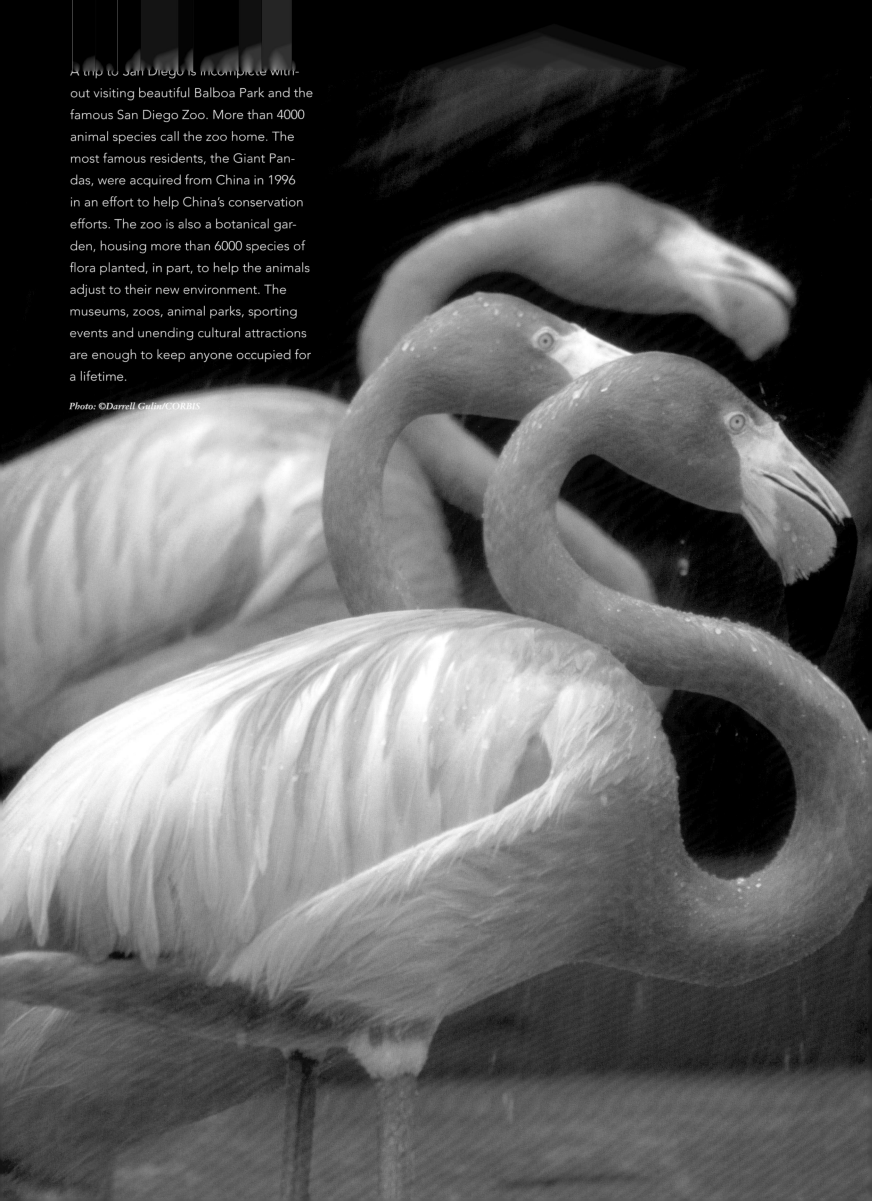

A trip to San Diego is incomplete without visiting beautiful Balboa Park and the famous San Diego Zoo. More than 4000 animal species call the zoo home. The most famous residents, the Giant Pandas, were acquired from China in 1996 in an effort to help China's conservation efforts. The zoo is also a botanical garden, housing more than 6000 species of flora planted, in part, to help the animals adjust to their new environment. The museums, zoos, animal parks, sporting events and unending cultural attractions are enough to keep anyone occupied for a lifetime.

Photo: ©Darrell Gulin/CORBIS

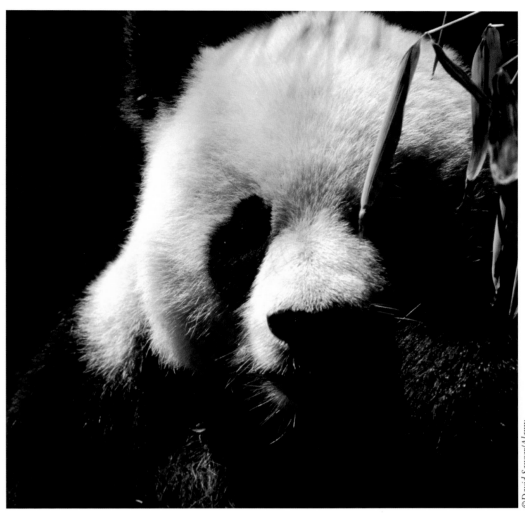

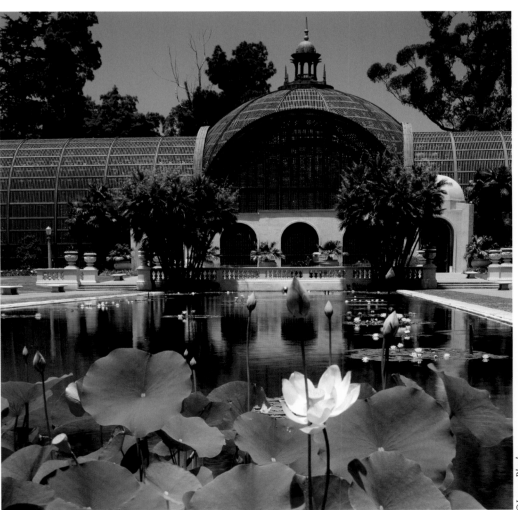

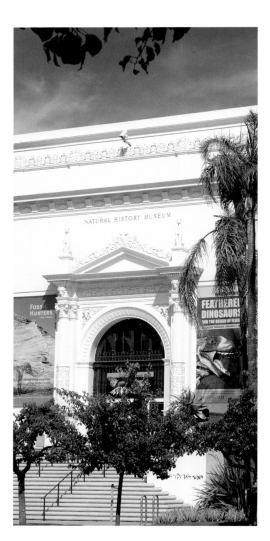

All photos this page ©Ron Niebrugge

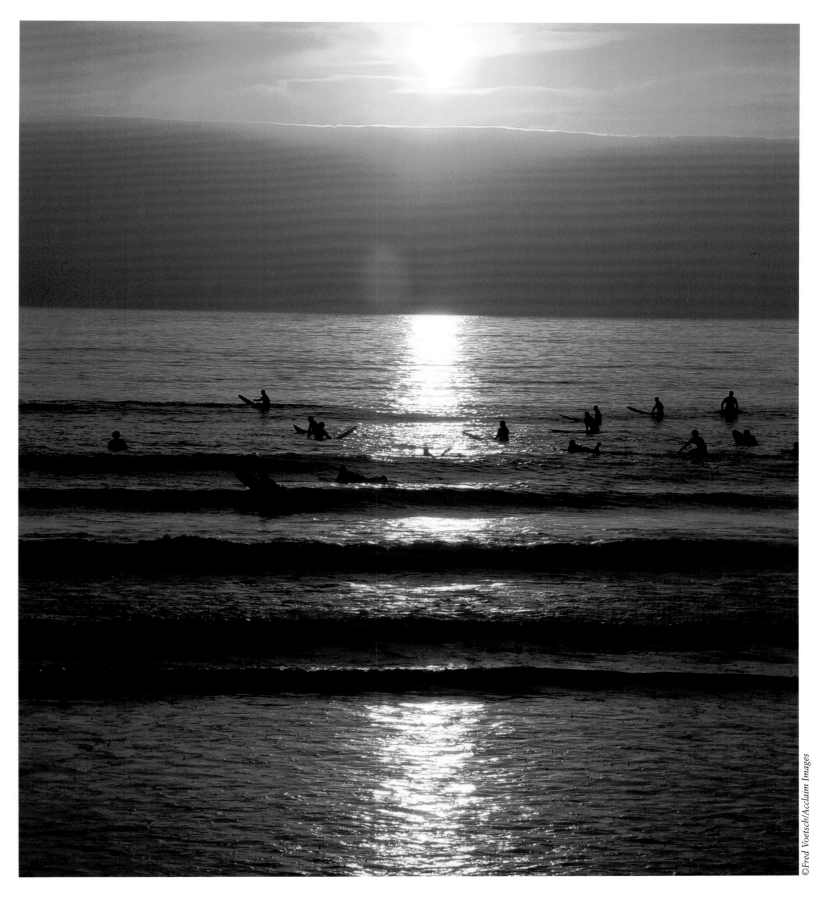

San Diego is a major tourist destination, attracting visitors from all over the world. A trip to San Diego is incomplete without visiting beautiful Balboa Park, the cultural heart of the city. The park is one of the largest in the country and houses more than 20 museums and various attractions devoted to fine art, folk art, astronomy, history, aerospace technology, sports, and model railroads.

For shopping, downtown San Diego is a shopper's dream-come-true with all the boutiques, art galleries, and upscale clothiers that reside in the Gaslamp Quarter. Horton Plaza, a colorful, multi-level six-block shopping mall is an attraction in itself. However you look at it, San Diego offers a lifestyle and lifetime of opportunity and entertainment for locals and visitors alike.

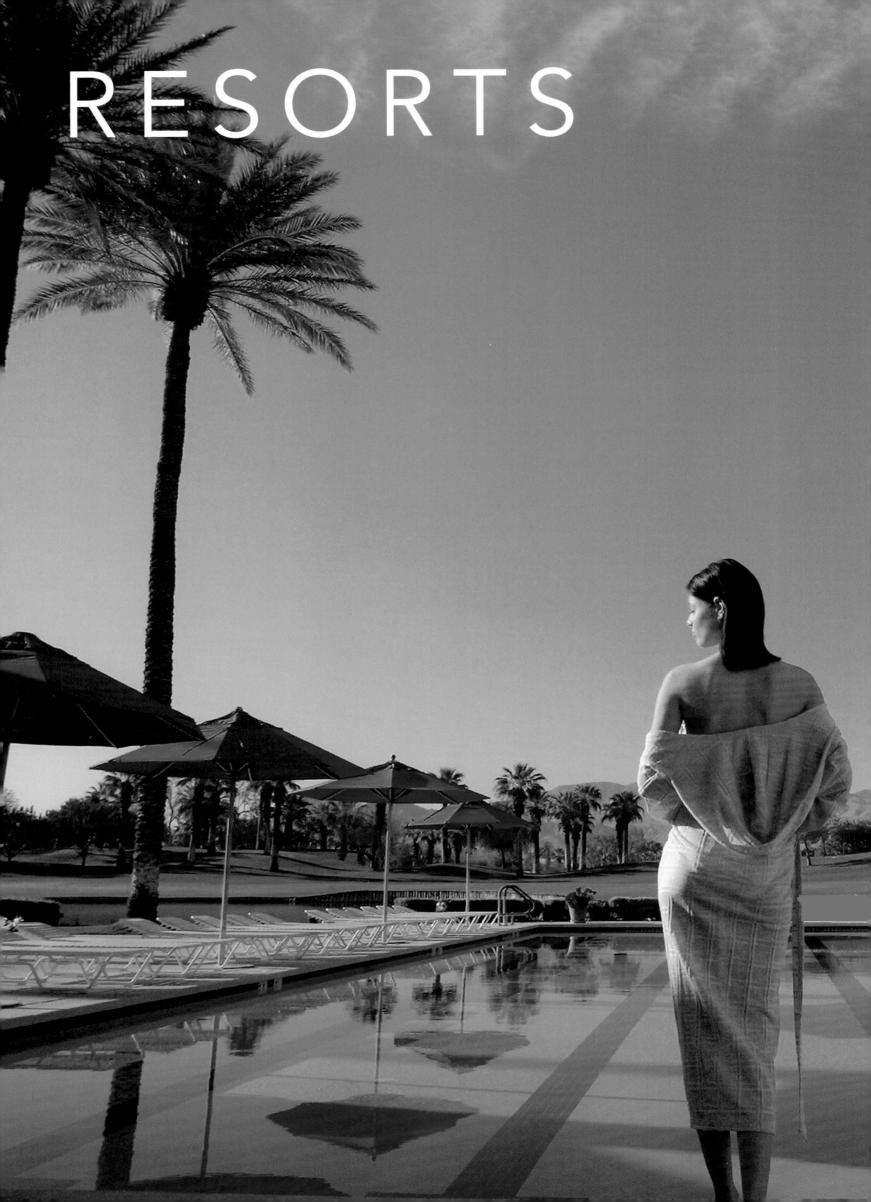

RESORTS

CALIFORNIA RESORTS LEAVE NORMS BEHIND. WHETHER IT'S THE SUN, THE COLORS, THE WATER, THE PALM TREES, THE SCENERY, THE STYLE AND OPULENCE, OR THE OPEN INVITATION TO INDULGE, THIS *EN LUXE* LIFESTYLE IS UNIQUE ON THE EARTH. FROM CLASSIC SEASIDE PALACES RISING FROM THE SAND, TO RENOWNED GOLF ENCLAVES, TO METICULOUSLY PRESENTED EARLY CALIFORNIA EXPERIENCES, TO QUINTESSENTIAL CATALINA, HERE TRULY ARE UNFORGETTABLE DESTINATIONS.

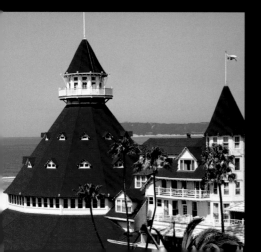

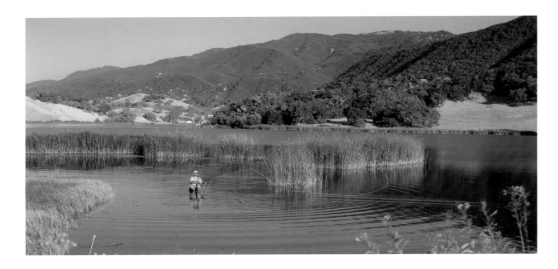

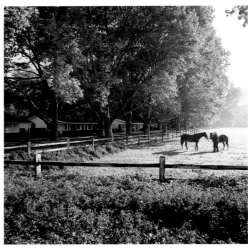

EARLY CALIFORNIA LIVING

There are few places in the world where time seems reluctant to move forward. The Alisal Guest Ranch & Resort, nestled in the beautiful Santa Ynez Valley and the renowned Santa Barbara County wine country, is one such rare retreat. The ranch is located 40 miles north of Santa Barbara and just minutes away from the quaint town of Solvang (Danish

THE ALISAL

Guest Ranch & Resort

1-888-4-ALISAL *www.alisal.com*

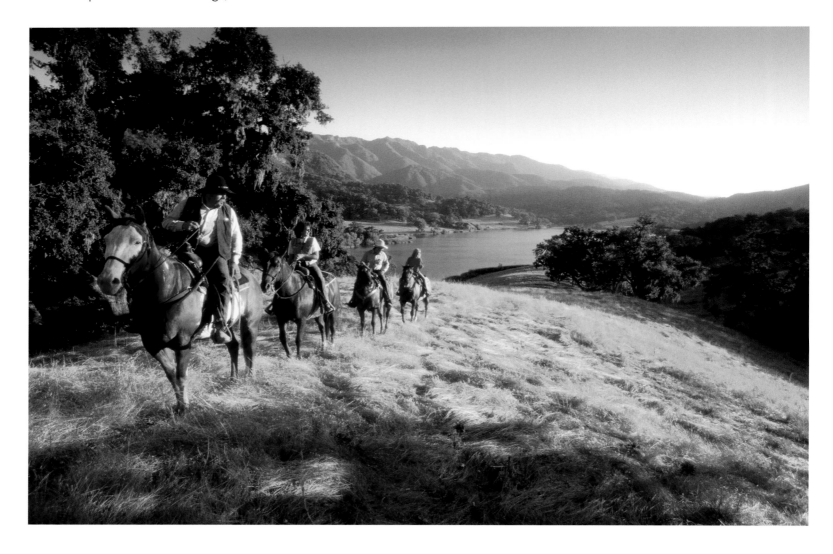

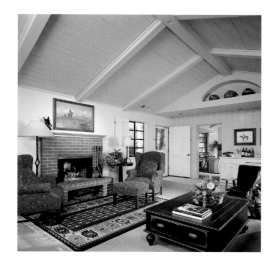

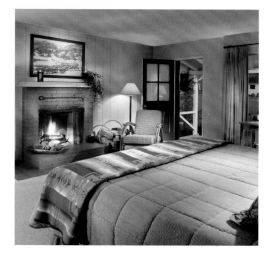

for "sunny fields") where you can take in the charming Danish architecture as you stroll through a myriad of shops and specialty boutiques. Here you will find everything from traditional Danish chocolates and baked goods to quality European imports and collectables.

The Alisal has been a hideaway for generations of families, couples and groups since 1946. As one of California's premier guest ranches, the Alisal will transport

you back in time to early California living at its finest. Set on a 10,000-acre working cattle ranch, this one-of-a-kind resort blends the best of nature with exceptional golf, horseback riding, tennis, fishing, first-class accommodations and fine dining.

With fifty miles of riding trails promising scenic canyons and shaded meadows full of wildlife, the natural setting of the Alisal Guest Ranch constantly summons the spirit of adventure.

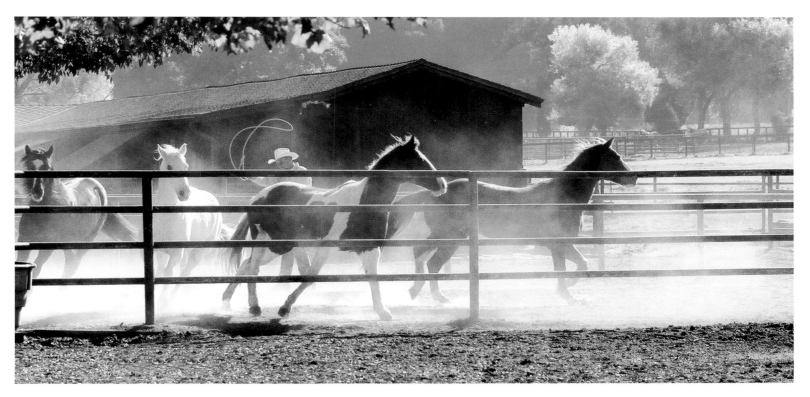

AVIARA

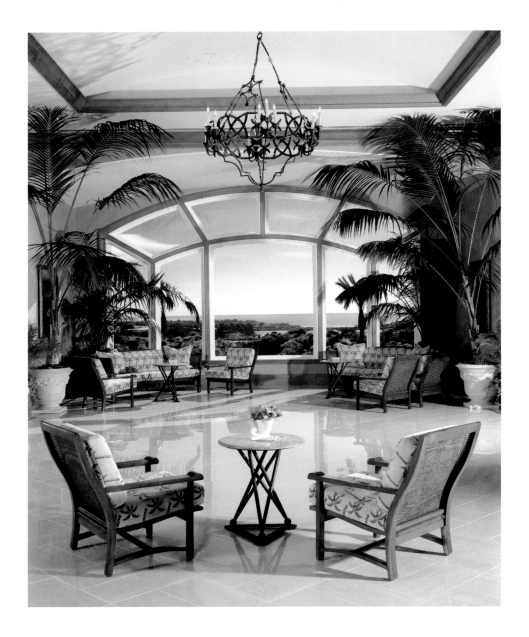

1.760.603.6800
www.fourseasons.com
Carlsbad, CA

Located 35 miles north of San Diego and surrounded by mountains, lagoons and the Pacific Ocean, the city of Carlsbad is a unique coastal community. Carlsbad is known for its antique shopping, boutique browsing, beautiful beaches, quaint downtown and being home to the Four Seasons Resort Aviara.

The setting for the Resort is spectacular. Bordered by the Batiquitos Lagoon, one of the most precious wetlands and aviary reserves in the state, and the Pacific Ocean, this natural setting is accented by wildlife and wildflowers. With 200 beautifully landscaped acres, Four Seasons Resort Aviara is surrounded by gardens, fairways, and the Spanish colonial architecture of Aviara's private residences.

For those on the go, the Resort provides guests with an array of sports and exercise facilities, including an Arnold Palmer designed 18-hole golf course, a tennis center, two swimming pools, spa and fitness center and a recreational center featuring croquet, badminton, bocce ball, volleyball and basketball.

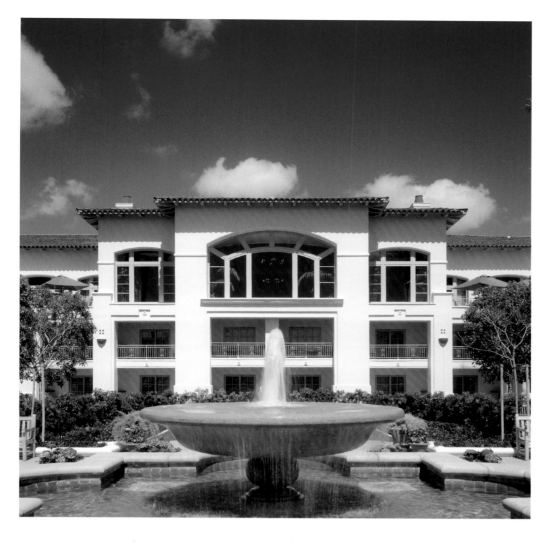

The Aviara Golf Course overlooks the Batquitos Lagoon. The challenging layout winds through rolling valleys and offers views of the Pacific Ocean encouraging both *Golf Digest* and *Golf Magazine* to name the course one of the best resort courses in America.

All 329 spacious guest rooms and suites are located in a low-rise building of Spanish colonial architectural design.

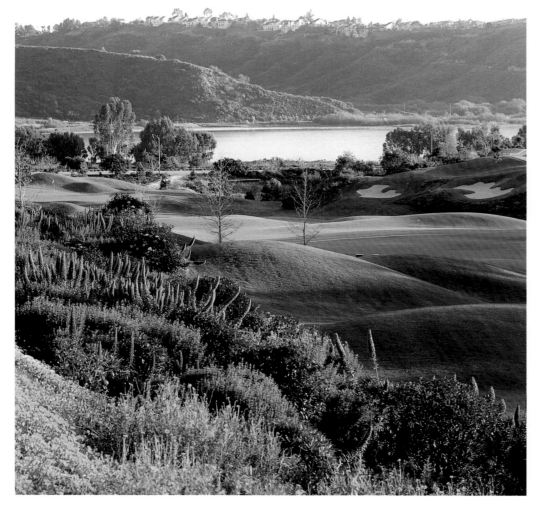

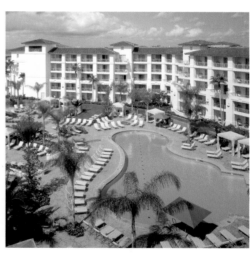

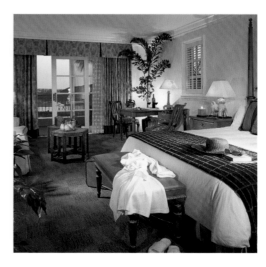

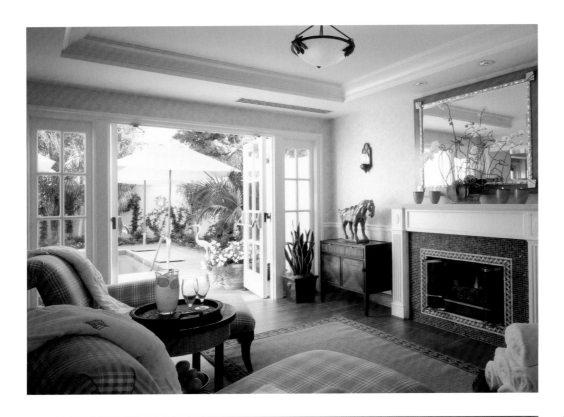

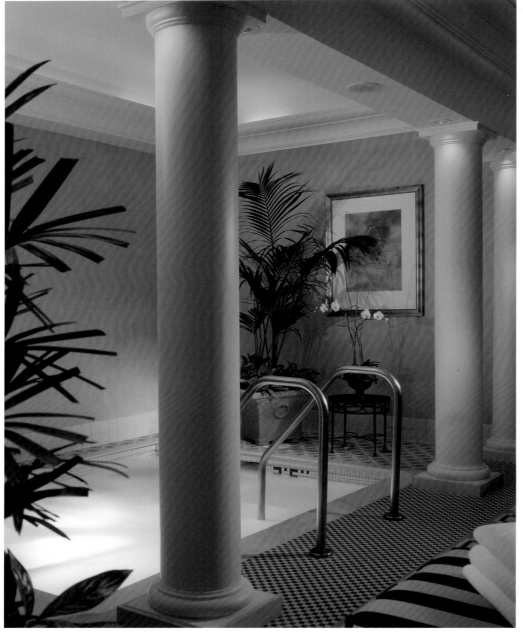

Each room opens onto a private balcony with the ground level rooms providing a private landscaped terrace. Beyond the comfort of the bed, the beauty of the flowers, and the serenity of the spa, the rooms are replete with the Four Seasons trademark amenities: original artwork, plush furnishings, marble bathrooms, private balconies and patios. The spa itself is a main reason many visit the Resort. This wonderful facility has a solarium lounge, whirlpools, saunas, steam rooms and locker rooms. And massages can also be given in your room if booked a day in advance.

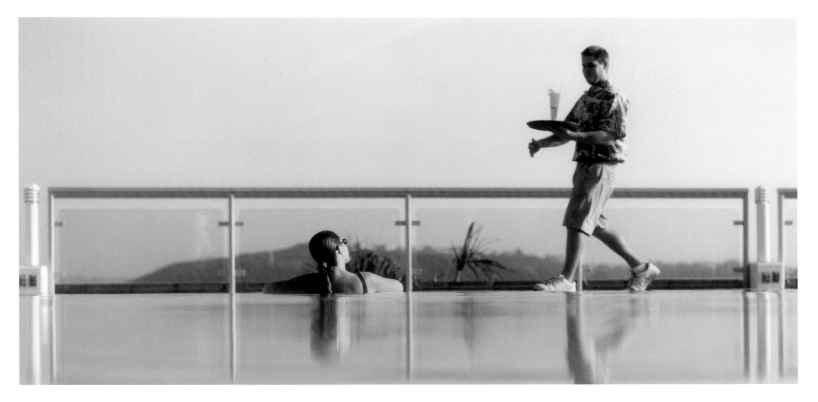

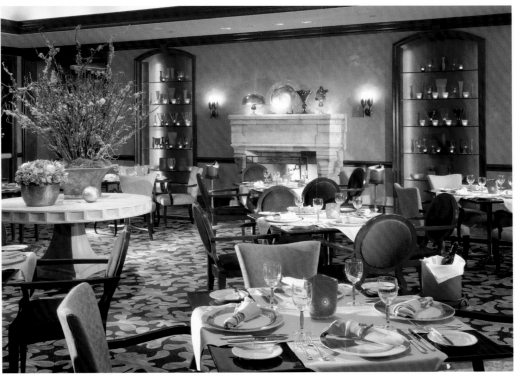

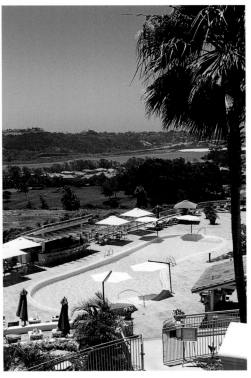

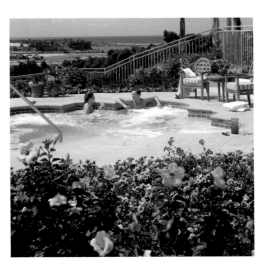

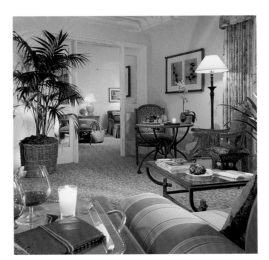

The Balboa Bay Club & Resort
Newport, California

In the US: 888-445-7153
www.balboabayclub.com

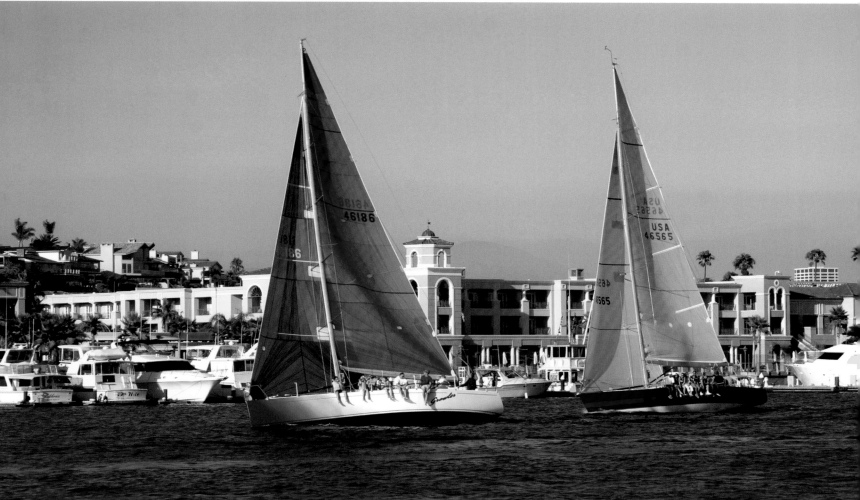

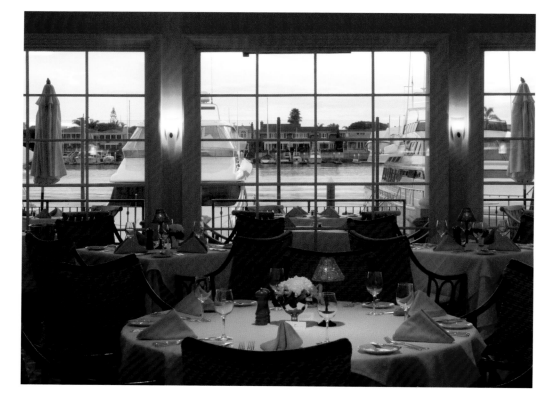

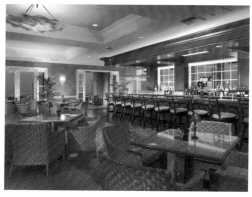

The Balboa Bay Club & Resort, in the heart of Newport Beach, is set against a stunning backdrop of sleek million-dollar yachts and spectacular bay views. By sharing 15 prime bay-front acres with the historic Balboa Bay Club, the resort offers guests the chance to enjoy the exclusive facilities.

The four-diamond hotel resort is reminiscent of an Italian villa in both grace and charm. Designed to take full advantage of the setting, the rooms open up to the bay at every opportunity with breathtaking views and sea breezes. It will be hard to decide whether to stay put or to venture out and explore nearby Balboa Island, the Peninsula, Corona del Mar, Laguna Beach, Fashion Island or the inexhaustible sights and sounds natural to Southern California.

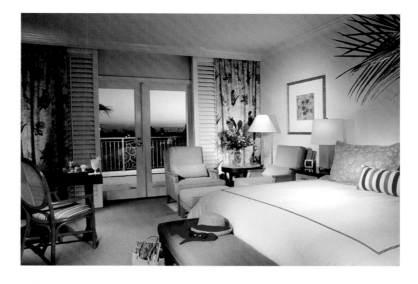

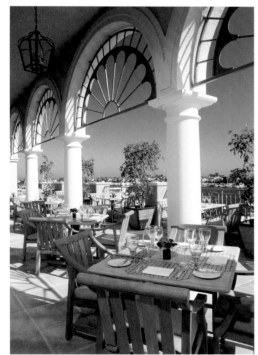

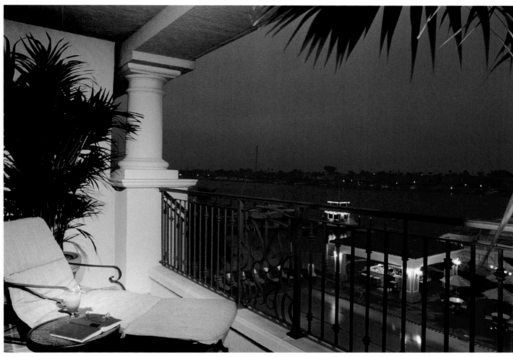

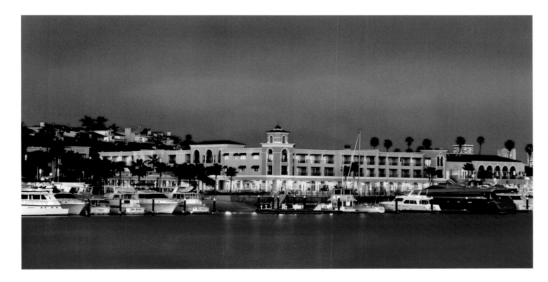

A highlight of any stay at the Balboa Bay Club is the dining at First Cabin, one of the finest hotel restaurants in California. First Cabin overlooks the yacht-filled harbor and features alfresco terrace seating. "Dukes Place" (named after John Wayne), a waterfront bar and entertainment lounge, is the ideal spot for enjoying light fare, cocktails and live jazz nightly.

With the unsurpassed hospitality they have been delivering since 1948, The Balboa Bay Club & Resort offers an illustrious past and inviting waterfront surroundings to provide for the ultimate California coastal experience.

HOTEL DEL CORONADO

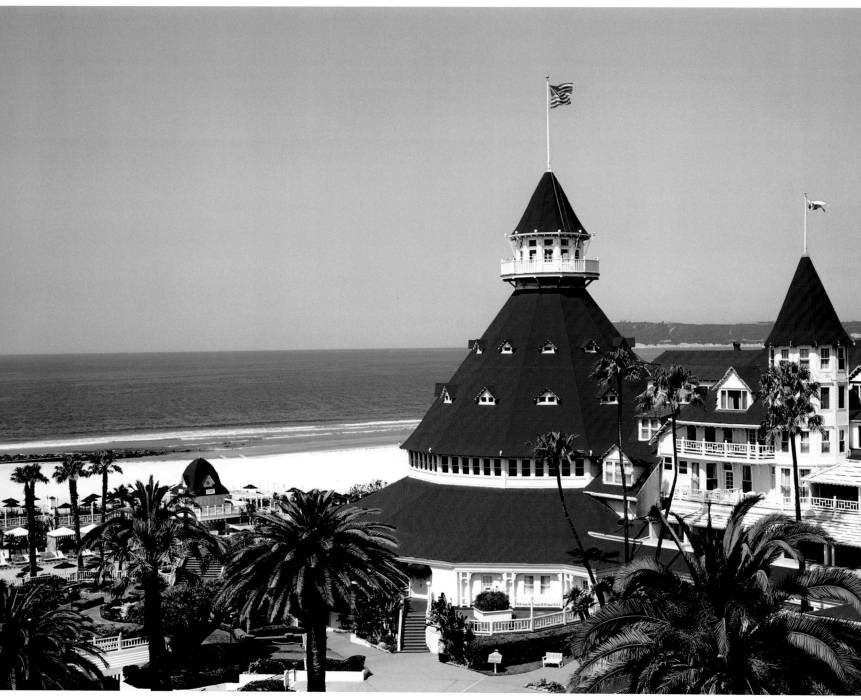

San Diego, California
800.hoteldel
www.hoteldel.com

Built in 1888, the Hotel del Coronado is an elegant example of Victorian architecture and is universally considered one of America's premier resorts. Located on 28 oceanfront acres on Coronado Island, just across the bay from downtown San Diego, founders Elisha Babcock and H.L. Story dreamed of building a resort hotel that would be the "talk of the western world." They succeeded with flying colors.

The Del has become a living legend with visits over the years by countless celebrities, U.S. Presidents, and dignitaries from around the world. It's speculated that the Duke of Windsor first met Wallis Simpson here, eleven presidents have been guests of The Del, and the movie *Some Like It Hot* was filmed here.

Today, the legend continues to unfold with dramatic Master Plan enhancements including 1500 OCEAN, a new signature restaurant, world-class spa, state-of-the-art fitness center, and the cottages and villas at Beach Village (78 luxury oceanfront guestrooms and suites).

The Del is known the world over as a mas-

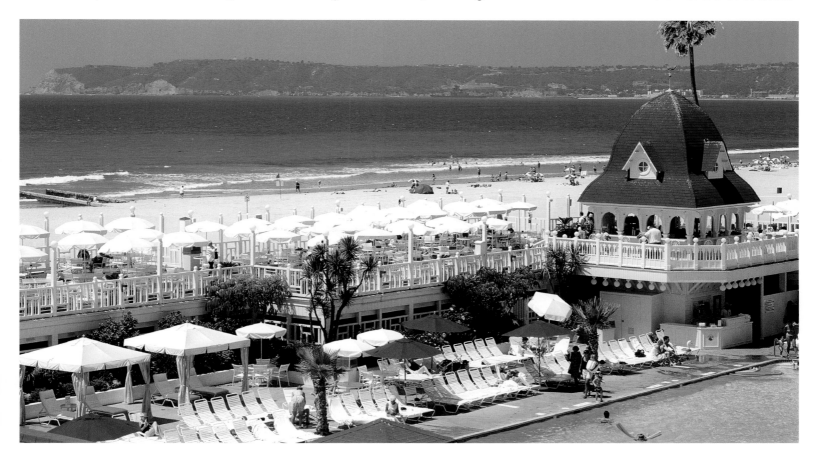

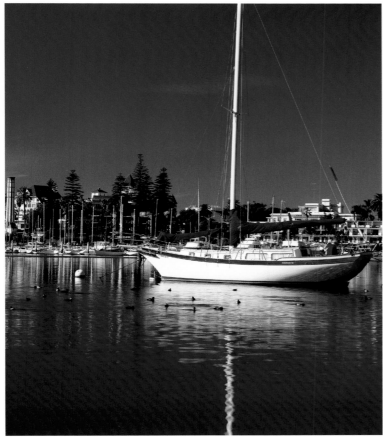

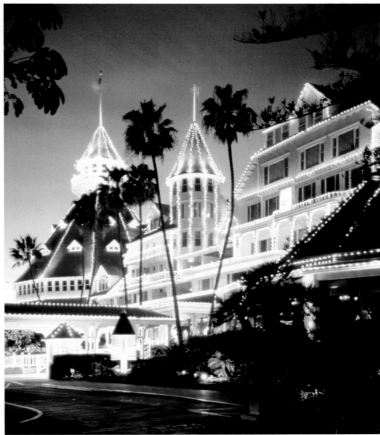

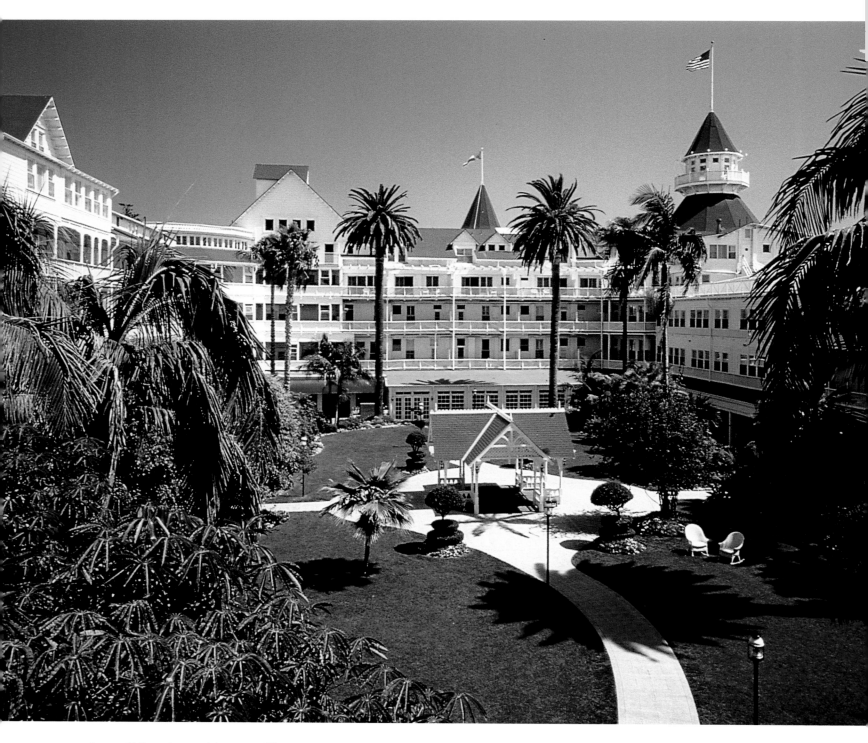

terpiece of Victorian architecture. The conical shaped roof with pergola and flagpole at its peak, quaint village atmosphere, and colorful history make it a favorite for locals and tourists alike.

For those seeking a romantic retreat, the magical architecture and island setting are perfect. The Del is also a wonderful family vacation destination, featuring a fully staffed recreation department with teen and children's programs. Sailing and boating are offered; golf is a short shot away. For getting down to business, planners can work with

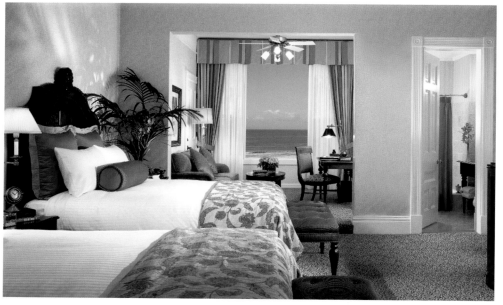

over 65,000 square feet of indoor and outdoor meeting and exhibition space.

The Del offers a variety of unique guest-room options. Victorian rooms feature famous historic ambiance and classic décor. The contemporary, seven-story Ocean Tower rooms and California Cabanas have been re-designed to reflect the tranquil oceanfront setting. Many guestrooms feature oceanfront, garden, or bay view. The new cottages and villas at Beach Village offer a private enclave with pools and hot tubs, front desk and concierge service and access to all the resorts amenities. The suites feature kitchens, dining and living rooms and cozy fireplaces. Many will have ocean view patios or balconies.

Coronado, the Spanish word for "crowned one" is just a quick drive to downtown San Diego and its many attractions.

Below: 1500 OCEAN - The Del's new signature restaurant and bar. A seaside taste of The Del's Victorian Jr. Suite and the resort at play.

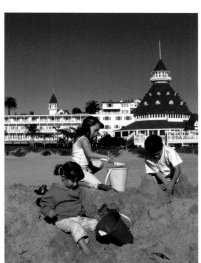

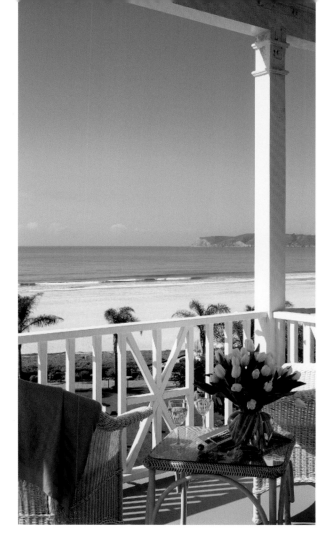

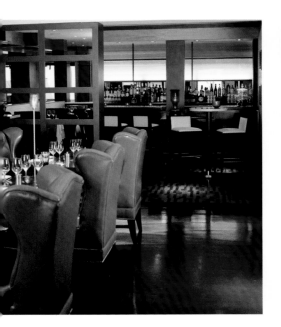

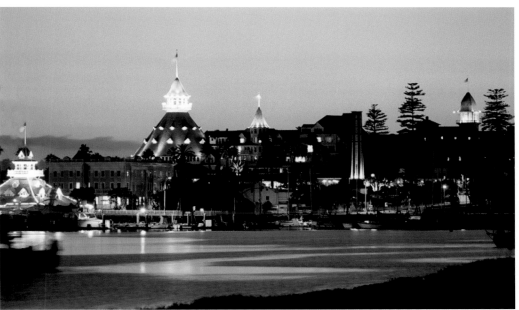

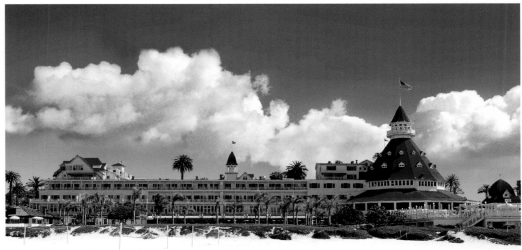

DESERT SPRINGS
PALM DESERT

Amid the pristine desert in the Coachella Valley near the Santa Rosa Mountains lies a lush exotic oasis that shines like the ever-present sun. Located in Palm Desert, the cultural and retail center of the desert communities, this one-of-kind resort offers two 18-hole championship golf courses, a European-style spa, 13 specialty restaurants, a high-energy nightclub, sparkling swimming pools and boutique shopping. With 8 floors, 833 rooms, 51 suites and 33 meeting rooms, the Desert Springs JW Marriott Resort & Spa is one of the largest and most luxurious convention resorts in the region.

With water everywhere, you can't help but feel you've been transported to a tropical paradise. Glittering pools and lakes entice you to cool off in this dazzling desert escape.

1-888-236-2427
www.desertspringsresort.com

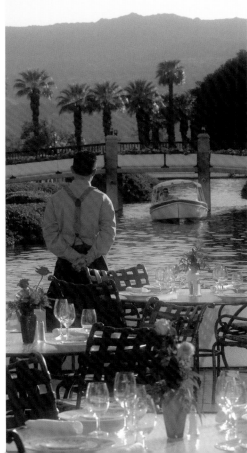

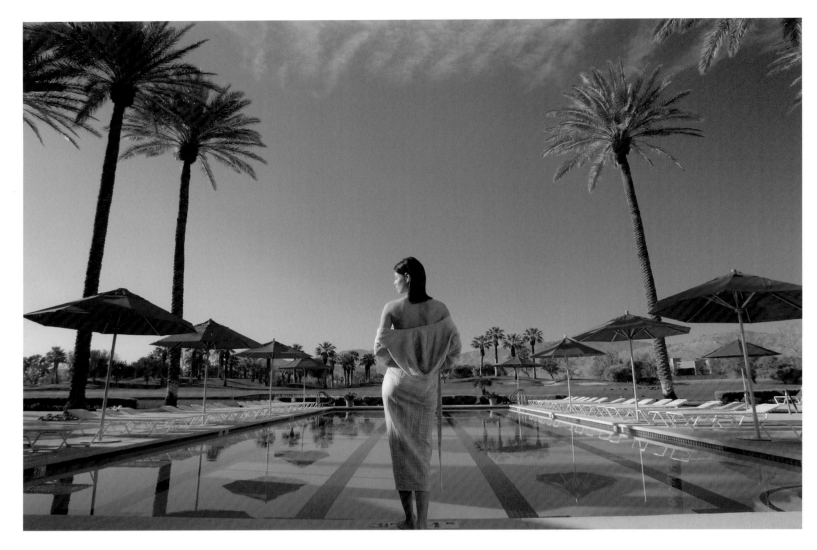

Set on 450 landscaped acres surrounded by desert imagination and mountains, hummingbirds flutter throughout the grounds while exotic birds inhabit the lobby. Venice-inspired canals wind through the lobby where a gondola waits to carry you to a favorite dining spot.

The lake island holds three large free-form swimming pools with a live band on the weekends. There's also a quieter Springs Pool and a Kid's Klub.

While the majestic Santa Rosa Mountains and spectacular desert landscape beck-

on you outside, the elegantly appointed guestrooms with luxurious amenities are persuasive enough to suggest the great indoors. Start by relaxing in the bath surrounded by granite, limestone and Italian marble, wrap yourself in the oversized bath towels and enjoy the views of the

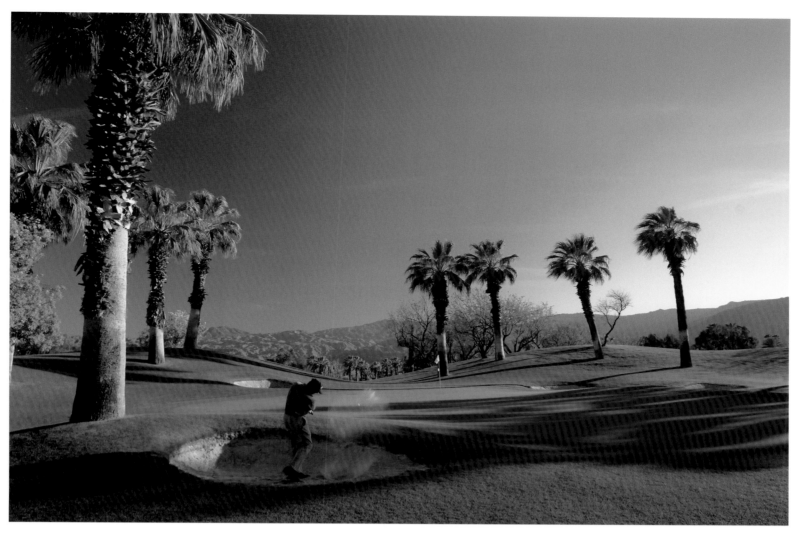

mountains, lush grounds, and lakes from the patio or balcony.

In addition to swimming, the resort offers unlimited recreational opportunities that include two golf courses plus an 18-hole putting course, twenty tennis courts, and one of the largest resort fitness centers in the United States.

The Inn on Mt Ada

Santa Catalina, California

Santa Catalina Island's charm and tranquility are showcased in the historic Inn on Mount Ada. Originally built in 1921 by Wrigley Chewing Gum magnate William Wrigley Junior and his wife Ada, this elegant Georgian Colonial has been classically restored and transformed into a luxurious bed and breakfast. Placed on the National Register of Historic Places in 1985, the Inn is where the Wrigleys

800-608-7669

www.innonmtada.com

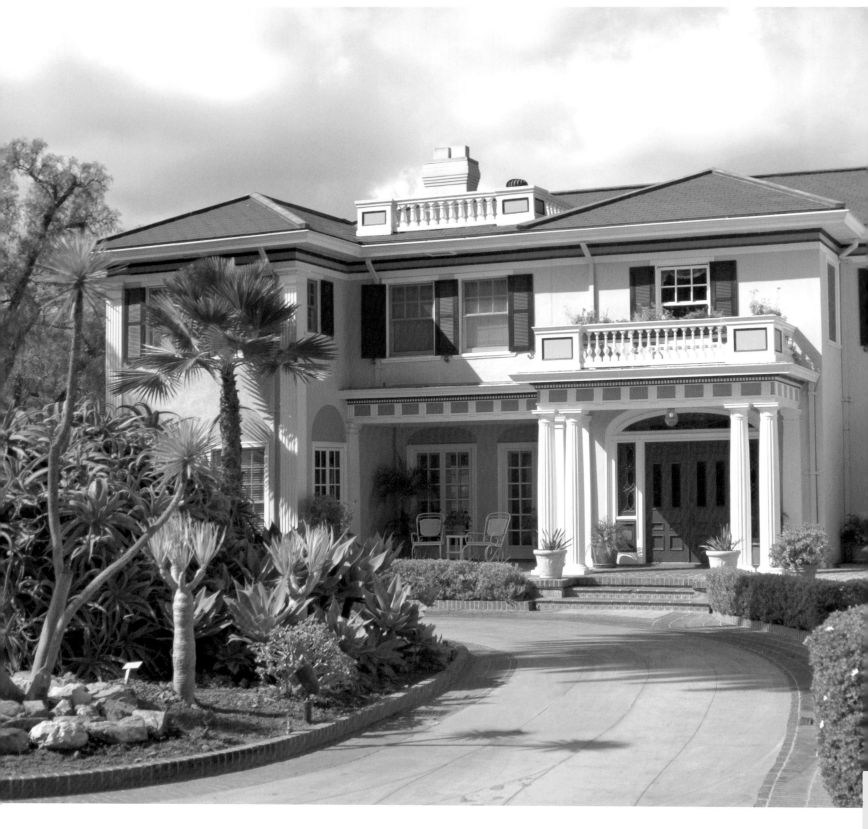

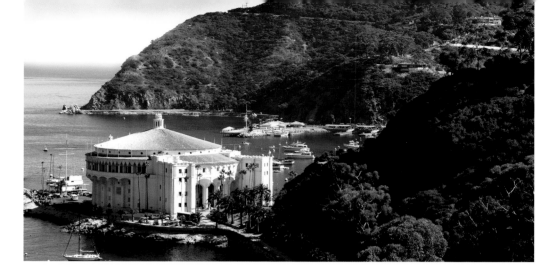

entertained Presidents Calvin Coolidge and Warren Harding and the Prince of Wales. The Chicago Cubs, Wrigley's own baseball team, held spring training on the island.

A landscaped courtyard, portraying a sense of dignity and prestige, invites guests to experience the refined charm and grace of the Inn. The elegant interior has been redecorated with antiques and reproductions similar to the original furnishings. At 350 feet above the town of Avalon, the Inn overlooks picturesque Avalon Bay and the historic dance hall - the Casino. The site takes advantage of the first sunlight in the morning and the last rays at sunset. The magnificent cliffs, coves, and natural beauty of the island are visible from every vantage point.

Whether relaxing beside the fireplace or enjoying a vista from the Inn's sunporch, the Inn provides welcome respite for hikers, shoppers or those simply experiencing the beauty that is Catalina Island.

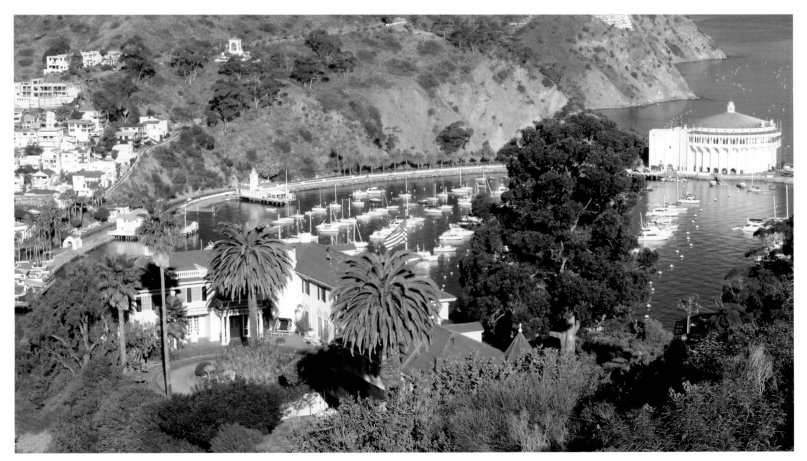

La Quinta
RESORT & CLUB
The Waldorf-Astoria Collection™
La Quinta, CA

800.598.3828 *www.laquintaresort.com*

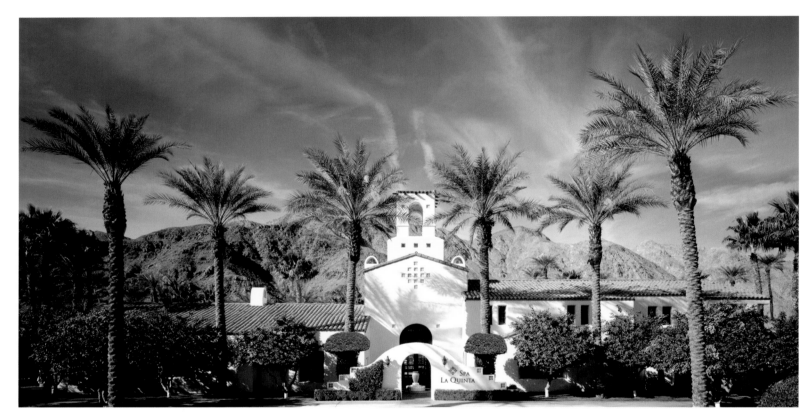

The majestic Santa Rosa Mountains, with their scenic vistas and natural treasures, provide the backdrop for the desert city of La Quinta. Just 30 minutes from Palm Springs in southern California's Coachella Valley, the desert setting and abundance of sunshine has turned the area into a year-round, multi-recreational resort community. La Quinta is one of California's fastest growing cities, and within this picturesque desert paradise is the charm and serenity of the La Quinta Resort & Club.

Originally built as a series of adobe bungalows on 45 acres of fruit trees, the La Quinta Resort & Club is an historic Hollywood hideaway that has been known for service and style since 1926. The resort features towering palms, brilliant flowers and fountains, 90 holes of some of the country's best golf, inviting swimming pools, refreshing whirlpool spas, complete full spa and meeting facilities, and more than 20 tennis courts. Resting as a hallmark among America's leading destination resorts for more than 75 years, La Quinta Resort & Club features timeless architecture and 800 guest casitas, suites and spa villas.

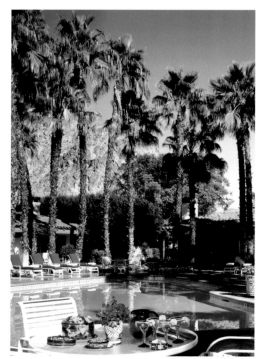

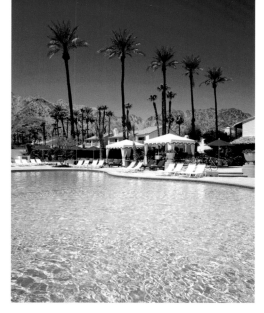

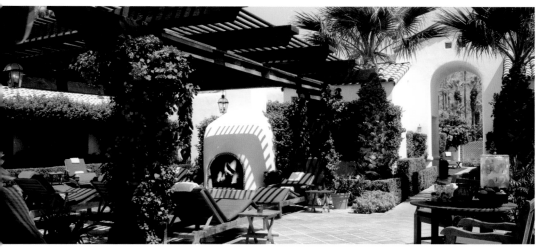

With Spanish Mission-style architecture and The Plaza serving as its centerpiece, the Resort offers one-of-a-kind shopping and dining experiences where the sounds of rushing water are highlighted by bright bougainvillea plantings.

Throughout the Resort, Casitas are found either in a garden setting or poolside with an option of a private enclosed patio. Other accommodation options are luxurious suites, perfect for small executive meetings, special family getaways or elegant escapes for two.

A stay would not be complete without a round of golf on one of the five world-famous courses, or tennis played on hard, grass, or clay surfaces. Placed in a unique resort community, this historic setting is where golf and tennis enthusiasts and people from all walks of life come first to visit and often to remain.

Mission Ranch Resort

1-800-538-8221
www.missionranchcarmel.com
Carmel, CA

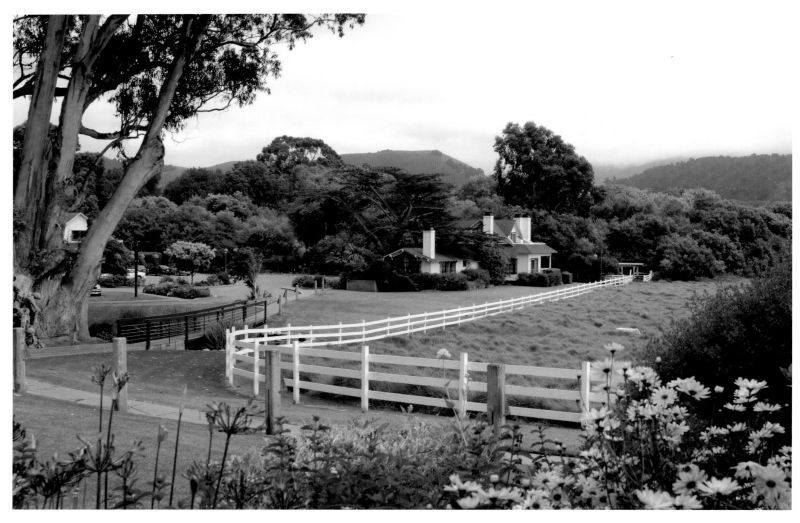

For locals, "meet me at the Ranch" can only mean one thing -- good food and good fun. Located on the Monterey Peninsula close to Carmel, the historic Mission Ranch Resort, with its meadows, wetlands and serene views is one of the most spectacular spots on the peninsula.

Purchased and remodeled in 1986 by movie actor, and former mayor of Carmel, Clint Eastwood, the resort has

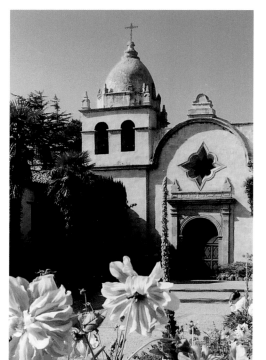

been restored to reflect its past architectural periods. From the 1850's feel of the restaurant and dance barn to the century old farmhouse, the 22-acre spread is an example of present day craftsman quality.

Moldings, doorframes, and hardware match the style of the original buildings and the sense of history that encompasses the resort is evident throughout.

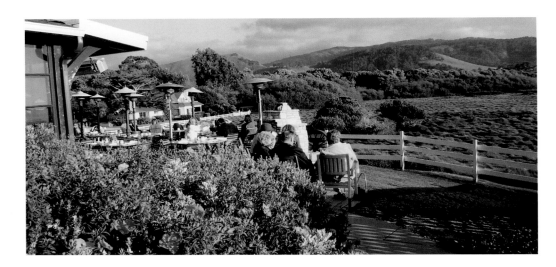

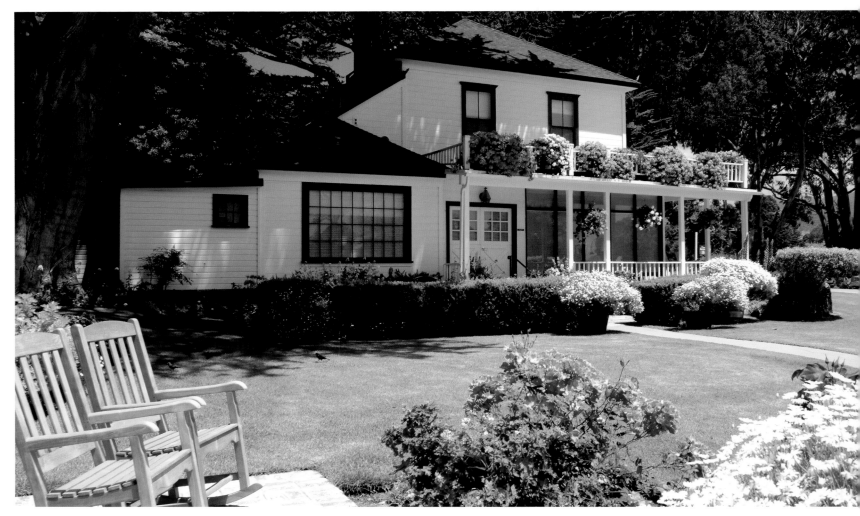

In the 1850's, the property became one of the first early California dairies, serving as a diary farm until the 1920's. What is now the restaurant was once the dairy's creamery. The dining room exhibits a ranch atmosphere and oversized stone fireplace. With music entertainment available seven nights a week, the bar is a popular hangout for locals.

The Lodge at PEBBLE BEACH

Pebble Beach, CA

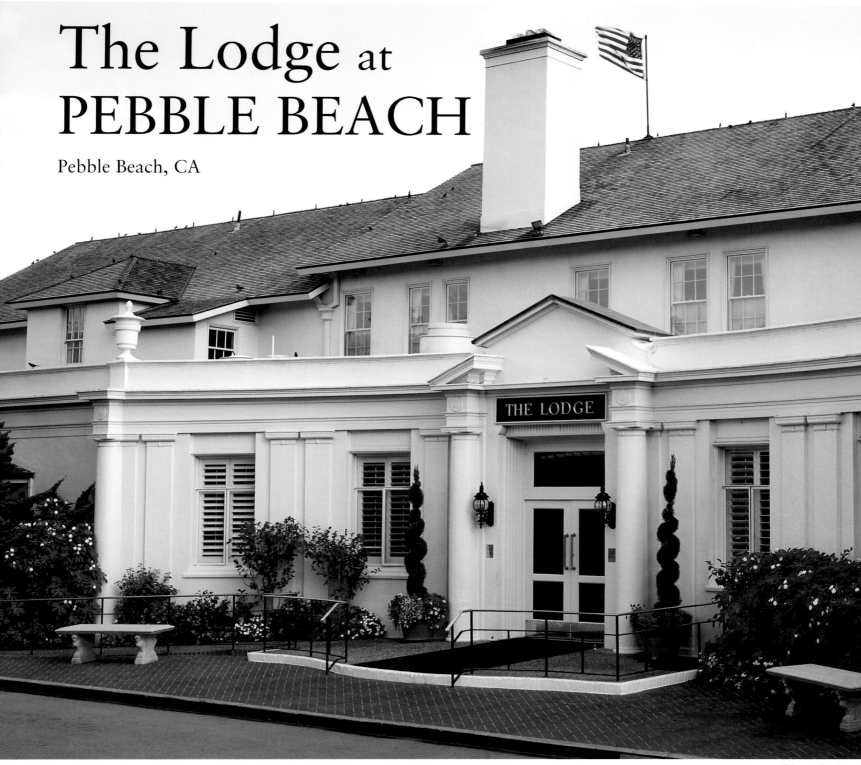

©Joann Dost

The Monterey Peninsula is world-famous for its natural beauty and compelling attractions. The stunning coastline includes Bird Rock, Tescadero Point, Lone Cypress, Carmel and, of course, Pebble Beach. This private 5,300-acre enclave, folded into the shaded arms of 17-Mile Drive, embraces not only some of the most picturesque coastlines anywhere but also the legendary Pebble Beach Golf Links. The Lodge at Pebble Beach is noted for its great accommodations, attentive staff and gracious hospitality.

Phone: 800-654-9300
www. pebblebeach.com

For more than 80 years, Pebble Beach Resorts has been celebrated for its unparalleled facilities, proximity to exquisite shops and historic towns, each resort a haven of pampered relaxation and luxury. The Lodge at Pebble Beach, The Inn at Spanish Bay, and Casa Palmero maintain time-honored traditions of exemplary service, welcome rejuvenation and stylishly comfortable amenities.

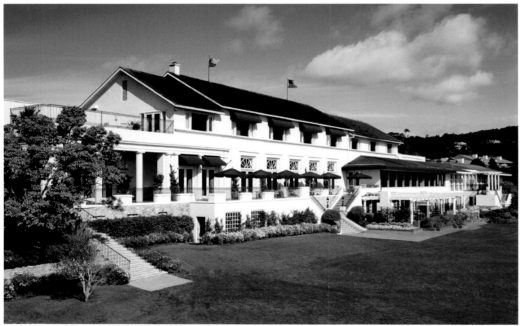

©Joann Dost

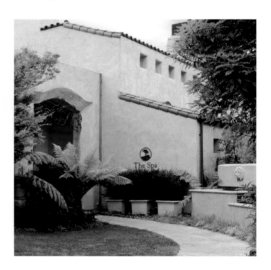

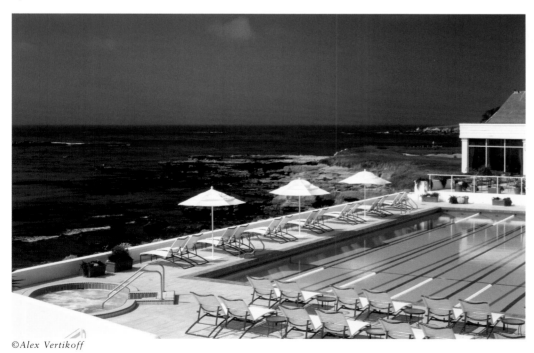

©Alex Vertikoff

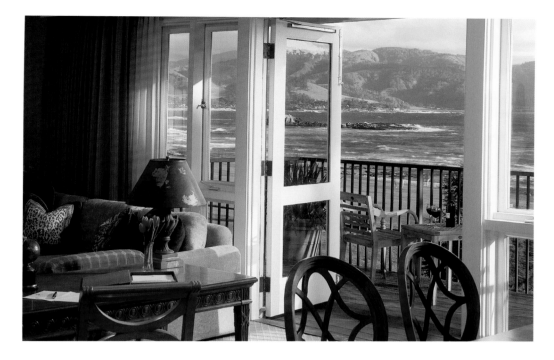

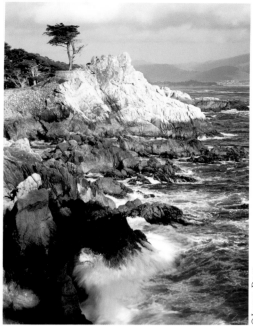

©Joann Dost

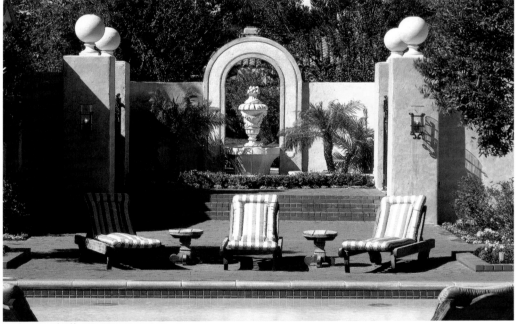

©Alex Vertikoff

Pebble Beach provides one of the most scenic settings for golf and recreation in the world. With its famous championship golf courses, it is hailed as a mecca for golfers. "If I had only one more round to play, I would choose to play it at Pebble Beach. I've loved this course from the first time I saw it. It's possibly the best in the world." – Jack Nicklaus

Host to the AT&T Pebble Beach National Pro-Am and numerous U.S. Opens, the links provide challenge and beauty unlike any place in the world. Designed by Jack Neville and Douglas Grant, the course is ranked No. 1 Public Golf Course in America by *Golf Digest*.

Top right: For over fifty years, Pebble Beach has been the host of the greatly anticipated and passionately attended annual Concourse d' Elegance.

The fifth hole (opposite center), was added and designed by Jack Nicklaus in 1998.

Bottom right: Perhaps the most recognized par three in the world, the short, but demanding, seventh.

©Scott Campbell

©Scott Campbell

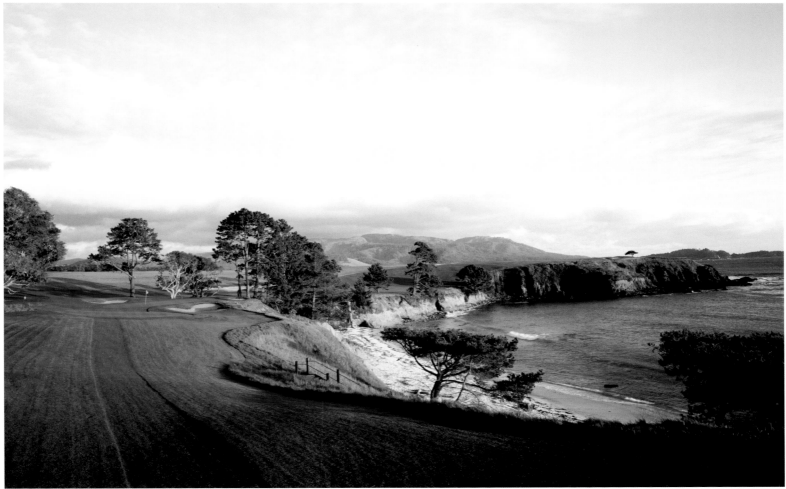

©Joann Dost

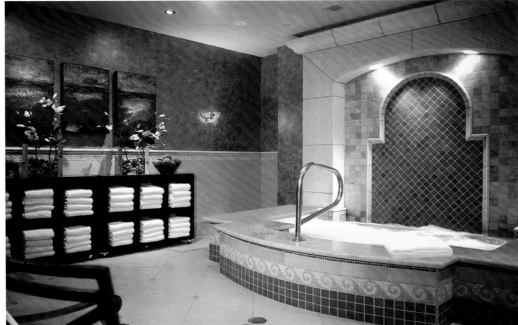

©Alex Vertikoff

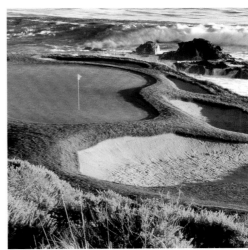

©Joann Dost

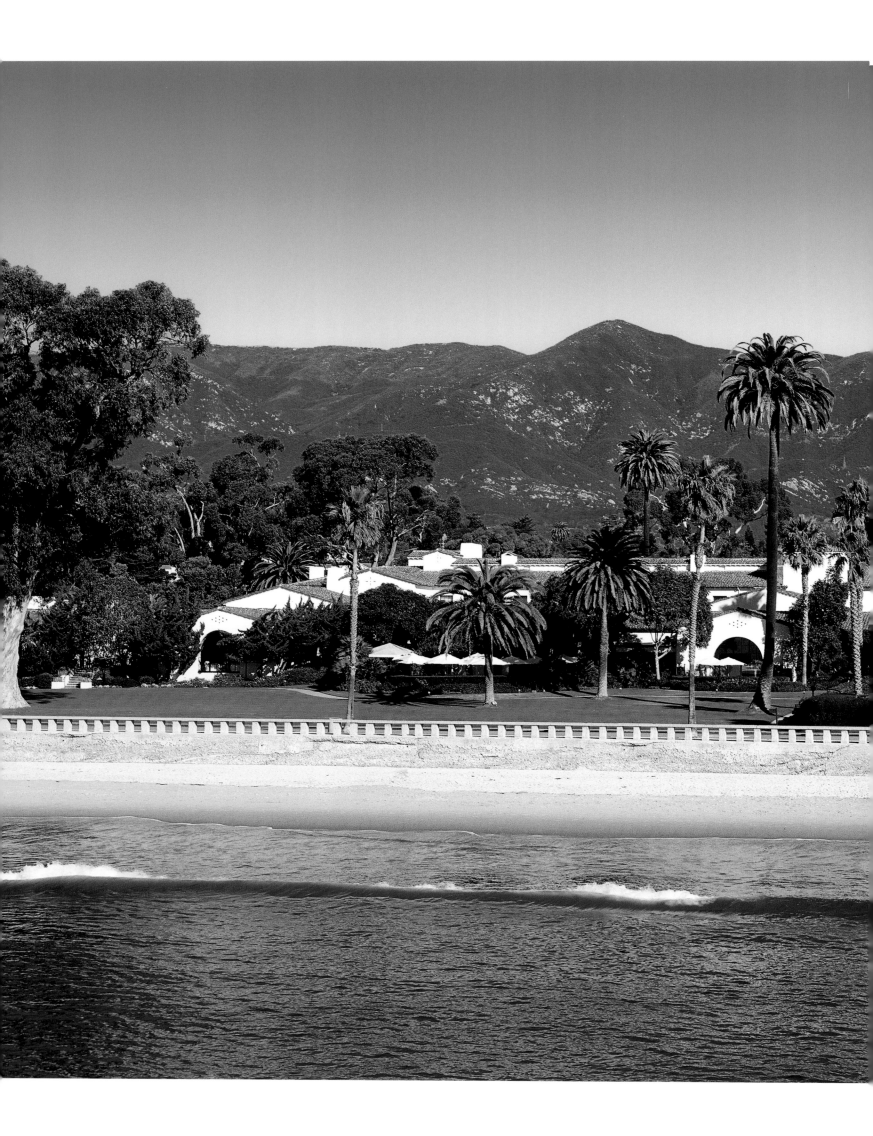

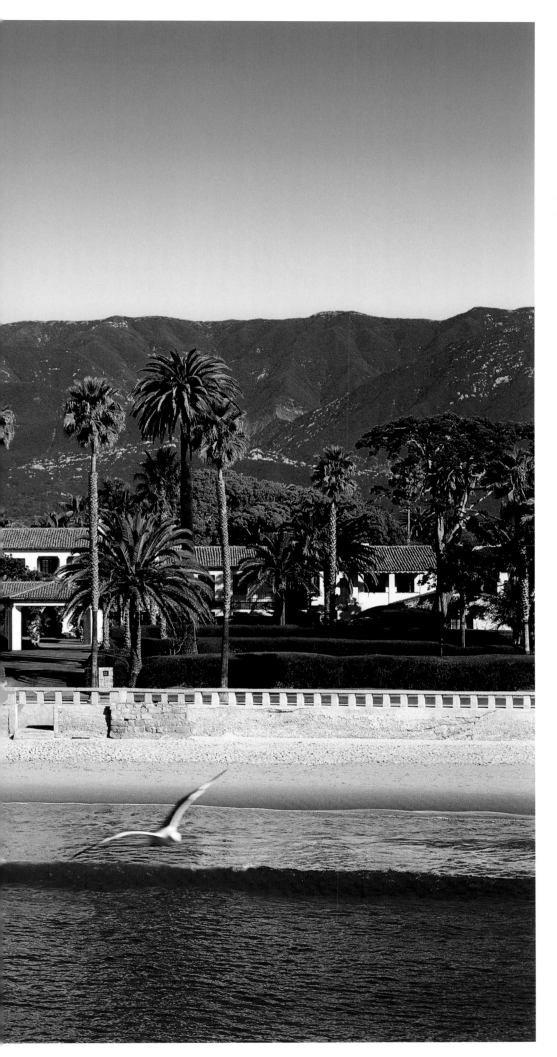

FOUR SEASONS RESORT
The Biltmore
Santa Barbara, CA

The city of Santa Barbara represents the essence of California, combining the art and culture of the big city and the heart and hospitality of a small coastal town. Here is where you will find terraced vineyards, rugged canyons, golden sand and the Four Seasons Biltmore in Santa Barbara.

Perfectly placed on Butterfly Beach in exclusive Montecito, the resort reflects the Spanish/Mediterranean aesthetics of red tile roofs, ivory adobe and graceful archways that are symbols of the architectural heritage of historical California.

Once a favored retreat for the Golden Era movie stars of Hollywood, the 22-acre resort is engaged in the final phase of a complete $200 million renovation and restoration project. The results have provided not only luxurious modern accommodations and historical ambience for the guests, but worldwide recognition and awards. AAA recently presented the resort the coveted Five Diamond award, in recognition of excellence for Hotels and Resorts in North America.

1-805-969-2261
www.fourseasons.com

With the ocean at its doorstep, a rugged mountain backdrop and lush botanical vegetation, this oceanfront hideaway combines the glory of California's historic past with the legendary service of the Four Seasons Resorts to provide an unparalleled experience of luxury, indulgence, and escape.

Started in 1927 and located in one of the best growing climates in the world, the specimen garden is a mixture of rare and exotic tropical and sub-tropical plants, a lush paradise where the day-to-day grind fades like the morning fog along the coast. The newly renovated pool and courtyard garden has been designed to integrate privacy and quiet interaction.

Period antiques and local art compliment the newly installed Spanish tile, decorative ironwork and mission style furniture in the guestrooms. Private steam showers, deep soaking tubs and rain shower fixtures are featured in the suites. High definition plasma screen televisions and wireless Internet connectivity are a sampling of the resort's many amenities.

With spectacular ocean views, a classically shaped swimming pool with private poolside cabanas, tennis courts, fine ocean-side dining and a world- class spa and fitness center, The Biltmore Santa Barbara is a masterpiece in resort luxury, historic ambiance, and hospitality.

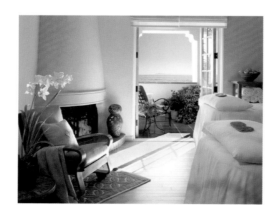

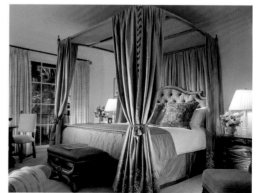

RECREATION

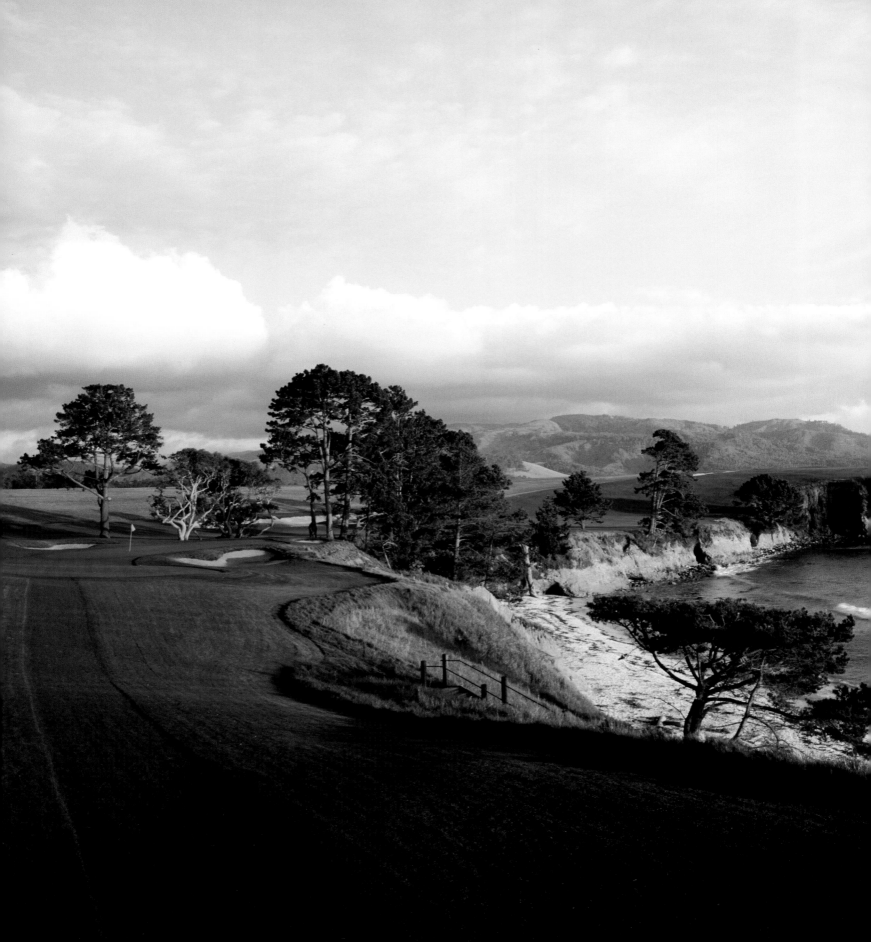

IN THE WESTERN US, THERE ARE PLACES KNOWN FOR SPECIFIC TYPES OF RECREATIONAL OFFERINGS, FOR SURE. BUT THERE'S ONLY ONE LOCALE WHERE VISITORS CAN PLAY IT ALL – CALIFORNIA. SUN, SURF AND BANG BEACH VOLLEYBALL ON THE PACIFIC. WATCH GRAN PRIX MOTOR RACING. GOLF AT PEBBLE BEACH. TOUR THE WINE COUNTRY. SKI AND HIKE IN THE SIERRAS. EXPLORE GHOST TOWNS AND YOSEMITE'S WONDERS. SHOW THE KIDS FAMOUS THEME PARKS AND MOVIE STUDIOS AND DO MOST OF IT IN A DAY.

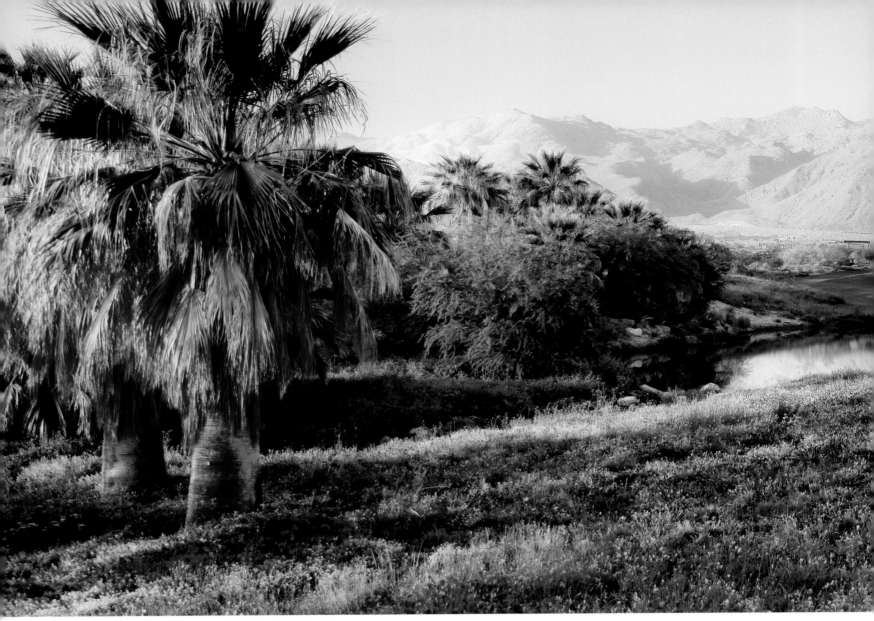

Golf...
CALIFORNIA STYLE

PLAYING IN CALIFORNIA IS A YEAR ROUND, STATE WIDE EXPERIENCE.
California is a mecca for outdoor activities and one of the premier golfing states in the country. The unique and diverse landscape of the state has presented a wealth of opportunity and challenges for golf course designers and architects, and they have succeeded in creating some of the most recognized courses in the world. The end results are a myriad of inspiring and memorable golf experiences that let the golf enthusiast pick from the simple and pleasant to the most challenging courses found anywhere. Whether it's by the seaside, in the desert, or in a high mountain setting — California has it all.

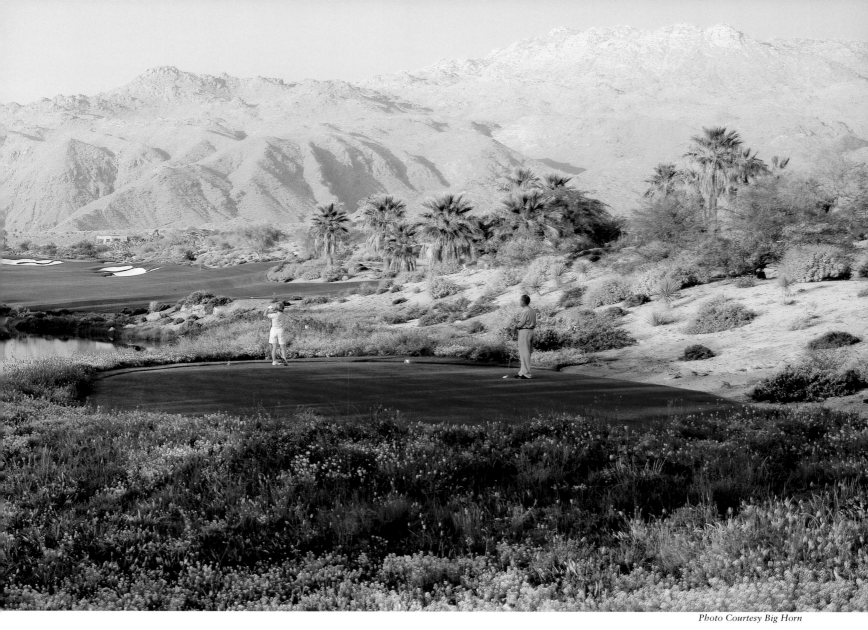

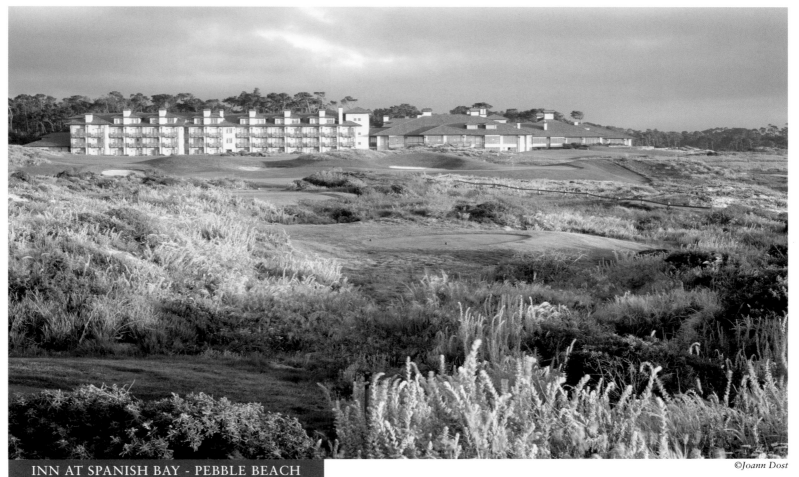

INN AT SPANISH BAY - PEBBLE BEACH

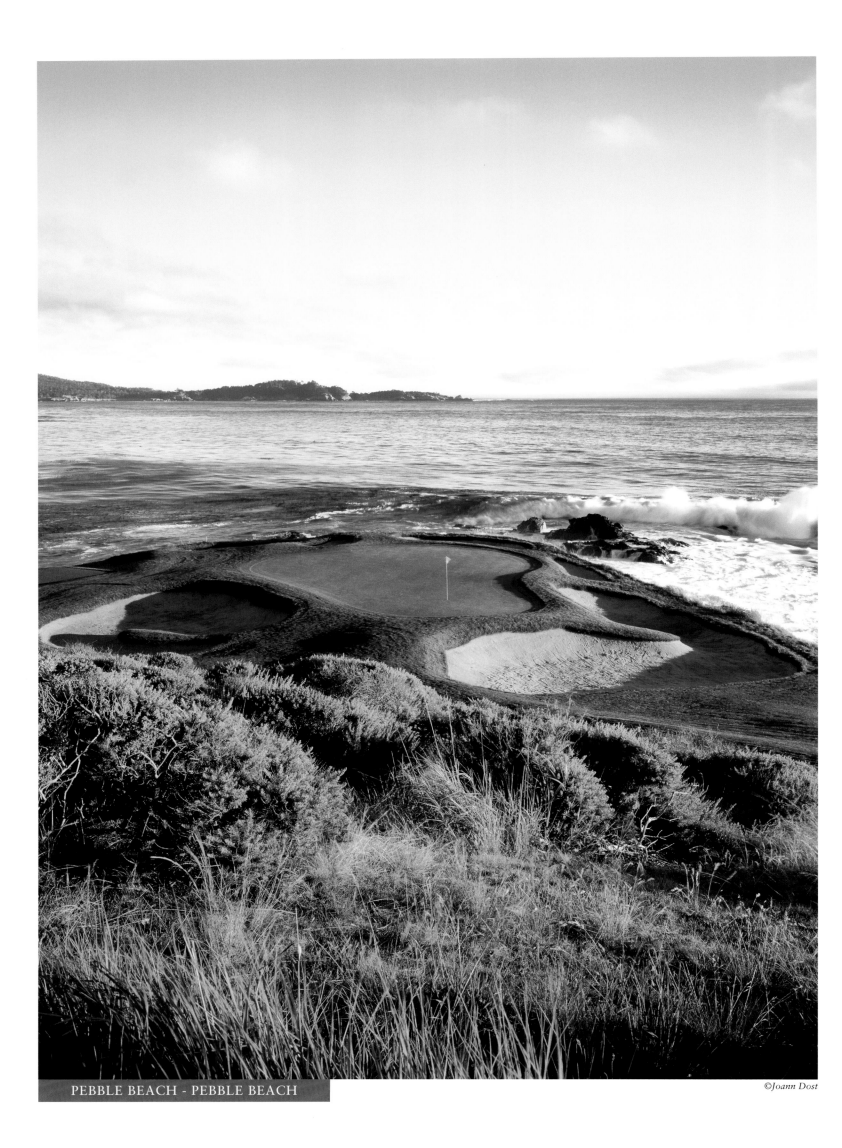

PEBBLE BEACH - PEBBLE BEACH

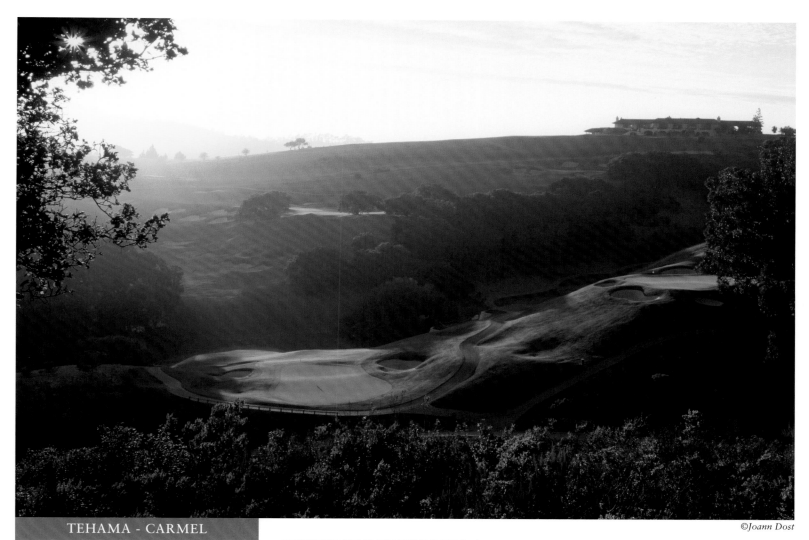
TEHAMA - CARMEL

©Joann Dost

The game of golf is at its best at Pebble Beach, ranked as the No. 1 golf resort in America by *Golf Digest Magazine* in 2004. Each of Pebble Beach Resorts' four courses offers breathtaking beauty and a once in a lifetime experience. This spectacular course has seen more players of more levels of skill than perhaps any other on the planet. Whether it's the oceanside locale bordered by a pristine forest or a justifiable reputation as one of the world's most challenging courses, Pebble Beach is renowned as much for its storied past as for what might occur with each new round.

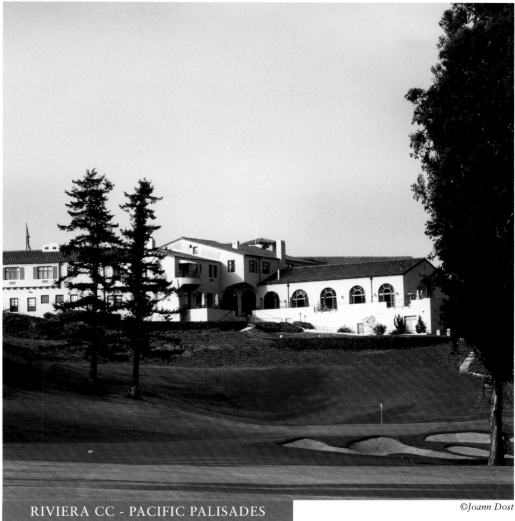
RIVIERA CC - PACIFIC PALISADES

©Joann Dost

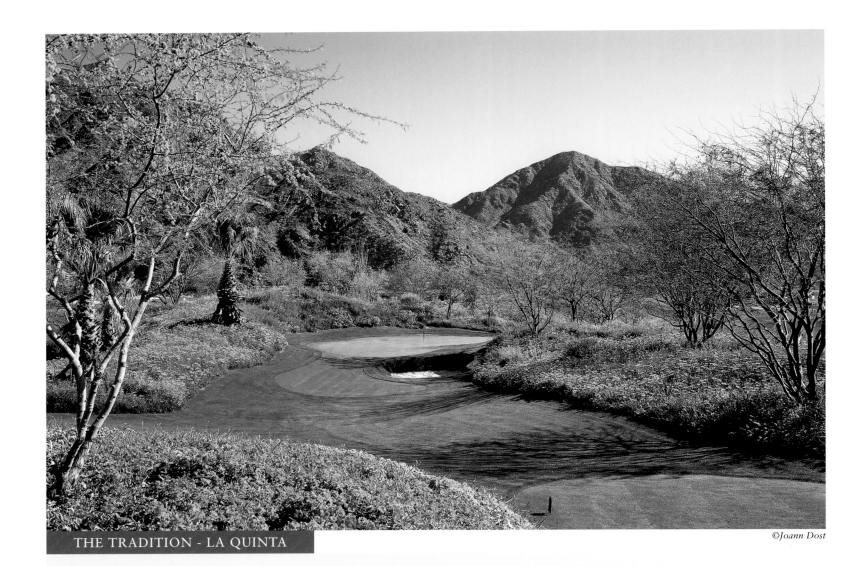

THE TRADITION - LA QUINTA

©Joann Dost

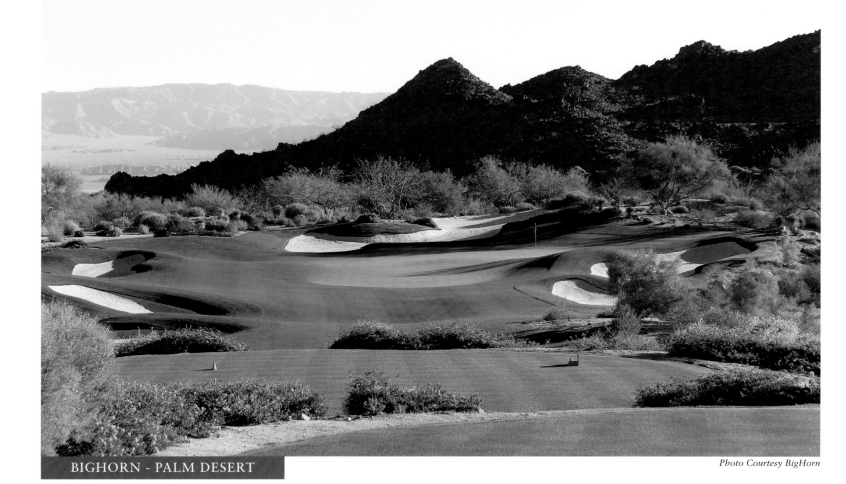

BIGHORN - PALM DESERT

Photo Courtesy BigHorn

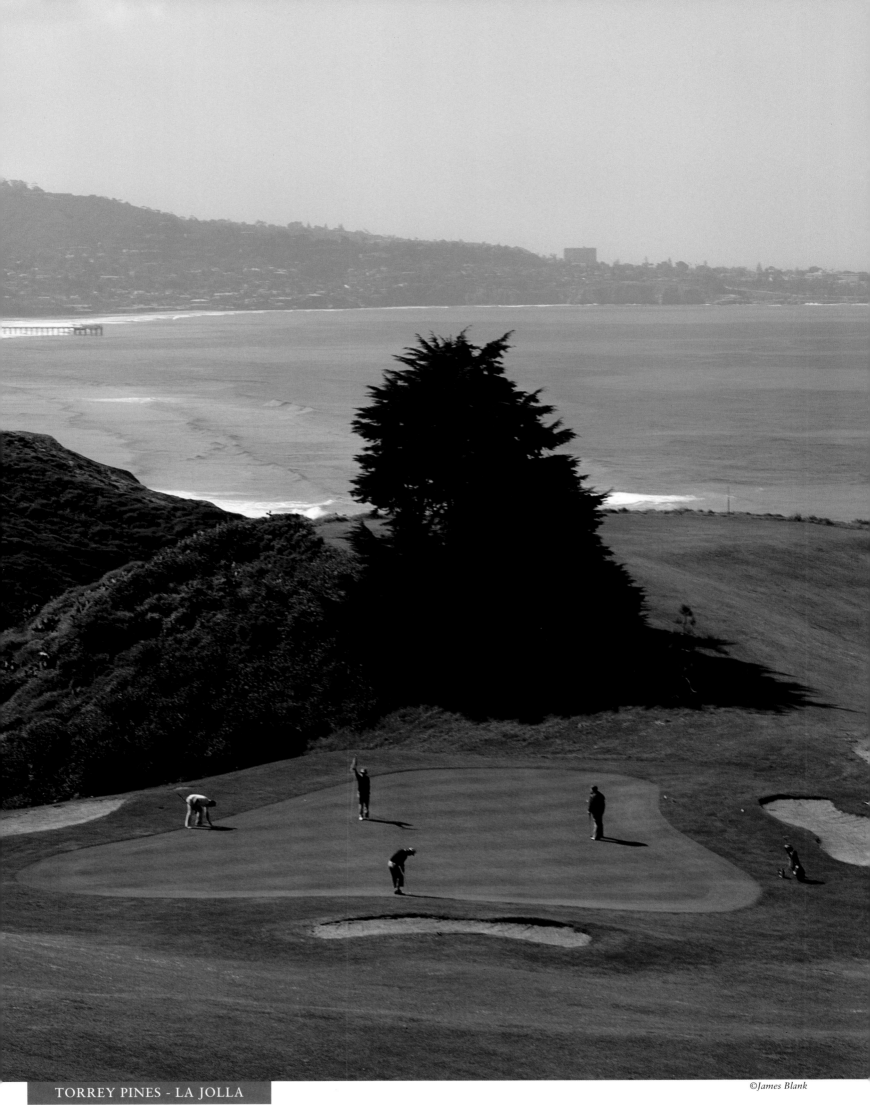

TORREY PINES - LA JOLLA

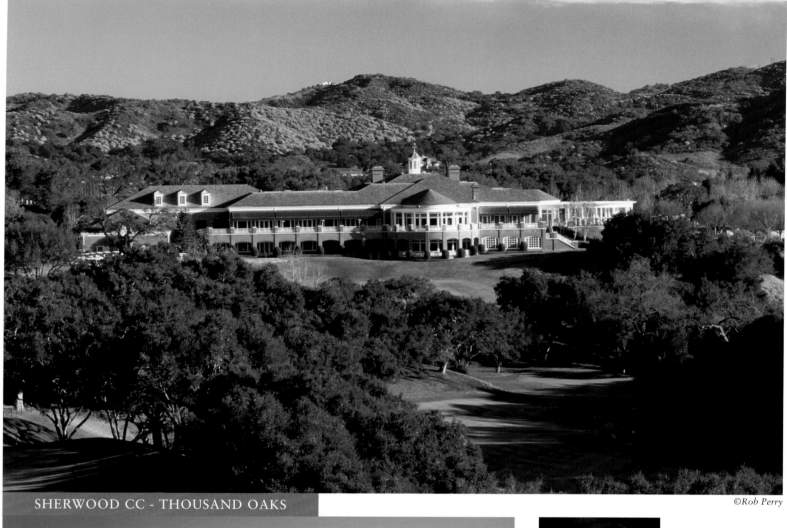

SHERWOOD CC - THOUSAND OAKS

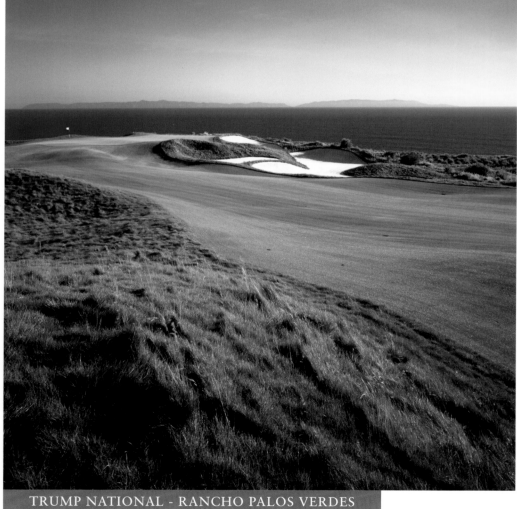

TRUMP NATIONAL - RANCHO PALOS VERDES

In 1998, Pebble Beach Golf Links un-veiled its first new golf hole in almost 70 years. Blanketed by a rolling, unbroken landscape from The Lodge in the north, to Carmel Beach in the south, the new 5th Hole, designed by Jack Nicklaus, is situated along the stunning oceanfront.

Spyglass Hill Golf Course takes its name from Robert Louis Stevenson's classic novel, *Treasure Island*. Local legend maintains that Stevenson once wandered the Spyglass area gathering ideas for his novels. A unique aspect of this course is that the holes are named after characters in *Treasure Island*. Hole names such as "Black Dog" and "Billy Bones" are hints for the unwary.

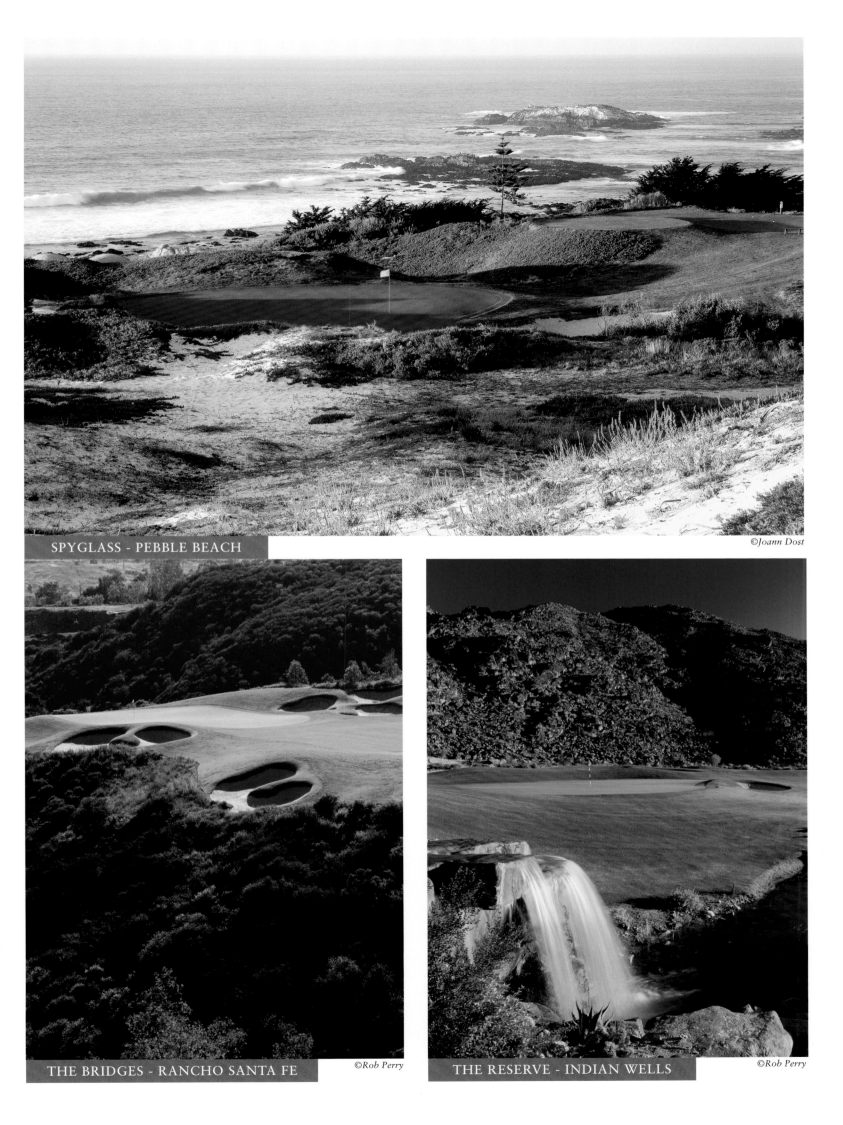

SPYGLASS - PEBBLE BEACH

©Joann Dost

THE BRIDGES - RANCHO SANTA FE

©Rob Perry

THE RESERVE - INDIAN WELLS

©Rob Perry

131

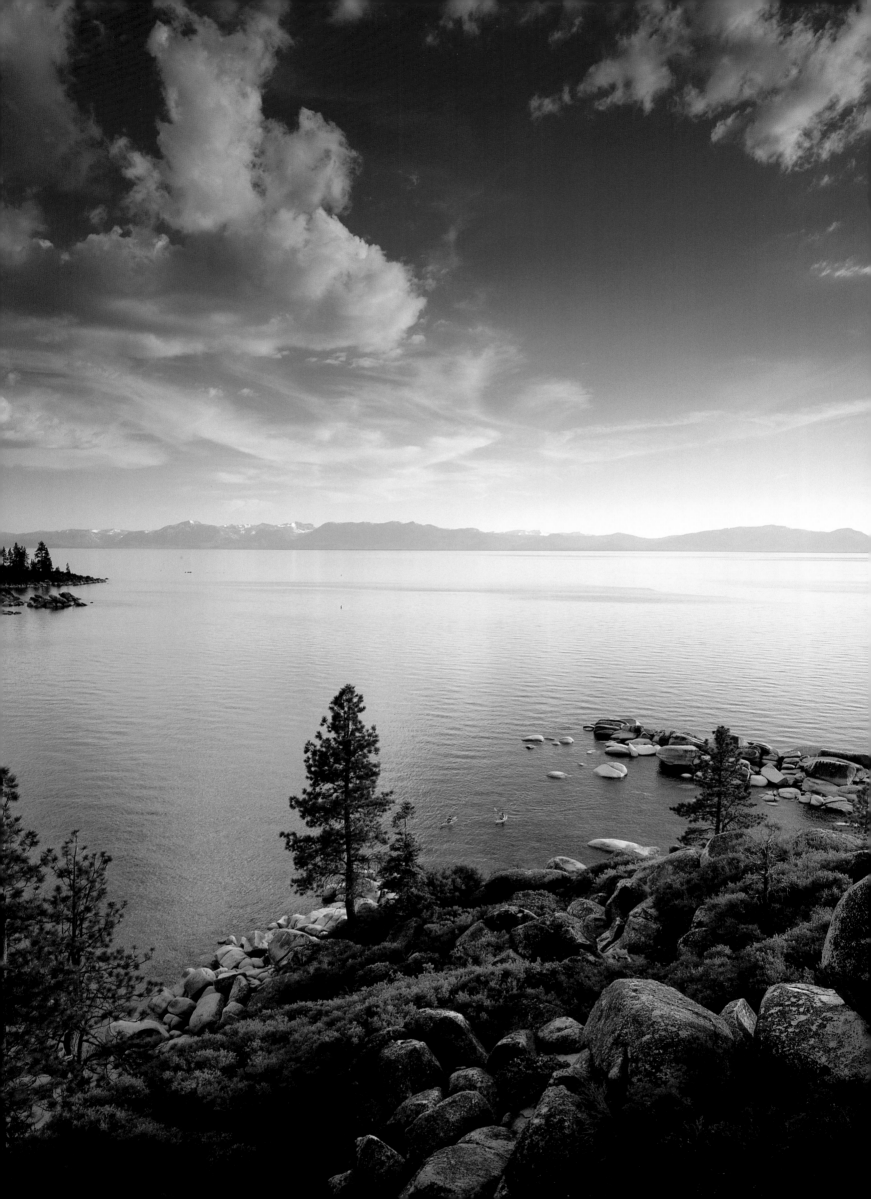

T A H O E

"As it lay there with the shadows of the mountains brilliantly photographed upon its still surface, I thought it must surely be the fairest picture the whole earth affords."

Mark Twain's description of Lake Tahoe in 1862

For its immense size and 6,200-foot elevation, Lake Tahoe is reputed to be the purest body of water in the world, a deep blue reflection of the spectacular Sierra Nevada mountains around it. Not only is it one of the world's largest, clearest, and most beautiful alpine lakes, it is also one of the deepest (1645 feet) lakes in the United States. Only Oregon's Crater Lake is deeper at 1930 feet. Located on the border of California and Nevada about 200 miles east of San Francisco, the lake is so deep it doesn't freeze and retains its sapphire-blue color throughout the winter

Much of the area surrounding Lake Tahoe is devoted to the tourism industry and there are many restaurants, ski slopes and casinos catering to visitors. During ski season, thousands of people flock to the slopes for some of the best skiing in the world. Lake Tahoe, in addition to its panoramic beauty, is well known for its blizzards. It gets more snow than anywhere in the United States. During the summer, the lake is popular for water sports and beach activities.

All photos this page ©Peter Spain.

Opposite page: ©Chris Talbot.

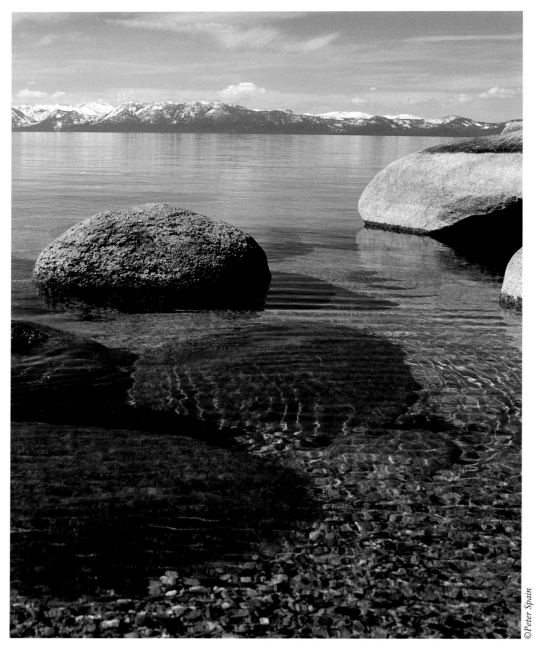

©Peter Spain

Coming from a Washoe Indian word meaning "lake in the Sky," Lake Tahoe's south shore is home to the largest city, South Lake Tahoe, which neighbors Stateline, Nevada. Tahoe City is located on the lake's northwest shore while the north shore features the Cal Neva Resort (once owned by Frank Sinatra) which has a marked state line running right through the swimming pool dividing California and Nevada.

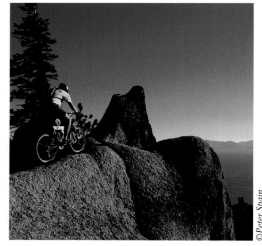

©Peter Spain

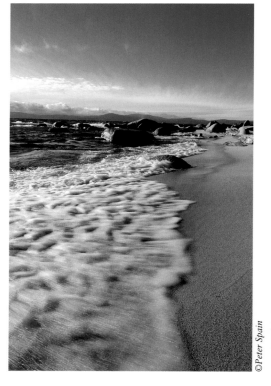

©Peter Spain

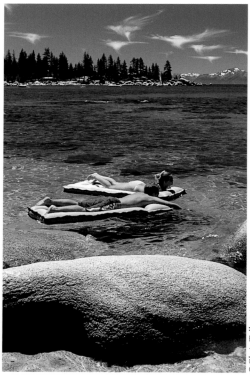

©Chris Talbot

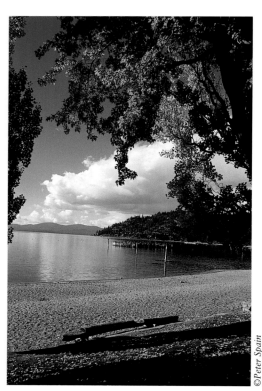

©Peter Spain

The thin clear mountain air allows the lake's pure crystalline water to reflect the blue sky above. It can also appear red during sunsets or grey-black during storms. Lake Tahoe is so clear in some places that objects can be seen to depths of 75 feet. Most of the snow and rain falls directly into the lake or drains through lakeside marshes and meadows that act as water filtering systems. It is always in motion and every winter the cold water on the surface sinks while warm water rises from the deep. This mixing motion keeps the lake from freezing over, though some protected inlets like Emerald Bay have been covered with a layer of ice. The water in Lake Tahoe is very cold, ranging from 41 to 68 degrees F, depending upon depth and season. At 600 feet below the surface the temperature stays a constant 39 degrees F.

©Peter Spain

©Chris Talbot

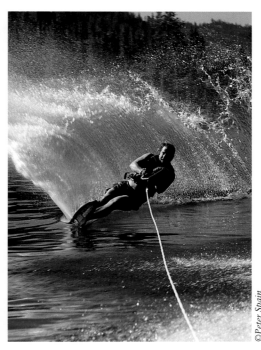

©Peter Spain

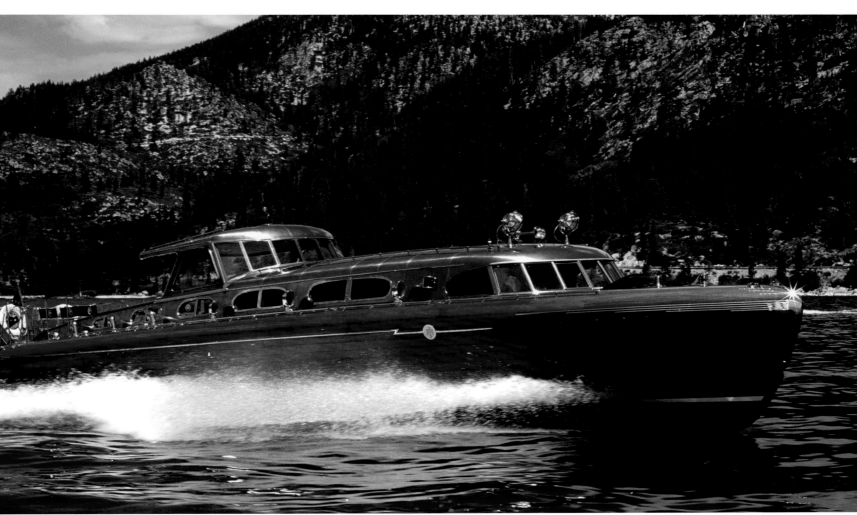

©Peter Spain

135

Skiers at Lake Tahoe can hit the slopes on one of the 182 ski trails in the midst of more than 8,800 total ski resort acres. At lake level, annual snowfall averages 125 inches. At alpine skiing elevations, the snowfall averages 300 to 500 inches each year.

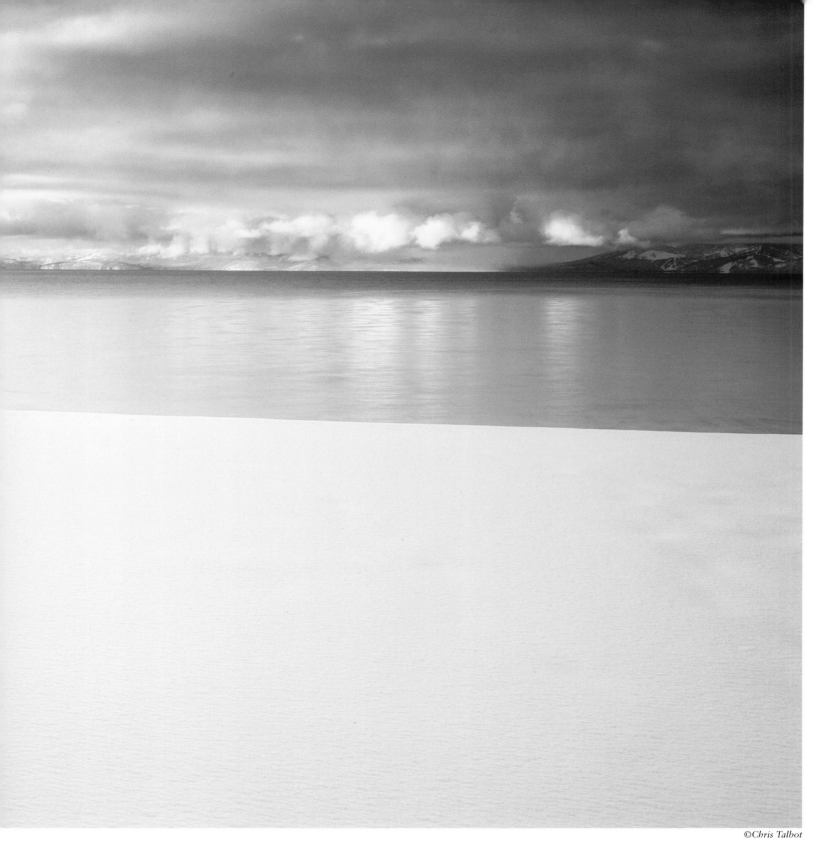

©Chris Talbot

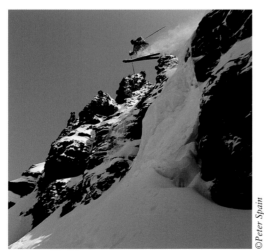

©Peter Spain

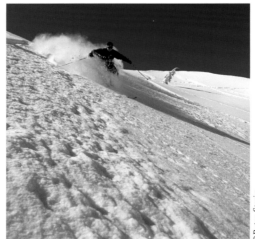

©Peter Spain

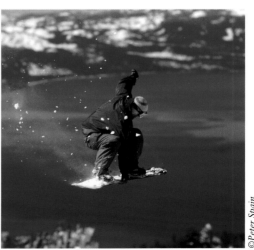

©Peter Spain

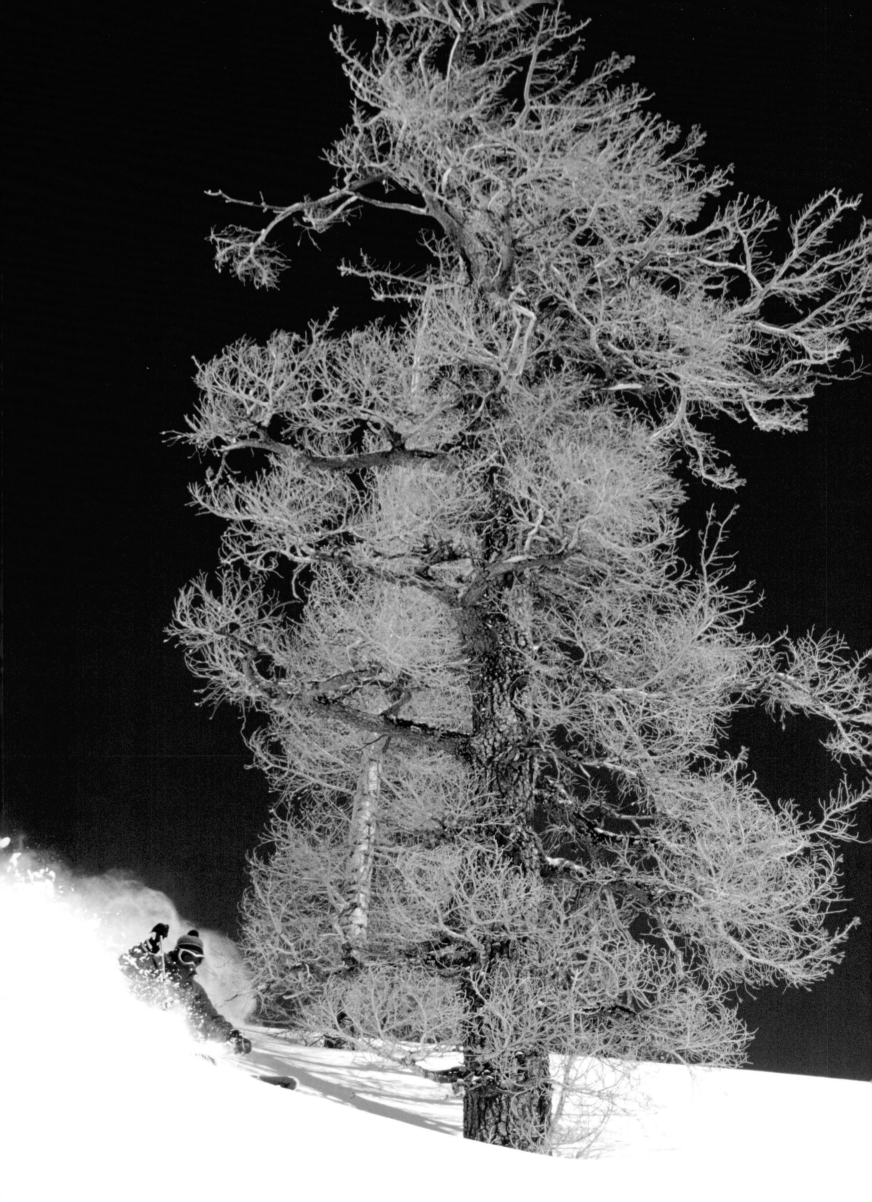

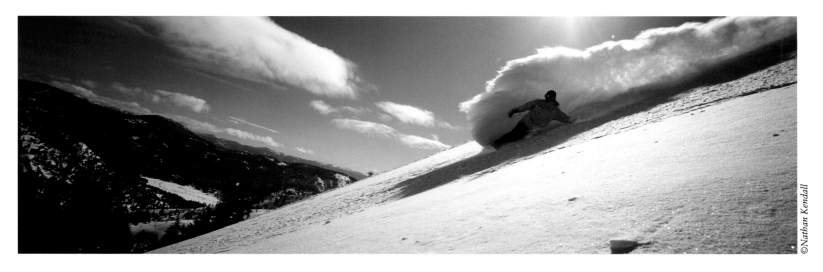
©Nathan Kendall

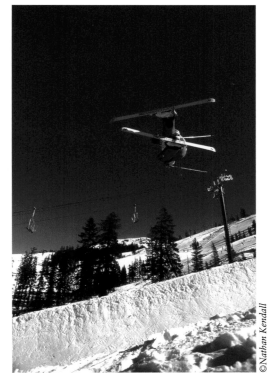
©Nathan Kendall

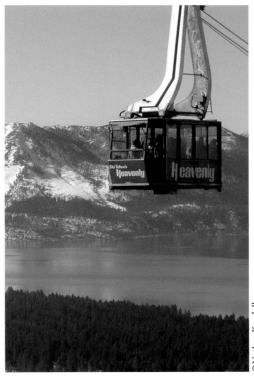
©Nathan Kendall

©Phil Teal

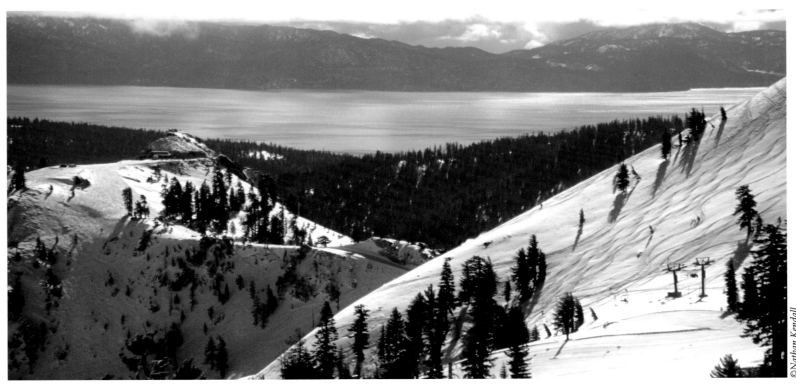
©Nathan Kendall

Opposite page: ©Keoki Flagg

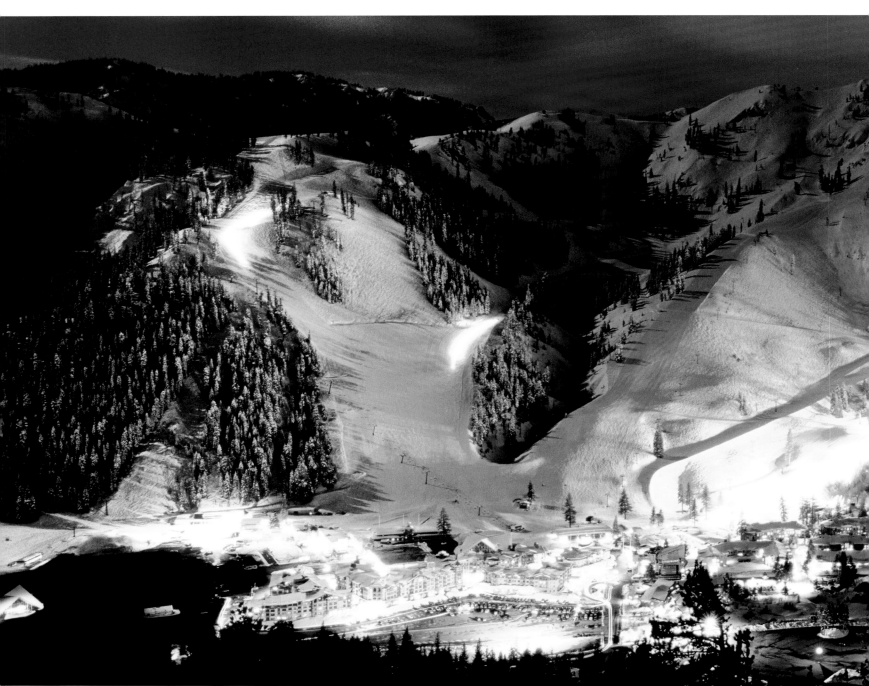

Full Moon Panorama, Squaw Valley

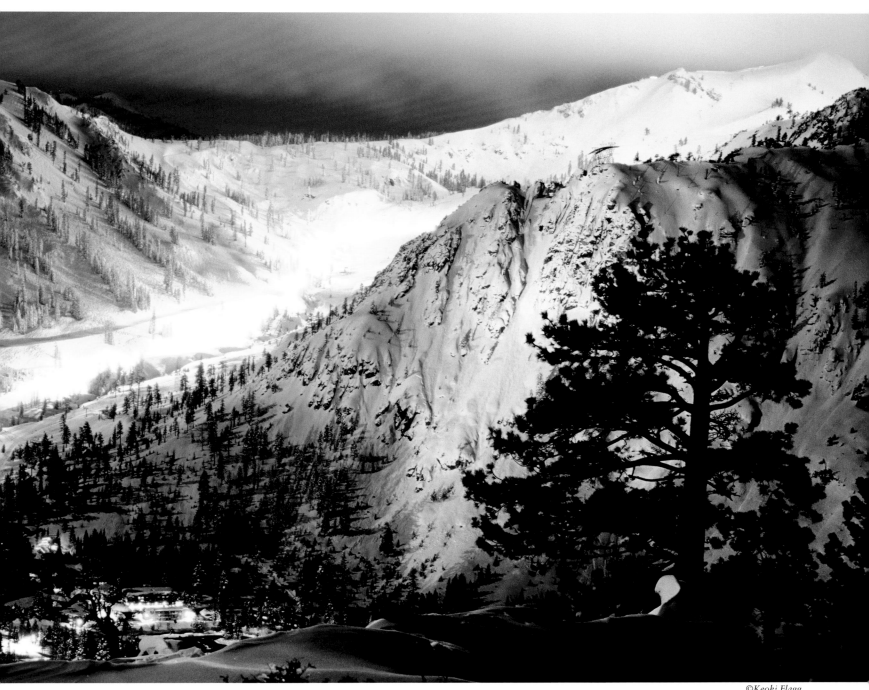

©Keoki Flagg

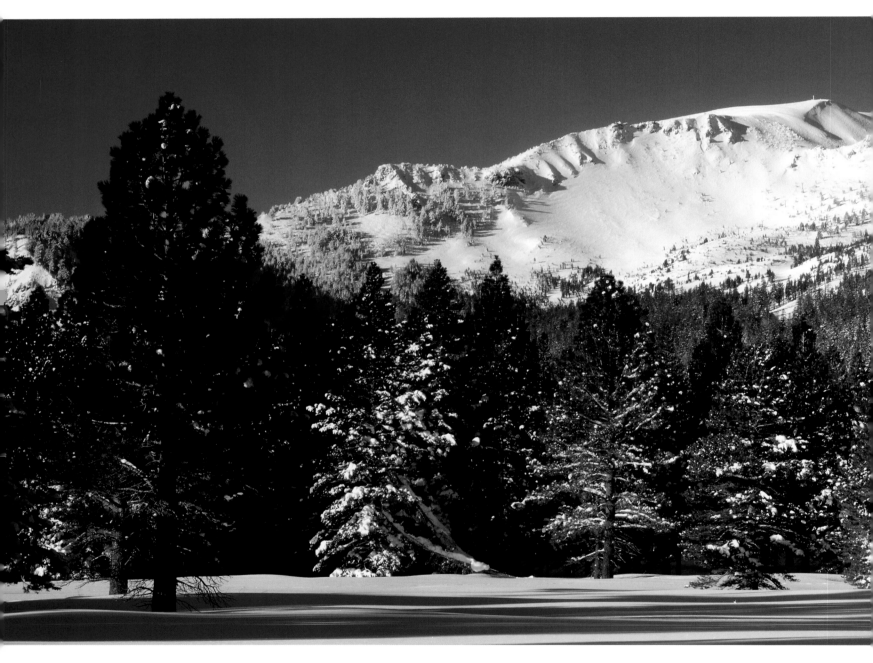

MAMMOTH

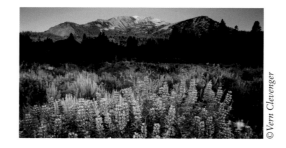

California's Eastern Sierra Nevada offers some of the most impressive landscapes in the world. If you're looking for roads winding through dramatic mountain backdrops, sparkling mountain lakes and waterfalls, authentic ghost towns, bubbling hot springs, moon-like rock formations, and the most spectacular and scenic outdoor adventures in the west, it's all available in the geologic wonderland surrounding the town of Mammoth Lakes.

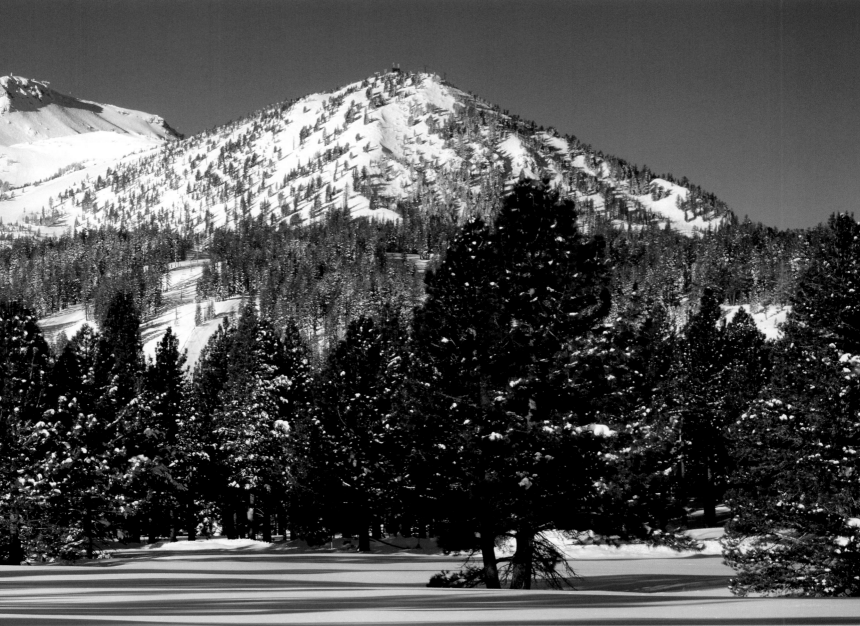

AND MORE

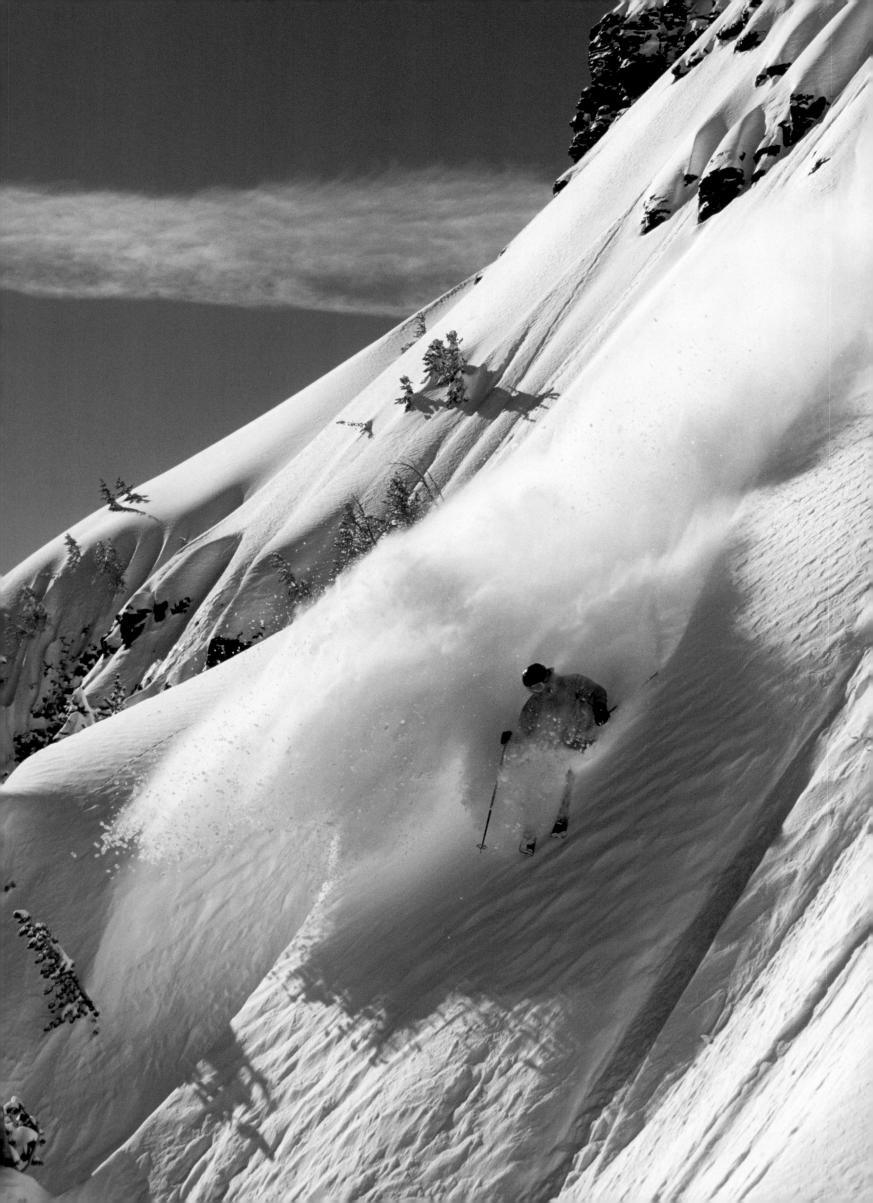

From the top of its 11,053-foot summit to its 7,953-foot base, snow falls light and plentiful making Mammoth one of the finest Alpine skiing mountains in the world. With over 3,500 acres and a variety of terrain, Mammoth's ski season is one of the longest in the U.S.

The new village at Mammoth has reinvented the resort's experience. A gondola connects the ski mountain to the village and a host of restaurants, shops, bars and nightlife. In Mammoth, when the sun goes down, the fun continues.

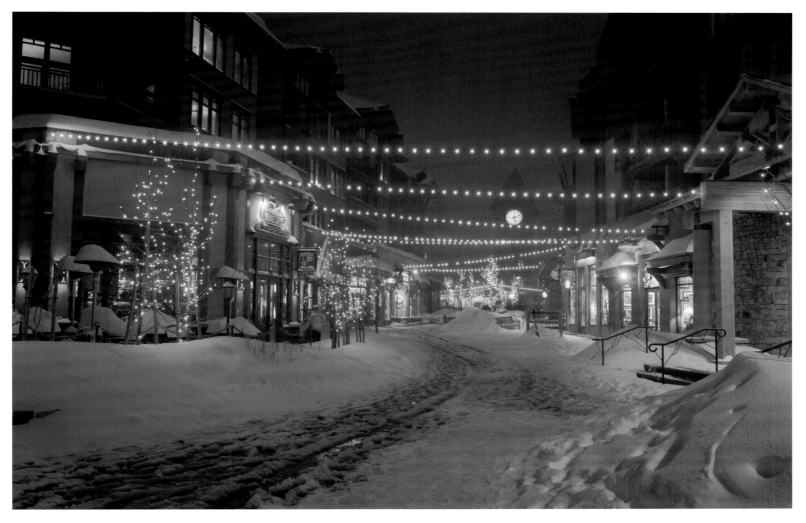

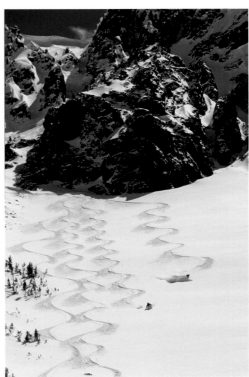

All photographs this spread ©Christian Pondella.

Opposite page: Skier Frank Fazzino.
Left photo: Skier Chris Benchetler.

Tucked in the scenic eastern Sierras, a region made famous by John Muir and Ansel Adams, Mammoth Lakes offers a variety of all-season experiences set within a panorama of glaciated lakes and never-ending beauty. The spring wildflowers and fall colors offer credence to Mammoth's reputation as a complete four-seasons resort.

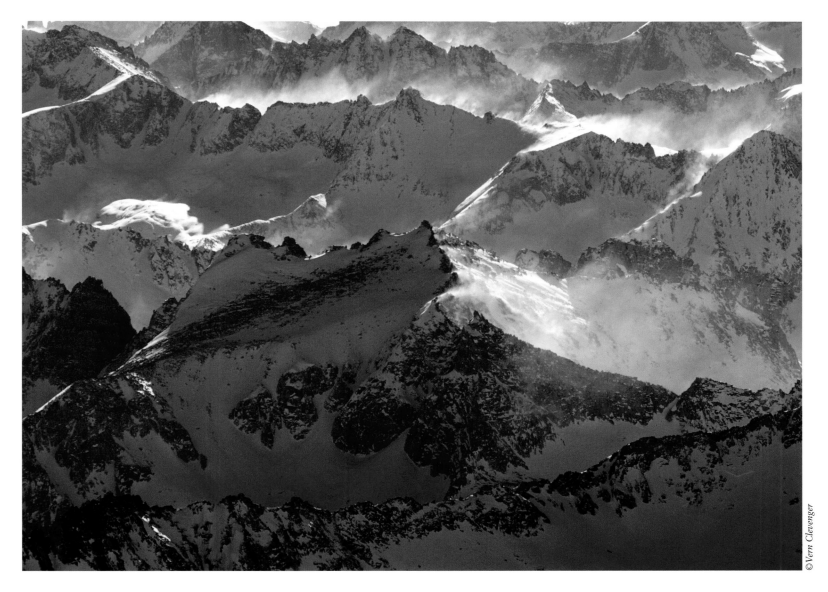
© Vern Clevenger

The evolution of Mammoth Mountain and the town of Mammoth Lakes is one diverse in background and history. From the early settlers looking for riches in the form of gold, to time spanning thousands of years back where volcanic eruptions formed the area out of molten rock, the Mammoth Lakes area has always been a land of fire and ice.

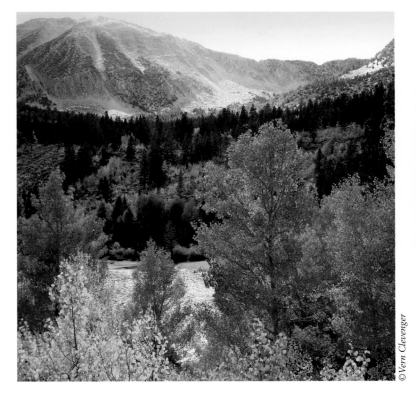
© Vern Clevenger

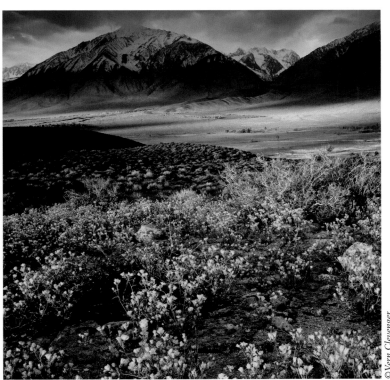
© Vern Clevenger

©Christian Pondella

©Londie Padelski

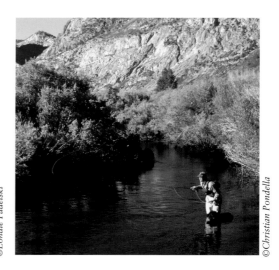

©Christian Pondella

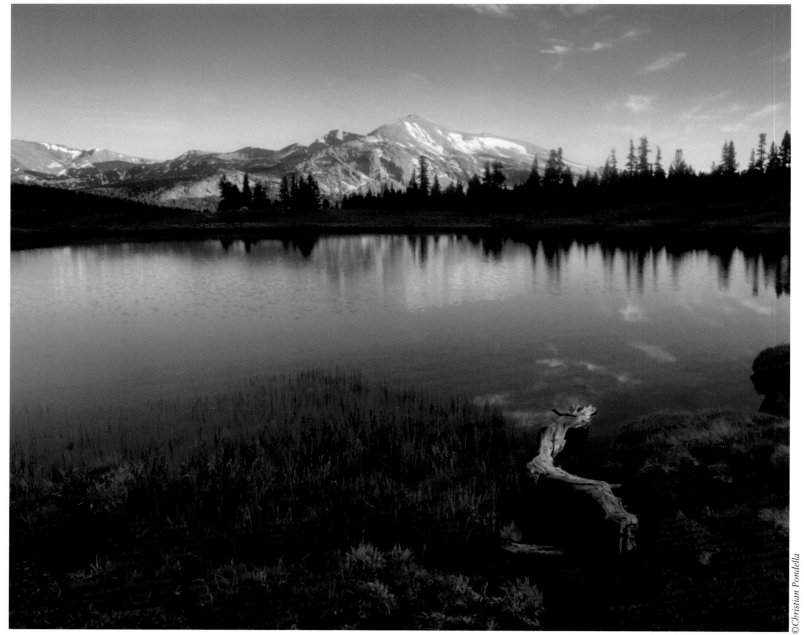

©Christian Pondella

The camping, hiking, fishing, sightseeing and overall dynamic beauty of the landscape confirm Mammoth as a paradise for recreation and serene contemplation. With over 400 inches of snowfall and 300 days of sunshine annually, Mammoth offers unforgettable memories for years to come.

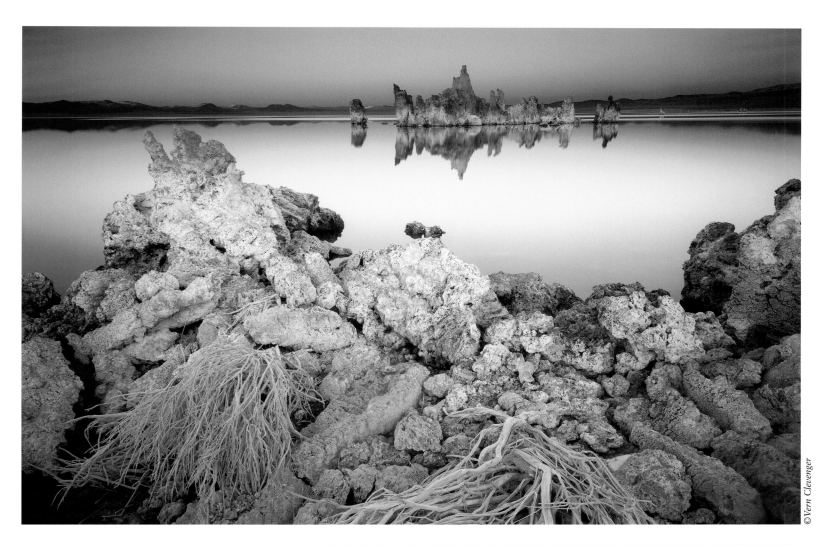

©Vern Clevenger

Extraordinary natural features such as obsidian domes, craters, steam vents and hot springs all attest to the region's active geologic past. About 30 miles north of Mammoth, Mono Lake stretches its glassy waters eastward from the base of the Sierra Nevada. The sweeping views of the glaciated range and the stark Mono craters make Mono Lake a special place.

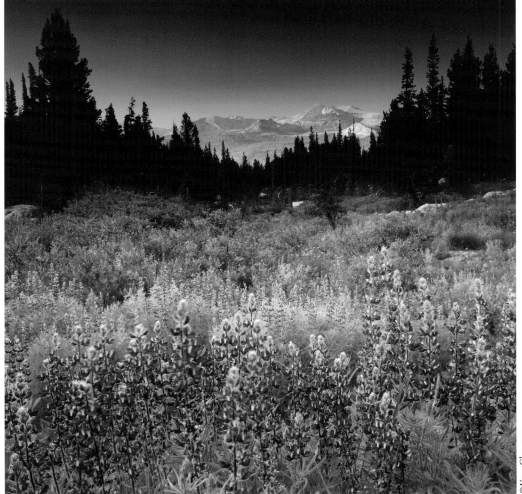

©Vern Clevenger

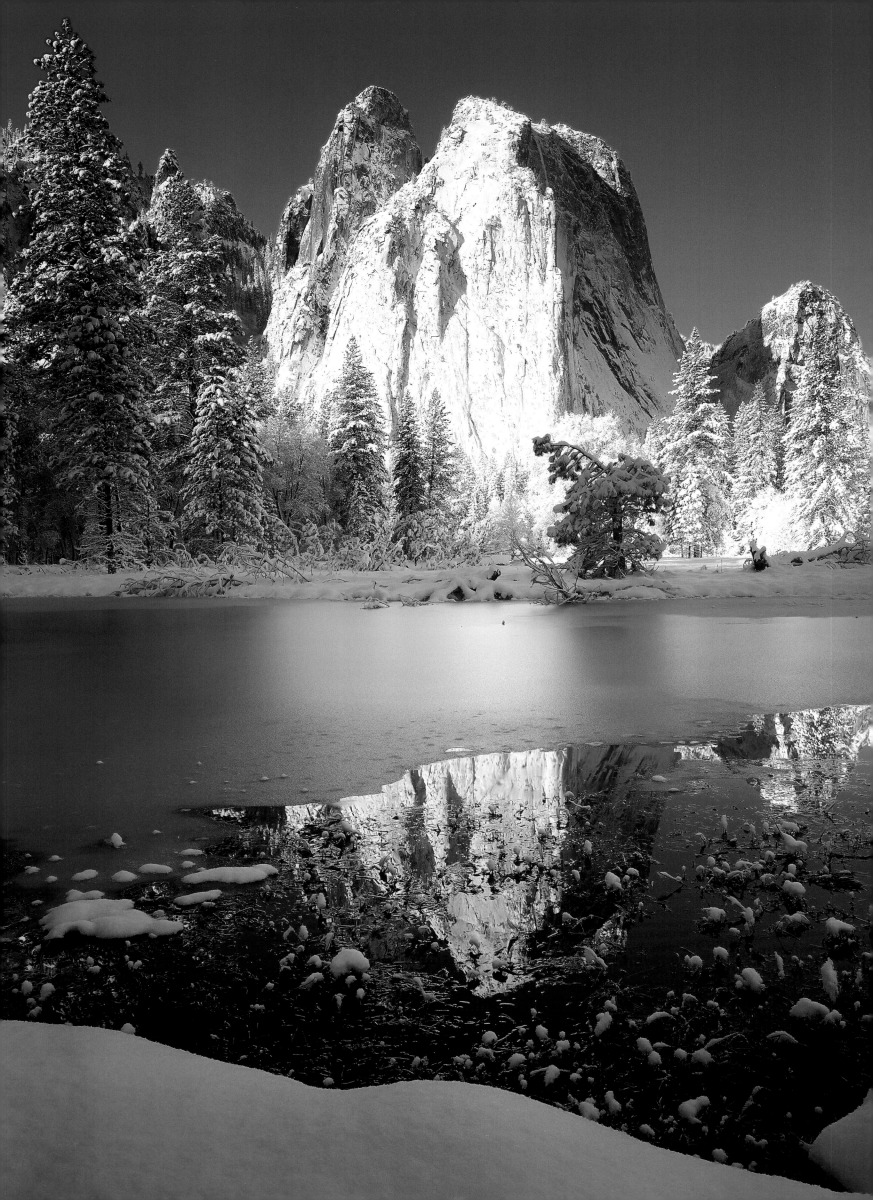

"National parks are the best idea we ever had. Absolutely American, absolutely democratic, they reflect us at our best rather than our worst." *Wallace Stegner*

With unmatched scenery and year-round recreation, Yosemite National Park covers a huge area of the western Sierra Nevada Mountains in central California. Recognized for its spectacular granite cliffs, powerful waterfalls, clear streams, innumerable lakes, serene meadows, giant Sequoia groves, monumental granite spires and endless Alpine scenery, Yosemite is the most famous glacially carved landscape in the world.

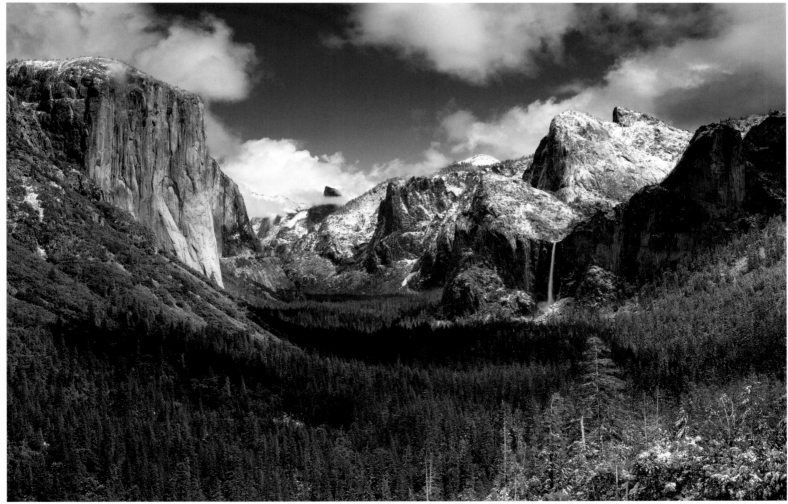

©Ric Ergenbright

Opposite page: ©Vern Clevenger

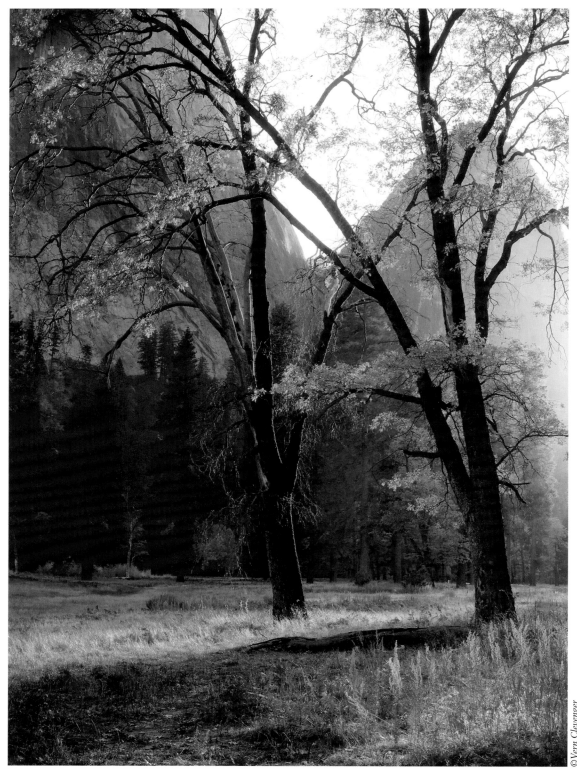

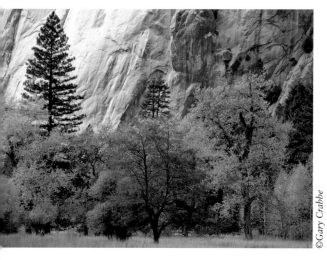

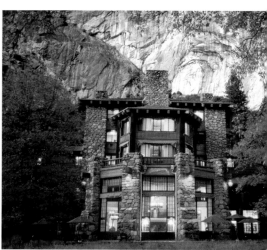

Courtesy The Alwahnee Hotel

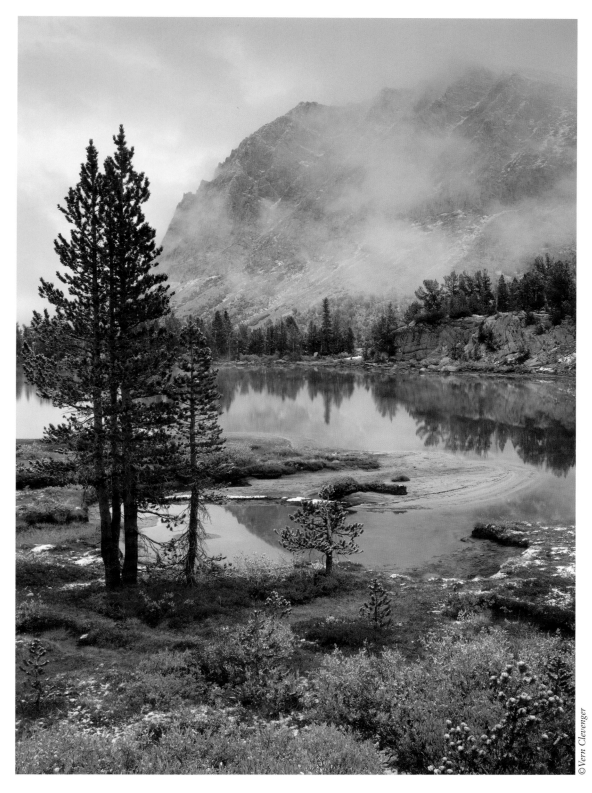

©Vern Clevenger

Yosemite was set aside as a national park in 1890 with 747,956 acres and 1,169 square miles. In 1984, Congress designated over 95% of the park as Wilderness. Here is where you can backpack the high country, walk among the giant sequoias, view majestic waterfalls and climb the largest piece of exposed granite in the world.

Highlights of the park include Yosemite Valley with its high cliffs and waterfalls; the Mariposa Grove which contains hundreds of ancient giant sequoias; Glacier Point's spectacular view of Yosemite Valley and the high country; The Ahwahnee, a historic mountain hotel built in 1927; Tuolumne Meadows, a large sub-alpine meadow surrounded by mountain peaks and among the most beautiful hikes in the world; El Capitan, a solid granite rock a half-mile high and a mile wide and Half Dome, perhaps the most recognized symbol of Yosemite. Rising over 4,000 feet above the Valley floor, Half Dome is one of the most sought-after landmarks in Yosemite.

Your first glance of Yosemite will have a similar effect as the one experienced by the early visitor. Here is where the world of reality completely fosters the world of imagination.

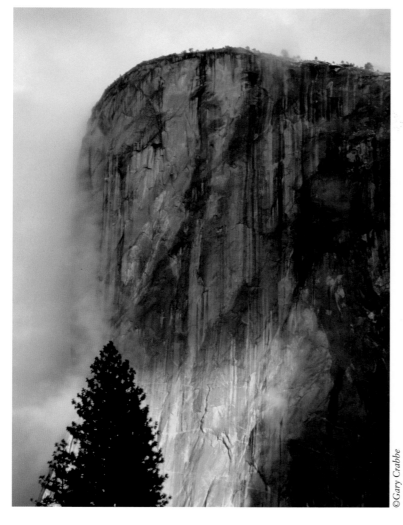

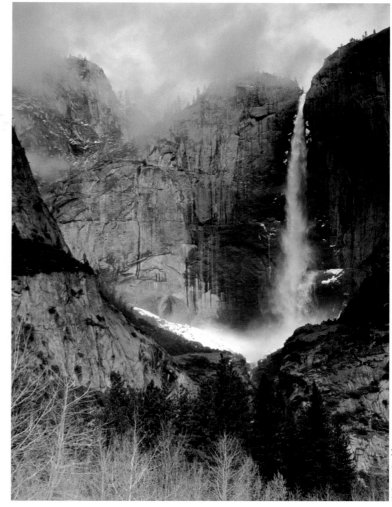

©Gary Crabbe

©Gary Crabbe

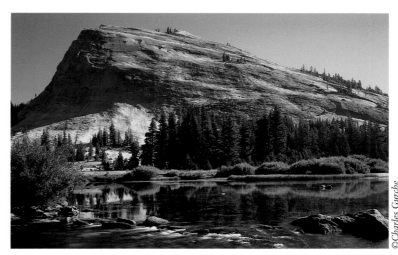

©Charles Gurche

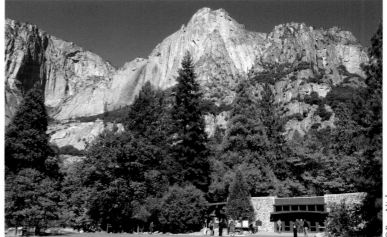

©Ron Niebrugge

©Ron Niebrugge

HOMES

HERE ARE 27 HOMES THAT REDEFINE THE CONCEPT OF "GREAT PLACE TO LIVE."

SOME ARE COASTAL, SOME GRACE INLAND LAKES, SOME RISE IN CITIES, SOME ARE

BOATS. ALL, THOUGH, ARE CALIFORNIAN, RESONATING THEIR SITES, FOLLOWING

BOLD ARCHITECTURAL CUES, EMPLOYING EXOTIC MATERIALS AND, IN A NUMBER

OF CASES, CRAFTED BY HAND FROM THE GROUND UP. WALK THESE HALLS, BEHOLD

THESE VIEWS, FEEL THE AMBIENCE IN THESE SPACES, AND YOUR UNDERSTANDING

OF "HOUSE" CHANGES.

STATUESQUE
Palm Desert

ARCHITECT **GARY LAMB** PHOTOGRAPHER **KAMINSKY PRODUCTIONS**

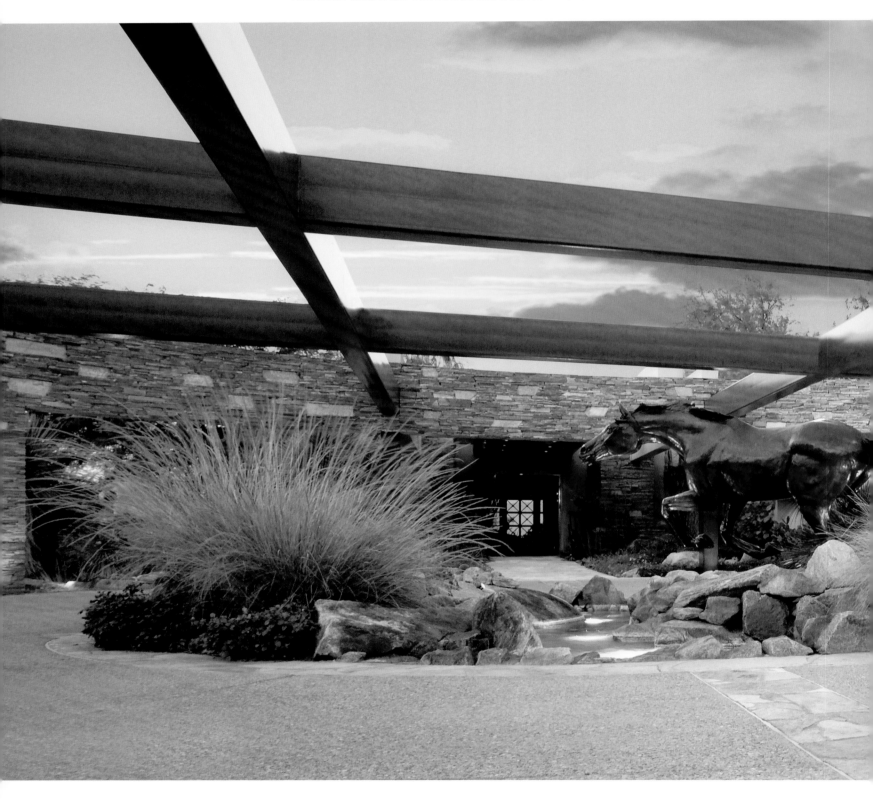

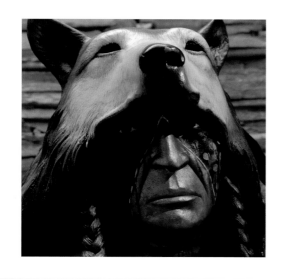

During his careers in education, business, land development and through his remarkable philanthropic contributions, his passion to preserve and appreciate the art and culture of the American West, R.D. Hubbard has exerted a powerful influence on the world around him. His own home embodies all the passion, energy and influence that define him. Maintaining one of the world's most extensive collections of Western American art, the Hubbards built their home around two rare Russell paintings that now form the physical and aesthetic center of the residence. The sculptures of Dave McGary and Remington lend the home a resonating sense of presence that is enhanced by the home's rich interiors, custom wall treatments and monumental design pieces. All of this fine art and craftsmanship reflects the natural magnificence of the sixth hole on the famed BIGHORN Mountains course, and provides an ideal setting

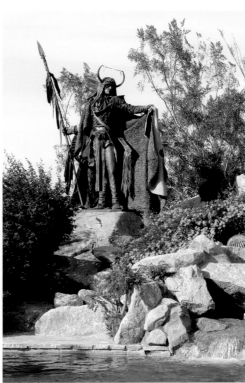

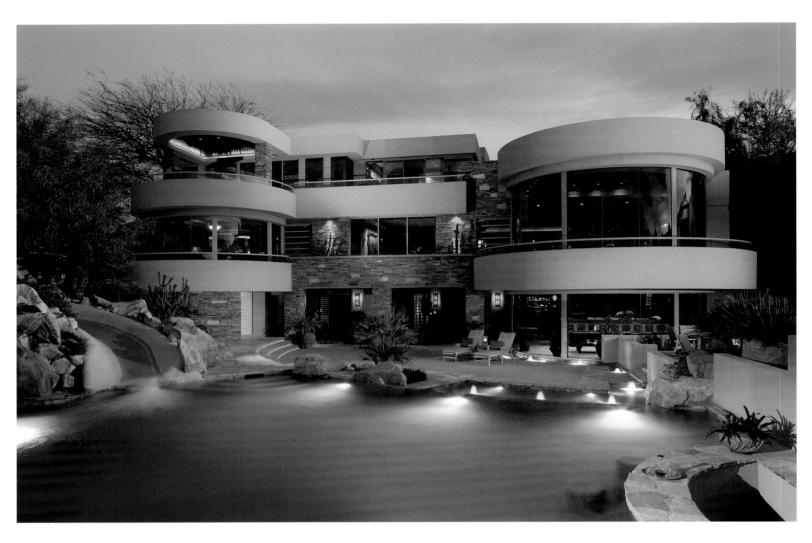

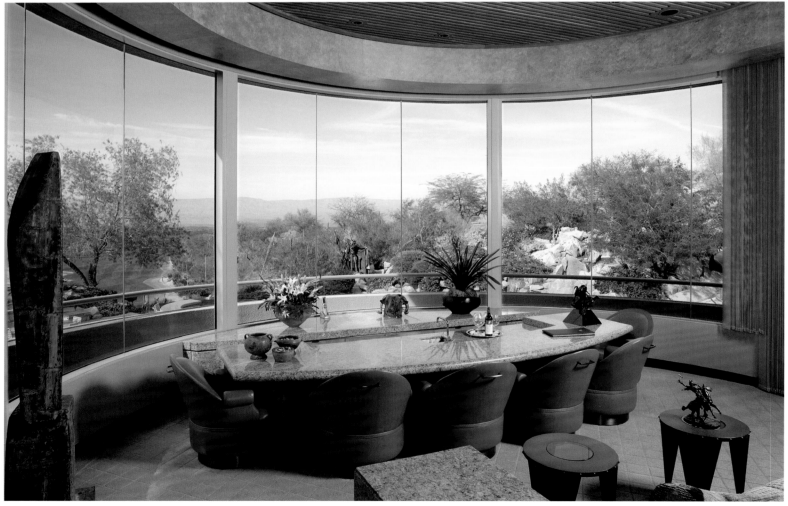

from which BIGHORN's founding couple can enjoy the sprawling beauty of their empire.

Handsome, contemporary architecture, curved panoramic glass, rich stacked ledger stone, copper accents, bronze thoroughbred horse statues and refreshing oasis waterfalls all within one of the country's most pristine locations of Palm Desert. It would be wrong to say that R.D. and Joan Hubbard's BIGHORN residence is the culmination of their prodigious dreams and accomplishments, because the Hubbards are nowhere near the culmination of their efforts. R.D. continues to envision and to build, and to make lasting contributions to the world around him. His private home, communities, museums and other public facilities, represent the most recent apex of a life and career that continue to soar.

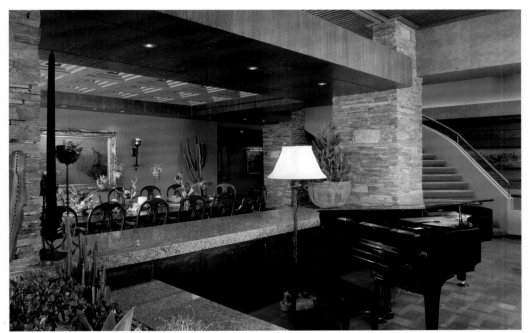
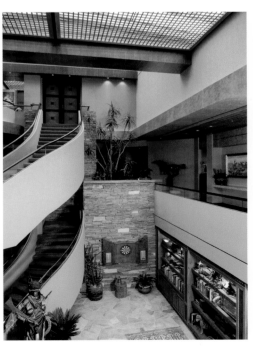
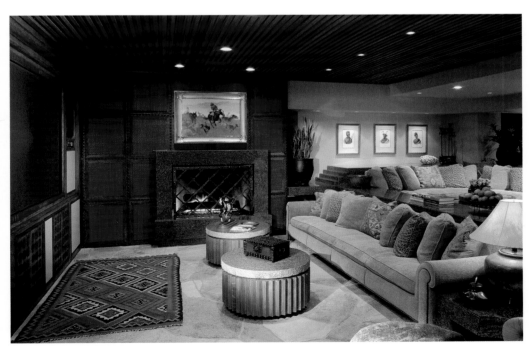

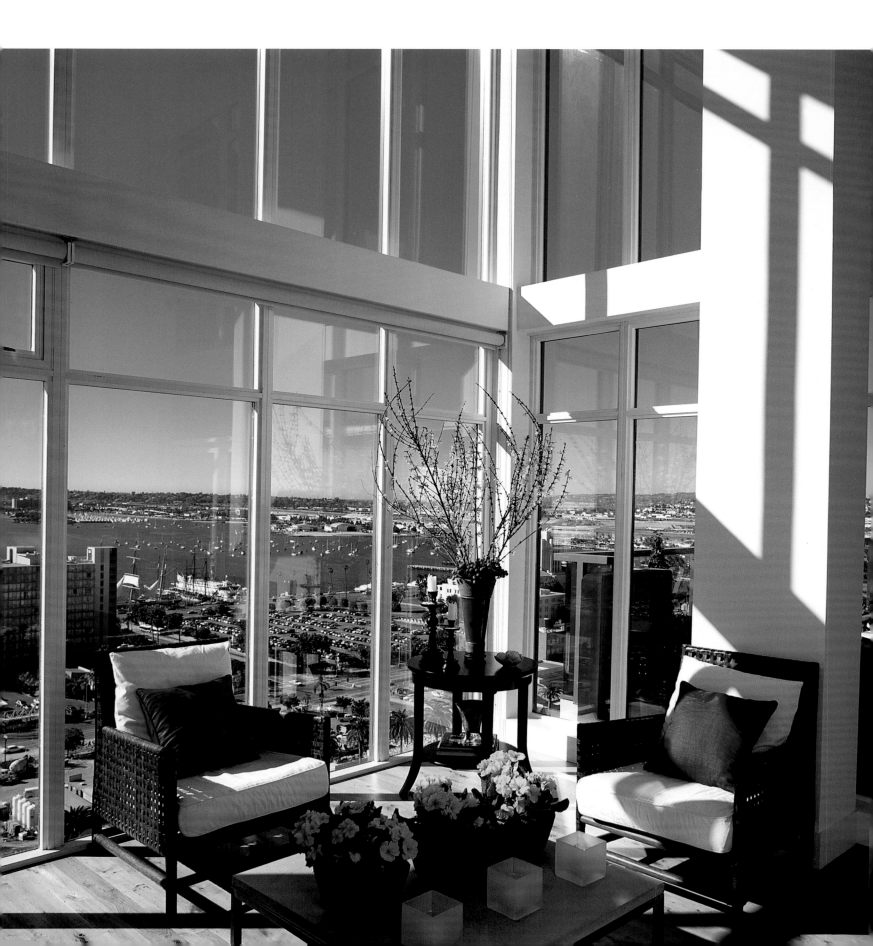

SAN DIEGO AERIE

ARCHITECT **BILL BOCKEN**
PHOTOGRAPHER **SHELLEY METCALF**
GARDEN DESIGNER **PAUL ADAMS**

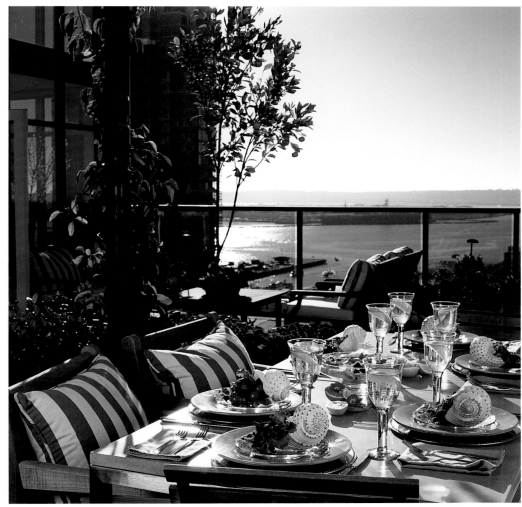

Located in downtown San Diego's Columbia neighborhood, this condo is situated on the 21st floor of the TREO building, a 24-story, 326-unit condominium project that includes street-level row-homes, 2,000sf of retail space and 4-levels of parking. With 2,100sf of living space, a 1,089sf outdoor terrace, windows on three sides and plenty of sunlight to flood the high-ceiling living room, the interior of this masterpiece is the creative result of architect Bill Bocken and floral/garden designer Paul Adams.

There are many appealing reasons for converting to sky living. Some say it's about the view and the light. Advancements in technology allows for energy-efficient floor-to-ceiling glass while living in a high-rise provides a constantly changing postcard view.

Since San Diego is blessed with sensational water, cityscape and geographic views, even bad weather is fun to watch when living in the sky. Overlooking North Island to the southwest, the bay to the west, the airport to the northwest, downtown all the way to Balboa Park, and with sailboats on the bay and Point Loma in the background, the living vistas are constantly in motion.

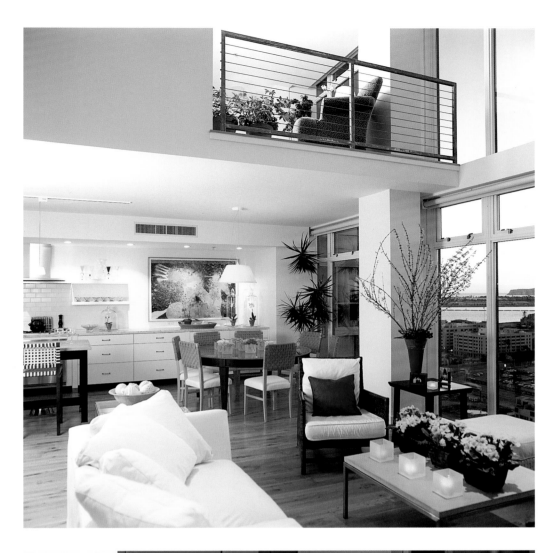

When purchased, this three-bedroom, three-bath unit was a blank slate leaving the interior design opportunities in the hands of the owners. The results are breathtaking. Above the living room, a wall was removed to expand views from and through the loft-like master bedroom. Steel-and-cable-railed stairs rise to a home office while oak-plank wood floors warm the room. The neutral color scheme complements the view and visu-

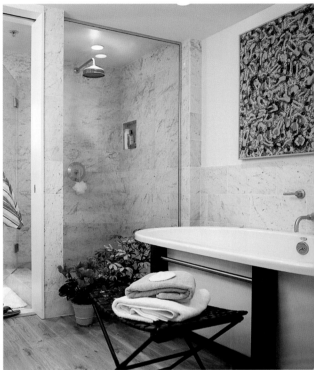

ally expands the interior. Although the opportunity to customize and refinish is an emerging trend that allows owners to tweak their unit plans and craft their own finishes, "don't compete with the view," says homeowner Bocken. "You'll lose."

The living room opens to the terrace where Adams has created a world of citrus trees, annuals and bamboo surrounding a casual seating area, a dining pavilion and a barbecue nook.

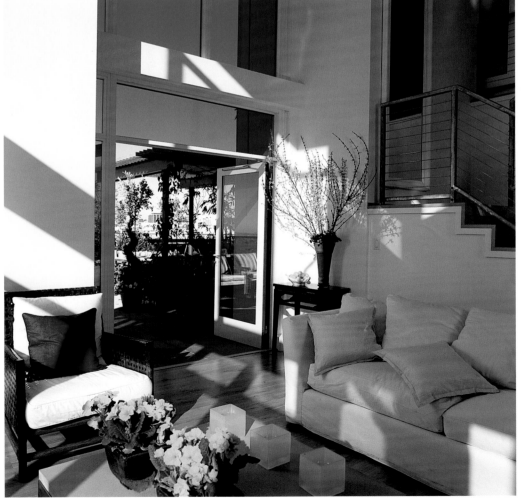

CEDᴬR FLᴬT

Lake Tahoe

ARCHITECT **BRUCE OLSON** PHOTOGRAPHER **PETER SPAIN**

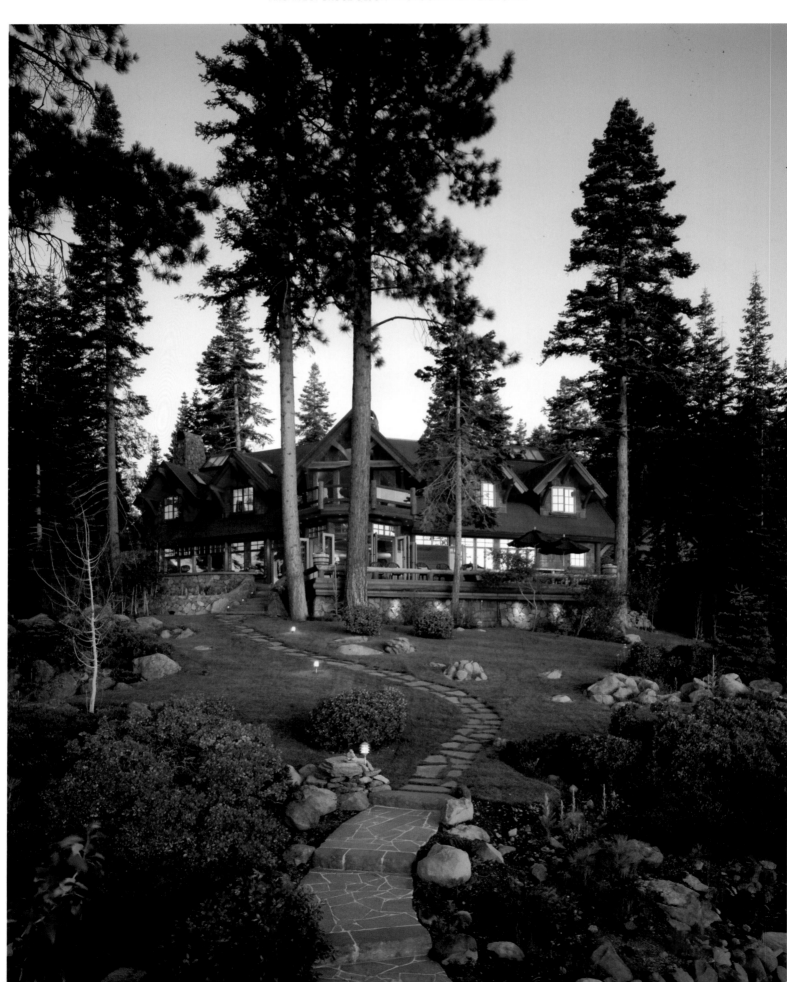

Bruce Olson's commitment to building in harmony with nature is evident everywhere in this gracious 5,300-square-foot home he designed and built for his family. Constructed of heart redwood and cedar siding and set back from the water's edge, the house blends as one with the natural surroundings. A waterfall greets you as you enter the estate through the controlled access gate. Water weaves down around a whimsical garden of native plants and natural granite stones, spilling into a calm pond.

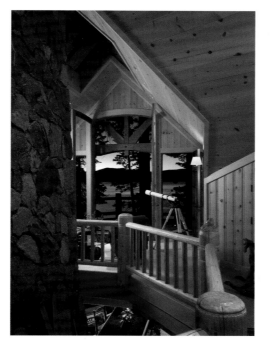

The main entry features native granite stone work and low roof forms that convey the guise of a cottage. A meandering stone path beckons as you walk up from the pier. A custom glass door invites guests, while the heated path melts snow as it falls.

The second level open balcony encloses the massive fireplace as it ascends into the peak of the roof. Carved animals perch atop the log baluster. Two impressive twelve-foot tall doors open onto an outdoor patio and views of Lake Tahoe.

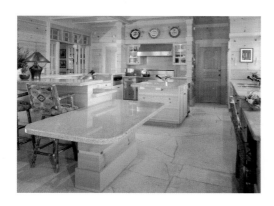
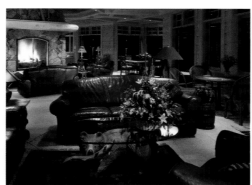
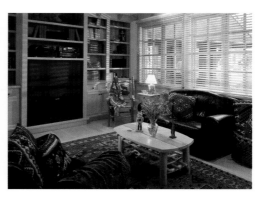

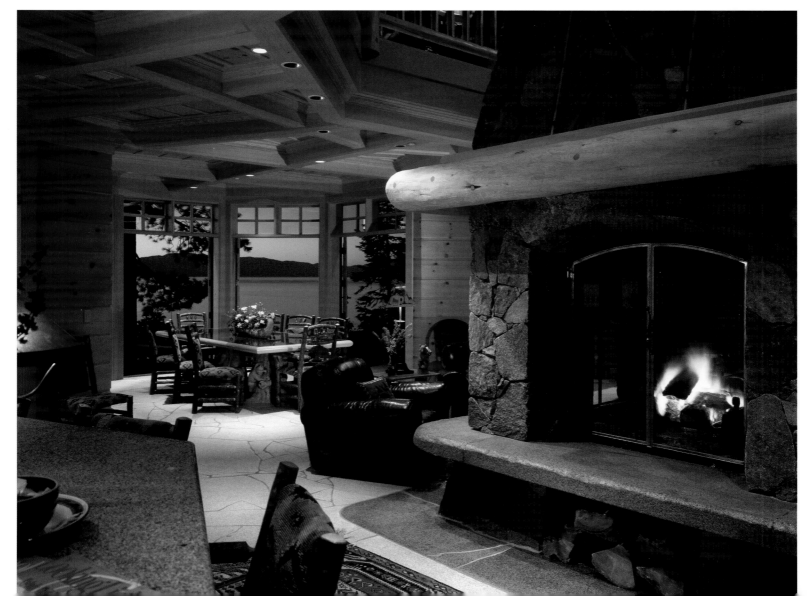

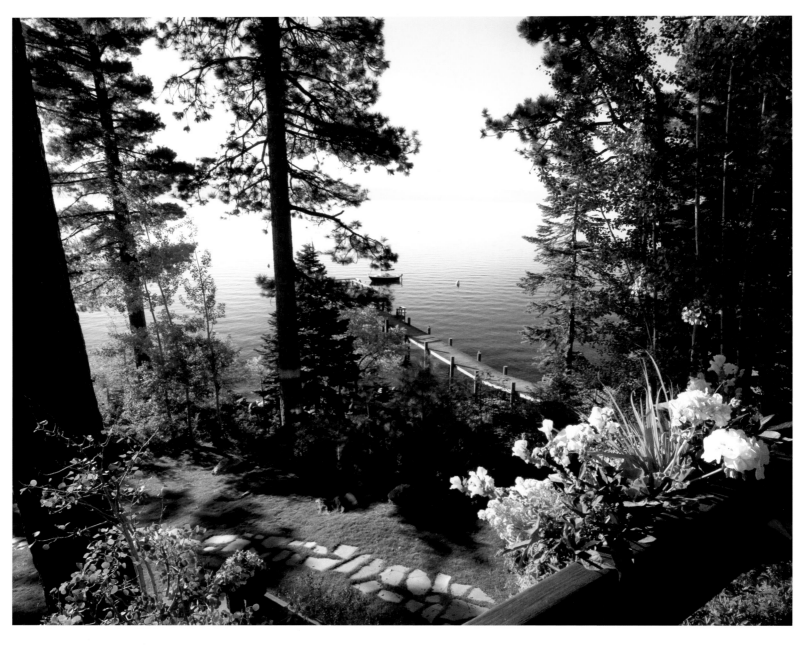

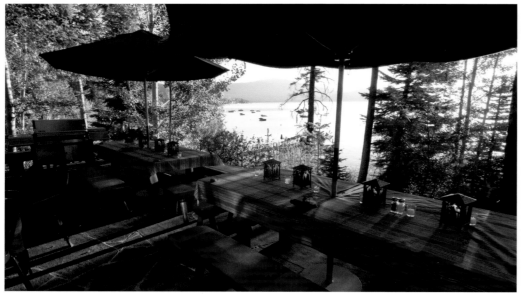

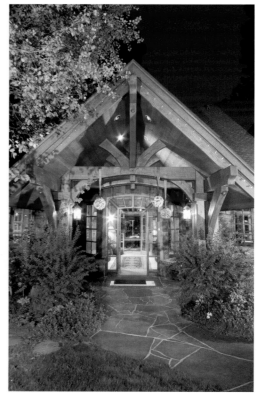

Designed to take advantage of the views, the kitchen faces out to the lake. The custom polished sierra white granite counter tops are a stunning feature. The counters are fixed at various levels allowing for a bar top, a serving counter, and telephone desk.

The family room showcases built-in bookshelves and entertainment center. Maple flooring compliments the pine wainscot, plastered walls and a coffered ceiling.

The view of the dining area and the lake beyond exhibits the massive four-sided stone fireplace at the heart of the home. An open balcony encircles the fireplace, passing light from the ridge skylights into the living space below. Coffered, sugar pine ceilings conceal recessed lighting and structural steel beams.

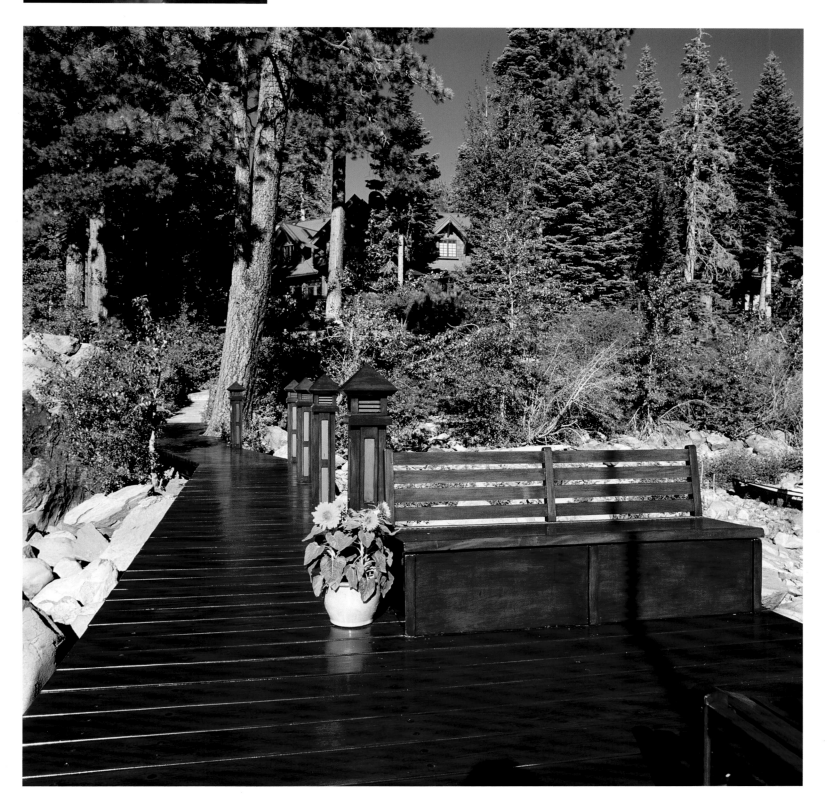

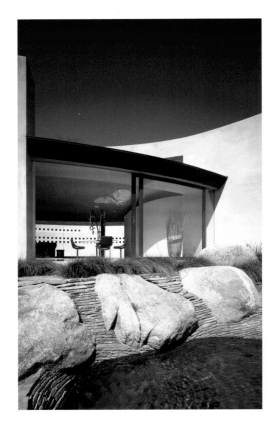

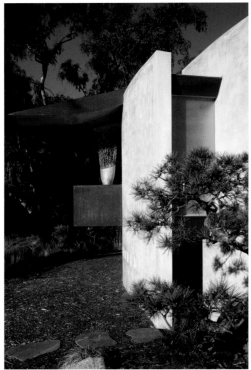

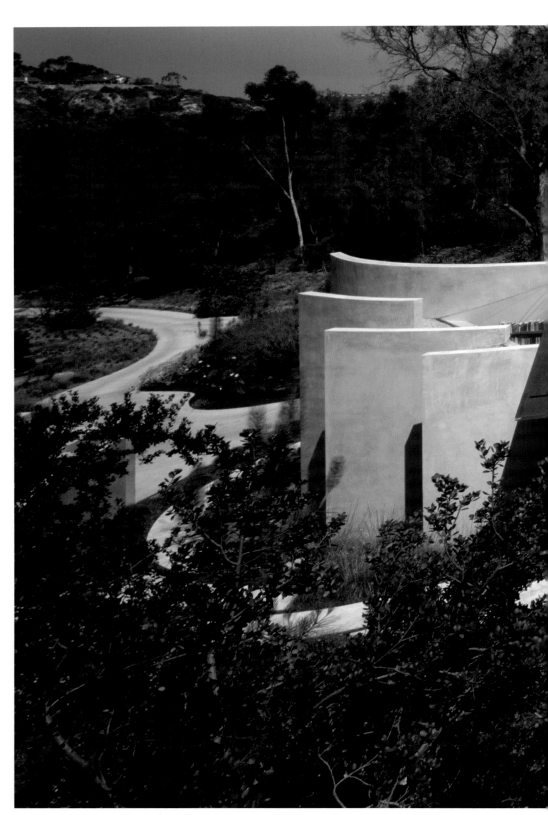

winghouse
san diego

ARCHITECT **WALLACE CUNNINGHAM** PHOTOGRAPHER **ERHARD PFEIFFER**

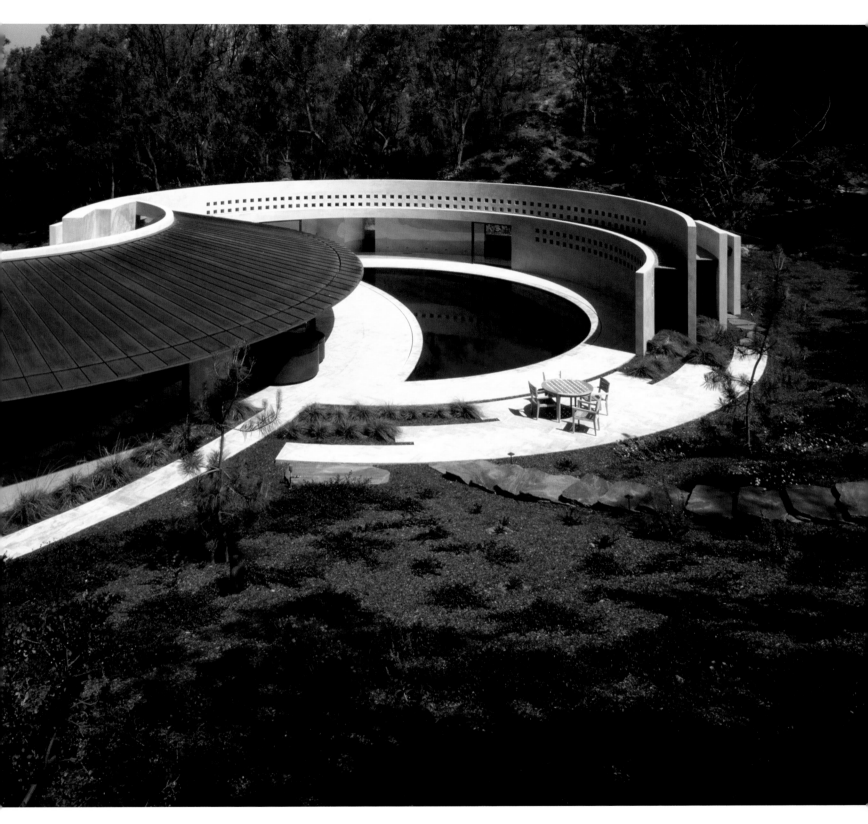

Winghouse is that rare instance where an architect designs a house, then comes back later to perfect the place. Sited in the Rancho Santa Fe hills, just north of San Diego, the original structure was designed and built in 1981 by Wallace Cunningham, an architect who "creates art that people live in." At that time, Cunningham walked the hilly 4-acre site and, in an inspired moment, drew his idea on the dusty ground with a stick — two interlocking semicircles, overlapping private wings with public spaces at the center, spiraling in opposite directions from a central core. It followed the geometry of the canyons that meet in a bowl on the site.

171

20 years later, asked in by Winghouse's third set of owners, Cunningham readdressed the house. This time, he focused on merging interior and landscape details, and on the concept of roofs floating over radiating walls. Room count was reduced and the floor plan opened, especially between the central living area and the library in the southwest wing. Beams supporting the elliptical skylight were removed. Windows were widened, removed from wood mullions and bowed into frameless curving sections that rolled on fine tracks. Carpets were replaced with limestone slabs that floated through walls. The roof was raised

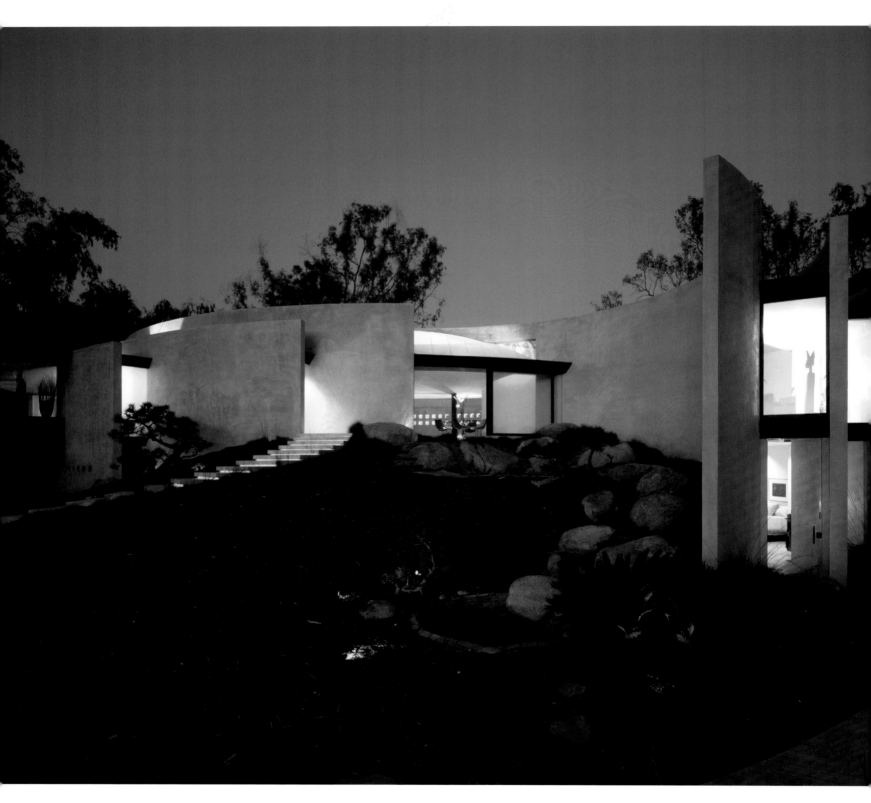

and sheathed with copper. And a moon-shaped, black-bottom pool was added in the private wing's curve, its crescent edge aligning with the geometry of the house.

Today, Winghouse spins the viewer's senses out into the rugged hillscape through sheets of glass. It is what it was meant to be.

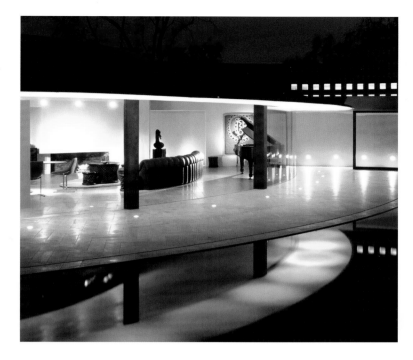
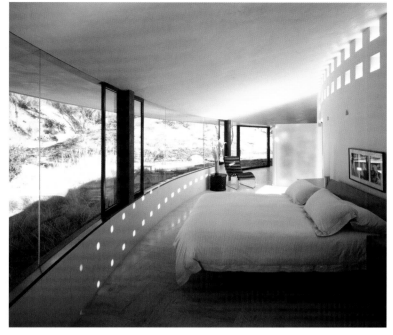
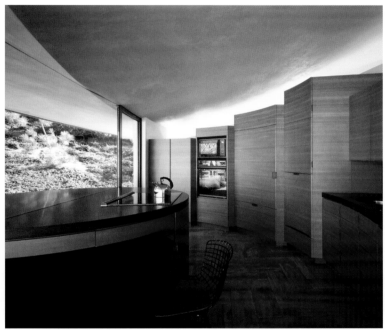

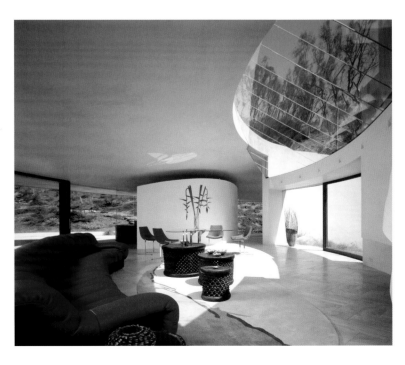
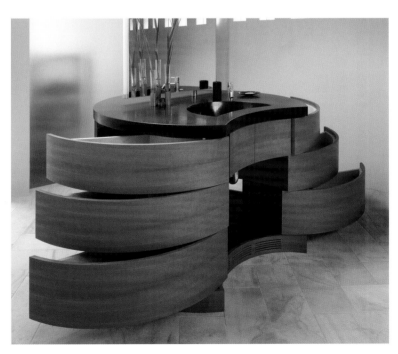

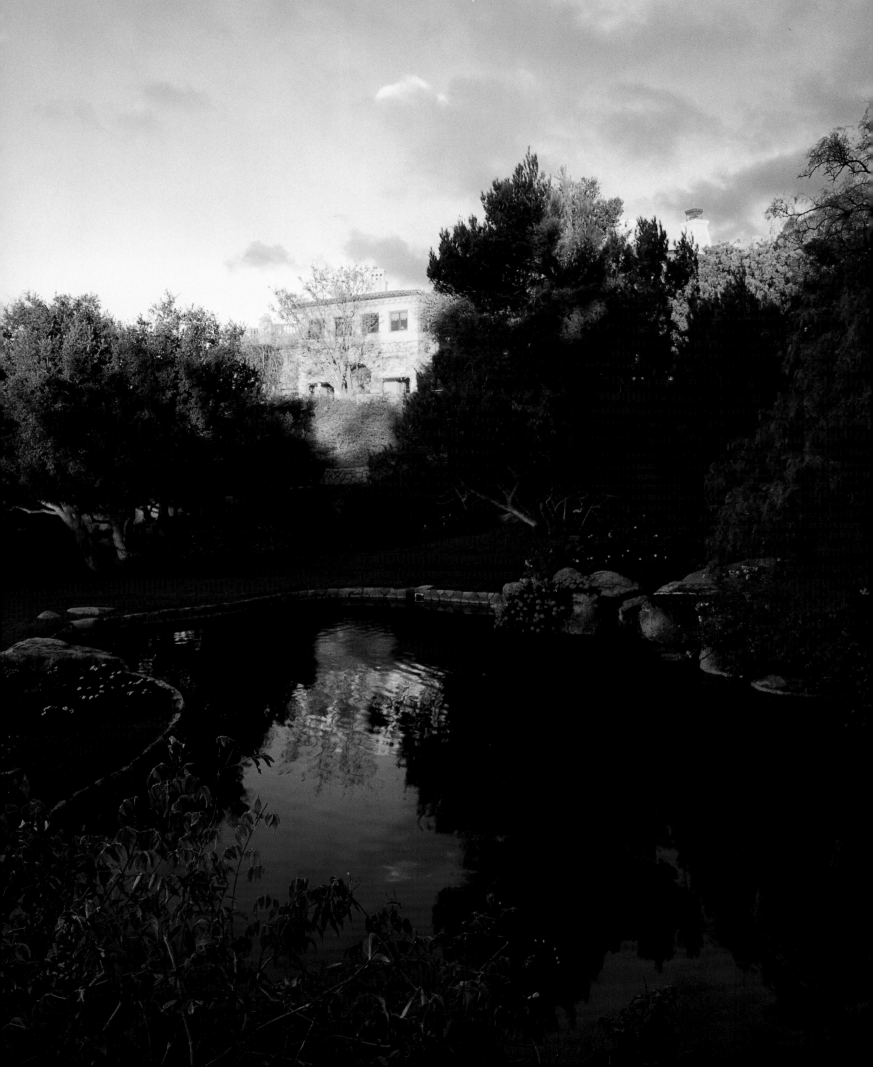

VILLA LUCIA

SANTA BARBARA, CALIFORNIA

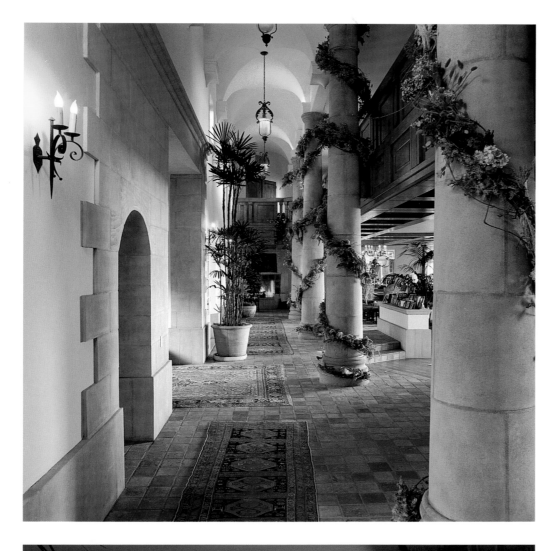

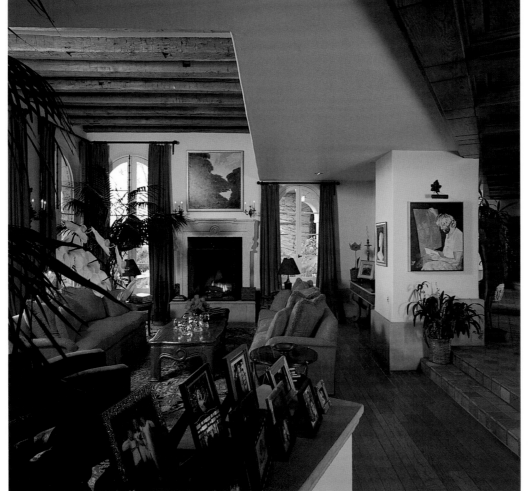

Because of its Mediterranean climate, magnificent coastline and dramatic mountain backdrop, Santa Barbara rests comfortably among the best of the best when it comes to selecting an ideal living environment. Within a breathtaking mix of mountains, valleys and beaches and a unique geographical location that reflects the golden hues, terra cotta earth tones and smoky greens of Tuscany, the Villa Lucia sits naturally in this special American landscape. After visiting the 8,500 sq. ft. residence amid twenty hilltop acres of beauty, the feeling is that the Tuscan sun shines daily here, and with pleasure.

The architectural and landscape elements of Villa Lucia are reminders of the villas, Mediterranean farmhouses and hill towns of Northern Italy and are the creations of famed American architect Barry Berkus and landscape architect Phil Shipley. Berkus describes the Villa Lucia as one that "reflects a love of Northern Italian vernacular, accommodates an active family lifestyle, and takes full advantage of the hillside location overlooking the Pacific Ocean. The intent of the design was to make this house feel as if it had evolved over a long period of time. Like a town that developed through the centuries, the house is a composition of living cores that are treated as autonomous buildings."

Opposite: Situated on a sun-drenched hillside, the home resembles a Tuscan villa and overlooks the estate's vineyards, olive trees and pond-style swimming pool.

Above: The archways and columns reflect the Tuscan Style. Floor tiles and cast stone wainscoting tie the family rooms to the great hall and entry.

ARCHITECT **BERRY BERKUS**
PHOTOGRAPHER **JAMES CHEN**

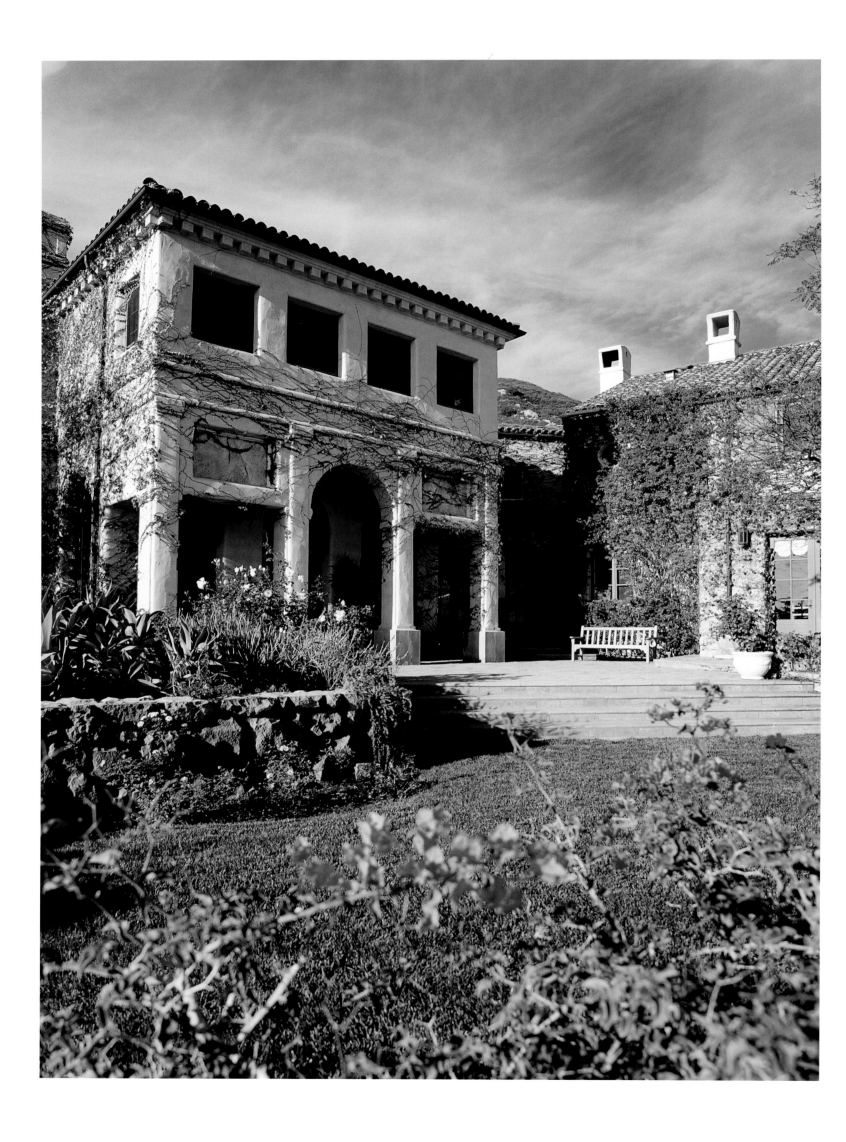

By providing both a lifestyle as well as a home, the aptly named Villa Lucia (House of the Light), reflects a way of life as much as a residence. The views from this Tuscan-style villa offers spectacular ocean and mountain scenes while the entire estate represents the flavor of Tuscany through the use of waterfalls, fountains, frescoes, fireplaces and courtyards. Stone laid in stucco dramatizes the interplay of light and shadow that's so much a part of Tuscan architecture.

Climbing vines add a sense of longevity while the studio tower provides a 360-degree view. From the tower, you also feel the full effect of Barry Berkus' concept of a visual journey, saying, "the eye picks up the changing light patterns and shadows as the sun moves across the sky."

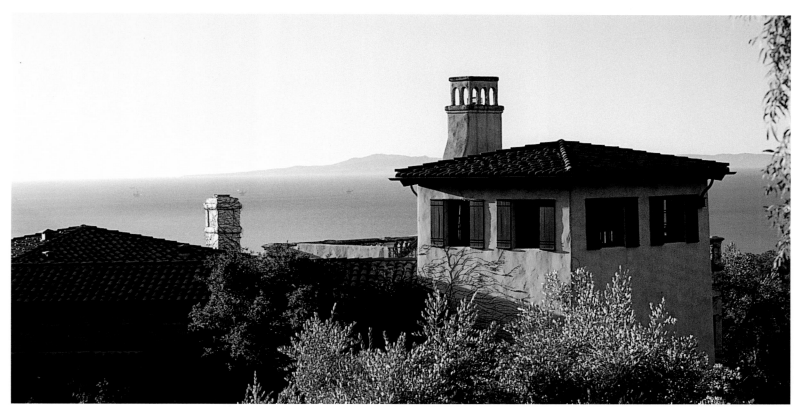

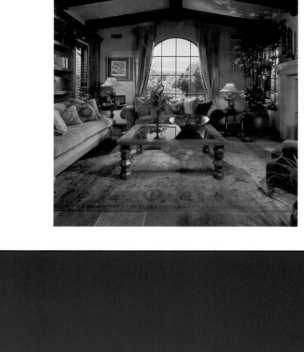
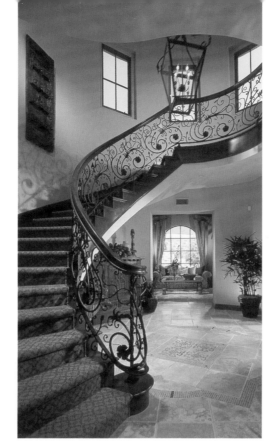
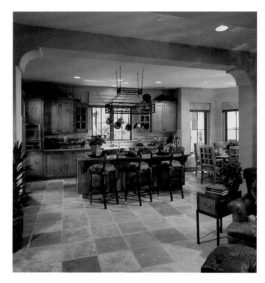
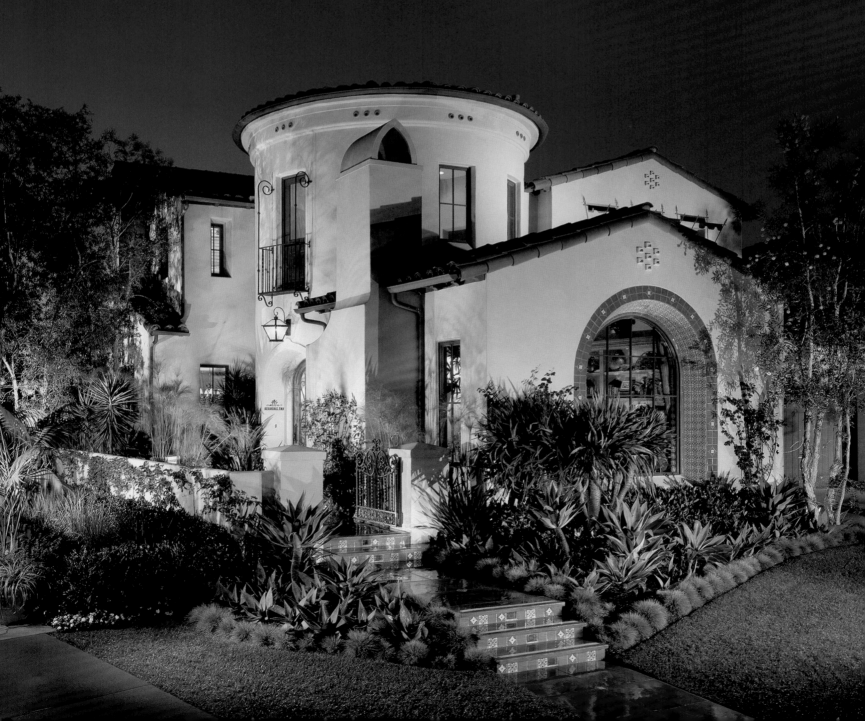

Windward

at Crystal Cove, Newport Beach

ARCHITECT **BASSENIAN / LAGONI ARCHITECTS** PHOTOGRAPHER **ERIC FIGGE**

*N*estled in a community overlooking the Pacific Ocean at Crystal Cove, in Newport Beach, Windward's individual character is apparent from first approach. Designed to fit a slender, sloping coastal lot, the house fits into a street scene that mixes old world and modern, formal and rustic, and openly invites neighboring. Half walls and walkways define the entry courtyard. A tawny turret with colonial and Moorish details stands over the entry itself, and around a corner a deep, tiled arch frames the home's feature window.

At the back of the house, low border walls, a covered loggia and upper level deck share their place in the sun with a rounded turret. Window surfaces are recessed into the walls like Spanish houses, and French doors allow indoor and outdoor spaces to mingle with ease.

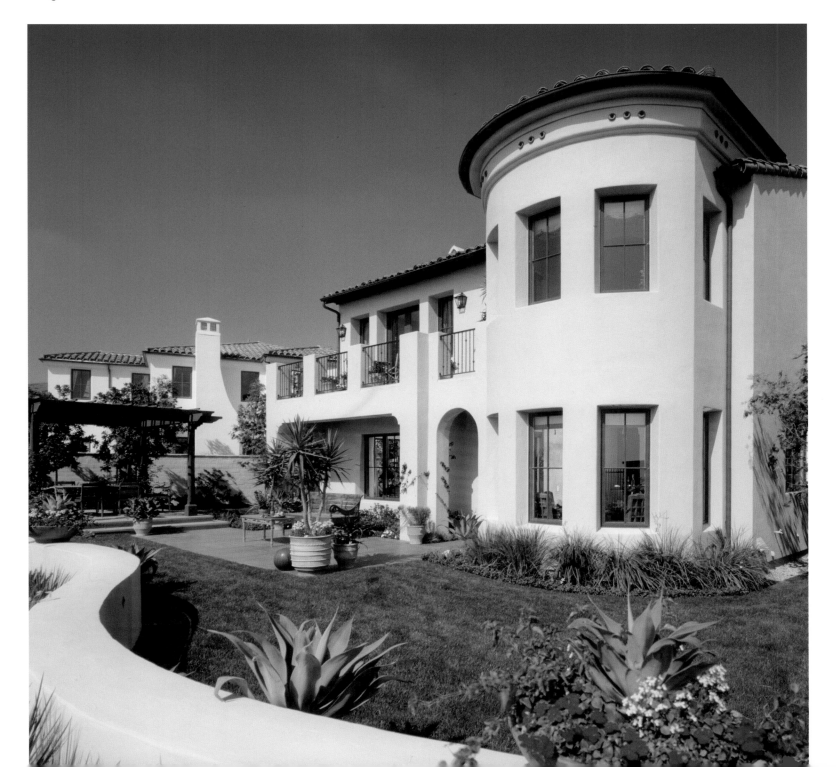

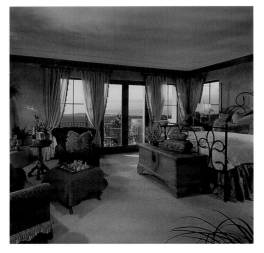

Intended as a retreat, the upper-level master suite offers calming views and access to a private deck through French doors. An adobe-like raised hearth fireplace and banco warm the space. Adjoining master bath captures panoramic ocean vistas in bay windows behind a step-up spa tub. Stone flooring, built-in cabinetry and wrought iron accents add interesting details.

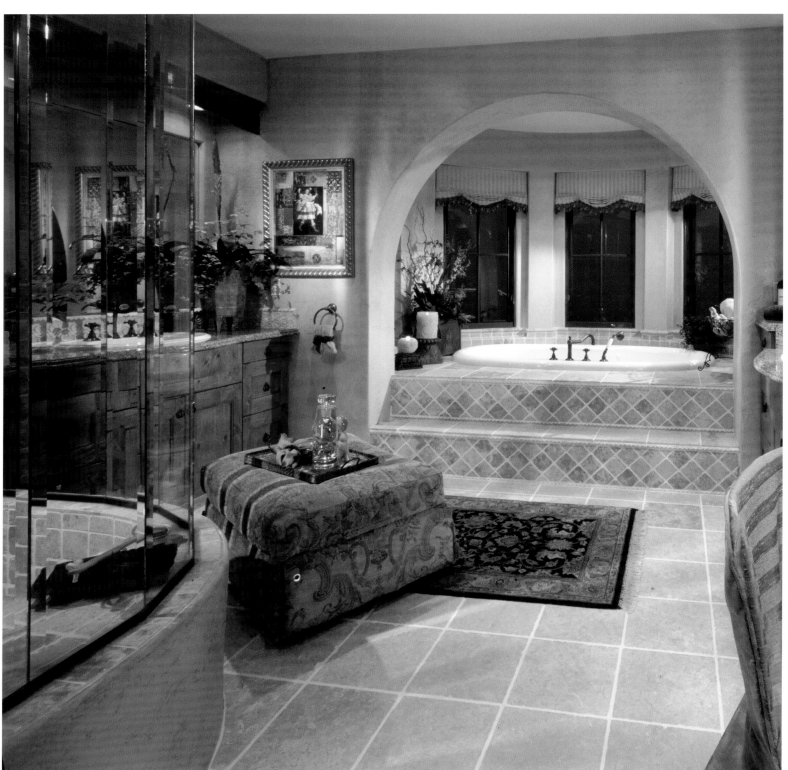

Windward's living areas are sometimes quixotic. In the living room, built-in cabinetry, overhead beams, a massive fireplace and central ocean view window project a grand scale. And the house's showcase foyer is dominated by an elegant curving staircase with scrolled wrought iron railings. In the kitchen, morning bay and family room spaces, however, sculpted arches bespeak a more open, informal, attitude.

At the end of a hall on the main level, an entertainment and media center offers ample accommodation for home theater screen and comfortable seating. The room is fully wired for all electronic controls and conveniences; it also converts into a fourth bedroom.

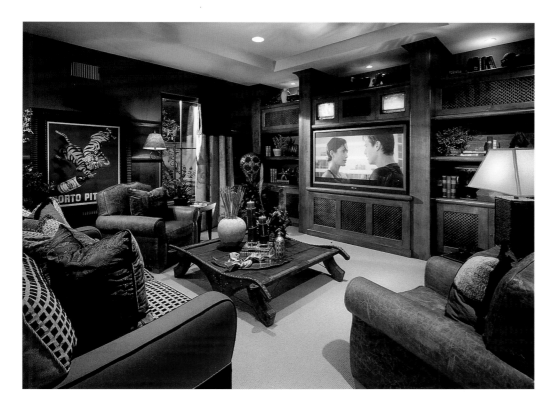

Windward's floor plan offers three bedrooms, all on the upper floor, with a fourth sleeping area available in the media center. The house also has useful small spaces, including an upstairs study and butler's pantry adjoining the kitchen on the main level. Most of the home's casual rooms are oriented toward the adjacent Pacific, and more formal, forward ones face the side courtyard.

Pfeiffer Ridge
Big Sur

ARCHITECT MICKEY MUENNIG
PHOTOGRAPHY ALAN WEINTRAUB

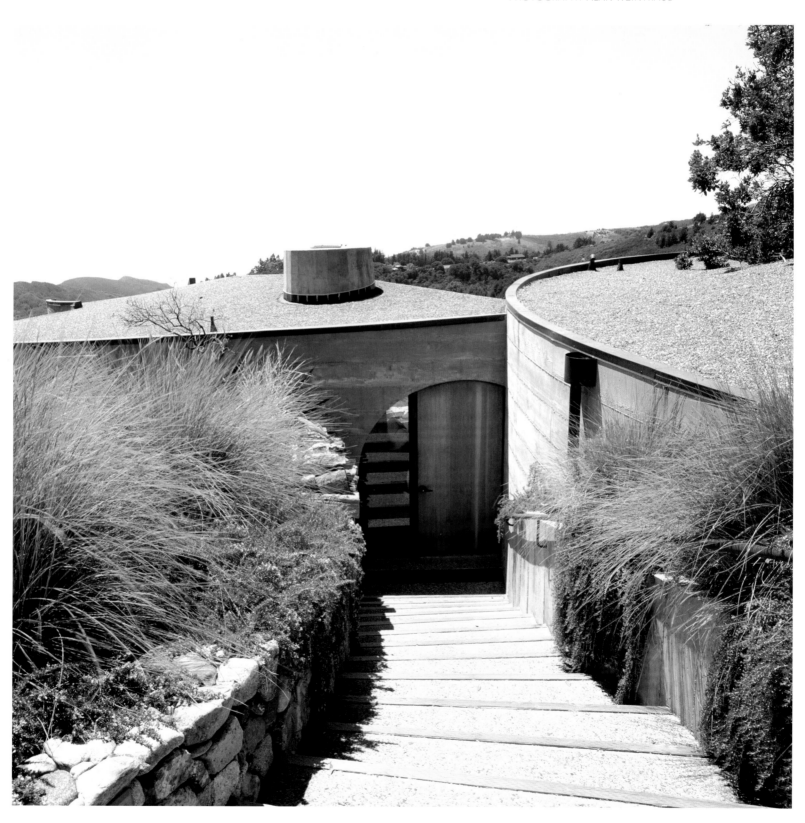

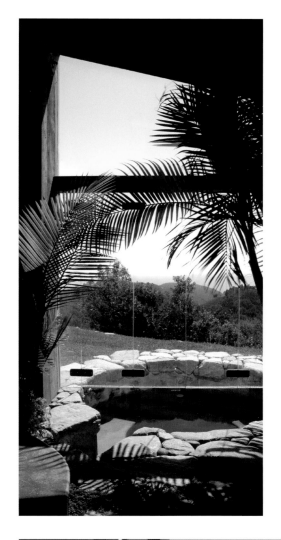

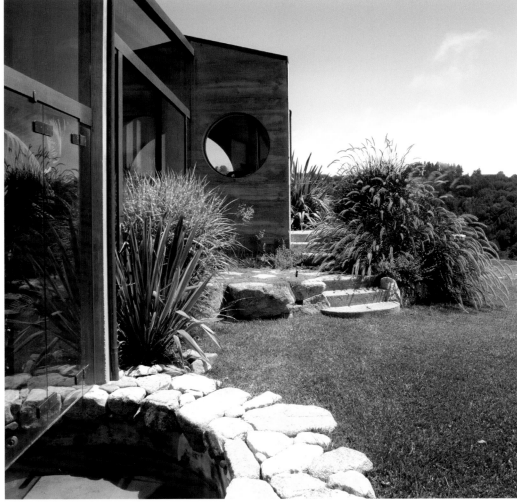

Defined by the natural features of mountains and water, Big Sur is where the Santa Lucia Range meets with the Pacific Ocean to create steep cliffs that cascade to rocky beaches and creeks that meander through colorful forests in a landscape that is virtually unspoiled by human contact. On this magnificent stretch of coastline between Carmel to the north and San Simeon to the south is where you will find the cliffhanging, hilltop homes of noted local architect Mickey Muennig.

The architect's homes dot the Big Sur coast, accentuating the endless ocean views through a wonderful use of glass, natural wood and warm rusted steel. Muennig's work reflects his quest for design excellence and personal love for the land on which it is built. His curved solutions blend in perfectly with Big Sur's twisting and turning landscape.

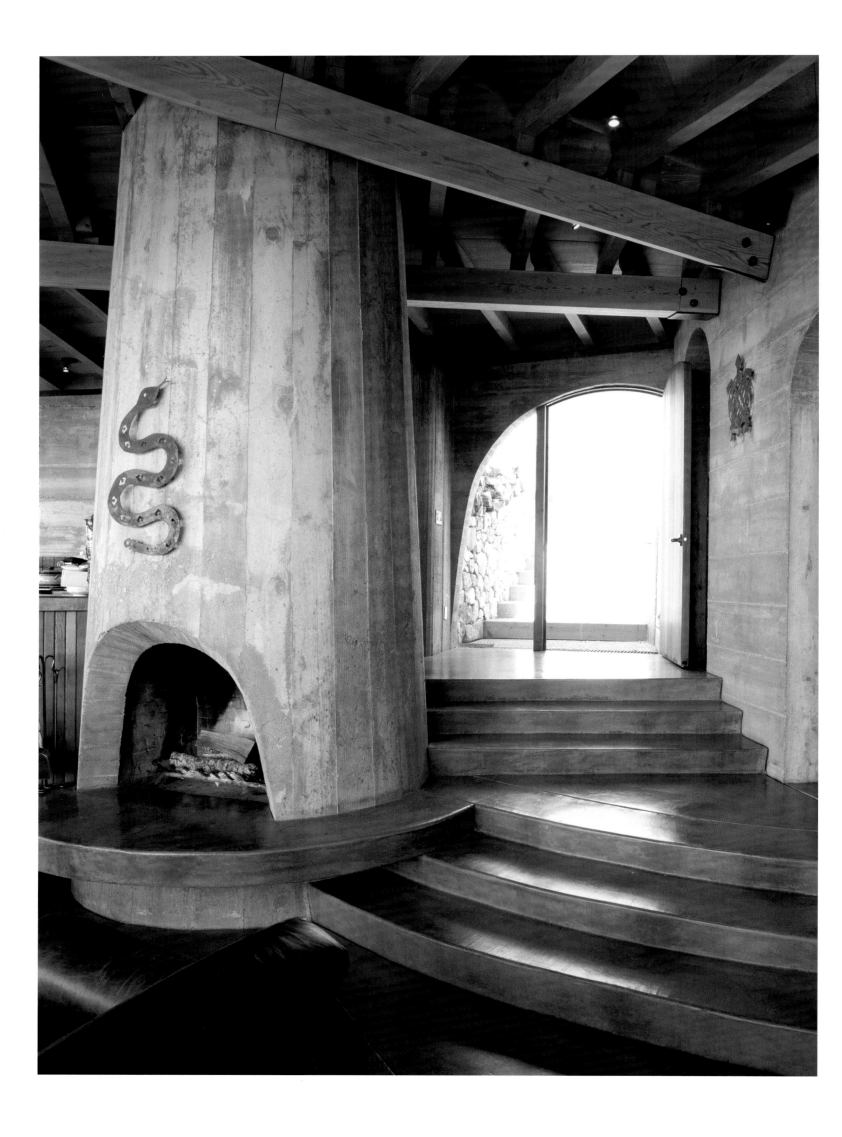

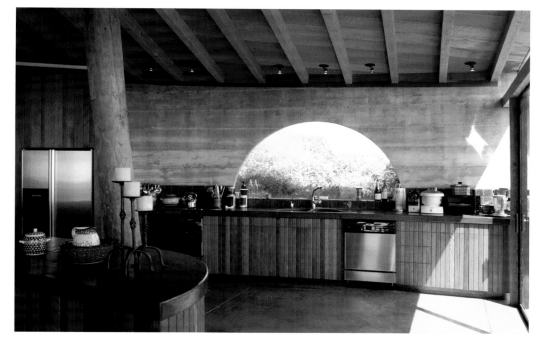

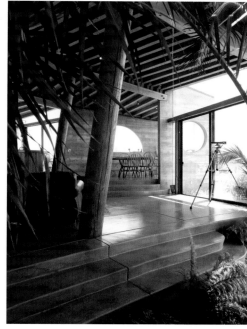

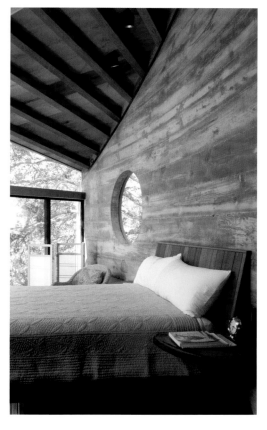

The site of our featured home on Pfeiffer Ridge is a secluded lot facing the Pacific Ocean, with access down a long, steep driveway. The house is built of concrete, with expanses of glass that showcase the views and let the sun shine in. The front door opens to the kitchen and dining area on the left while steps lead down to the living area with fireplace and interior garden. The hot tub is half inside and half outside until the glass doors are opened. Bedrooms on the northeast side have sliding glass doors that open to private areas filled with oak trees.

While viewing Big Sur's spectacular landscape through walls of glass, one quickly recognizes the achievements of Muennig's respect for the preservation of the Big Sur environment. "The magnificent sea cliffs, mountains, and trees were already in place; it was up to me to fill in the spaces with elements as natural and as peaceful as the land." With any Mickey Muennig home, you will always find creative design solutions that are expressed through a merging of the natural landscape with the functional elements of the structure.

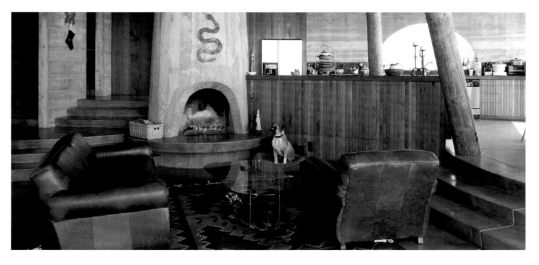

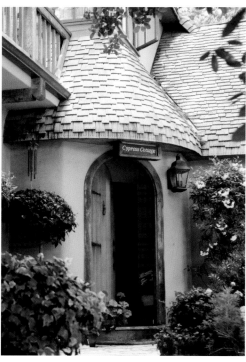

It's like a fairy tale, pure and simple. One look at the trees and strange house growing out of them and you know this is Cypress Cottage – local landmark and one of the more famous sights in the entire community of Carmel-by-the-Sea. The features, of course are the Cypress trees, huge writhing shapes curling upward, but the stone and found-stave walls add character, too.

ARCHITECT STEPHEN WILMOTH
PHOTOGRAPHER TERRY HUNTINGDON TYDINGS

CYPRESS COTTAGE
CARMEL-BY-THE-SEA

Cypress cottage is revered by residents, who love its charming appearance and often point it out to visitors. Inside the house, the warm, homespun feel is striking and high rail shelves invite an eclectic gathering of art and collectibles.

A handsome master suite is warmed by a high hearth and fire and enjoys a private deck, offering views of Point Lobos and the sea.

Vaulted ceilings with hand-hewn beams tower above stone fireplaces. Gleaming hardwood floors reflect in bay windows. And a collection of French doors, almost shy in their appearance, open to walled and flowered courtyards.

Outside, in addition to the amazing trees, rustic cedar shingle patterns cover a rolled roof straight out of Hansel & Gretel. Windows peek out of gables. And an iron gate festooned with grapes opens to admit callers.

Stone fencing with ship lantern lighting seems to grow out of the ground, casually establishing boundaries. An arched door in a turret-like portico opens to a garden walkway thick with shrubs and plants. And a stone fireplace chimney wanders up one end of the house like a crooked walking stick.

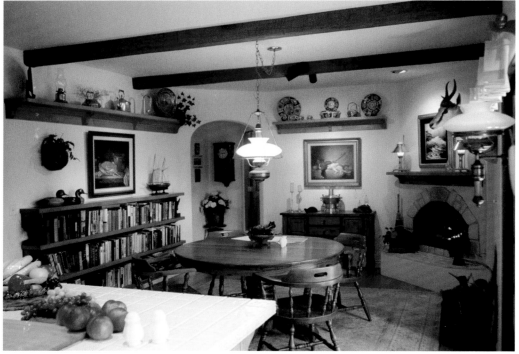

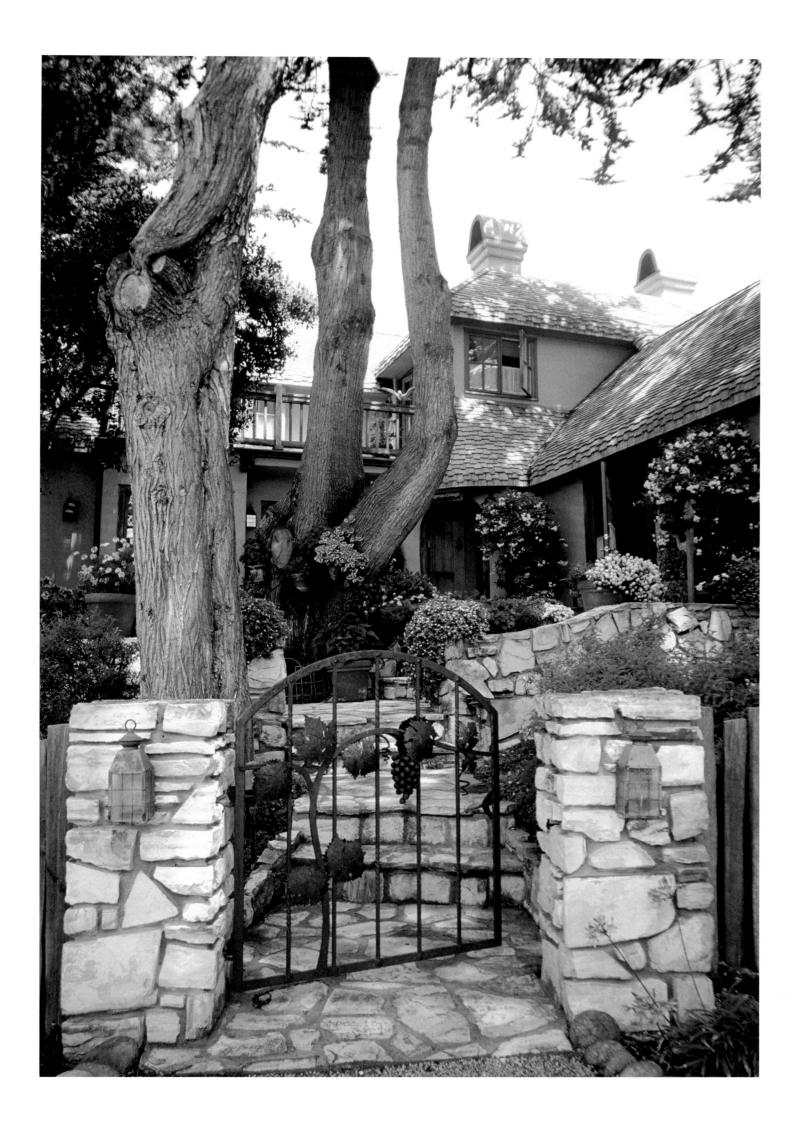

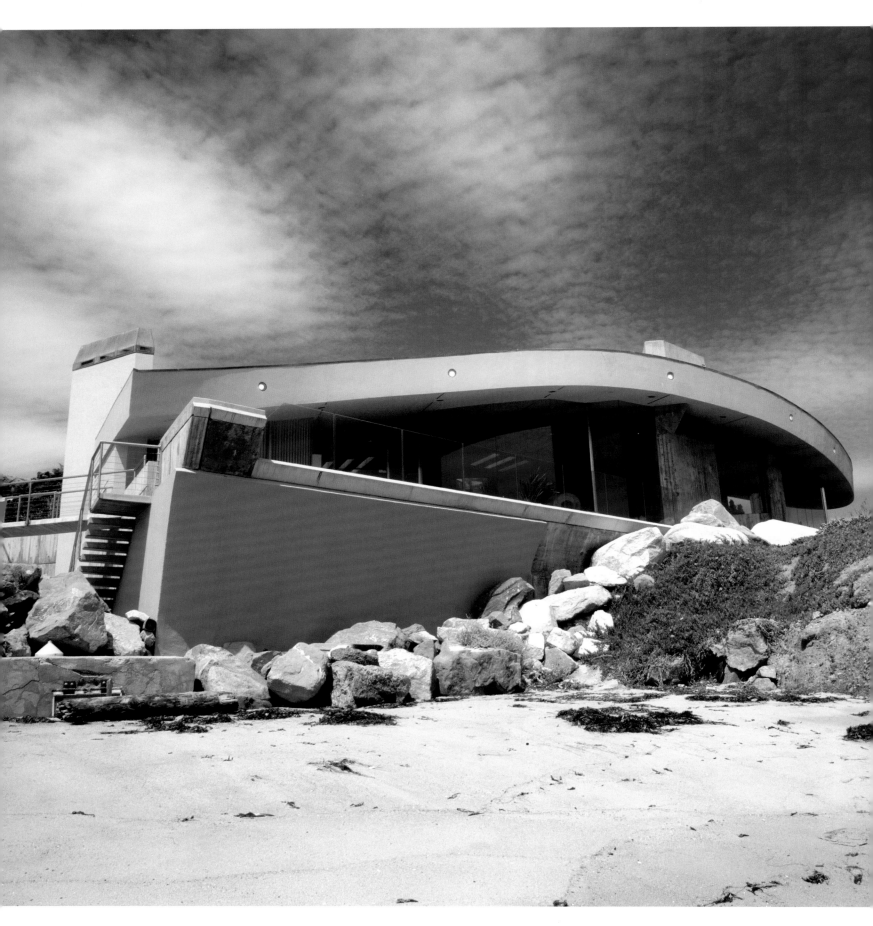

the beyer house

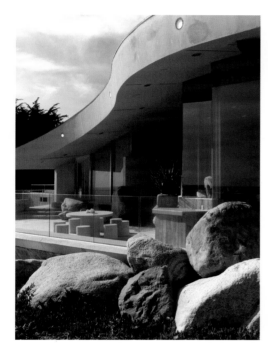
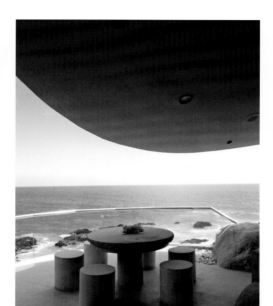
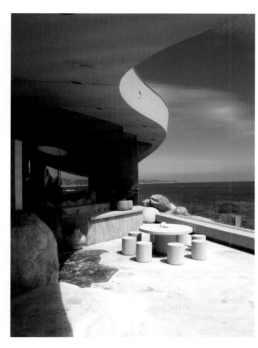

With its near perfect climate, secluded coves, tide-pools, and dramatic ocean views, Malibu presents the heart of the California coastal lifestyle. Along the cliffs of this strikingly beautiful twenty-one mile coastline are the showcase homes of some of the most prominent architects of the last century. Frank Lloyd Wright, James Moore, Frank Gehry, Welton Becket,

Neutra, Shindler, Stern, and O'Herlihy are among those who have been commissioned to design along this dramatic stretch of Pacific Coast Highway. Another is John Lautner. With his genius and insight for recognizing and applying the underlying concepts that intertwine home and landscape, Lautner's designs represent humanism, and joy and offer unlimited vistas into the delicate relation-

ship between people and the natural world; exactly what we find in the Beyer residence in Malibu.

Although Lautner often designed his own interior furnishings and textiles, with the Beyer house he teamed with one of the most respected interior designers of the Twentieth Century, Michael Taylor, to create a composition of natural materials

ARCHITECT **JOHN LAUTNER**
PHOTOGRAPHER **ALAN WEINTRAUB**

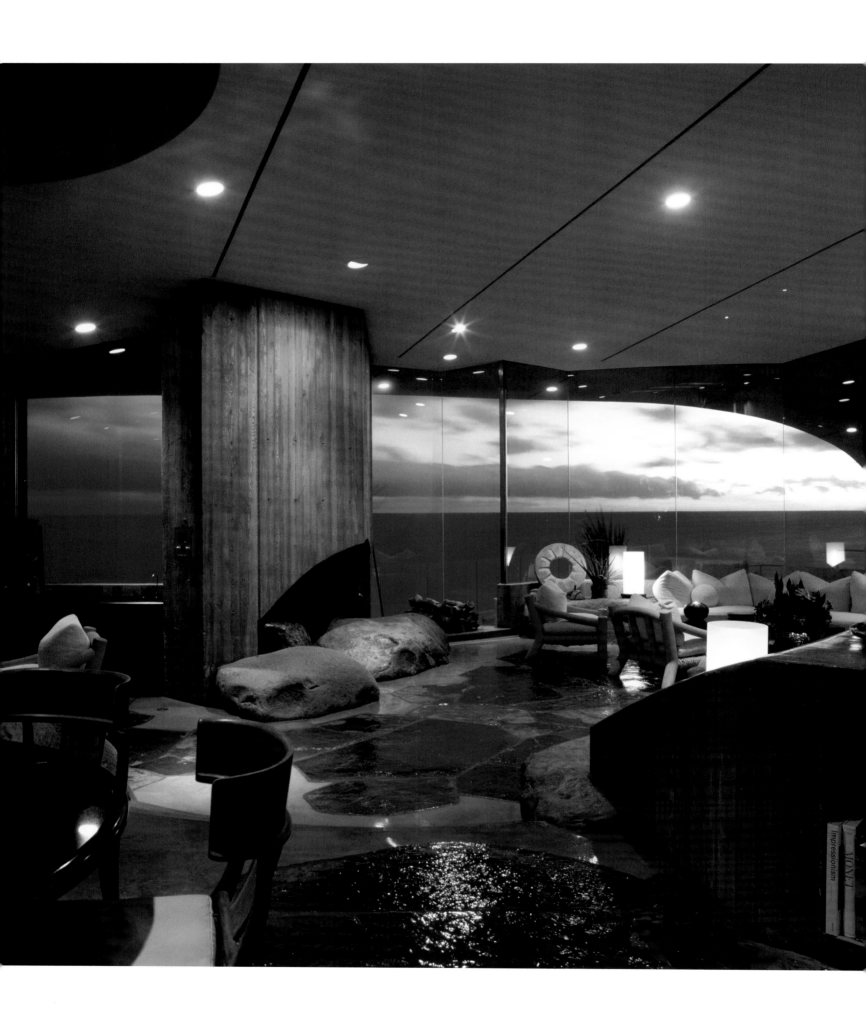

and dramatic vistas. Interior and exterior spaces become one through rock and slate used throughout the garden courtyards where they combine with molded concrete walls. The rocks of the rugged cliffs are duplicated inside the house. Living spaces are joined together by the positioning of the boulders and curved marble steps. Slate flooring unifies the interior, another feature that brings the magic of the exterior inside the house. With terraces outside inset with 1/2 inch thick glass panels to protect onlookers from the spray of the waves below, you are made to feel as if you are riding the break while standing behind the expanse of glass.

The sandy beach, steep sea cliffs and waves breaking against the rocky shores, combined with architecture in harmony with the environment provide an intimate experience of the California coast.

Coastal Curves

Carpinteria

ARCHITECT **NEUMAN MENDRO ANDRULAITIS**
PHOTOGRAPHER **BILL ZELDIS**

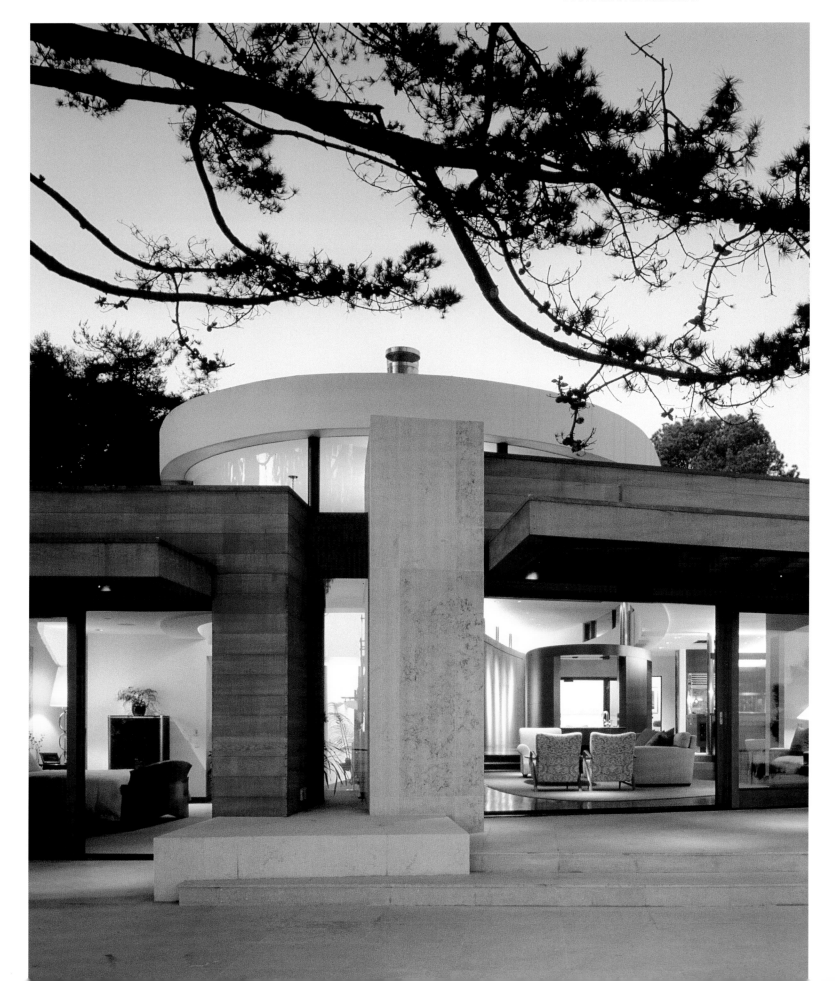

Running along a 27-mile strip of beautiful Pacific coastline, Carpinteria's unique setting by the ocean and coastal range offers a premier and coveted location in Southern California. Along with their natural beauty, the beaches, mesas, and canyons here have also created special challenges for architects and designers. By weaving together the design elements with the client's desires and the site and its surroundings, architect Andy Neumann has linked all three to create a special sense of place in this dynamic yet practical oceanfront home. Situated at the point of a long south-facing bay, the owners requested a dramatic yet contemporary house design that could be used as a place of retreat. The key element in the setting is the powerful curve of the shoreline springing from the home-site and diminishing

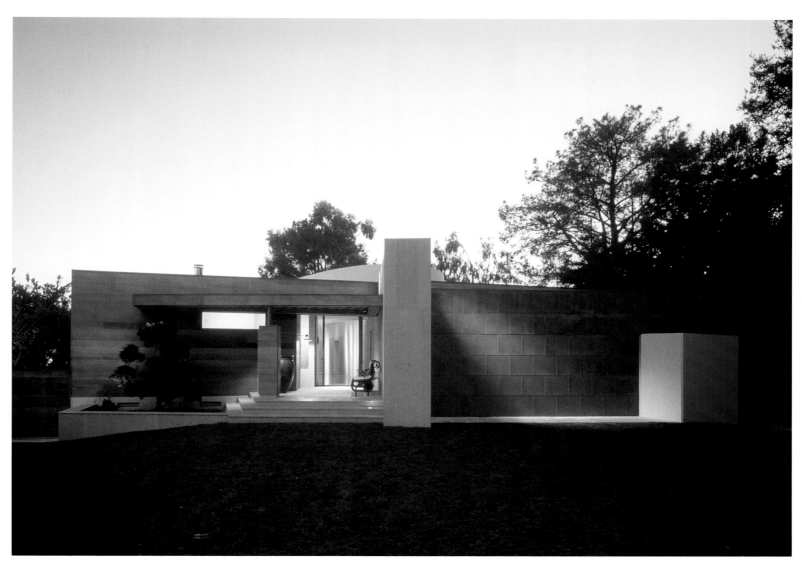

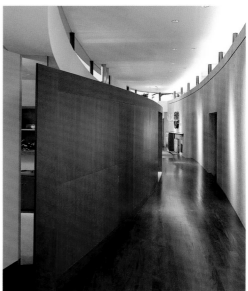

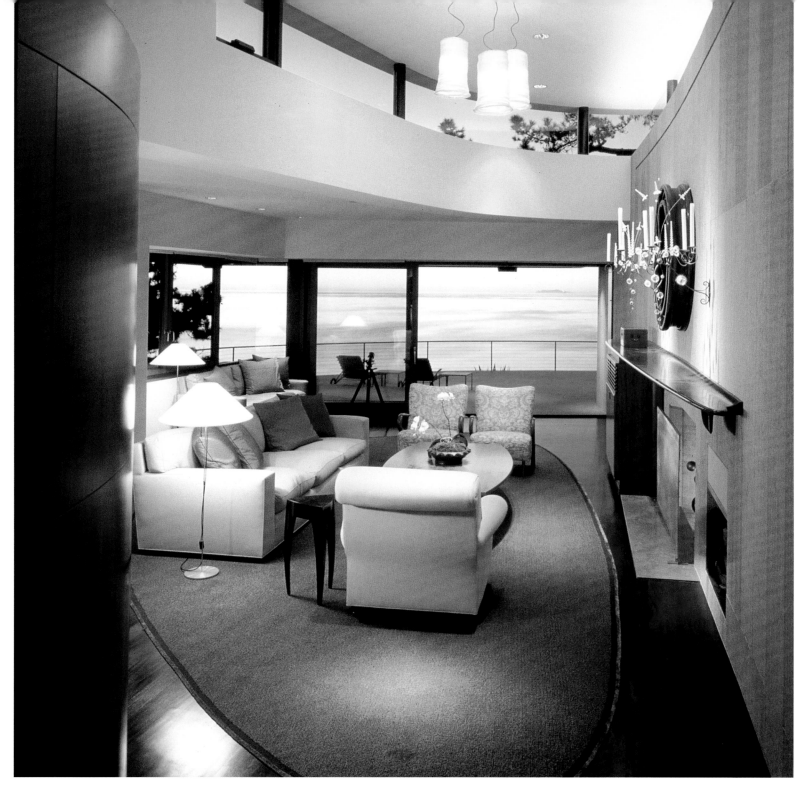

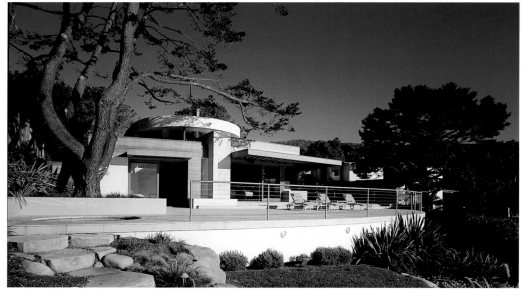

eastward into the distant horizon. The curving arc of the cove became the inspiration, metaphor, and point of departure for the forms of the design.

The design is centered on a lime-stone clad wall that arcs through the house and serves as the spine for the interior spaces. As you enter, the gently arcing wall orchestrates a sense of arrival, gradually opening to an expansive ocean view. Functionally, the wall creates a physical separation between the more

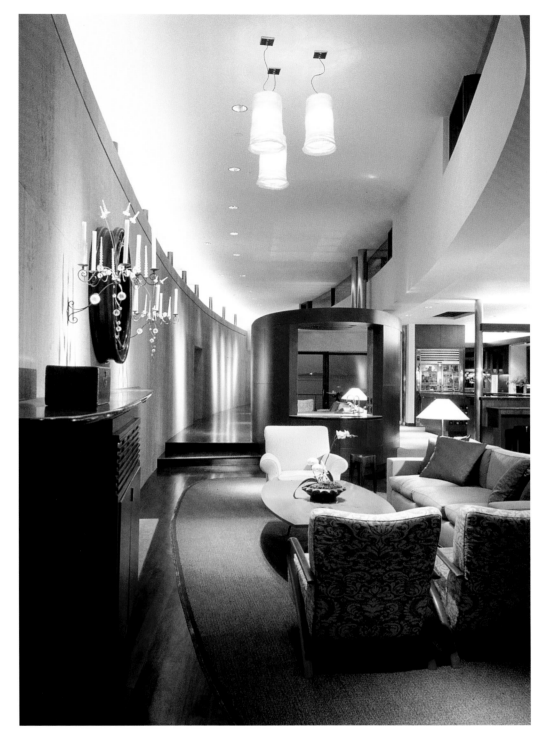

public area of the home and the private bedroom spaces.

Using natural materials, the 5,100 square-foot home includes French lime-stone for the walls and mahogany wood for the floors and cabinetry. The interior is meant to reflect a sense of simplicity, utilizing subtle textures and accents including a mantel in the form of a vintage surfboard.

An elliptical atrium clerestory floats high above the curved wall and interior spaces. This ellipse manifests itself differently in every room and provides an ever-changing natural light quality into the interior spaces. The guest bedroom at the back of the home has a "periscope" window that utilizes mirrors to offer a glimpse of the ocean over the roofline.

While powerful, dynamic and contemporary, the home also maintains an intimate and warm quality that serves a family seeking the relaxed lifestyle of a beachfront retreat.

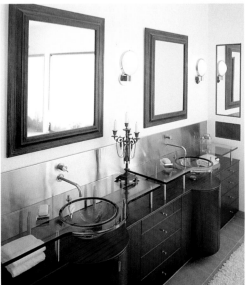

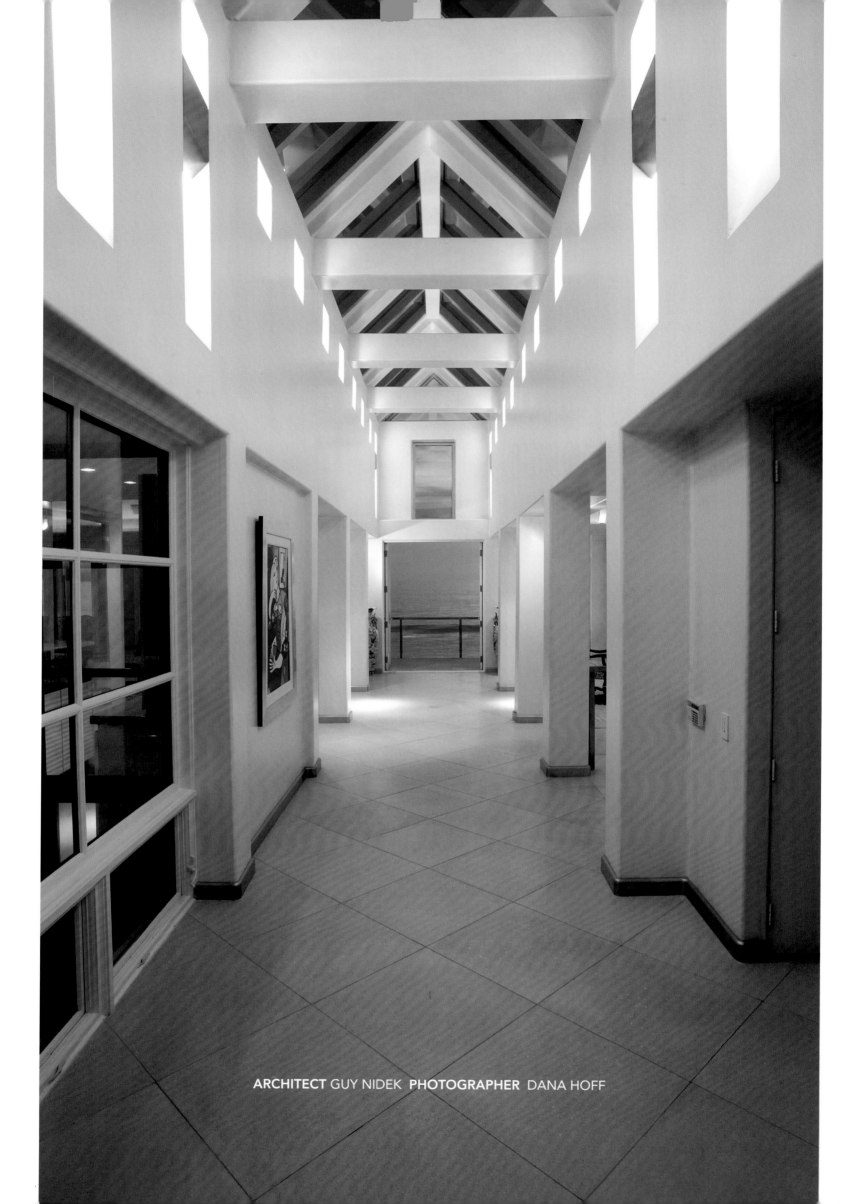

ARCHITECT GUY NIDEK **PHOTOGRAPHER** DANA HOFF

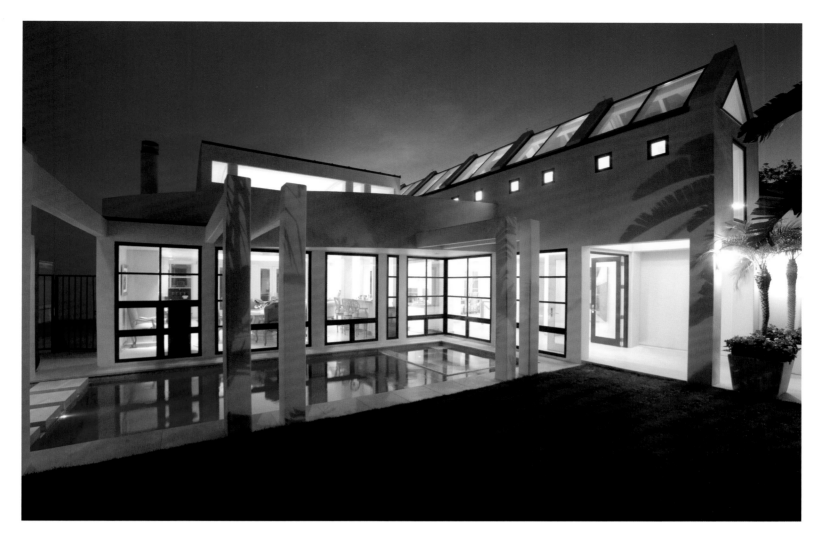

A dramatic, purposefully open and airy home in its own right, this artful contemporary also sits at the ocean's edge, on a rare Malibu Road double lot. Designed to create the illusion of living on a water-encircled peninsula and with waves crashing literally outside the door, here is an example of truly fine beach-front living. On one side, towering glass windows open to the sea, sky and surf; on the other, to a tiled swimming pool,

MALIBU SEASIDE

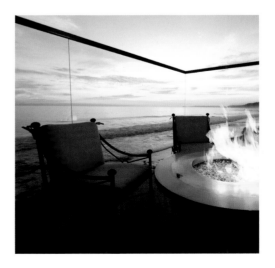

waterfall and spa.

Not overlarge at 3 bedrooms plus 1 bedroom for guests, the house nevertheless feels spacious. Views from many rooms are of endless sea. A peaked axial roof with shaded skylights runs the width of the upper floor. And outside, expansive decks wrap around 180 feet of beach frontage.

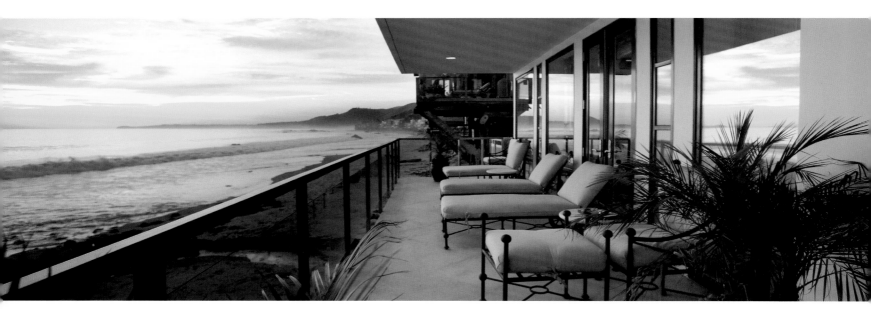

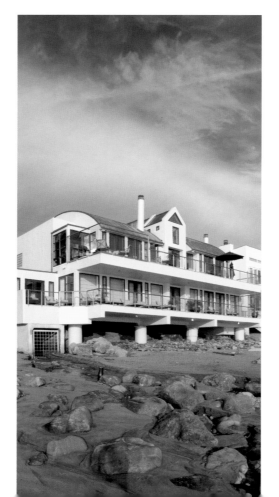

A stainless steel gourmet kitchen features stools that impart almost a diner feel. Master bedroom suite, adjacent gym and large wine cellar offer opulent touches. And a separate, very luxurious guesthouse accommodates guests handsomely.

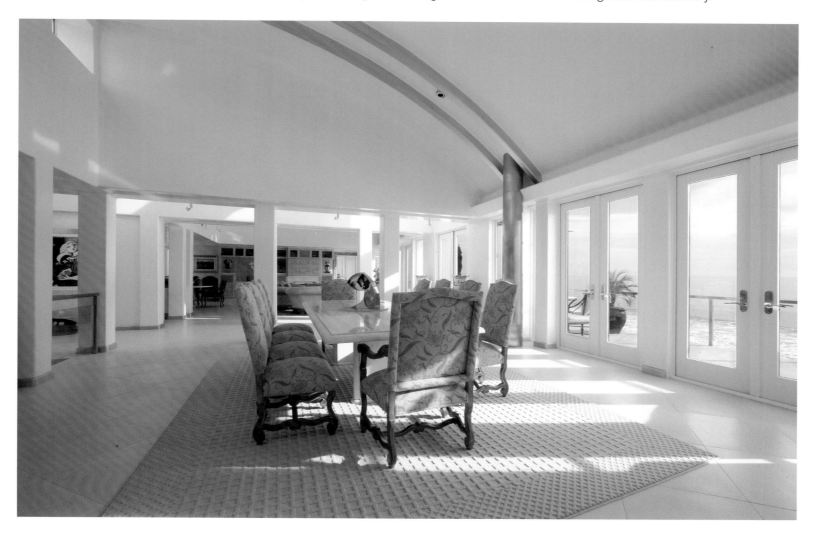

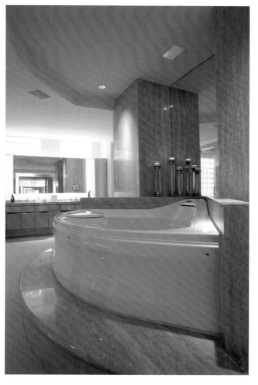

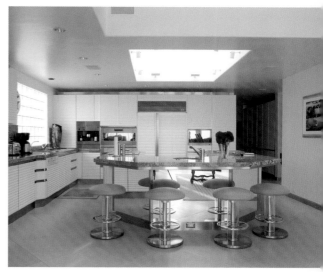

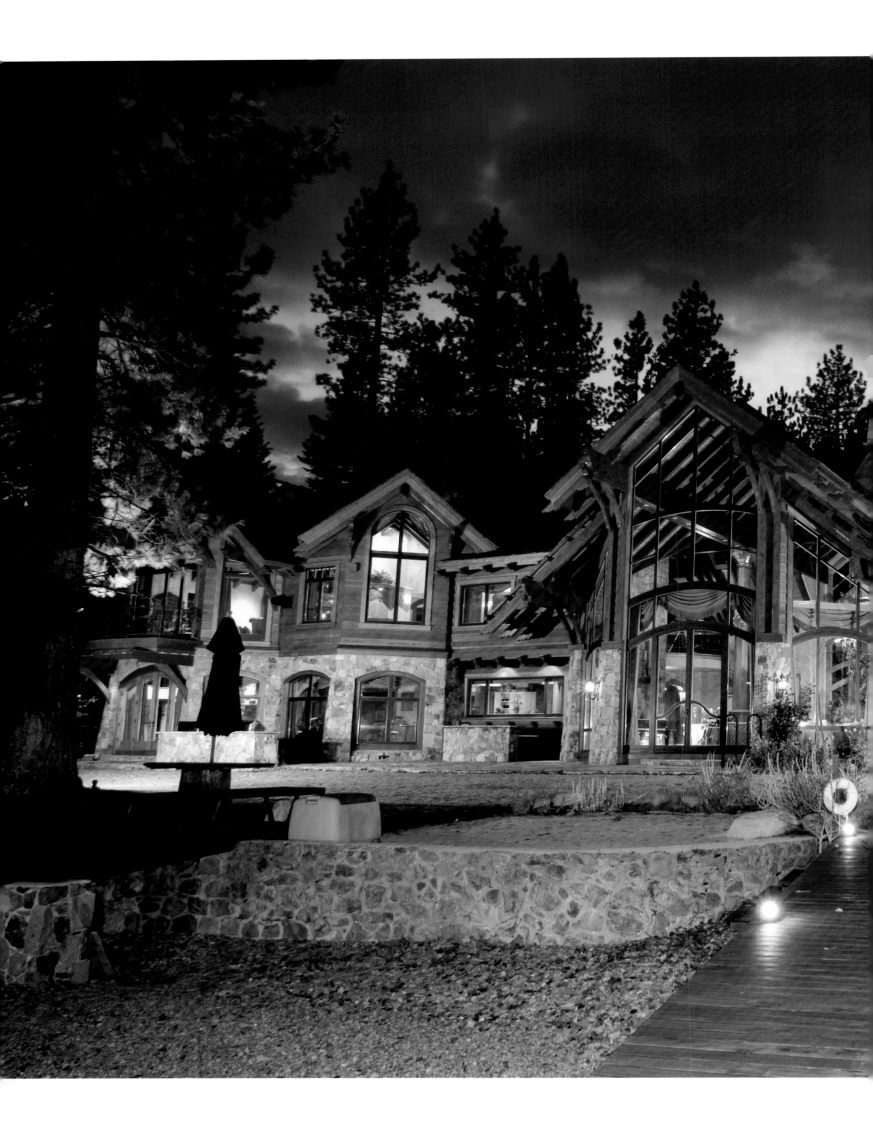

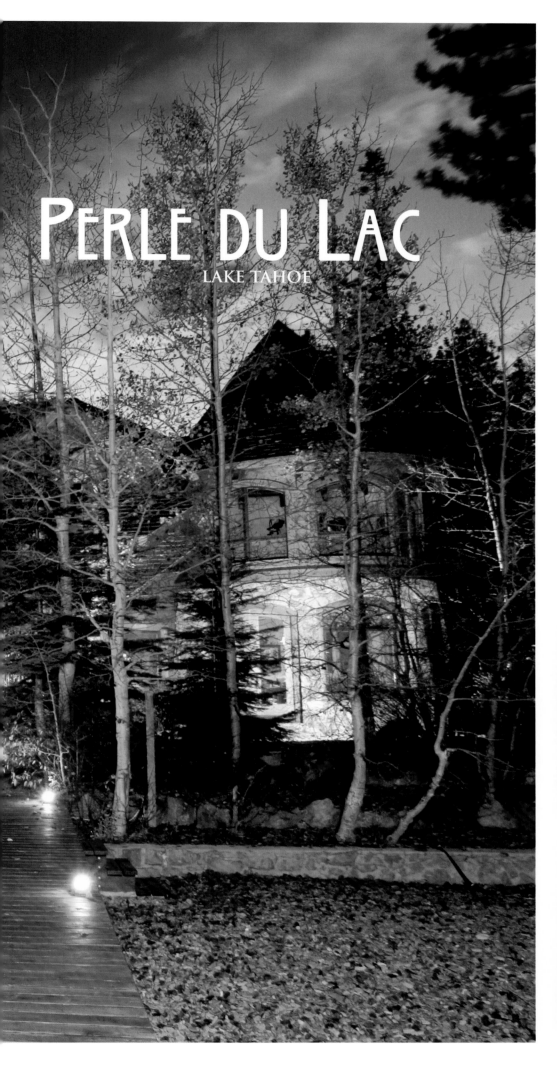

PERLE DU LAC

LAKE TAHOE

The level of communication between owner, architect and builder is always "key" to a successful custom home project and Perle du Lac is an example of a near-perfect collaboration. The architect/builder drew upon his experiences with the rugged climate found in the Sierra Nevada Mountains in bringing the intrigue of this mountain environment into the home design.

The exterior view captures extravagant arched stonework and the intricacy of exposed timber and beam construction. A slate roof with copper flashings enhances the rooflines and extended eaves while the two-story turret on the North end represents the careful craftsmanship and architectural detailing of the home. The main entry features native granite masonry, glass entry doors and an open beam ceiling and leads guests to a warm fireplace in the Great Room.

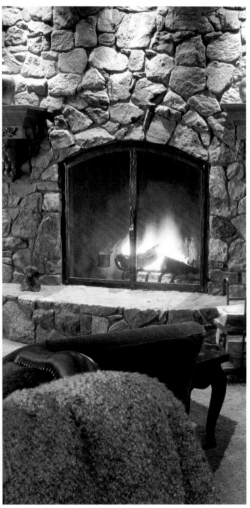

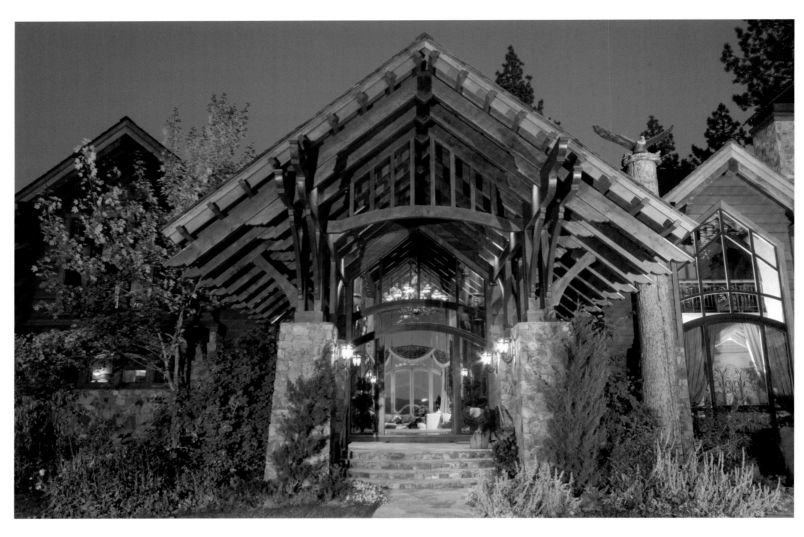

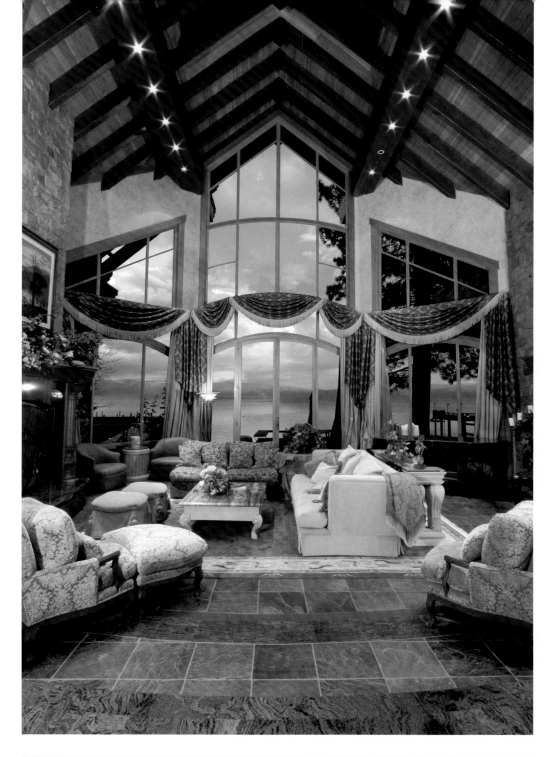

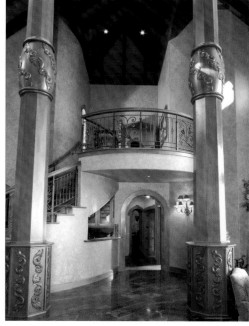

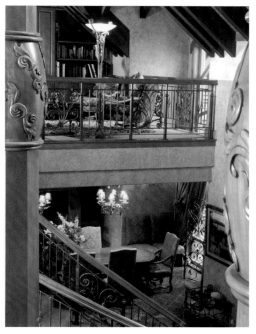

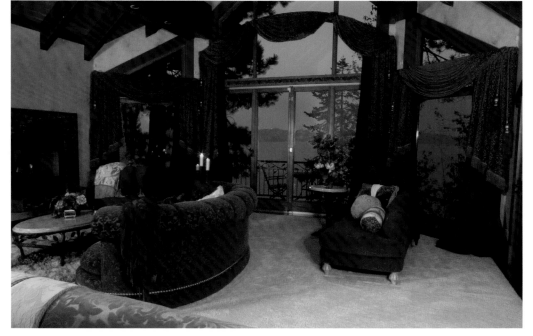

Descending from a long line of builders and carpenters of Swedish heritage, builder Bruce Olson has developed a style that borrows from the craftsman movement and Scandinavian architecture that fits so perfectly into the Lake Tahoe setting. In an area rich with massive granite and bountiful timber, Olson studied the materials in the surrounding landscapes - color, scale, massing, and texture - and skillfully incorporated all into this waterfront estate.

ARCHITECT **BRUCE OLSON**
PHOTOGRAPHY **PETER SPAIN**

CURLEW

DANA POINT

ARCHITECT **JOHN G. ALDEN** BUILDER **FRED F. PENDELTON** PHOTOGRAPHERS **DIANE PRENDERGAST & SIEGFRIED HOPF**

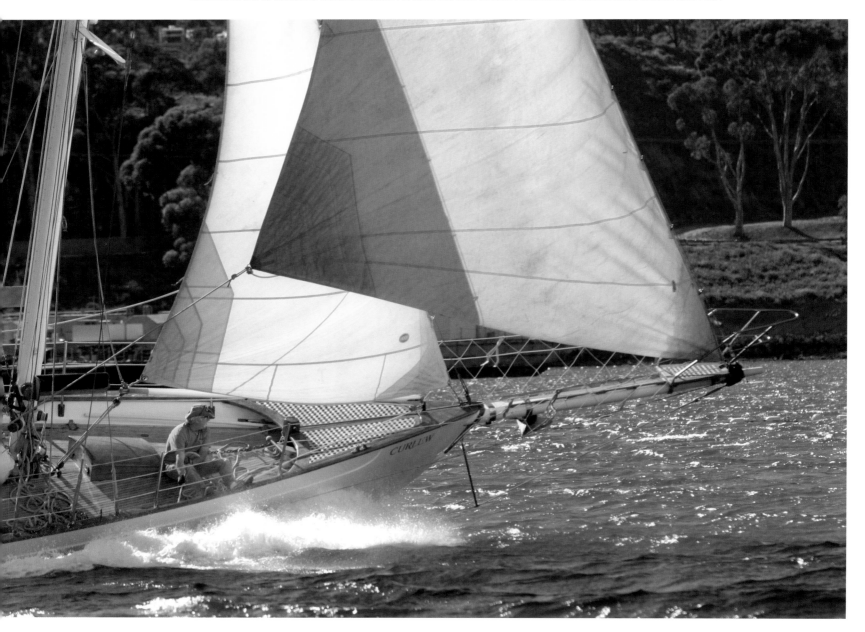

Curlew is a classic wooden planked-deck ocean yacht, a fast, able sailor with a long record of wins including the George Minney trophy for first-to-finish / Ancient Mariner class in the 2004 Tommy Bahama Newport to Ensenada run. Drawn in 1926 by legendary designer John G. Alden and built at Fred Pendelton's shipyard in Wiscasset, Maine, Curlew has become to her crewmen over the years as "close to a living thing as a man can build."

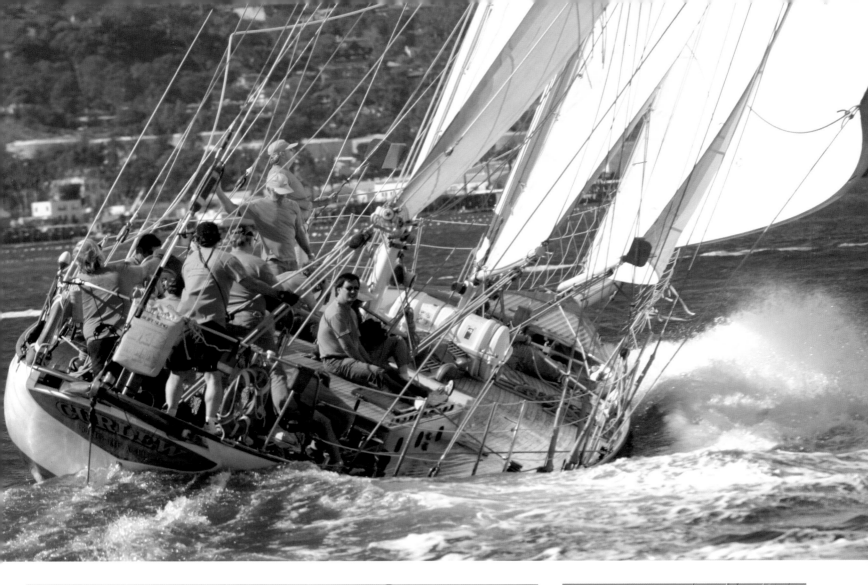

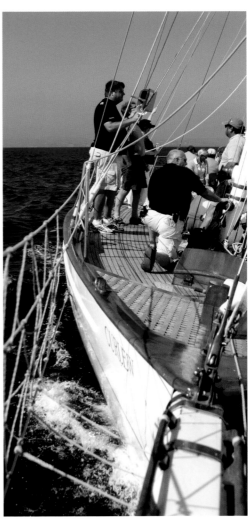

A traditional 2-masted staysail schooner, *Curlew* is 65 feet long (82 feet counting bowsprit and fantail platform). Her hull is sheathed in long leaf yellow pine over ribs of white oak. Originally owned by Charles Andrews of the NY Yacht Club, the vessel successfully raced in NYYC's ocean cruising class in the 1930s, and competed often in the Newport to Bahamas race.

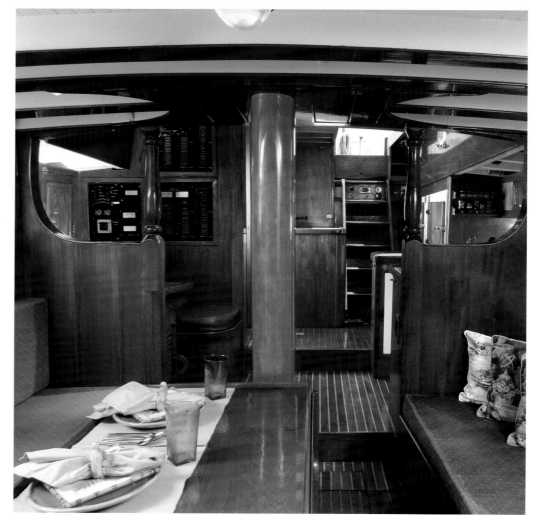

In January, 1940, *Curlew* was donated to the Merchant Marine Academy at King's Point, NY, where she served as a sail-training vessel and patrolled the coast for submarines during WWII. She can accommodate 36 passengers, plus crew and captain. Today, fully restored and certified by the US Coast Guard, *Curlew* is in active service out of Dana Point, CA.

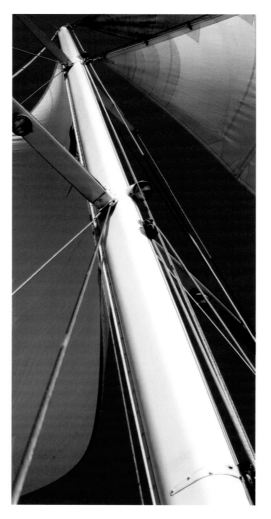

The vessel's interiors are understated but not Spartan. The galley is well equipped and efficient. The spacious main cabin is finished in varnished wood. Electronics and navigation gear are complete and in orderly display. And inlays, scrollwork and stained glass panels add decorative interest.

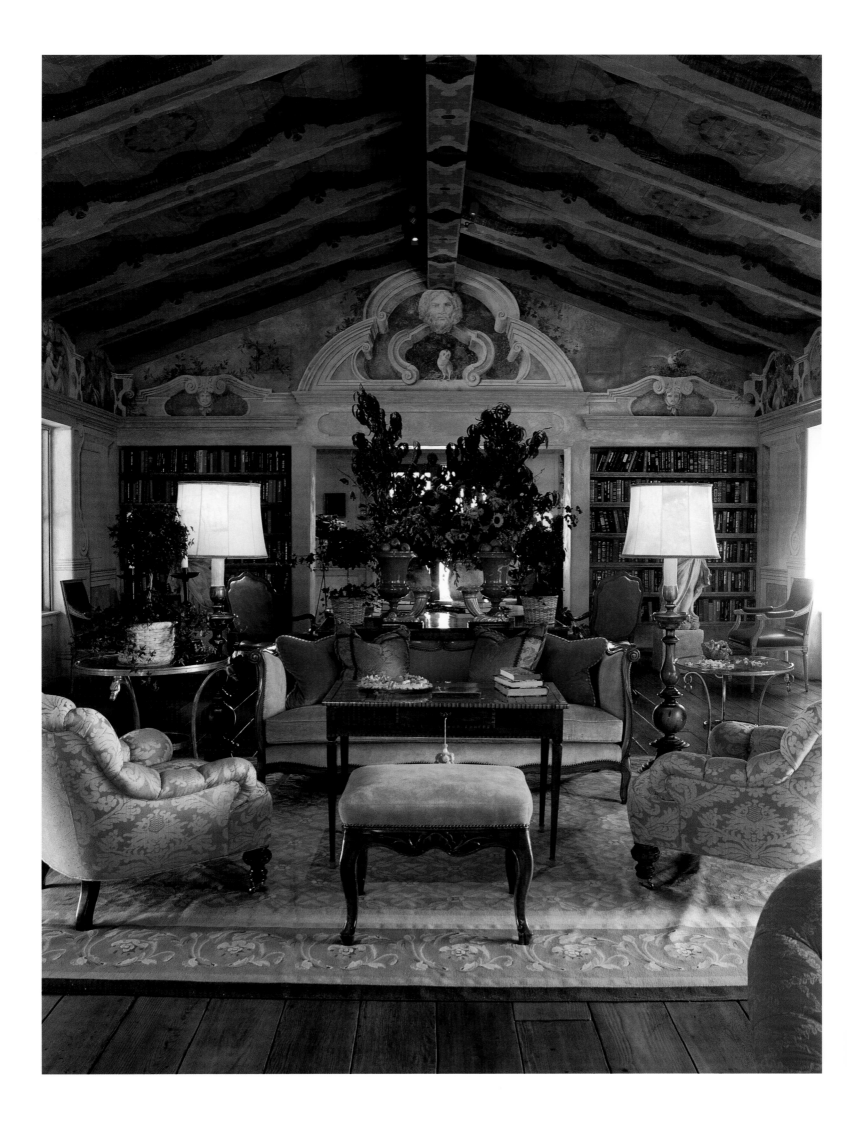

A TUSCAN WELCOME

SONOMA

Natural beauty and warm Mediterranean climate has made the Napa Valley one of California's most desirable areas to live. Near the Silverado Trail where Black Bart, Buck English and other highway bandits once held up stagecoaches, and in the midst of fertile wine country where grape growers have adapted old-world winemaking traditions, you will experience an authentic Italian afternoon.

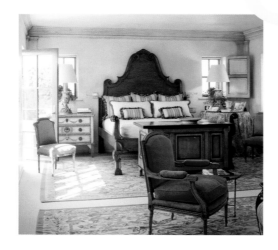

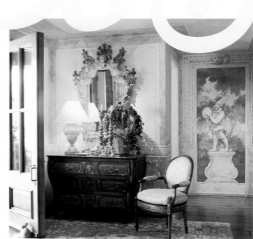

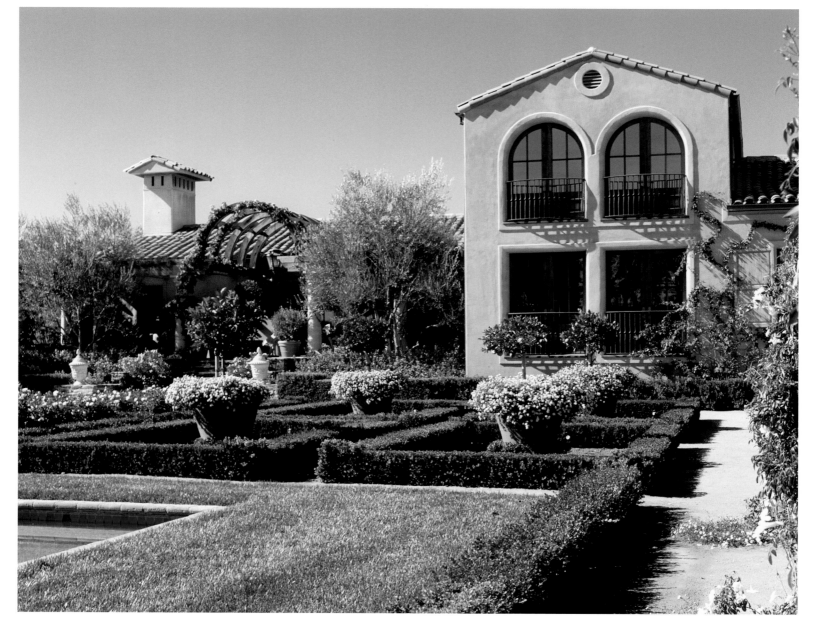

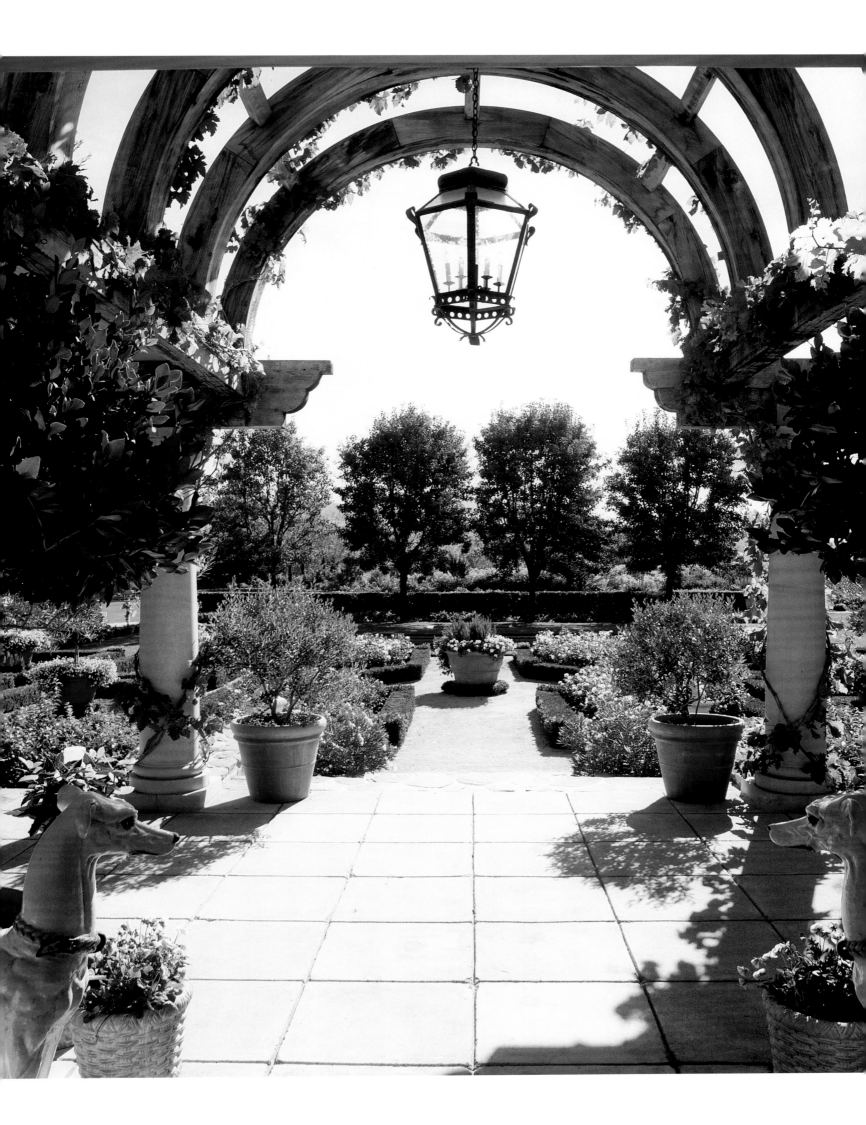

Set on three-and-a-half acres in the middle of the Valley, the harmony of home and landscape is portrayed in rich, inviting colors also common to the Veneto region in northeastern Italy. Burgundy, gold ocher, sage green and cream highlight this utopian setting where the golden morning light blends with purple hues captured in the skyline. The landscape is laced with cypress, citrus and olive trees while the gardens are parterre, creating a living tapestry accented with a wide variety of roses, potted shrubs and flowers.

The home is a work of art, with a welcoming ambiance that captures the beauty and inspiration recognized worldwide as the spirit of old Italy.

ARCHITECT STEVEN KIM
INTERIOR MOTIF PAINTING CARLO MARCHIORI
PHOTOGRAPHER ALAN WEINTRAUB

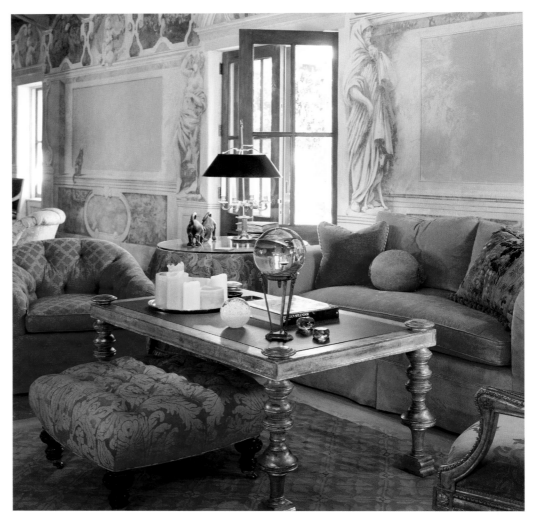

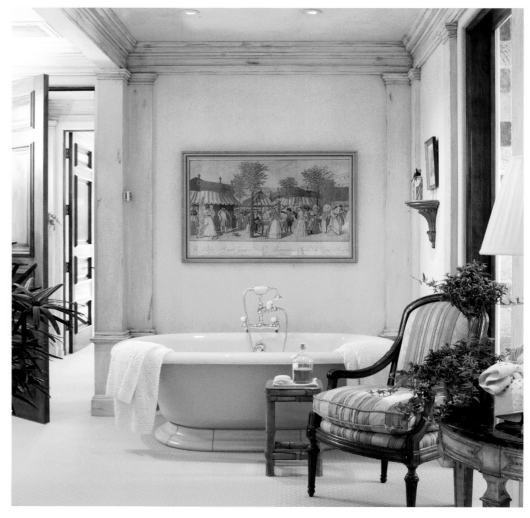

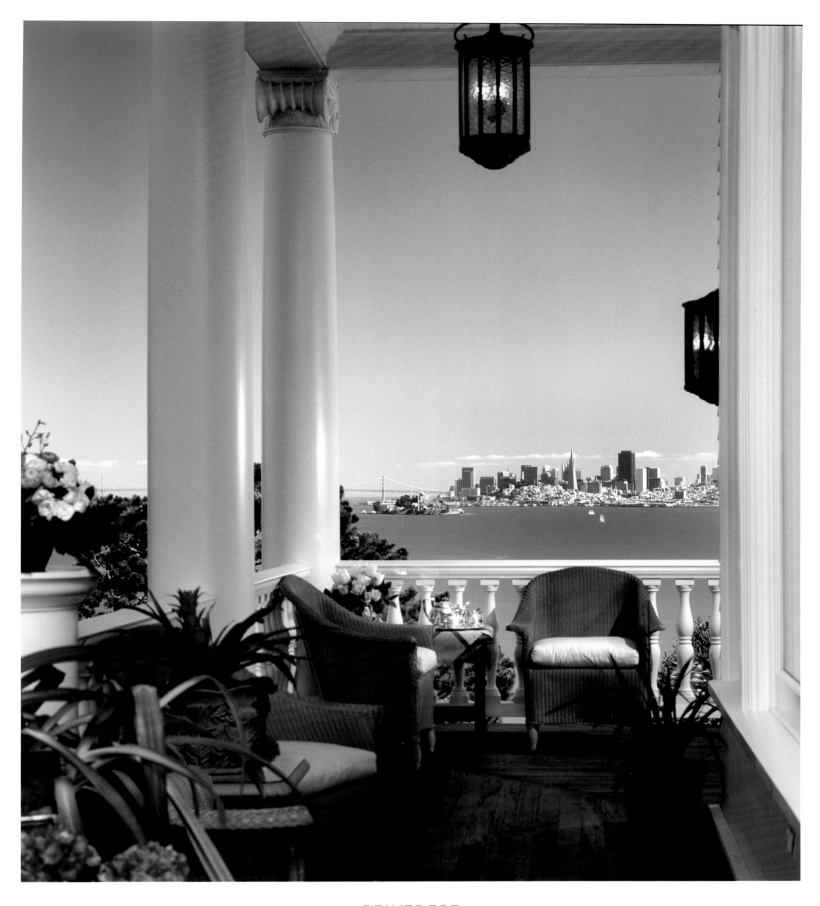

BELVEDERE

Locksley Hall

Located in beautiful Marin County, Belvedere is surrounded on three sides by the waters of San Francisco Bay and is one of the most desirable places in the world to live. Belvedere is an architectural term adopted from the Italian (literally "fair view"), and refers to any architectural structure that is sited to take advantage of the view.

The porte-cochere, with 15-foot-high ceilings, opens into a foyer with a bronze-balustrade staircase. The mahogany wainscoting and hand-glazed walls create an Old World ambiance.

With spectacular vistas of San Francisco, Angel Island, the Golden Gate Bridge, Sausalito, Alcatraz Island and Mt. Tamalpais, that is exactly what Locksley Hall, this 10,000-square-foot mansion that sits at the tip of Belvedere Island, is all about.

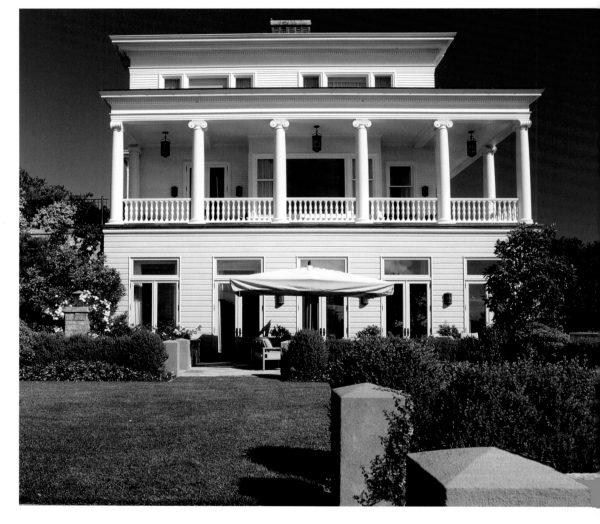

ARCHITECT **JULIA MORGAN**
PHOTOGRAPHER **VINCE VALDES**

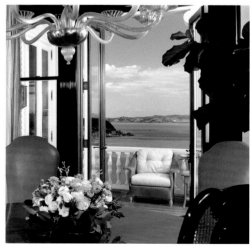

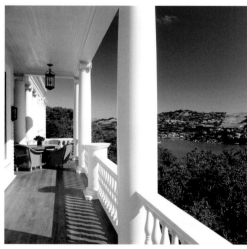

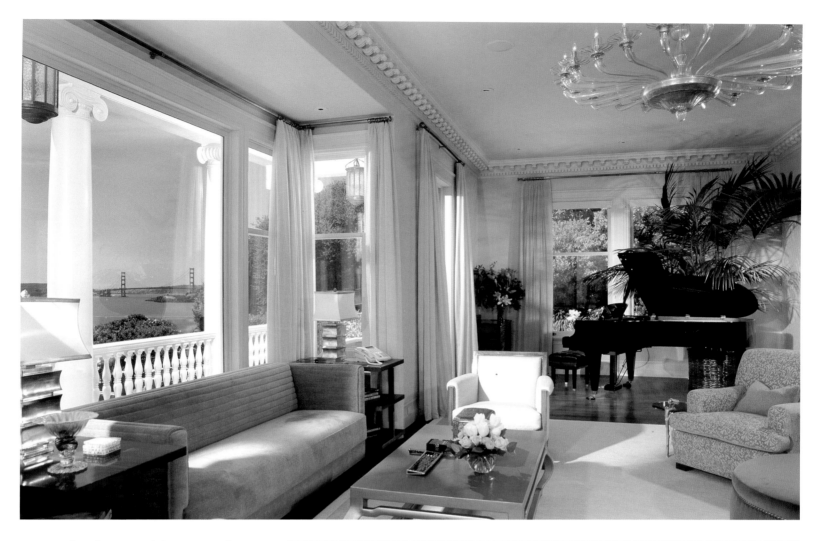

Acquired at the turn of the century by Gordon Blanding, a wealthy San Francisco lawyer, Locksley Hall was designed by Hearst Castle architect Julia Morgan and named after the stately manor in a famous contemplative poem by Alfred Lord Tennyson.

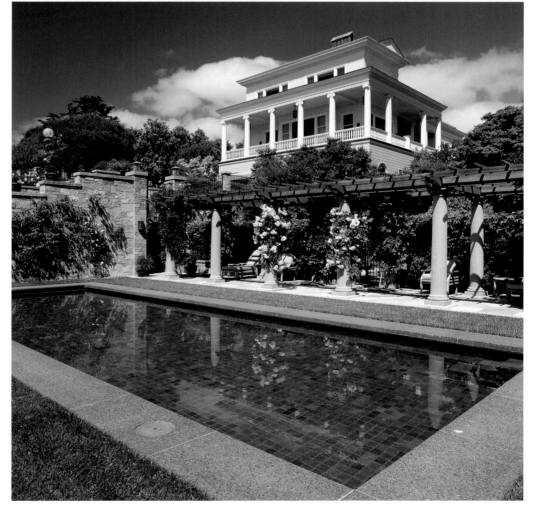

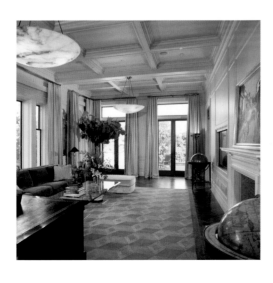

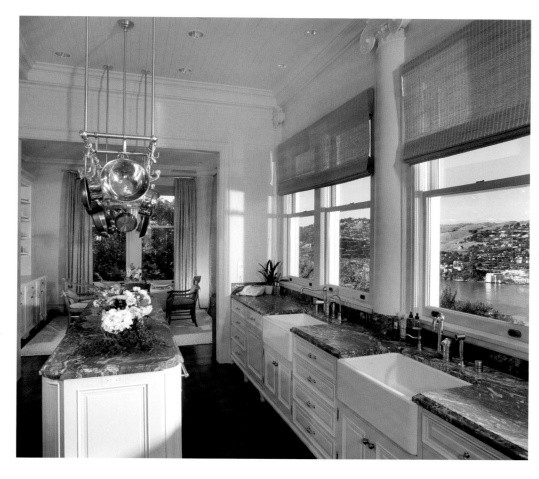

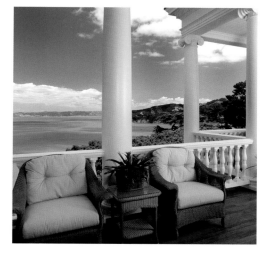

Upstairs, the master suite includes a spa tub, sitting room, office and service kitchen. The upstairs level is completed by three guest suites that include sitting rooms and marble baths.

Locksley Hall sits on more than an acre of land, a rarity in the area. A complete reconstruction of the six-bedroom home was began by the current owner in 1998 and took six years to replicate the original detailing and finishes complete with modern amenities.

The porte-cochere, with 15-foot-high ceilings, opens into a foyer with a bronze-balustrade staircase. The mahogany wainscoting and hand-glazed walls create an Old World ambiance. The views from the wraparound veranda are framed by spectacular Corinthian columns and present the best of San Francisco Bay.

The columns define Locksley Hall and enhance the home's dramatic setting. Vistas from the home's top level include city lights and extend to Alcatraz. With one of the best locations in the country combined with water and city views and privacy only minutes from San Francisco, Locksley Hall has it all.

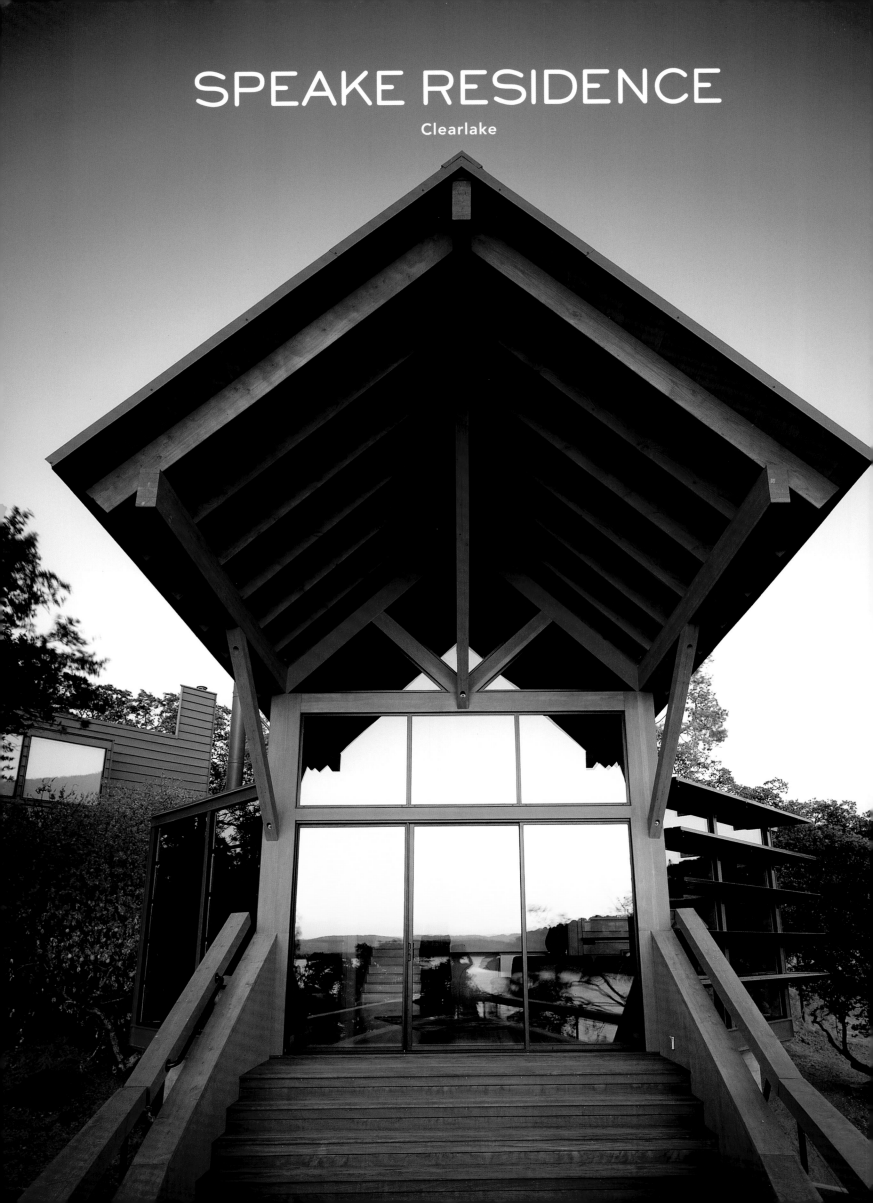

SPEAKE RESIDENCE
Clearlake

Located within 2 1/2 hours from San Francisco Bay along Highway 20 near the Shasta-Trinity National Forest is Clearlake, the largest and oldest natural lake in California. On the lake at Buckingham Point is the Speake Residence, a classic contemporary home perfectly placed on a 2 1/2 acre wooded site with spectacular views of both the lake and 4,300-foot high Mount Konocti.

The Speake Residence is an award-winning example of both site location and construction. Integrating the design scheme with the existing woodland, as well as capturing spectacular views, were the primary design and building challenges.

By creating a central spine that steps down the slope to the 30 ft. high basalt cliffs and incorporating appendages that expand the spine laterally, this unique

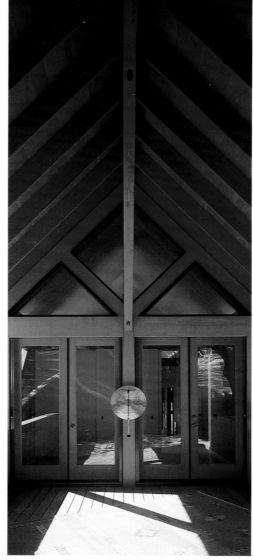

design achieved both a minimal removal of major trees and provided perfect southern sun exposure for most rooms.

Instead of placing the home broadside to the shoreline, the architect placed the home perpendicular to the water. This allows you to enter on the wooded side and journey to the great room with its stunning views of the lake. After you enter the house and move down through the central spine, the ground outside drops away dramatically. Movement through the home towards the lake permits a graceful way to achieve elevation above the Toyon and Manzanita undergrowth without climbing a standard stairway.

The stepping gable roofs of the central spine are carried on ridge beams supported by a series of center post trusses and lateral steel moment frames. The

roof and appendage walls are reddish-brown metal accented against earth colored plaster – hues that are harmonious with both the local earth colors and the summer landscape. Because of the home's long, slender shape and the site location, the steel frames include welded connections in the framing to prevent seismic and wind damage.

With four distinct seasons and almost every year a snowfall or two, the area's natural beauty and wide variety of recreational opportunities help make Clearlake an excellent location choice for lakeside living in a shoreline home.

For natural lighting, the roof is designed as an inverted butterfly with skylights that follow the valley while tall windows enhance the view. Inside, the home has two main levels. On the first level, a glass bridge connects the foyer to the master

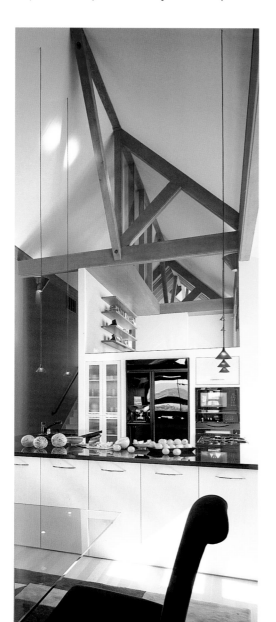

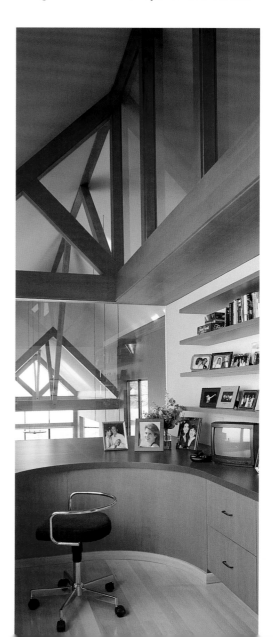

ARCHITECT **OBIE BOWMAN**
PHOTOGRAPHER **TOM RIDER**

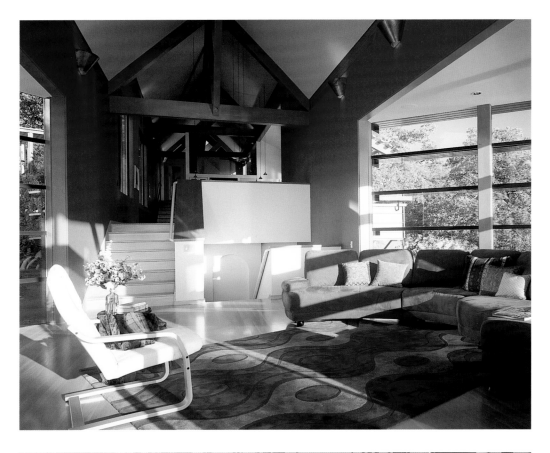

suite and office. Steps lead down to the living room, dining area, kitchen and guest rooms and provide another unique feature of the house - a wood floor staircase that wraps around on three sides integrating a desk for the home office.

This absolutely pristine area of California has provided the challenges and rewards architects live for. The result is a house that includes 3,300 square feet of living space plus a 950 square foot garage that runs 207 feet. To further enjoy the natural wonders of the site, decks extend the home to the outside where a lap pool and spa take advantage of the sun and the views. With the lake being more than 19 miles long and 9 miles wide with 100 miles of shoreline, it's little wonder that this tall, narrow home with three gable roofs has been compared to a ship about to embark on a voyage across the sea.

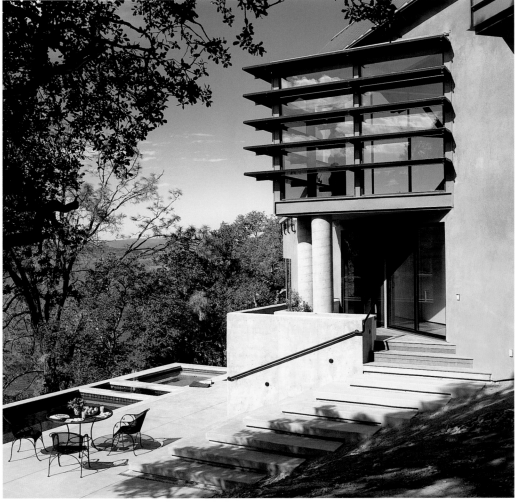

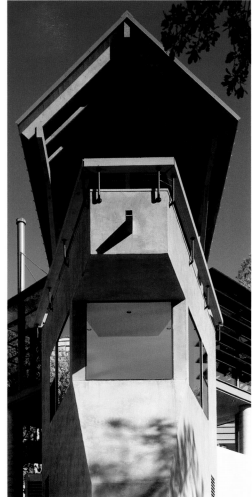

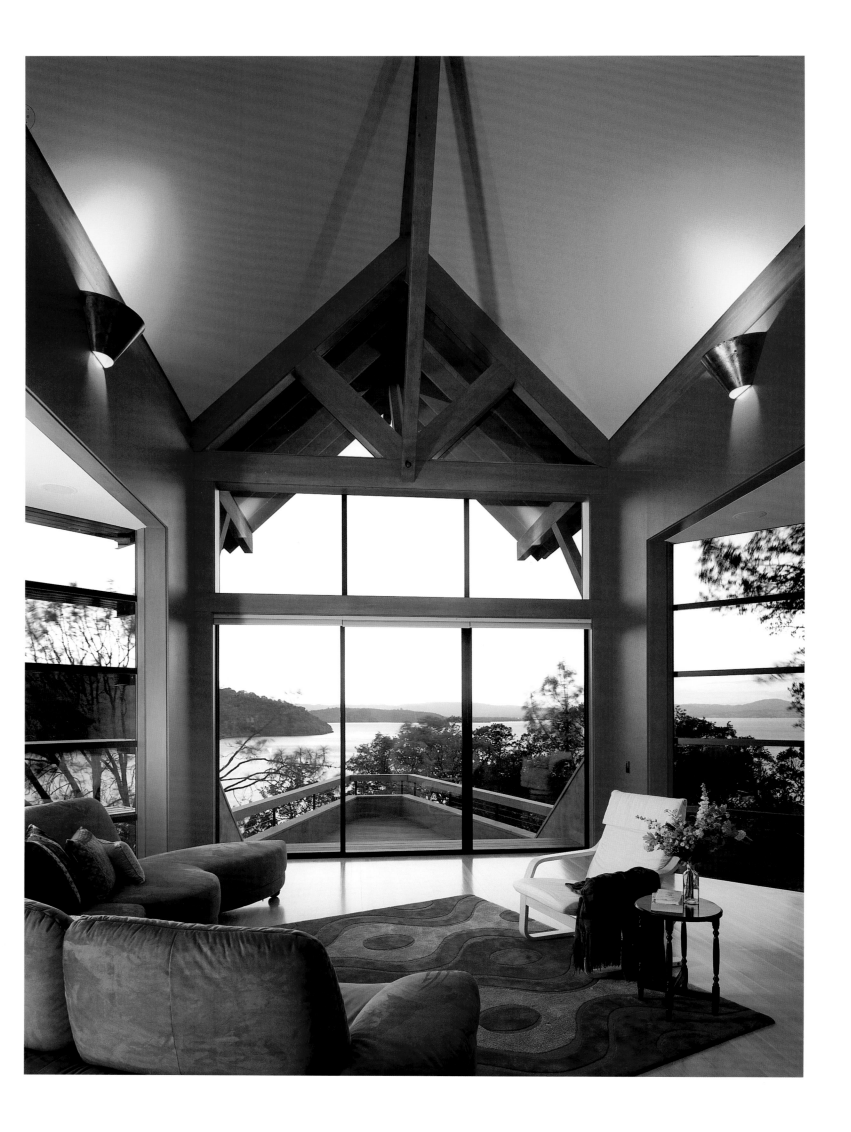

The
Price Residence

CORONA DEL MAR

ARCHITECT **BART PRINCE**
PHOTOGRAPHER **ALAN WEINTRAUB**

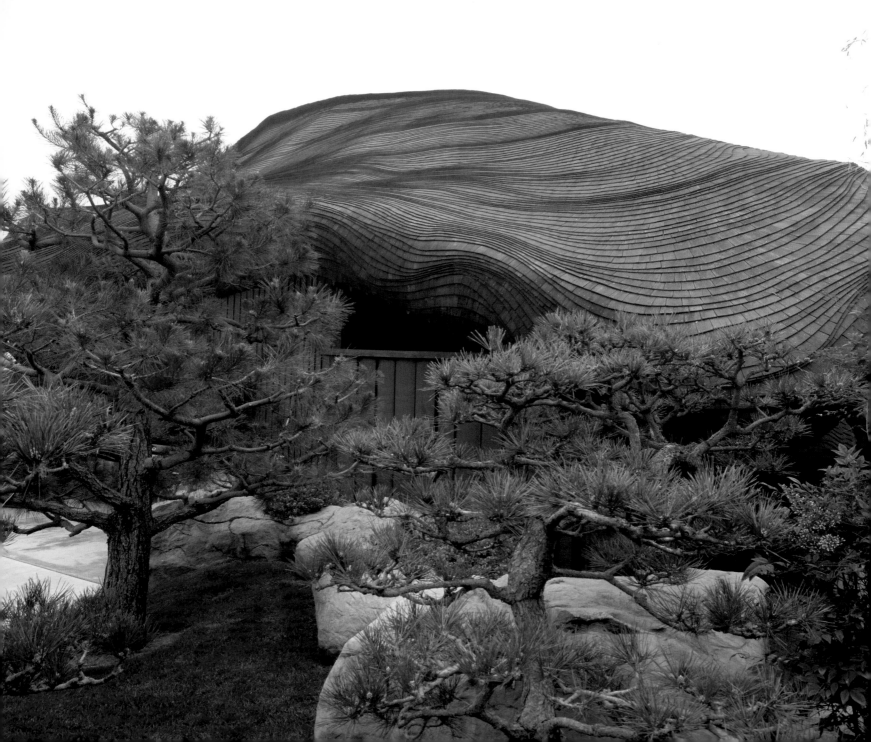

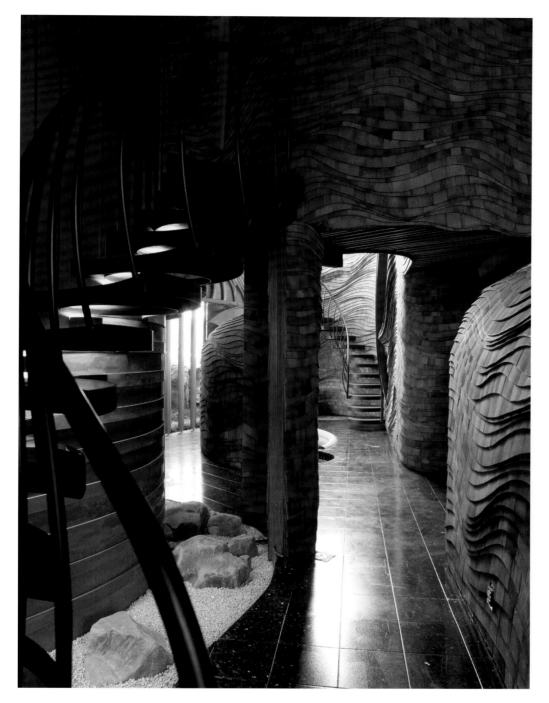

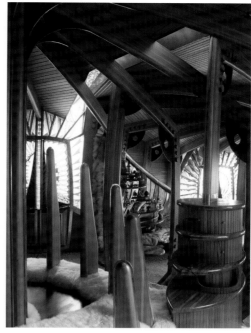

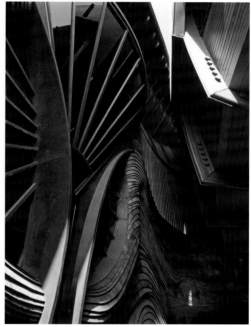

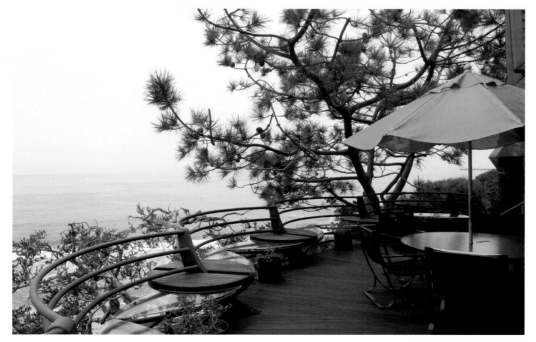

Corona del Mar (Spanish for "Crown of the Sea") is officially a neighborhood in Newport Beach. At one time, in the late 1920s, this tiny village was accessible from the peninsula by boat at high tide or by a muddy road that crossed through the Irvine Ranch. Today, running along the scenic Pacific Coast Highway north of Laguna Beach, CDM offers trendy shops and restaurants, rugged coves for some great snorkeling and scuba diving and is the birthplace of a truly American original home.

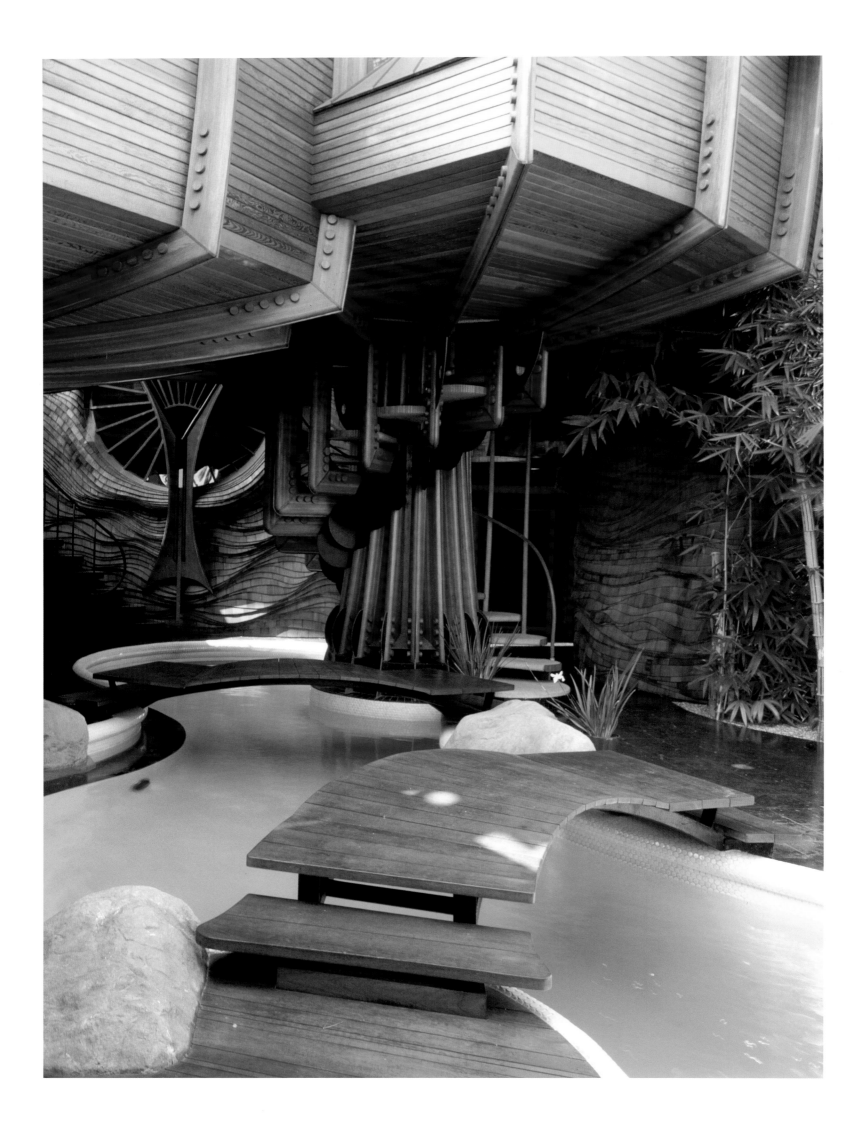

When Joe and Etsuko Price found this beautiful site in Corona del Mar, they commissioned architect Bart Prince as designer. According to Prince, "the scheme grew from the inside-out beginning with the desires of the client for privacy as well as an integration with the site and close association with the sea."

The architecture offers a process of discovery and experimentation that shifts attention from the abstractions to what Prince believes to be architecture's proper subject - the experience of place produced when an architect responds to the realities of a client, program, and budget in the context of the site.

The homes created by Prince are some of the most interesting and creative expressions in American architecture today. In his own words, "Architecture comes about as a result of the synthesizing by the architect of creative responses to input from the client; data gathered from the site and the climate; and an understanding of structure, materials, space and light. Working from the inside-out, the architect guides the growth of an idea resulting from the combination of these responses to a completed design which is as much a portrait of the client as it may be of himself." This process has placed Prince as a leader in contemporary creative American architecture.

Despite the design's focus on privacy, the home's uniqueness has made it a tourist attraction. For the observer, behind the exterior walls are three levels of designed spaces separated by sliding panels and platforms that fan out to take in the ocean view. Visually floating staircases, rock gardens, stained-glass windows, wall-to-wall sheepskin, and organically carved work areas abound. "The house, like everything I've done, is responsive to its situation, its site, and the client," says Prince.

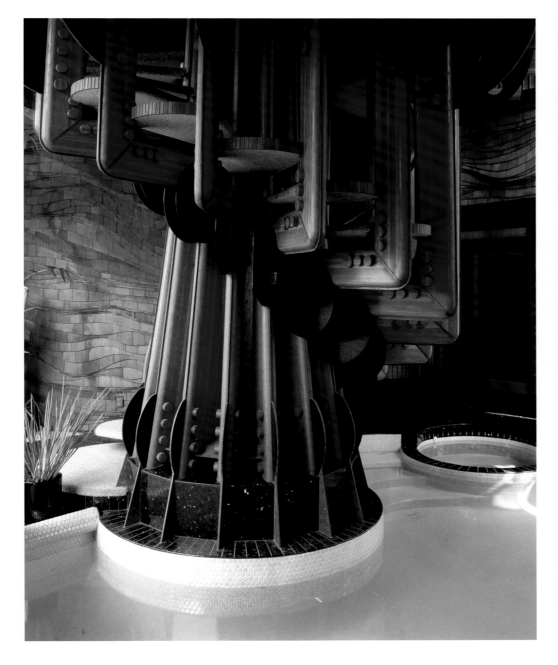

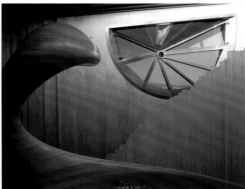

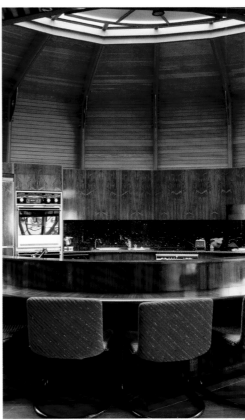

LA QUINTA

Montecito

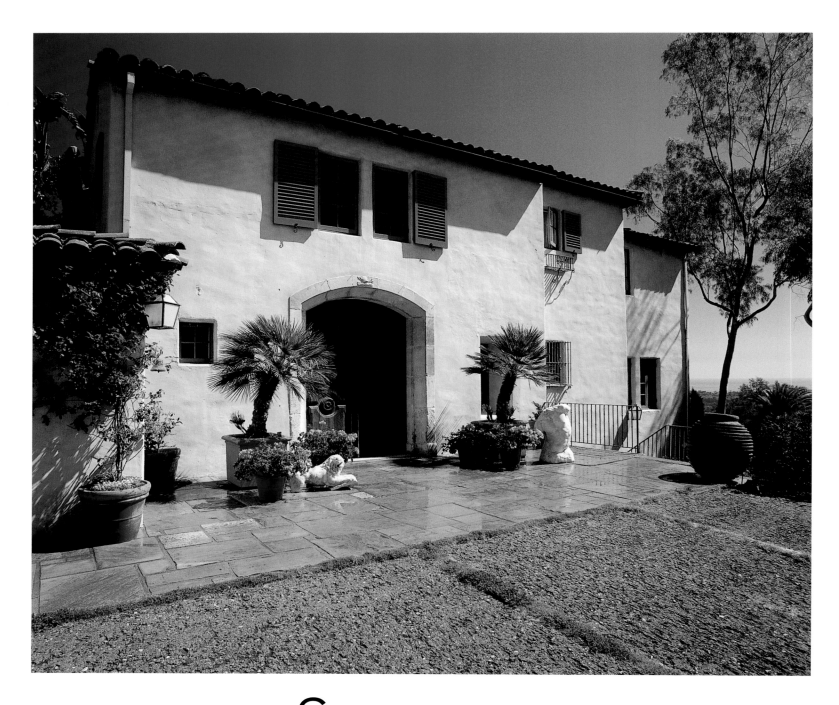

South of the Santa Ynez Mountains and adjacent to the city of Santa Barbara is the small community of Montecito. The mild climate, mineral hot springs and spectacular views have attracted visitors and residents since forever. Today, with its superb restaurants, boutiques and quaint shops, Montecito is renown for its lifestyle and treasure trove of unique homes that represent the architectural style that give Santa Barbara its inspiration and Mediterranean grace. Among the finest is La Quinta, built in 1922 by noted architect Carleton M. Winslow Sr.

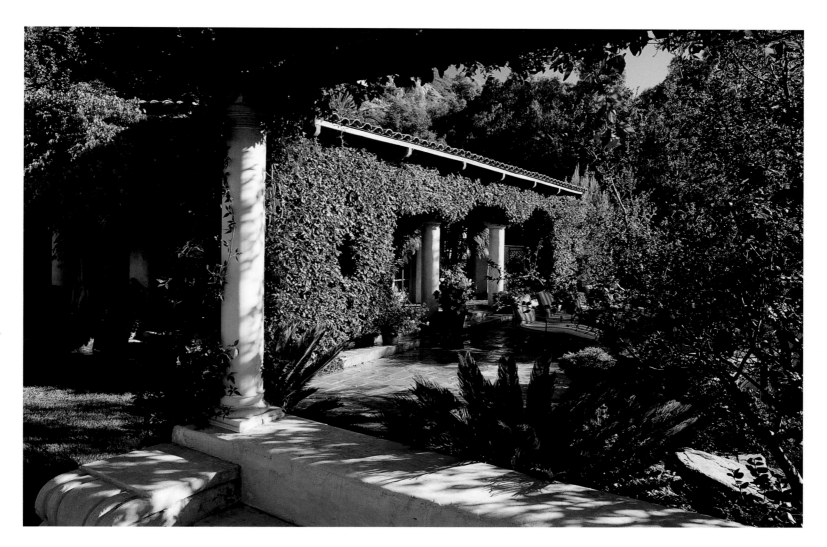

Walking through the stucco archways and over the tiled courtyards, La Quinta reflects the fact that nothing remains forever unchanged. All great masterpieces, including Botticelli's Venus, the Mona Lisa, the Sistine Chapel ceiling and the Casa Mila Barcelona in Spain would perish without care and restoration. To maintain the past, we need to preserve it and that is what the owner has undertaken with La Quinta (the Little Hotel). Restored surfaces, decorative treatments, expanded outdoor living spaces and remodeled interiors have all given the original home an authentic yet contemporary look.

Offering one of the most spectacular views of the ocean and the Santa Barbara Channel Islands, La Quinta reminds us of the history of Spanish architecture, from Moorish to Byzantine to Renaissance. La Quinta embraces the entire Mediterranean world by its use of arches, courtyards, plain wall surfaces, tile roofs and inspired landscaping.

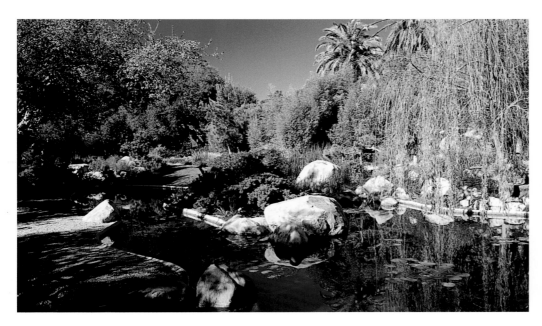

227

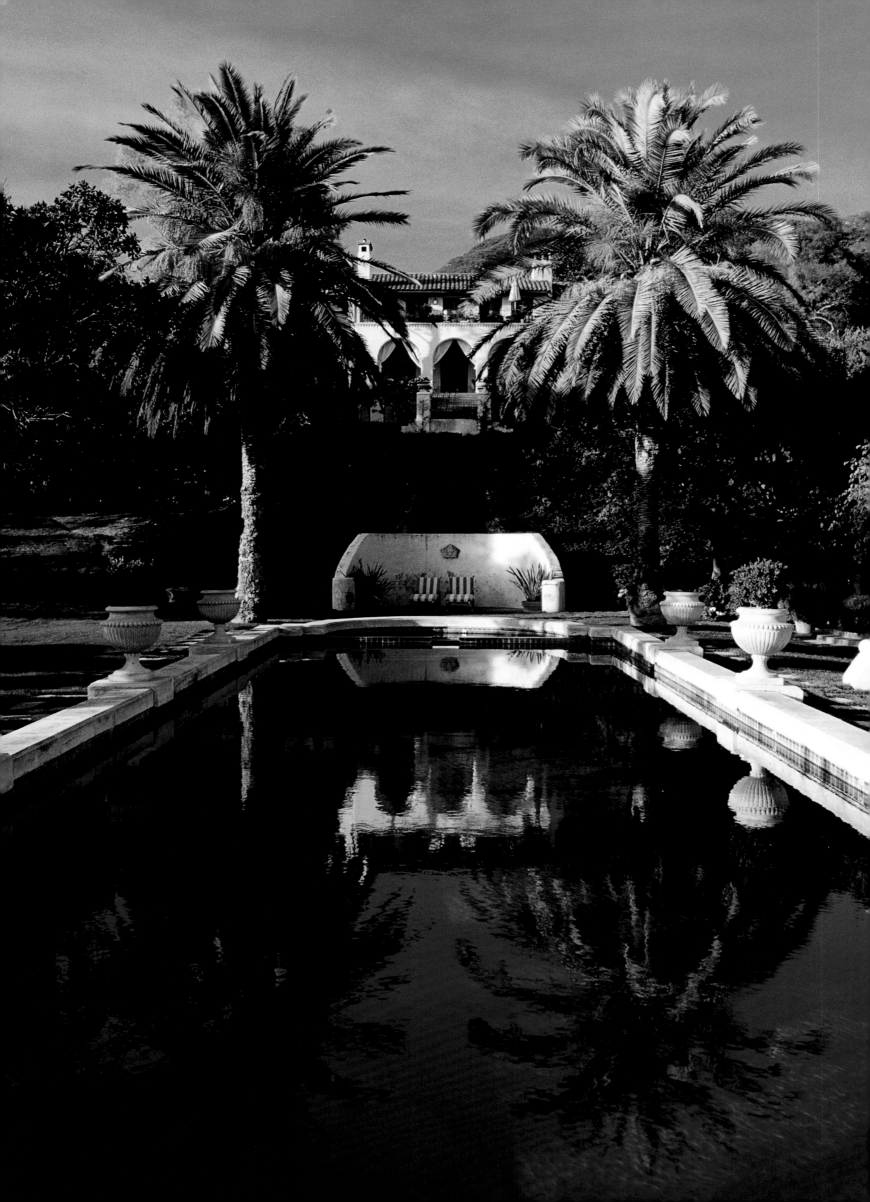

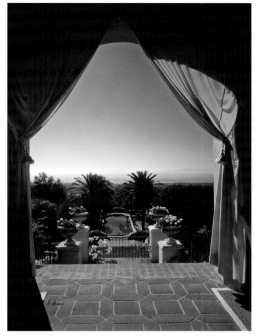

Brought up on the beautiful Spanish island of Majorca, the owner has put all her Mediterranean sensibility into renovating La Quinta. The interior is decorated with richly upholstered furnishings and European art and antiquities that compliment the dark stained beams and white walls.

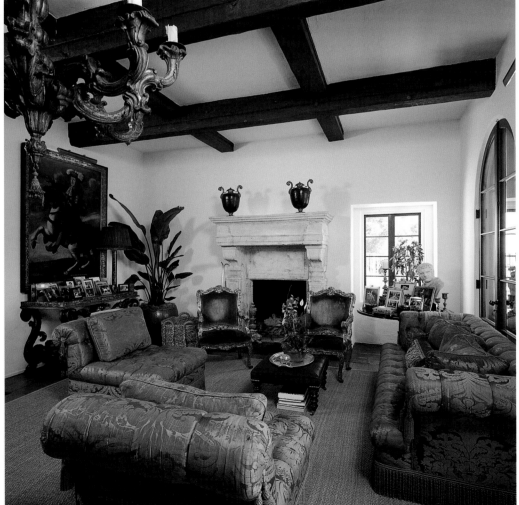

The established landscaping includes luxurious foliage set in period Italian, a three-acre Japanese garden, a citrus orchard and enclosed herb garden. The outdoor patio was transformed to create a private interior courtyard, while the spacious guesthouse near the main residence is also surrounded by irreplaceable floral and foliage.

The restored harmony between the exterior images, interior spaces, decorative elements, and the home's function help insure that La Quinta will carry on the rich tradition of Hispanic architecture and Mediterranean skyline that define this seven acre estate, Montecito and Santa Barbara.

ARCHITECT **CARLTON MONROE WINSLOW, SR.**
PHOTOGRAPHER **JAMES CHEN**

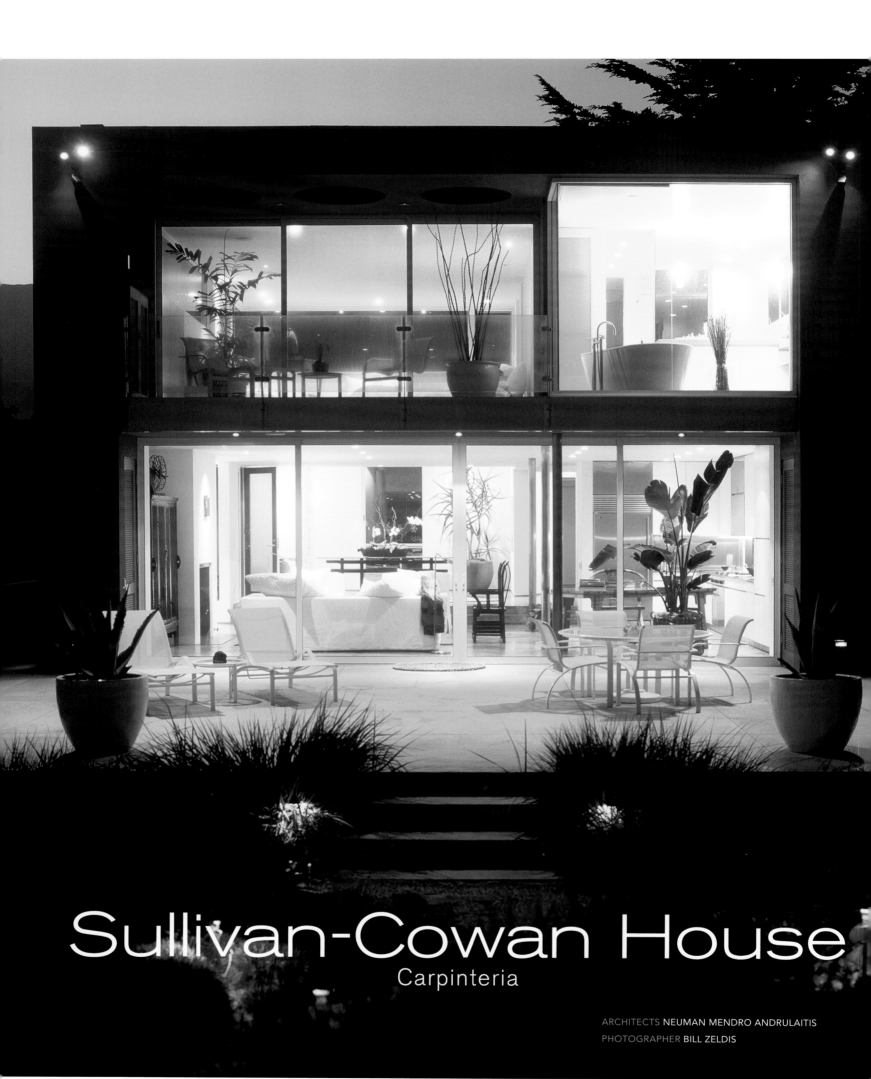

Sullivan-Cowan House
Carpinteria

ARCHITECTS **NEUMAN MENDRO ANDRULAITIS**
PHOTOGRAPHER **BILL ZELDIS**

Carpinteria is a coastal paradise located between the Santa Ynez Mountains and the Pacific Ocean. Situated about 10 miles south of Santa Barbara, floriculture and agriculture thrive here as farmers and orchard growers ship roses, chrysanthemums, giant colored daisies and avocados worldwide. On the edge of this small beachfront town, surfers enjoy the waves at Rincon Point, known world wide as one of the planet's top spots. It is in this coastal setting where you will find the Sullivan-Cowan residence, a house where owners and architects have blended the physical and spiritual elements of home and environment to create an ambiance of simplicity that personifies oceanfront living.

Architect Andy Neumann and owners Susan and Connell agreed the design should center on natural environmental features and evolve from the owners' desire for a second home that reflects tranquil living, art, and retreat. By focusing on available space and minimizing interior wall structures, they have created an open design that captures the essence of this beachfront property.

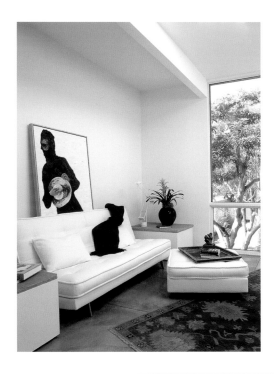
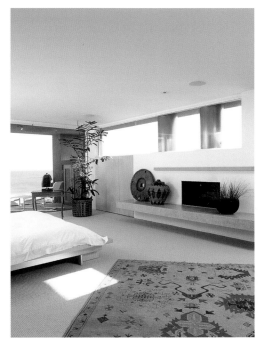
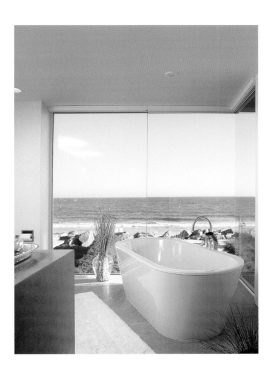

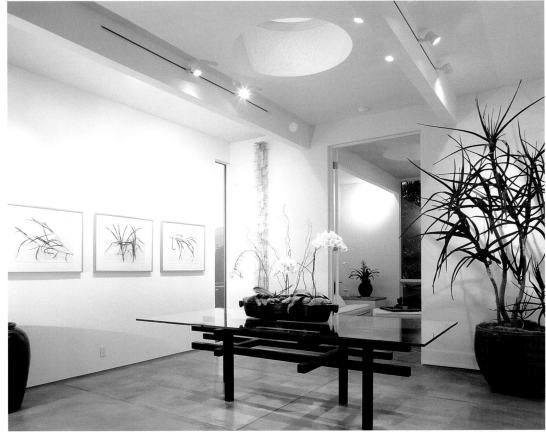

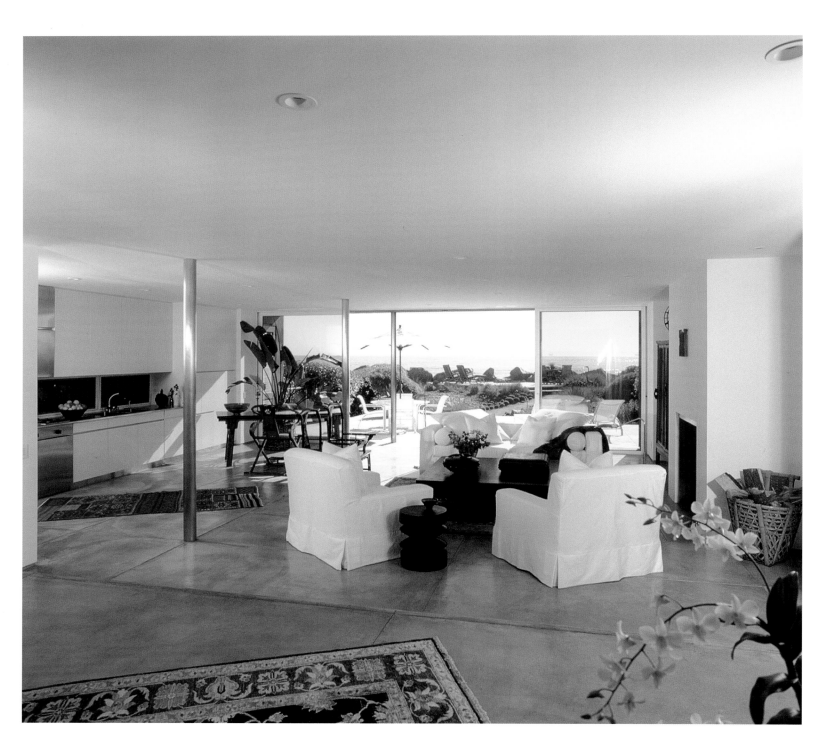

A wall of glass provides views from the upstairs master suite and free-standing soaking tub that look over the granite boulder seawall and out into the Pacific.

Clean lines and glass panels create open space and connect the 2,680 square foot interior to the outdoors. Glazing and roof openings transform the coastal sunlight into natural day lighting. The light that flows into the rooms accentuates the sculptural building forms like the spiral stair with opaque glazing and glass treads that lead to the master suite.

The minimal design directs the viewers focus toward the fundamental role of the space itself. The kitchen, for example, is

one wall of the living room, allowing this elegantly rendered design to follow Mies van der Rohe's classic credo of "less is more."

Building materials were selected for their natural beauty and suitability for the coastal environment. Integrally colored stucco, Corten steel, exposed concrete, stainless steel, opaque and clear green glass, maple, and natural stone comprise an understated palette of materials with a quiet tranquility.

The original owners would be amazed at the transformation. Like an old surfer remembering the early days of long boards, foam and traditional California surf culture, the renovation reflects an understanding of the past and the rewards of improving upon it.

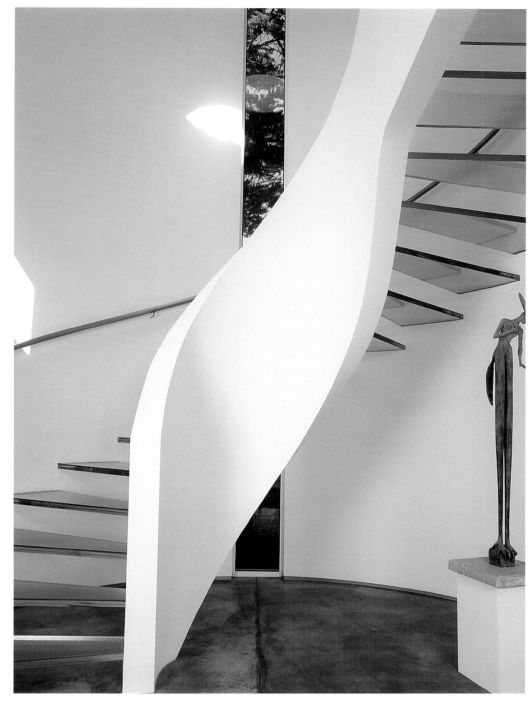

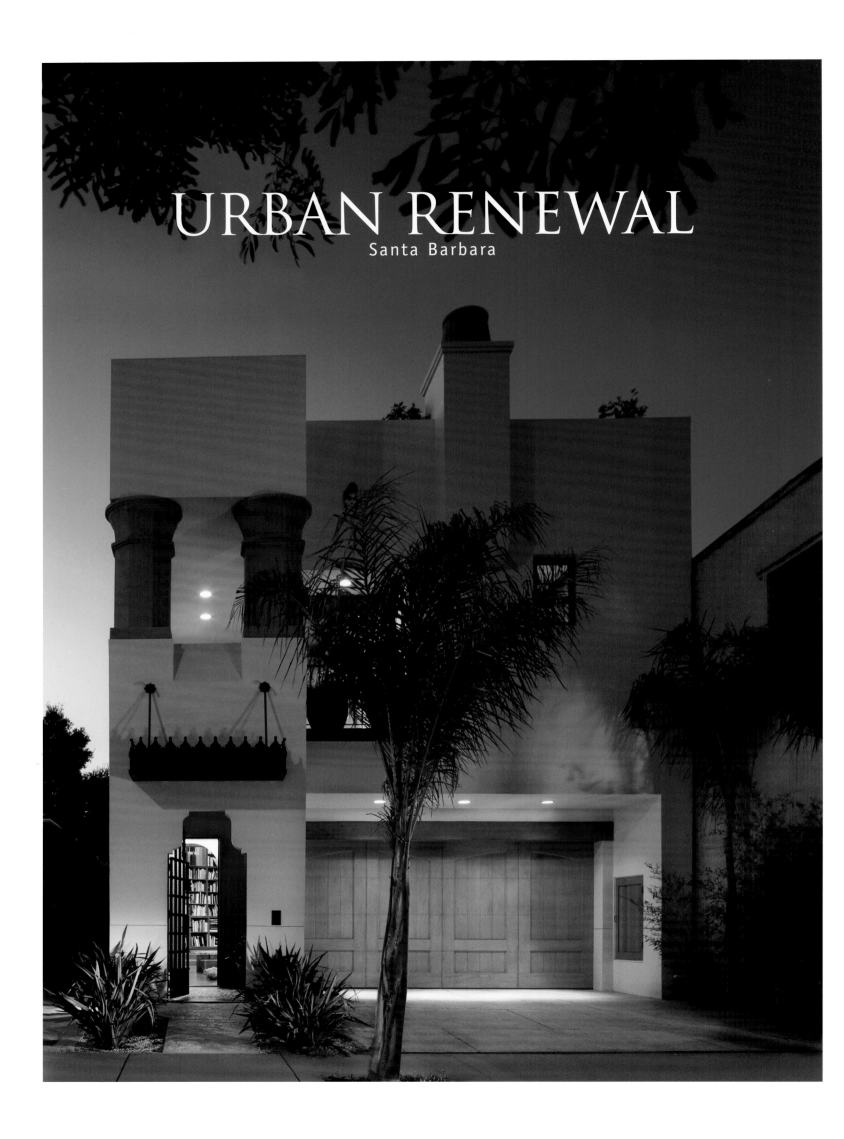

URBAN RENEWAL
Santa Barbara

ARCHITECT **BERRY BERKUS** PHOTOGRAPHER **FARSHID ASSASSI**

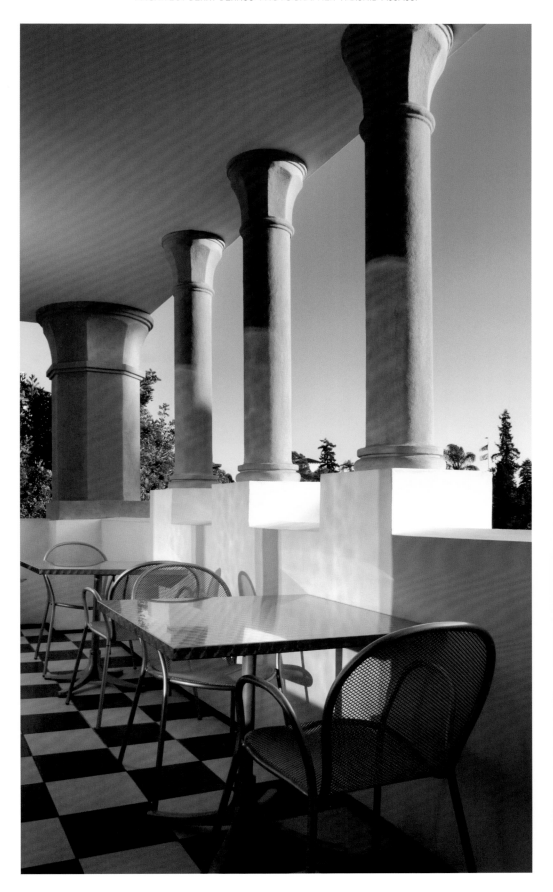

Historically, Southern California has resisted development of high-density urban living, but after years of urban sprawl, the mood has changed. The national trend toward downtown living is sweeping the country as urban pioneers have been reinventing this lifestyle.

World-renown architect Barry Berkus, whose innovative designs include mixed-use urban buildings, lofts and downtown living-environments, has been involved in downtown projects since the 70's. So when the opportunity presented itself, Berkus decided to experience first-hand the concepts he has championed. "I think one of the hardest things an architect can do is design a house for himself or herself," says Berkus. "It's your calling card, your message to the public about you and your architecture." The message here is a clear justification why the Berkus name has become synonymous with innovation. The home, a creative example of structural eloquence that blends traditional Santa Barbara architecture with an artistic flair, is located discreetly

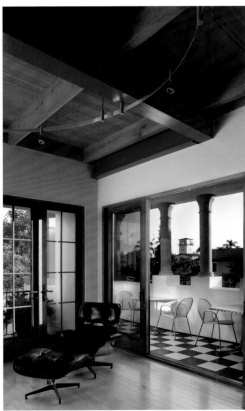

downtown on a narrow lot on one of the shortest streets in Santa Barbara.

A trio of glass and wrought iron entry doors connects to the street, garage and the side entry. The vaulted tunnel connects the entry to the interior. Walking through an opaque glass door, the entry chamber showcases blue walls and

a mosaic tile rug that exhibit the transition from a Santa Barbara exterior to the artistic flair of the interior.

"The science of designing spaces that replace the suburban dwelling and become attractive, stimulating places to live within a city is achieved by exploring a formula of height and light. They work

together to create interior landscapes
that stimulate thought and dialogue and
act as a backdrop for personal expres-
sion of spatial décor," states Berkus.
To solve the height, bulk and scale
restrictions imposed by city ordinances,
windows were placed so that the light,
changing from morning to afternoon,
casts different moods on the space.

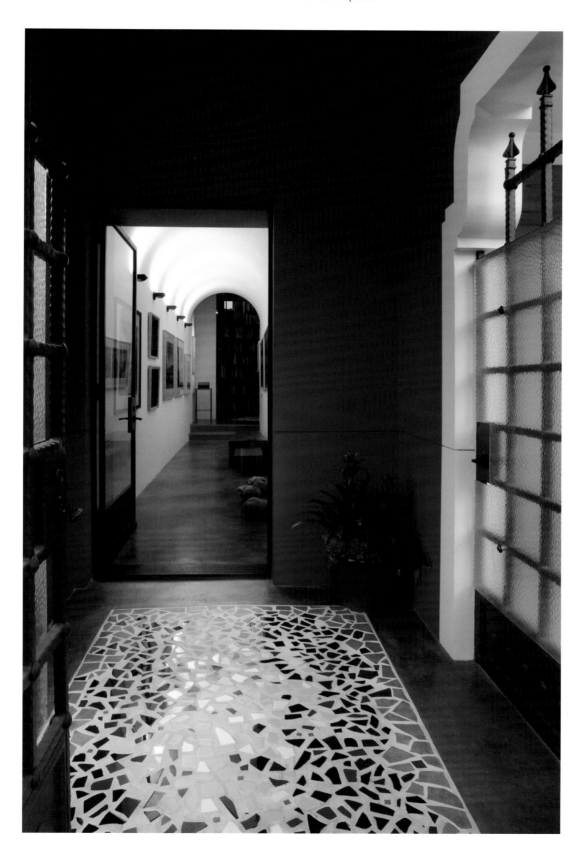

HOME ON THE ROAD

NEWPORT BEACH

BUILDER MARATHON COACH

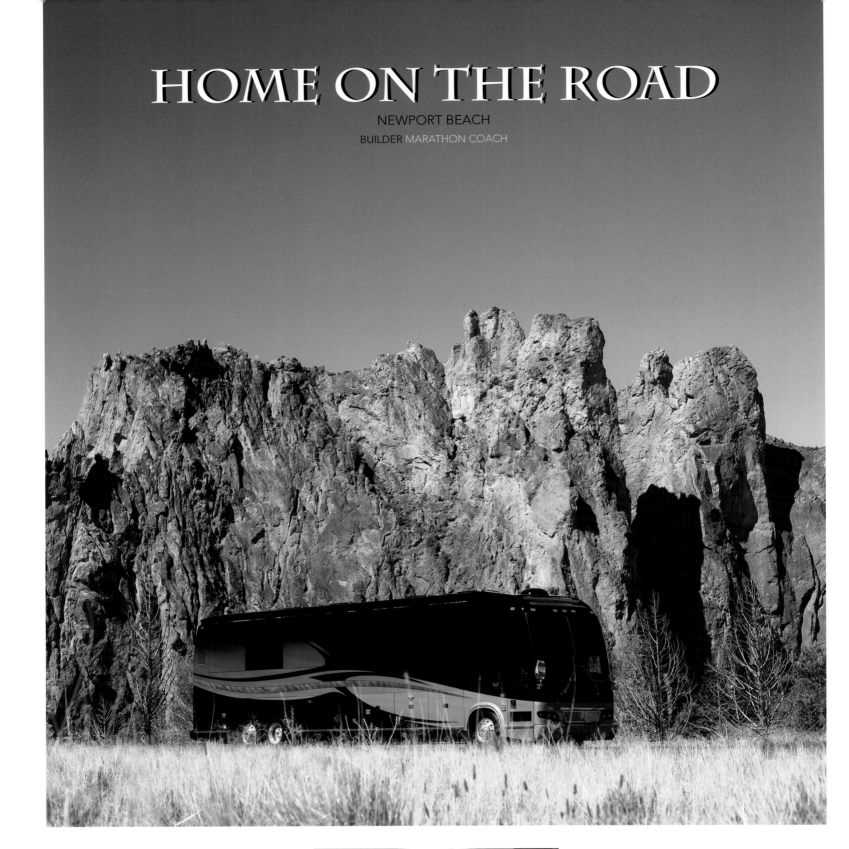

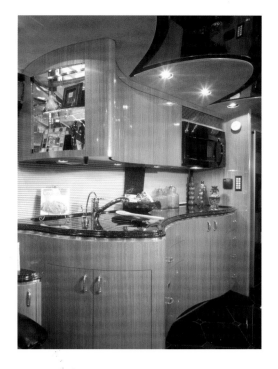

Exploring the open road has long been a tradition of American culture. From Daniel Boone through Manifest Destiny, *Blue Highways* and *Travels With Charlie*, the idea of discovery and adventure has defined the country. Rolling down the interstates and blue highways in the luxury bus conversions that are available today offers a new meaning to adventure travel. The risk taker that created the first commercial motor home by placing a canvas tent on a trailer bed would be awestruck by the evolution and amenities available in the modern day traveling coach.

Seeking the best ways to travel in style, comfort, and luxury, Marathon Coach, Inc. began converting bus shells into recreational vehicles and corporate coaches in 1983.

This exotic coach includes a host of luxuries and conveniences. With double slide-outs and a remote-controlled awning system, it's equipped with a monitor that allows the owner to control operations from either inside or outside the vehicle. The interior features granite, leather and a state-of-the-art electronics package. This system includes four television screens: a 42-inch plasma screen that drops down from the ceiling; a disappearing 20-inch flat-screen TV at the living area table; a 20-inch flat-screen TV in the bedroom; and, for those outside, a 30-inch LCD TV with Bose speakers.

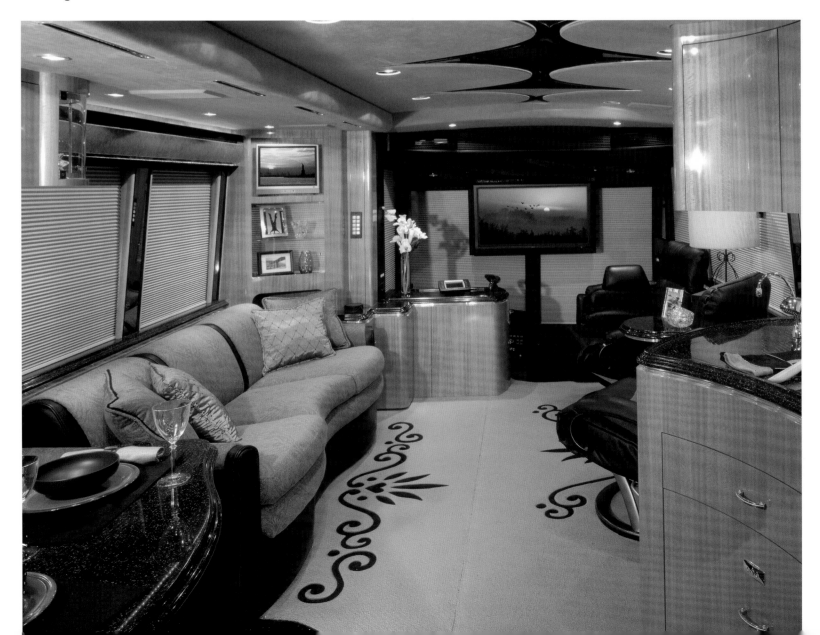

Other features include an in-motion satellite system, satellite radio, Internet reception and the OnStar assistance system for concierge and emergency service anywhere in the United States. A menu-driven, touch-screen control system allows the owner to operate the TVs, lights, and surround-sound stereo system from anywhere in the coach.

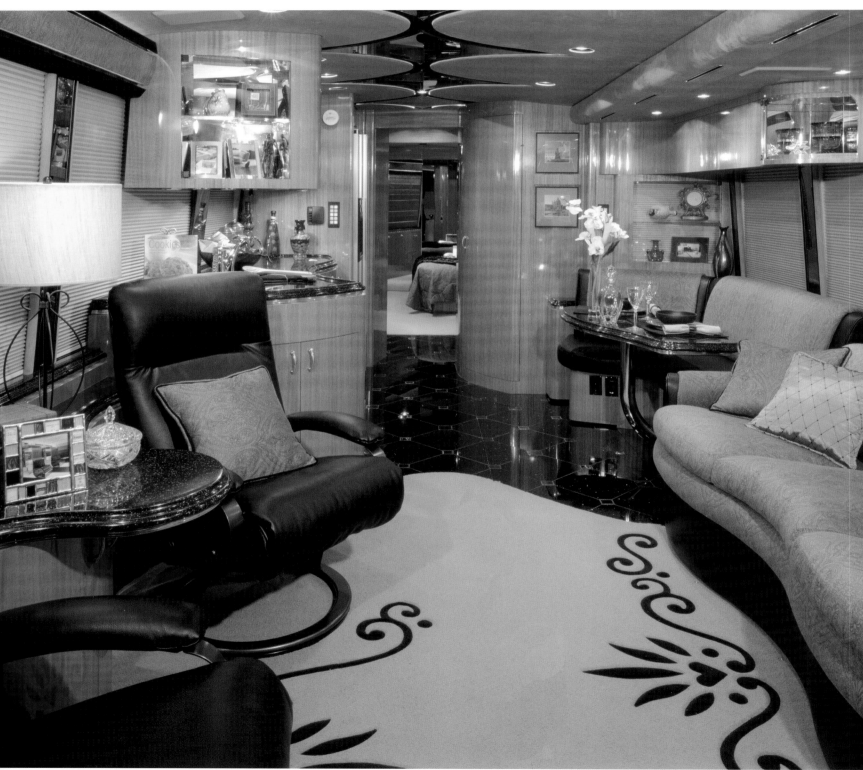

These luxurious, multipurpose traveling vehicles are used for luxury shuttles, business conferencing, and hospitality suites, not just vacations.

One of the joys of California is the abundance of natural beauty in every corner of the state. From the intriguing coastlines to the mountainous national parks, through the wine country and into the deserts, California offers an eternity of travel and natural wonder. Imagine one day strolling along San Francisco's Embarcadero and Fisherman's Wharf then cruising up to Yosemite Valley. Calling it a day, you drive to a posh RV park outfitted with lakes, waterfalls, tropical landscaping, swimming pools, clubhouses, golf courses and private lagoons. This is what its like to be a part of today's RV lifestyle and a long way away from the covered wagons and wagon wheel ruts of early day travelers.

ARCHITECT WALLACE CUNNINGHAM **PHOTOGRAPHER** TIM STREET-PORTER / HEWITT GARRISON

a CiTy HoUsE
La Jolla

In one sense typical because it's big and fitted tightly onto a small urban lot, in another sense unique because of the interior openness it achieves, the City House in La Jolla, California almost defies description.

Comprised of three pavilions – one for cooking, sleeping, work; another for entertaining; the third for guests – the design is sliced into thin bays, four feet apart. Interior spaces aren't really rooms because walls are carved away to create openness. Passages through long, low corridors end in dramatic arrivals at high wide spaces. A glass wall in the kitchen reaches to the full height of the house and delivers a panorama of the main court's Japanese garden. Most other rooms have a glimpse of gardens as well. Glass and light are everywhere.

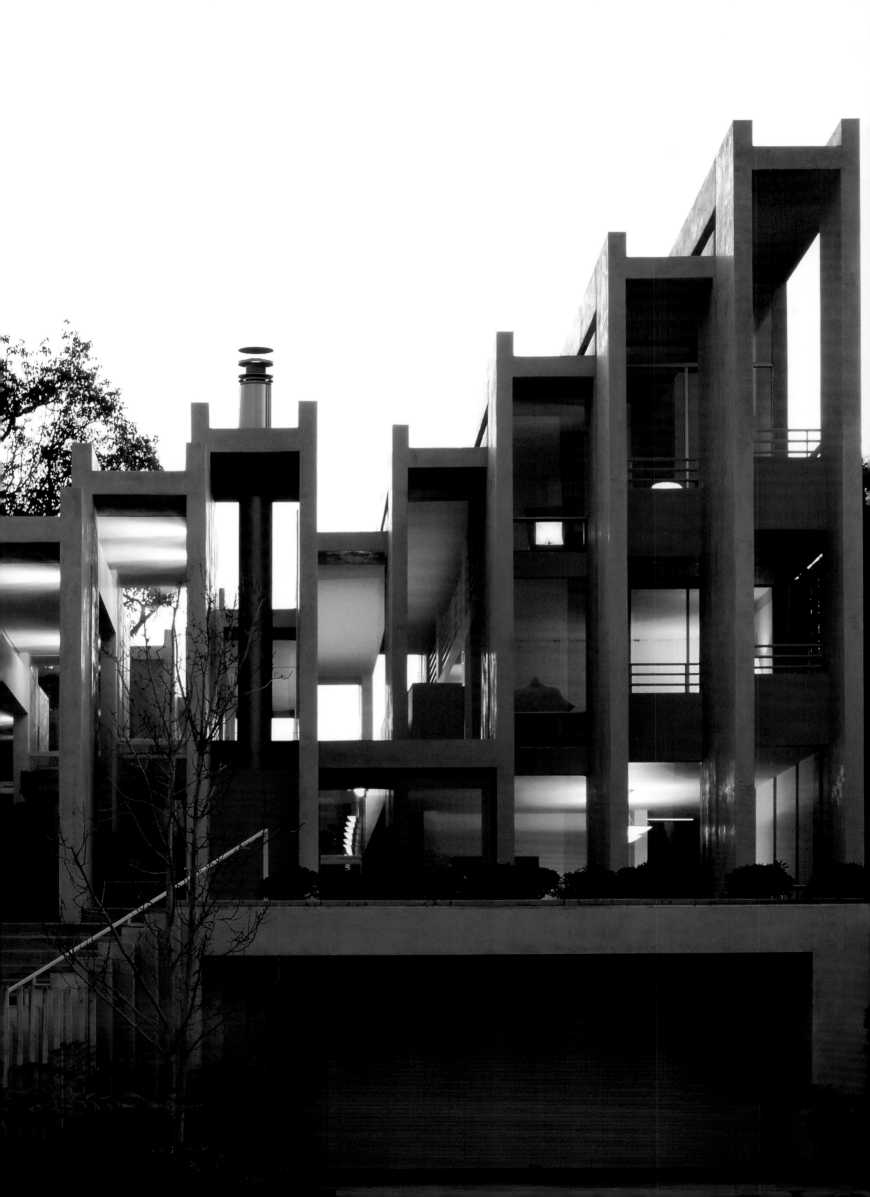

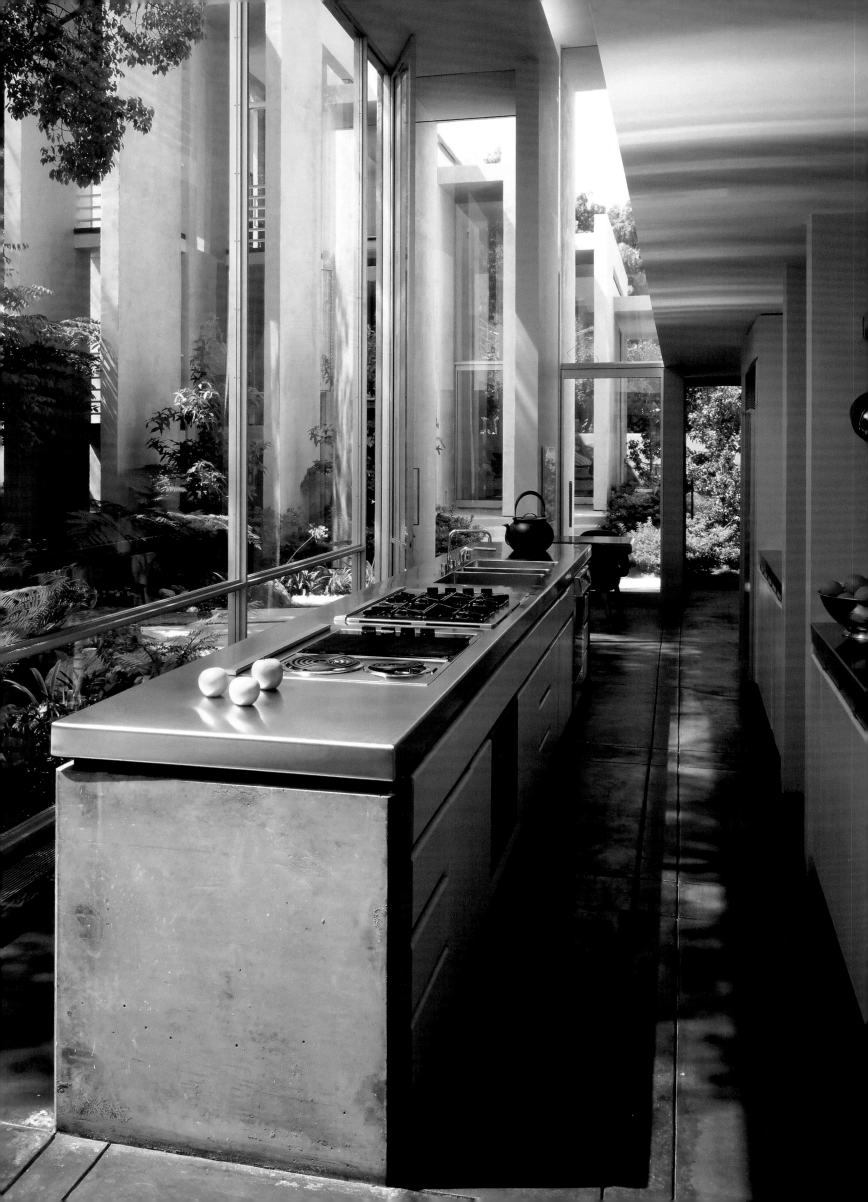

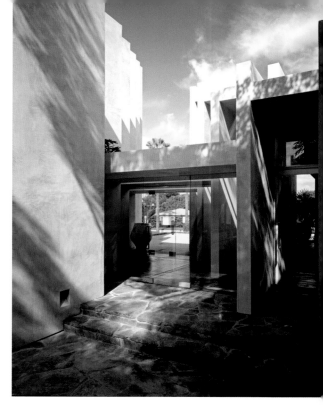

Designed by Wallace Cunningham, City House has a centrally located kitchen, ample pantry, several entertaining areas, a study, two bedrooms, extensive storage, and lots of walls for art display.

Glass fills spaces between the slices, which virtually disappear, leaving living areas surrounded by light and greenery. High ceilings create an impression that the sky alone is overhead. If one stands in the right location, viewing the parallel walls on end, the structure nearly vanishes, leaving only a lush garden home.

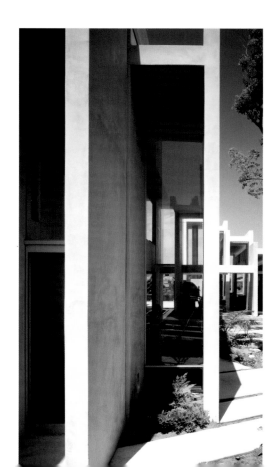

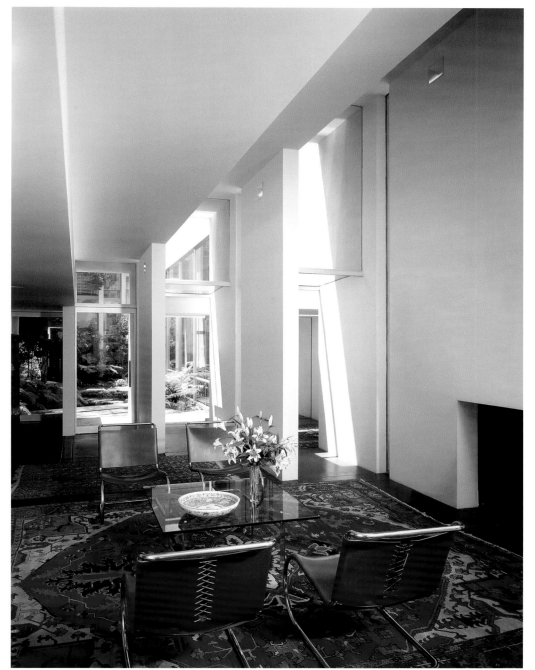

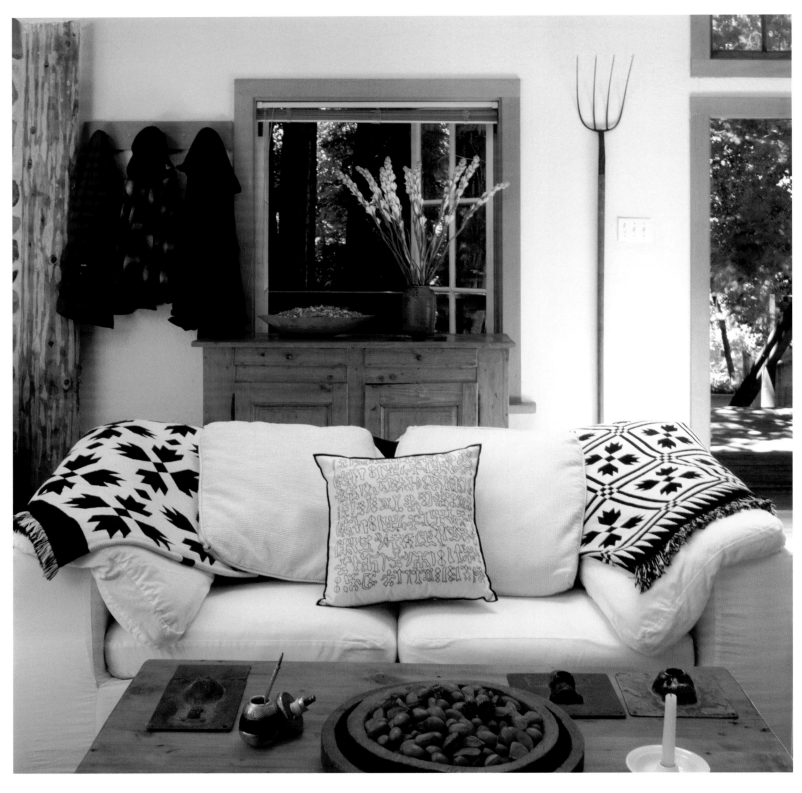

Santa Cruz

seclusion

ARCHITECT **STEPHEN KANNER** PHOTOGRAPHER **ALAN WEINTRAUB**

*N*o architectural form has captured the imagination of the American people more than the log cabin. Located within the wooded seclusion of the Santa Cruz Mountains, only minutes from the Pacific Ocean and a 90 minute drive from San Francisco, what is today a charming log cabin home was once a neglected vacation retreat in desperate need of repair.

Originally built in the 1930's near the historic logging town of Boulder Creek, the beauty and quiet of this mountain environment invited the challenge to not only restore but to improve the original structure. The current owners, Isda Funari and Tony Melendrez, undertook the task and have created the perfect mountain retreat.

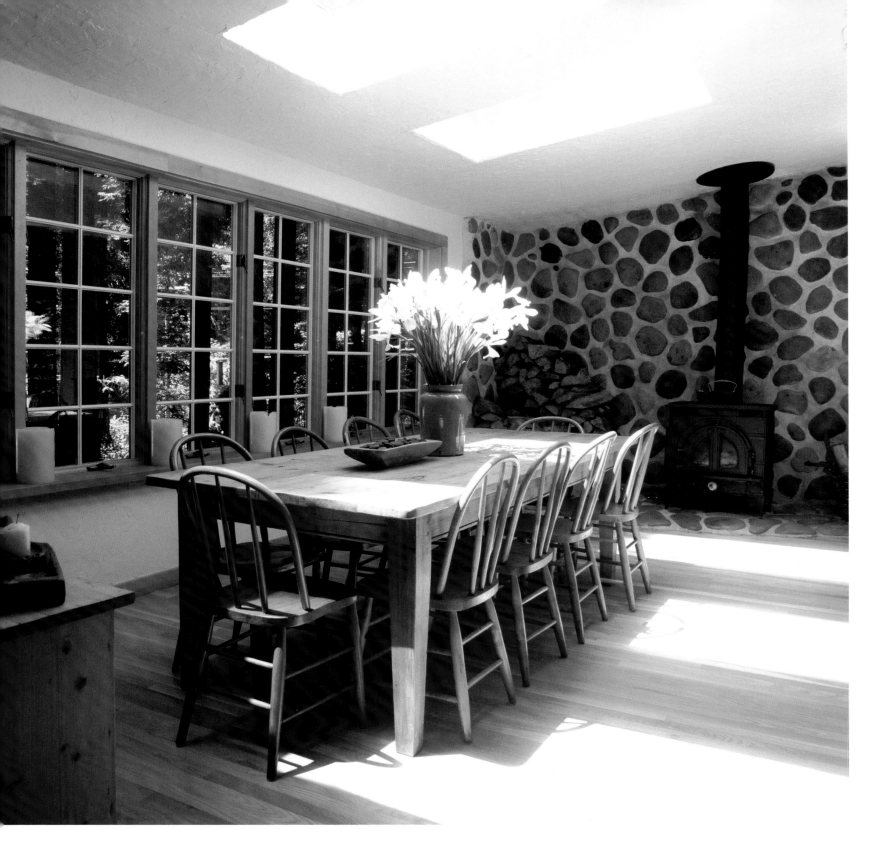

Where grizzly bears were once more numerous than old-growth redwoods are today, fashion designer Funari has chosen simplicity as beauty for the interior composition. In the living room, two sofas are covered in white cotton, the walls are white plaster and skylights fill the interior with daylong sun.

In keeping with both tradition and modern craftsmanship, a log burning stove, hardwood floors and a pine table are accentuated by the well placed white-framed windows, blending old and new.

Boulder Creek offers the unique lifestyle of mountain seclusion, one that is perfectly suited for the current owners.

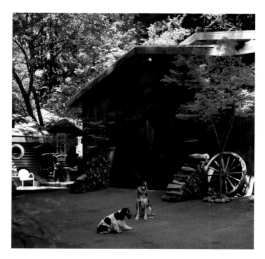

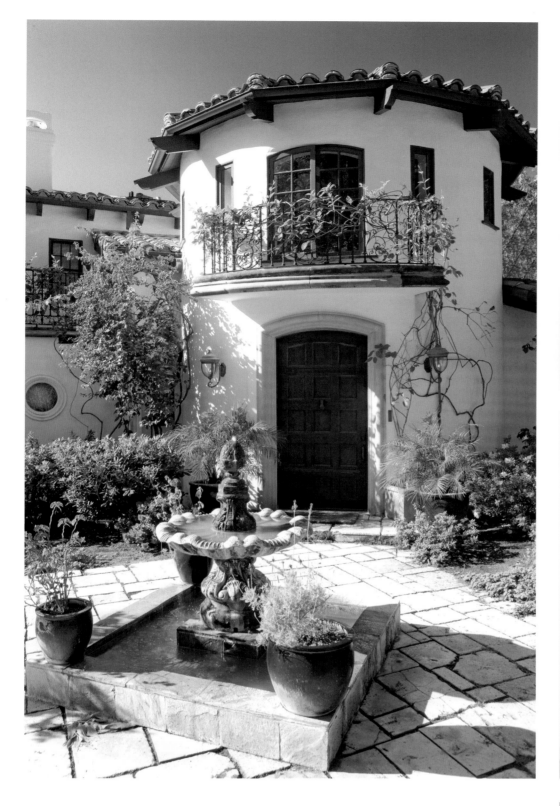

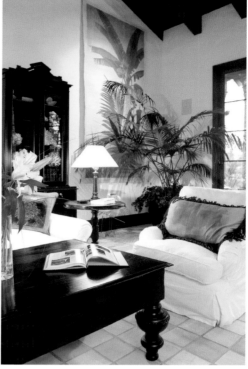

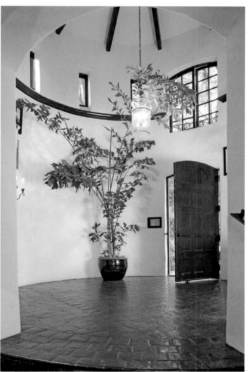

vistas durar para siempre

Los Angeles

ARCHITECT FRED SMATHERS

PHOTOGRAPHER DANA HOFF

In peaceful Nichols Canyon above West Hollywood, this private retreat rests on an acre of sloping ground. The estate's name, in English, means, "The views go on forever." And so they do, both of the distant Los Angeles skyline and of valley greenery nearer at hand. Because of the neighborhood's tenor, the grassy lawns and the European architecture, the home projects a serene, Zen-like quality that's extremely pleasant and relaxing.

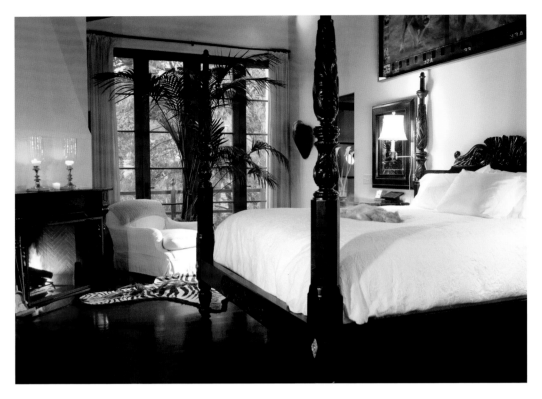

Living room ceilings soar 20 feet above terra cotta tiles, and glass doors swing out over spectacular vistas. But the heart of the house is its amazing media room. With a near theatre-size viewing screen, this entertainment center is equipped with hidden kitchen, fireplace, full AV electronics and entry doors from the Empire State Building. The rest of the main house offers four bedrooms. On the lower level, rooms include a full bar, den with fireplace and billiards table, office with bath, and separate guest unit, designed like a hunting lodge. For exercise, the home offers a soundproofed gymnasium with sauna, and a tennis court with night-lights, covered viewing deck and patio.

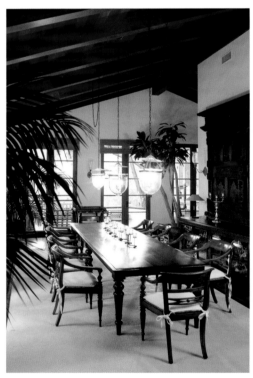

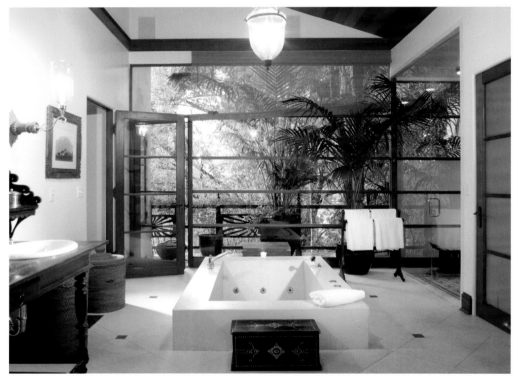

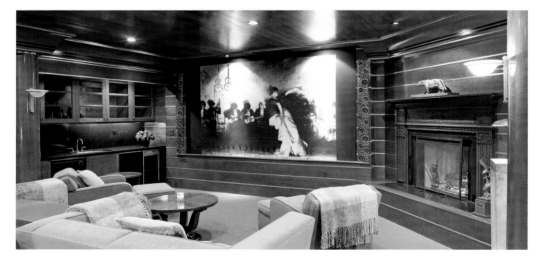

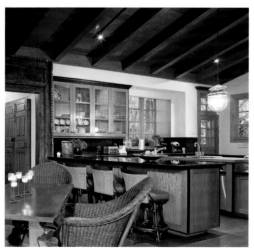

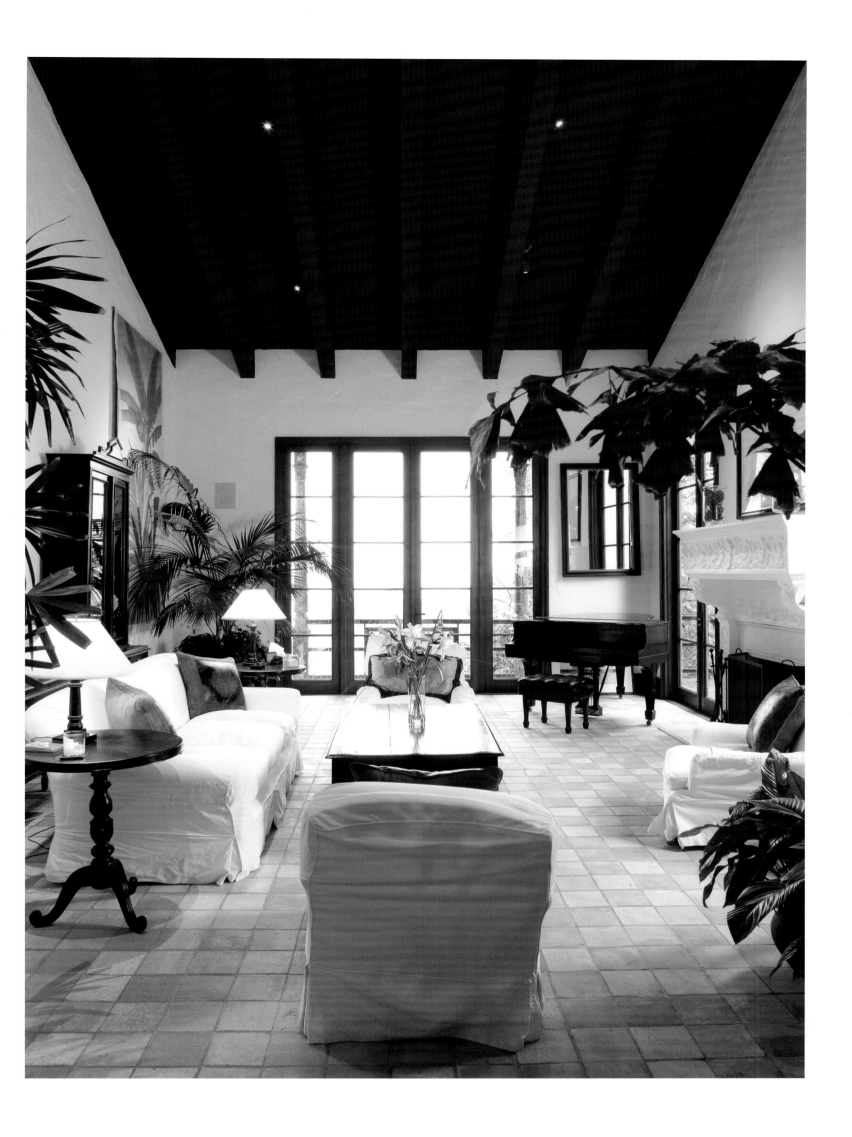

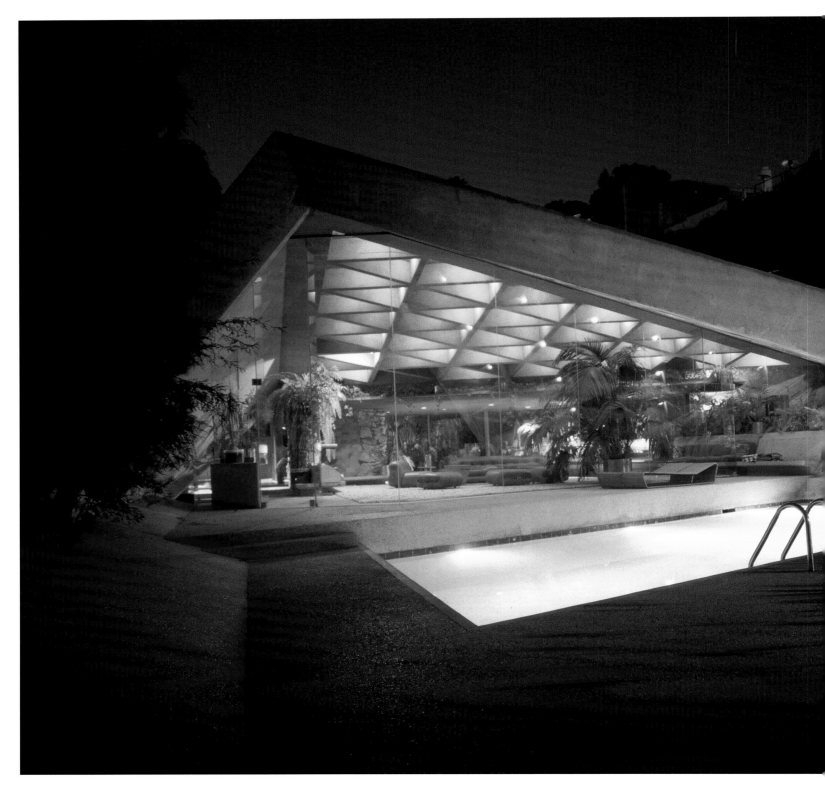

SHEATS-GOLDSTEIN VOYAGE
LOS ANGELES

"The world's richest nation should be able to produce a free, beautiful architecture for
individuals – for people – to daily increase the joy in life." Architect John Lautner

Up the lush green hillsides and winding tree-lined roads of Benedict Canyon in the Hollywood Hills, and overlooking the entire city of Los Angeles, is the Sheats-Goldstein house designed by renowned architect John Lautner. One of the most successful graduates of Frank Lloyd Wright's Taliesin Fellowship, Lautner's designs are a combination of logic, originality, technical daring, space-age flair and experimental vision.

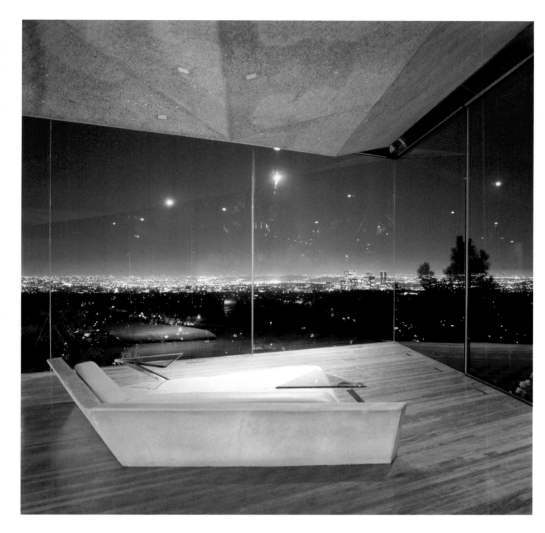

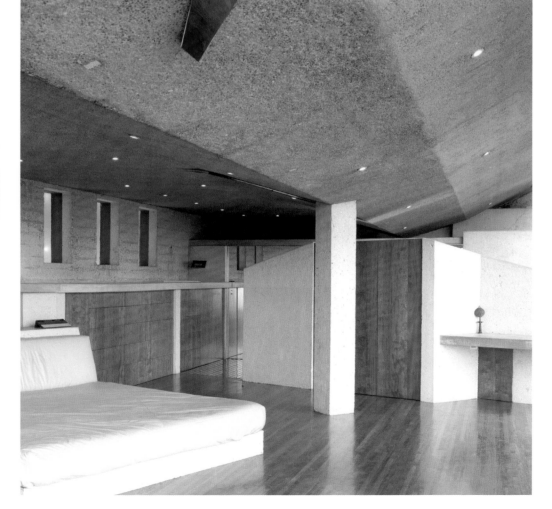

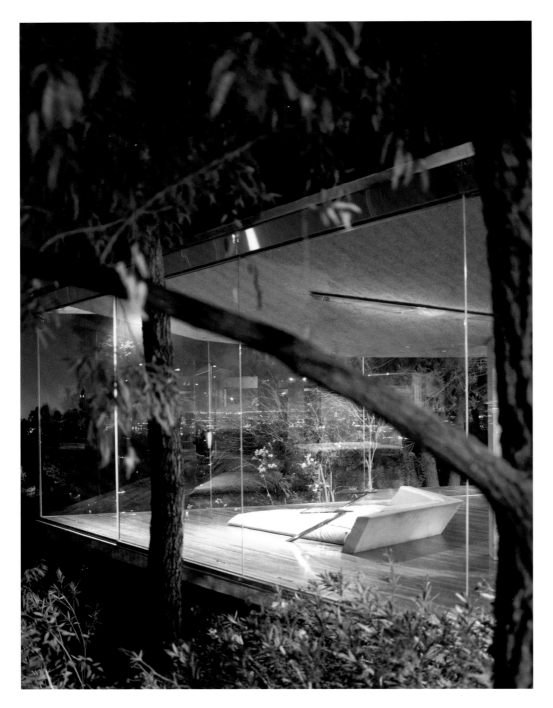

Lautner was originally commissioned in 1963 by Paul and Helen Sheats to design a home on the steep hillside above the city. Over time, the residence fell into disrepair until current owner Jim Goldstein provided the insight, passion and means to restore the home to its current

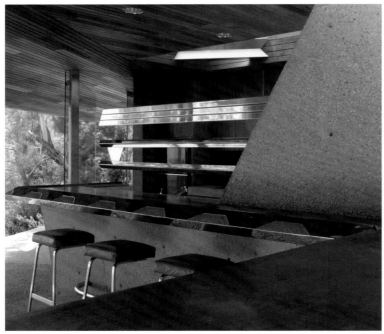

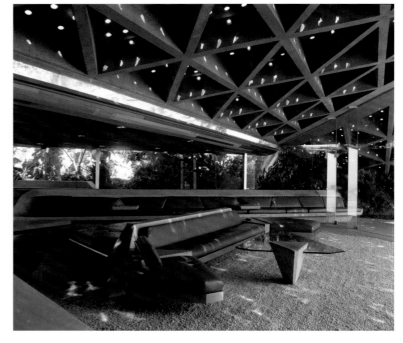

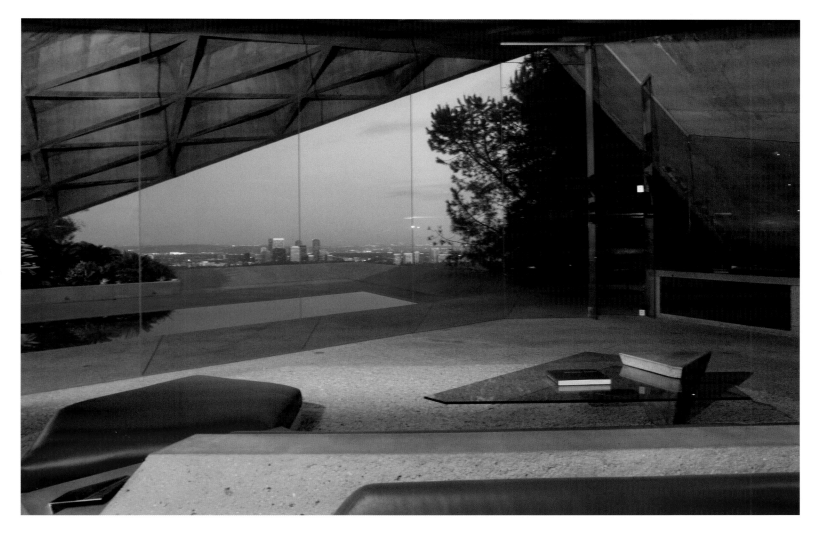

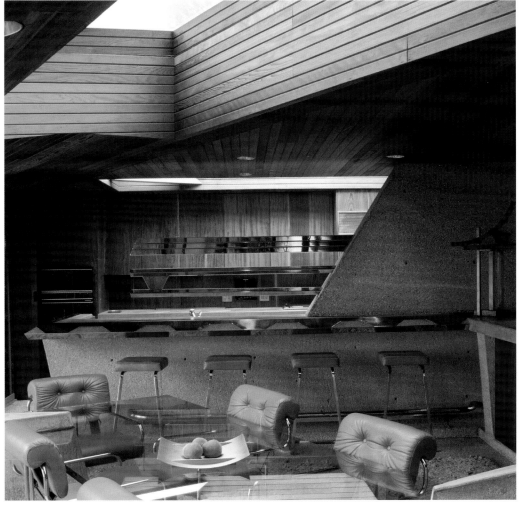

level of brilliance. The transformation integrates technology with the natural surroundings. With magnificent vistas that reach the Pacific and beyond, it's difficult to tell whether you're inside the home or out. With no right angles in the design, the triangular glass window presents an open view to the pool terrace and downtown Los Angeles. During the day, the living room is lit by hundreds of tiny skylights created by drinking glasses inserted into holes on the roof.

A work of art in constant progress, one thing remains certain - as long as Jim Goldstein is living here, the Sheets/Goldstein home will continue its voyage into architectural history.

ARCHITECT **JOHN LAUTNER**
PHOTOGRAPHER **ALAN WEINTRAUB**

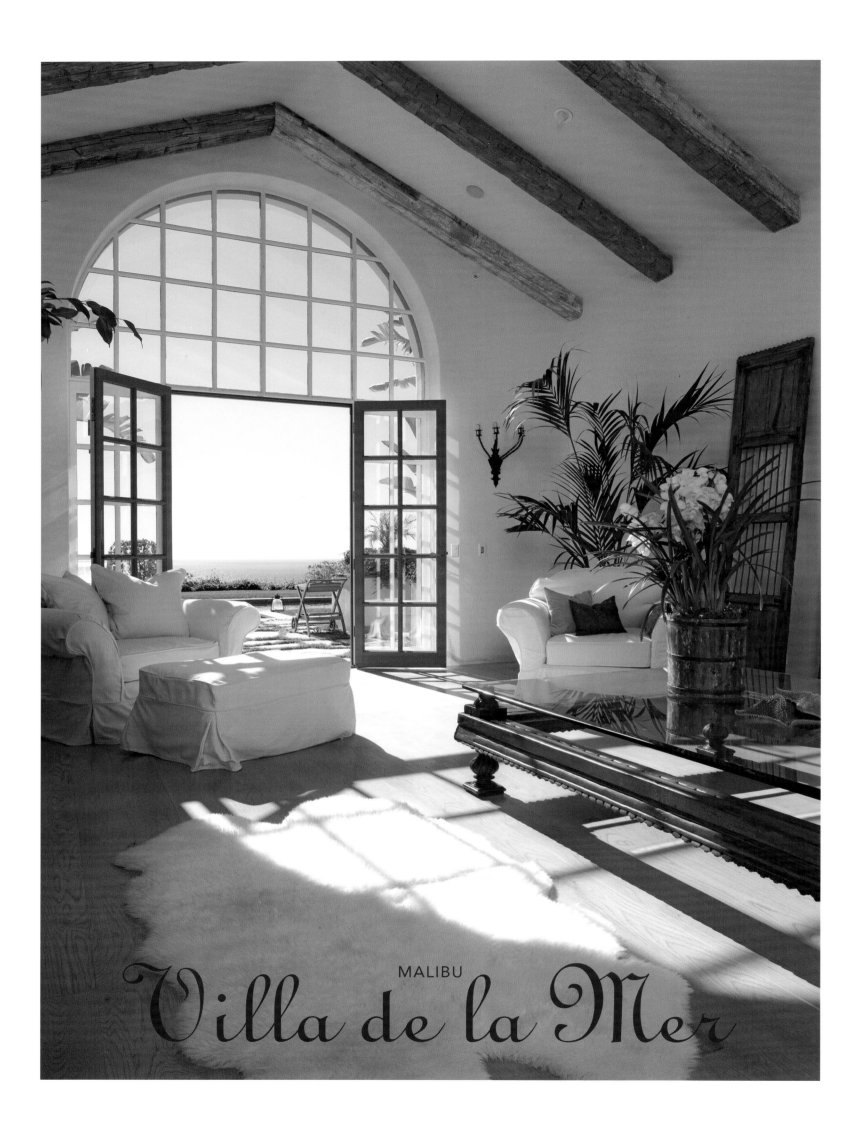

MALIBU
Villa de la Mer

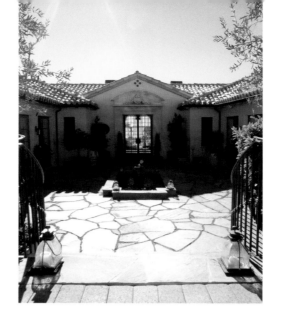

Along historic Pacific Coast Highway 1, with Pepperdine University up the hill and Malibu Bluffs Park a neighbor just down the road toward Santa Monica, this sunny hacienda rests on slopes above the sea.

Even the air can make you feel better here, and this barefoot house, simple but sophisticated and blessed with unending ocean views, offers a heavenly hideaway.

PHOTOGRAPHER DANA HOFF

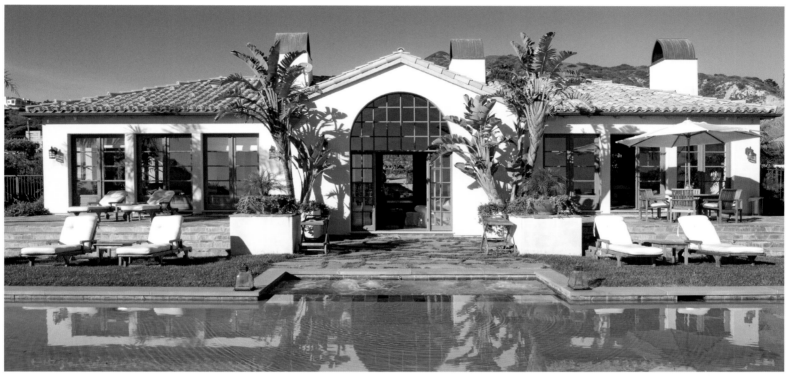

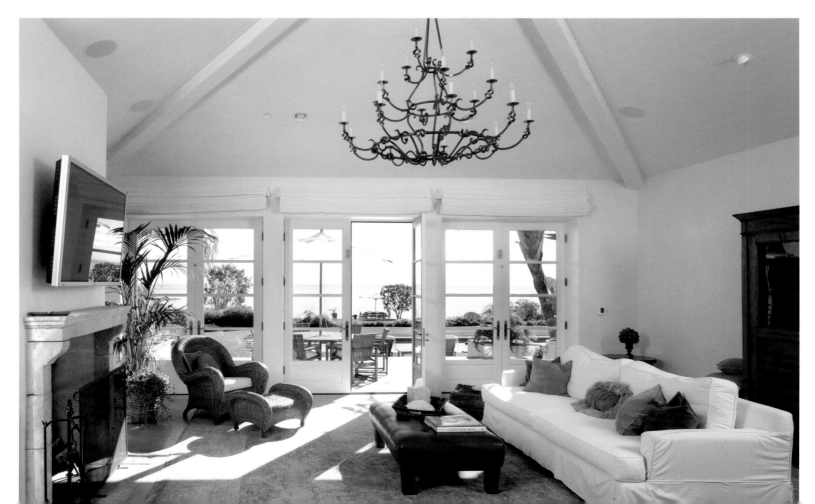

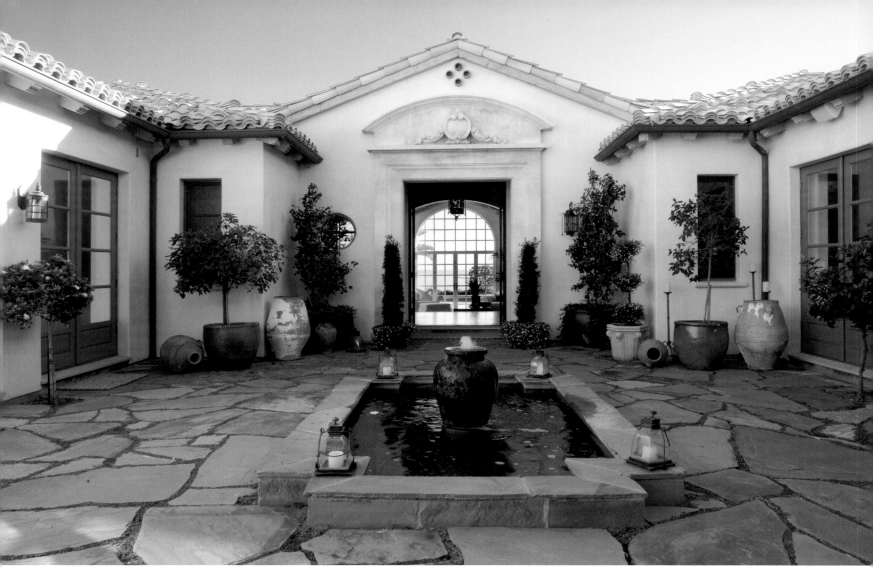

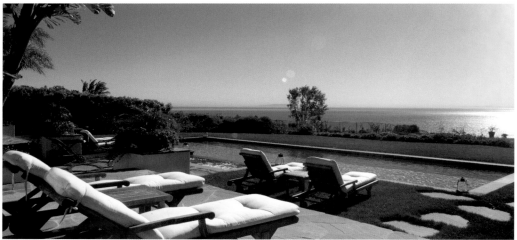

From the private gate, you move through a succession of vistas large and small, from gardens to flagstoned courtyards on down to the ocean that seems almost a personal possession.

Elegant wrought iron entry doors reveal a sightline through the house and frame the ocean blues beyond. This is an easy, uncomplicated home, wide open, light and air-filled. Nevertheless, it offers 5 bedrooms from which to enjoy sunrises and sunsets over the sand.

European elements liven a number of spaces. Antique oak floors and rescued roof beams color the living room. Fireplace mantles are from 18th century France. And the kitchen, although quite contemporary in capability, appears rustic in appearance with limestone counters.

From entry courtyard with urn-style fountain to the reflecting pool beyond the house toward the sea, this house is comforting, but never boring.

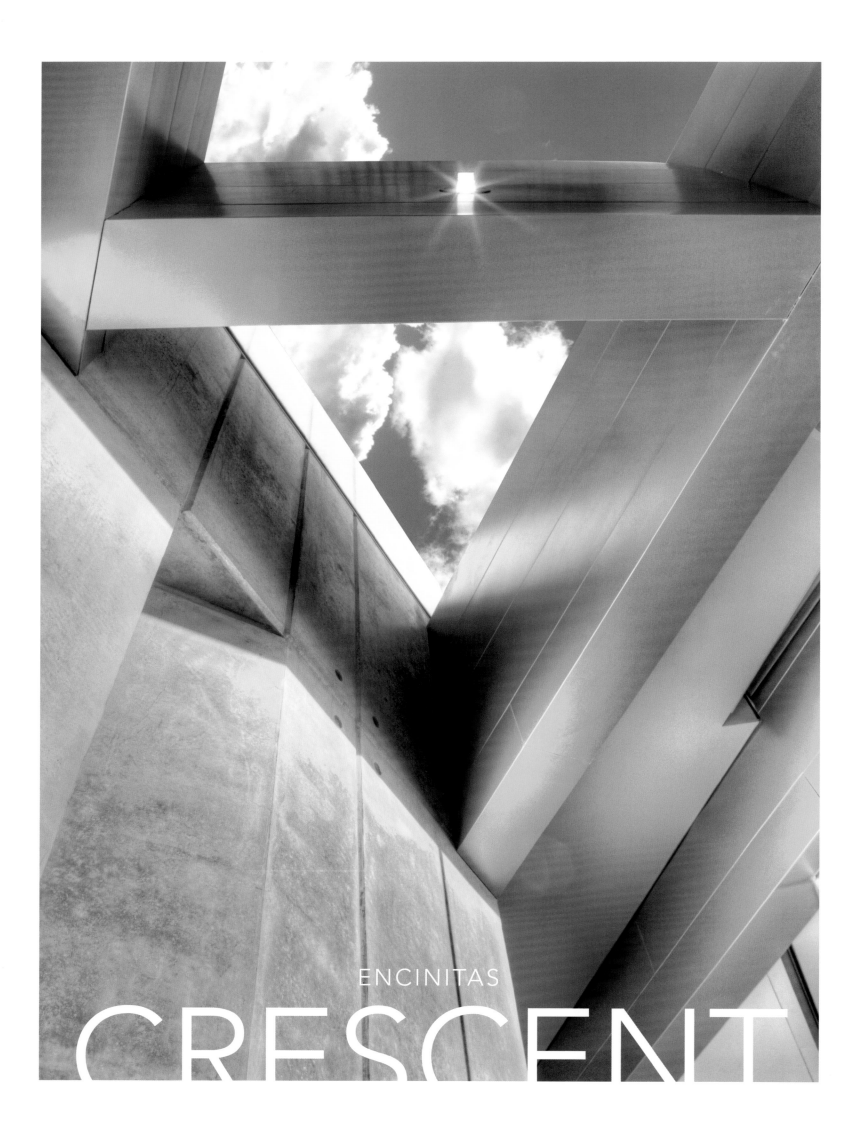

ENCINITAS
CRESCENT

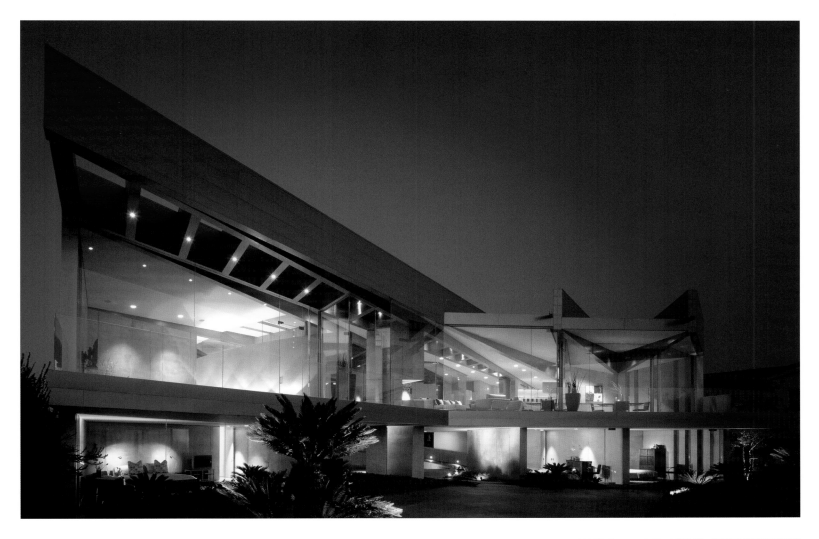

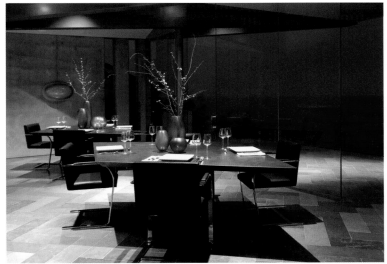

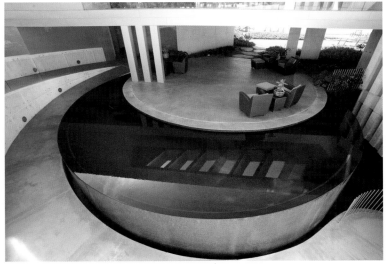

With six miles of rugged coastline, spectacular ocean views and shady tree-lined streets, Encinitas is characterized by coastal beaches, cliffs and steep mesa bluffs. The rolling hills and picturesque settings are what attract homeowners to this perfect view paradise and with premiums fixed on unique coastal real estate, challenges constantly present themselves to architects and builders to accomplish wonders on the available prized lots. Success in challenge is what architect Wallace E. Cunningham completed with this coastal home of concrete, steel and glass.

"Houses should be portraits of their owners, not the architect," says Cunningham. "Although each project is driven by the site and program, the design should be triggered by some poetic quality of the person who will live there." Since the owners had dreamed of living in a concrete home, long-span concrete technology was used to integrate the complex structure into this fragile coast setting. Materials include poured-in-place concrete walls, Kynar paint finish, frameless glass walls and custom stainless steel.

ARCHITECT **WALLY CUNNINGHAM** PHOTOGRAPHER **ERHARD PFEIFFER / HOLT WEBB**

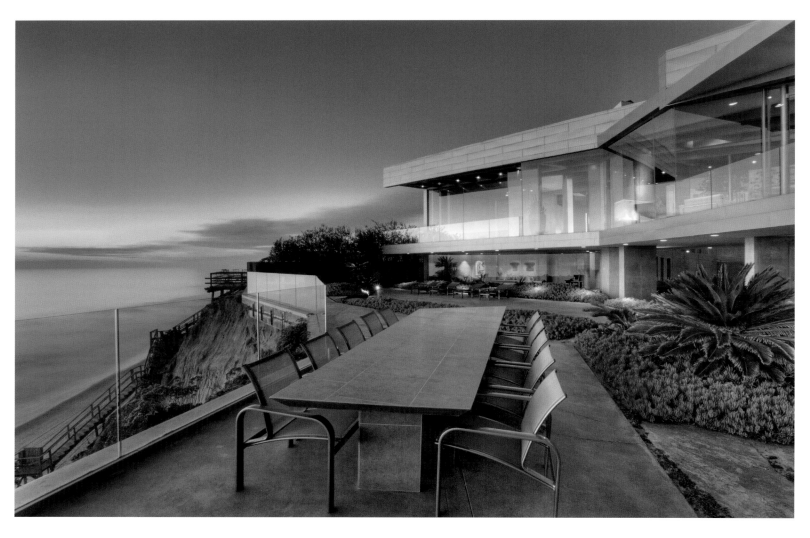

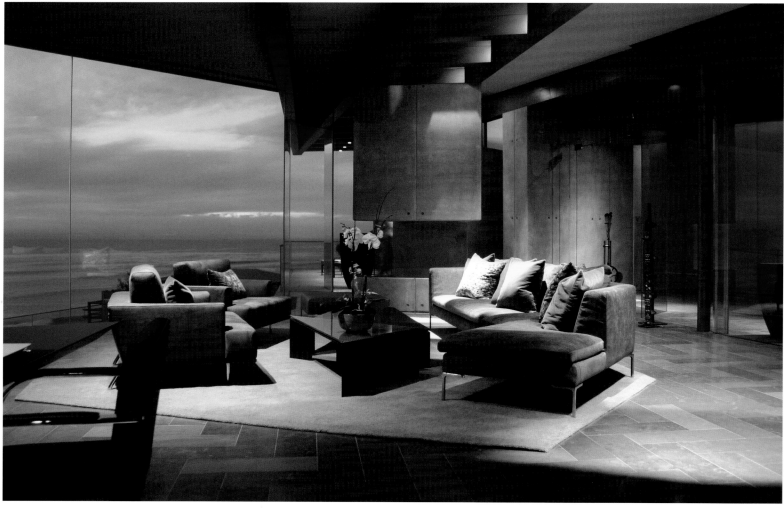

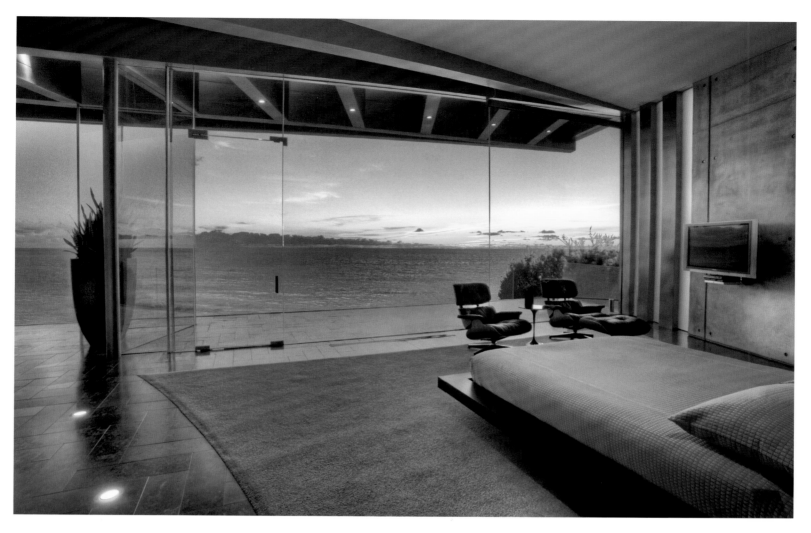

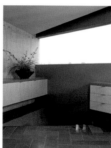
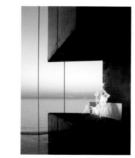
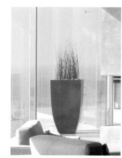

Overlooking the water on the upper level are the master bedroom and the living and dining areas. On the level below, several guest rooms are separated by an opening to the pool terrace and the courtyard.

The building form resulted from both the site configuration as well as a desire to isolate the interior spaces from the surrounding neighborhood. The north and south elevations are bounded by concrete walls punctured just enough to allow light to enter. A processional sequence begins as the visitor leaves the street, moving along a concrete ramp past an overflowing crescent shaped pool. The terminus is the public upper level, where the eye is thrust past the glass perimeter towards the ocean outside. This directional force is enhanced by the complex sectional geometry of the roof, whose fractional forms slope up and outwards. A segmented glazed spline cuts along the length of the roof allowing filtered natural light to penetrate, dissolving the distinction between interior and exterior space.

THE CALIFORNIA
ECONOMY

On January 24, 1848 James Marshall discovered gold at Sutter's Mill in Coloma, and California was changed forever. From the Gold Rush to the explosive arrival of the Internet at the beginning of the 21st century, California's economic history has been one of change, growth and prosperity.

From a sparsely populated Western frontier with fewer than 100,000 residents in 1850, the population now exceeds 34 million. With an economy that was too small to measure before the Gold Rush, California is now the fifth ranking economy in the world. While agriculture and other traditional sectors remain strong, the state is also a major innovator and producer of high-technology products and services. It has been the birthplace of many of the world's most significant innovations, a model of economic creativity and prosperity and an example for the rest of the nation. As this new century unfolds, there are few economies better suited to the "information age" than California's.

Over time, new industries were introduced that, rather than displacing established industries, were simply added to the existing base. This pattern of adding rather than displacing industries gives California its rich economic texture in which long-established industries thrive alongside emerging industries. Never without challenges, the state's resourcefulness has always risen to the occasion, carrying the state to its current status as the largest and most diverse economy in the nation.

Opposite page: ©Rodney Lough

AEROSPACE

This industry is an example of economic vitality and resilience and a contributor to the global advancement of high-tech applications.

California has a long history of aerospace manufacturing. Aircraft, the predecessor to the modern aerospace industry, sprang to life in the 1920s. By 1935, Boeing was the only major airplane manufacturer outside of California. The state's multiple weather patterns made California an excellent place to build and test airplanes. In 1919 Allan Lockheed started Lockheed Aircraft in Santa Barbara, relocating shortly thereafter to Burbank. During World War II, it became a major defense manufacturer. In the Cold War, Lockheed led the aerospace industry in missile development. In 1920 Donald Douglas founded Douglas Aircraft, two of whose planes in 1924 became the first to fly around the world. In 1932 the company signed a contract with TWA to produce passenger aircraft. Their first model, the DC-1, could only seat 12 passengers, but in 1935 it rolled out the DC-3, which became an industry standard. Douglas Aircraft went on to manufacture 30,000 aircraft during World War II.

With more than 1,070 aerospace firms, shipping $28 billion worth of products, the California aerospace industry today makes up about 20 percent of the nation's total aerospace employment. The state's industry has contributed enormously to the history of aviation, space exploration and the end of the Cold War. Technology leadership in aerospace includes the manufacture of aircraft and parts; missiles; space vehicles and parts; and search and navigation equipment.

The aerospace industry is a heavy consumer of electronics and component parts, another of the state's premier industries. State-of-the-art computers, electronics and avionics give aerospace its cutting edge. In return, the demands to excel in aerospace continually push the capabilities of electronics to new levels.

Aerospace production is concentrated in Southern California with more than half of the employment in the Los Angeles/ Long Beach area. Other counties with high aerospace employment are Orange, Santa Clara, Riverside and Ventura.

Combined with Los Angeles, these five counties have over 90 percent of the state's aerospace employment. An example of California's economic vitality and resilience, the aerospace industry is a significant contributor to the global advancement of high-tech applications.

AGRICULTURE

Diversity has always been important in California agriculture, which grows over 200 different crops. In contrast, other farm states may produce only 12-15 crops. Several famous scientists spearheaded agricultural research in California, including Luther Burbank. He settled in the Santa Rosa area in 1875 and developed new varieties of plants including 40 types of prunes and plums, a white blackberry and the Russet Burbank potato. Today, this potato accounts for forty percent of the potatoes sold in the United States. Although agriculture is gradually yielding to industry as the core of the state's economy, California leads the nation in the production of fruits and vegetables, including carrots, lettuce, onions, broccoli, tomatoes, strawberries, and almonds. The state's most valuable crops are grapes, cotton, flowers, and oranges. Dairy products contribute the single largest share of farm income; and California is the national leader in this sector. The state also produces the major share of U.S. domestic wine. California's farms are highly productive as a result of good soil, a long growing season, and the use of modern agricultural methods.

Because of agriculture's dependence on water, California has built massive irrigation projects. As early as 1945, 63 percent of California's farms used water brought in by irrigation. The largest projects were the Owens Valley, Central Valley Project and the Colorado River Project. However, one of the state's most challenging problems remains its appetite for water and today irrigation is especially critical in the San Joaquin and Imperial Valleys. The once fertile Owens is now arid, its waters tapped by Los Angeles 175 miles away. In the lush Imperial Valley, irrigation is controlled by the All-American Canal that draws from the Colorado River.

Cutbacks in federally funded water projects in the 1970s and 80s led many California cities to buy water from areas with a surplus, but political problems tied to water sharing remain a challenge for the state's agricultural industry.

The success of one industry led to the success of another. California banking is an example of an industry that grew with the success of agriculture. Two of the state's leading banks throughout much of the 20th Century - Bank of America and Security Pacific - had their roots in agricultural lending. Both were popular lenders to many growers. Another industry that developed with agriculture was canning. Advances in technologies enabled California companies to can food and ship it to the rest of the world. Several canned food labels, such as Del Monte, Libby and S & W, originated in California early in the century.

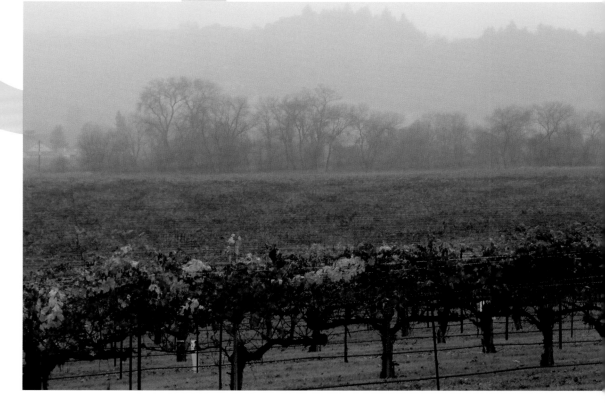

APPAREL

California apparel design caters to active outdoor living and casual relaxing. Clothing made in California is distinct from garments made in the eastern United States, and is second only to Hollywood as a means of conveying a positive image of the California lifestyle. The state is the leading manufacture of apparel in the country, producing over $13 billion in products each year and exporting more than a billion dollars worth of goods. The industry continues to introduce advanced technology for further efficiency and design creativity. The growth of the California fashion industry followed the growth of the motion picture industry. As the public increasingly wanted to emulate movie stars, clothing designers flocked to Hollywood. Major department stores had movie stars endorse their clothes. In 1927 Joan Crawford and Clara Bow endorsed hats for Sears. Eventually, apparel manufacturing followed the designers. Apparel and other textile product manufacturing was a bright star in California manufacturing in the 1990s. Throughout most of the decade, national apparel employment declined steadily while California's increased. By the end of the century, California accounted for one-fifth of the entire nation's apparel manufacturing jobs. The largest apparel cluster in the nation is in the Los Angeles area, providing more than 136,000 jobs. Los Angeles is also home to the California Mart, the largest wholesale apparel center in the United States. This 3 million square foot complex is where manufacturers and retailers make their deals. The San Francisco Bay area is the nations third largest apparel-manufacturing center. The California lifestyle is perceived as trendsetting and casual. The varied climate and geographic diversity allows for active year-round outdoor living, inspiring a diversity of clothes.

BIOTECH

The latter part of the 20th century witnessed a biological revolution that opened new horizons in the life sciences and created the industry of biotechnology. With its world-class research universities, California is both the birthplace and home to a large share of the industry. One in four U.S. biotech companies is located within 35 miles of a University of California campus. It has more biotech jobs than all of the other states combined. Strength in research, as well as its large share of the U.S. biotech industry, will continue to make it one of the most attractive places to form biotech companies. The state's strong research capacity, long tradition of venture capital investment, and high quality labor pool already provide the necessary ingredients for a highly successful biotech economy.

California accounts for 47 percent of the nation has developed policies or incentive programs to attract biotech firms, the industry's very distinct and complex requirements are met in California, and for the present, that's not likely to change.

California is home to over one-quarter of the nation's biotech firms and a high proportion of world-renowned research universities. Ph.D. scientists working at universities or research institutes have founded nearly half of the venture-backed biotech start-ups in the United States. Moreover, two-thirds of those scientists chose to start their firms in the same state where they were conducting research. A full 82 percent of California's "professorial entrepreneurs" stayed in the state to found their companies.

The importance of being in close proximity to pioneering biological, chemical, and medical research hasn't diminished since the industry was first founded. Over half of the state's biotech jobs are in start-up companies.

California accounts for 47 percent of the national R&D spending rates & 53 percent of the nation's biotech revenues.

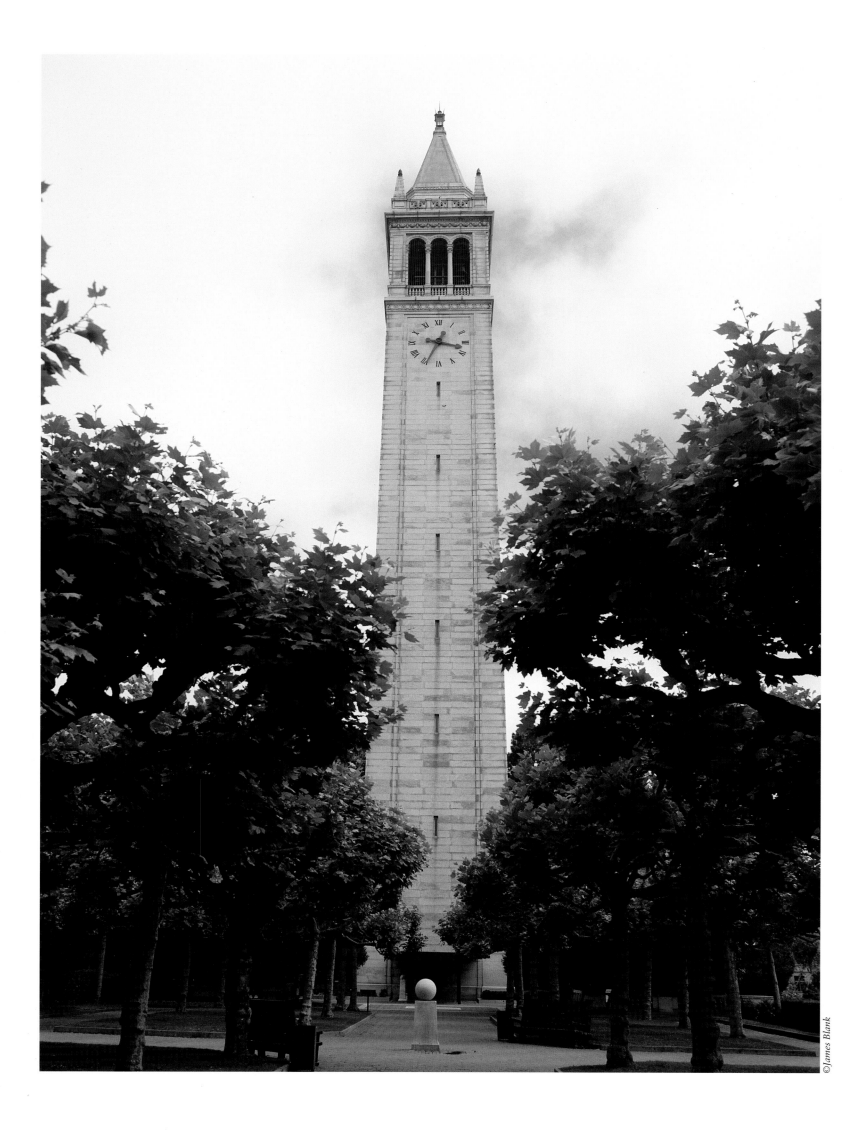

EDUCATION

California's public educational system is supported by a unique constitutional amendment that requires 40% of state revenues to be spent on education.

The preeminent state university is the University of California, which employs more Nobel Prize winners than any other institution in the world, and is considered one of the finest public higher-education systems in the country. The nine general UC campuses are in Berkeley, Los Angeles, San Diego, Davis, Santa Cruz, Santa Barbara, Irvine, Riverside, and Merced. The University of California, San Francisco, teaches only graduate health-sciences students, and the Hastings College of Law, also in San Francisco, is one of UC's four law schools.

The University of California also administers federal laboratories for the Federal Department of Energy including Lawrence Livermore National Laboratory, Lawrence Berkeley National Laboratory, and Los Alamos National Laboratory. With over 400,000 students, the CSU system is the largest in the United States, including 23 universities and provides education for teachers, the trades, engineering, agriculture and industry.

Notable private universities include Stanford University, the University of Southern California, Santa Clara University, the Claremont Colleges, and the California Institute of Technology which administers the Jet Propulsion Laboratory for NASA. Plus, California has many other private colleges and universities, including religious and special-purpose institutions. Public secondary education consists of high schools that teach elective courses in trades, languages and liberal arts with tracks for gifted, college-bound and industrial arts students. In many districts, junior high schools or middle schools teach electives with a strong skills-based curriculum. Elementary schools teach pure skills, history and social studies, with optional half-day kindergartens beginning at age five.

©Ron Hall

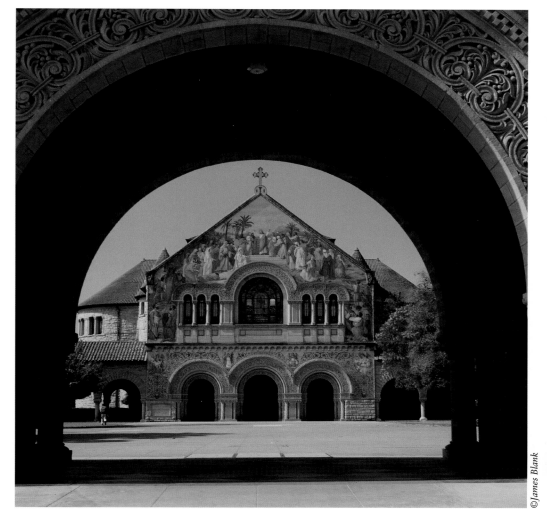

©James Blank

©James Blank

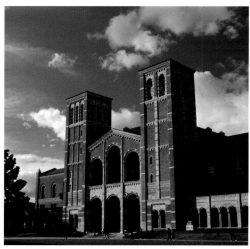

©Robert Landau

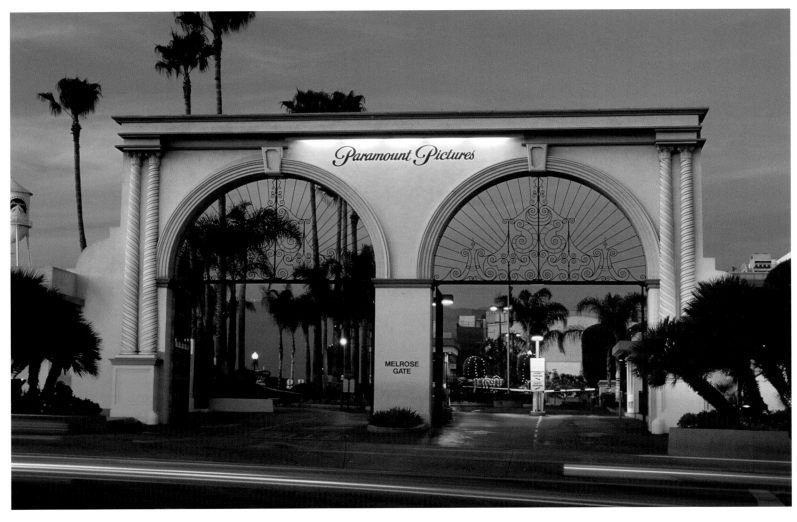

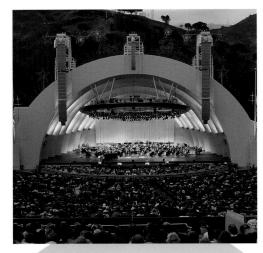

ENTERTAINMENT

If you're looking for entertainment, come to California. You can hike the wilderness areas of the rugged Sierra Nevada's; ski Lake Tahoe; drive the coastline; swim in the lakes; sun on the beaches; play golf in the desert or simply sit in any street corner cafe and watch the people go by. Entertainment is everywhere. However, when we think of entertainment in California, our thoughts go immediately to the motion picture and television segments of the industry where California and entertainment are intrinsically linked.

Recognized worldwide because of its movies, television programs, recordings and countless technical and artistic innovations, entertainment is California's signature industry. It is part of California's mystique and a major economic force within the state, generating well over $32 billion annually and sustaining nearly 300,000 jobs for Californians. Los Angeles and Hollywood are the centers of the American entertainment industry. In Los Angeles County the film and television industry is the fifth-largest employer.

Many in the motion picture industry viewed the rapid spread of television in the 1950s with considerable alarm. Indeed, television sounded the death knell for low-budget "B" movies and for many neighborhood "second-run" theaters. However, the major film studios began devoting some of their efforts and resources to producing shows for the emerging television medium. Some of the popular shows produced in California at this time included *I Love Lucy, Maverick, Lawman, 77 Sunset Strip, Cheyenne, and Hawaiian Eye*. Eventually, Hollywood and nearby Burbank became the center of the television entertainment industry. Today, the vast majority of prime time television originates in California.

By the 1990s, Hollywood, with its superior production and post-production capabilities, had even captured most TV commercial production from Madison Avenue. Moreover, the balance of power in the industry continued to shift westward. The classic split between financial control from Wall Street and creative activity on "the Coast" began to break down in the 1980s as studios and independent producers accessed investors directly through limited partnerships, Silicon Valley's venture capital model. Of the four leading commercial networks today, two are owned by the California headquartered companies of Disney and Fox.

By the end of the century, independent filmmakers were producing many films. The major studios eventually came to focus less on film production and more on film distribution, and the provision of a variety of other services, including providing financing, physical facilities and technical equipment and skills.

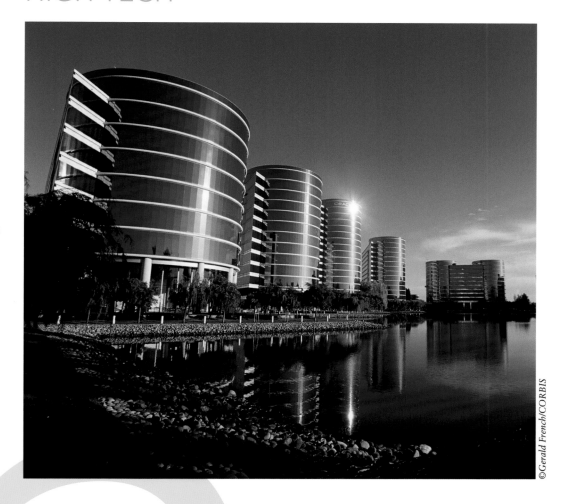

©Gerald French/CORBIS

A major economic transition occurred in the last quarter of the last century. After the end of the Cold War, defense spending in the state had waned. However, electronics manufacturing, spurred by World War II and the Cold War, had sowed the seeds of the new electronics and computer industries of the future; California would rise to dominate the high technology industries that dramatically altered the economic landscape of the 1990s.

Silicon Valley-based companies such as Hewlett-Packard and Intel drove the technology industry into the 21st century. Hewlett-Packard was founded by two Stanford University graduates in 1938 and the company's first major order was from Walt Disney. Disney purchased oscillators used in the stereo sound system in the ground-breaking animated film Fantasia. By 1962 Hewlett-Packard was listed in Fortune's top 500 companies.

Apple Computer, a pioneering computer company born in California, added an essential component to personal computers. Apple Computer was founded in 1976 and initially prospered from the Apple II computer. Building on this success, it introduced the Macintosh computer in 1984, which included a graphical user interface (GUI) that greatly simplified its operation. Before the GUI, computers were predominantly the domain of hobbyists, sophisticated users, and technicians. The GUI turned the personal computer into a mass marketable appliance with broad applications, which in turn created vast new economic opportunities.

Most of the value in a personal computer resides in the silicon chips, each containing millions of semiconductors or

transistors. The most important chip is the central processor unit, or CPU. The development of the personal computer industry can largely be traced by CPU development. In 1971 the world's leading microprocessor designer and manufacturer, Intel produced its first microprocessor, the 4004, for use in a business calculator. By 1985, Intel was producing the 386 processor which was more than 100 times faster than the original 4004. In 1989, Intel introduced the 486 processor, which was powerful enough to fully support the graphic interface (point and click) pioneered by Apple. In 1993 the even more powerful Pentium Processor was introduced which enabled computers to easily incorporate more complex data such as digital sound, photographs, and motion pictures. The 1990s were a pivotal and paradoxical decade for California. It began with a severe economic slump and ended with a record-breaking expansion. During the latter half of the decade the state's economy consistently grew faster than the nation as a whole. Computer industry developments, such as falling chip prices and the development of the Internet, sparked a boom in various high technology fields. Electronics manufacturing—computers and telecommunications—recovered from the recession, but, more dramatically, computer-related services proliferated to support the propagation of personal computers, personal communications devices and Internet business activities. All this combined to generate historically high levels of employment, income growth and wealth accumulation. The Silicon Valley of the 1990s represented the 20th Century's Gold Rush. California high technology companies received over $16 billion of venture capital investments in 1999 alone.

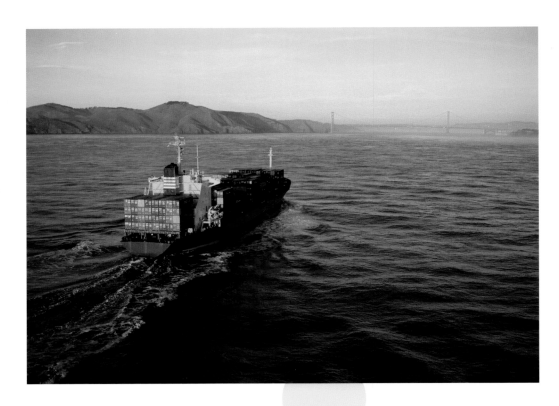

INTERNATIONAL TRADE

California is the prime hemispheric gateway for trade and investment in the United States and the top exporting state, producing $1.4 trillion in goods and services annually. California exports well over $90 billion worth of goods annually (not including trade in services) to 222 countries worldwide. International trade and exports translate into high-paying jobs for over one million Californians, placing California as the nation's leader in export-related jobs.

These export values do not include trade in services. The services sector accounts for at least 80 percent of the United States' total Gross Domestic Product (GDP), and for over one-quarter of U.S. exports. California is a leader in most of the top ten U.S. services exports, including financial services (banking and insurance); professional and technical services (accounting, advertising, construction and legal); education; entertainment; information technology services,

telecommunications, and health care. Although the federal government does not calculate services exports on a per-state basis, given the size of California's economy and its dependence on the services sector, it is likely the number-one state in terms of services exports combined with manufactured exports. The key to California's economic success as a large exporting state is its diversity in terms of industries and export markets. The state is home to several important export industries, including computers and information technology; entertainment; agriculture; chemical production; aerospace; biotechnology; manufacturing, and a myriad of other manufacturing technology fields. California's export patterns are reflective of its advantageous geographic location on the edge of the North American Pacific Rim and its shared border with Mexico and proximity to the rest of Latin America. Because of its location and large ocean shipping port, California has served as the gateway to Asia for U.S. exporters, while sales to the Americas and Europe are nearly as significant.

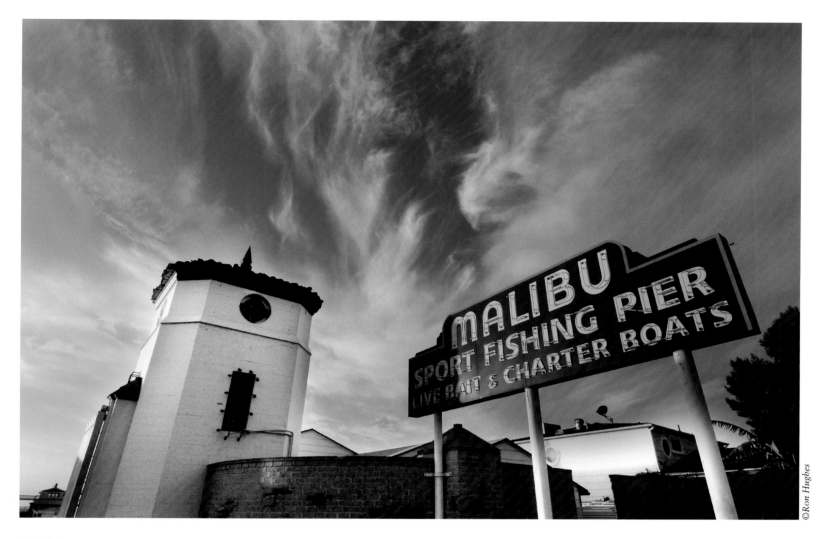
©Ron Hughes

©James Blank

©Scott Campbell

©Rob Perry

MARINE AND COASTAL

California has always been influenced by the sea. Unlike other western states, California was founded from the sea inward, first by the Spanish and then by the European-Americans. Its connections to the ocean are evidenced by the economic activity of thousands of businesses, its burgeoning ports, and in the behavior of millions of people who flock to the shore.

Beaches are the top destination for tourists and one of California's greatest assets. Besides attracting millions of people, California's coast is a mixture of broad sand beaches, enormous estuaries turned ports, and rocky cliff formations that make it conducive to differing economies and lifestyles. As the first state to pass coastal management legislation in 1976, it continues as a model for other states by its responses to coastal issues. California's growing population and historic popularity as a tourist destination have brought it both economic wealth and the accompanying challenges of enormous pressure on all of its natural resources, particularly those along its more populated coastal areas.

By 1940 California was a leading fishing state because of the sardine industry. Between 1914 and 1929, an average of 300 million pounds of sardines were caught each year. Sardines were used for fertilizer, fish oil, salmon bait and other products. By 1910 Monterey was the canning capital of the world. In 1967, a fishing moratorium was declared and Cannery Row became one of California's most famous tourist attractions. California also became the nation's leading tuna fishing state. Croatians living in San Pedro established the industry, and it became the nation's tuna fishing capital. Although the fishing industry accounts for less than 1% of the annual gross state product in California, the state is a major national producer of fish, supplying about 4% of the value of the national catch. Principal species caught are anchovy, swordfish, salmon, tuna, and herring. Essentially all the commercial catch, including shellfish, are taken from salt water off the California coast.

SOFTWARE AND INFORMATION TECHNOLOGY

California is leading the world in a revolution of productivity and economic growth. This revolution is centered on information, technology, innovation, and human capital. The state is by far the nation's leading producer of electronic equipment and components and the machinery used to manufacture high technology goods. In addition to high-technology manufacturing, California is also the nation's leading provider of computer services, including software and the Internet.

The development of the computer industry also fostered a boom in the software industry. By the late 1990s, Microsoft's Windows software was the dominant operating system used by over ninety percent of the world's personal computers. Software companies such as Electronic Arts began to develop enter-

tainment software for this operating system and the computer games industry exploded. During the 1990s, computer-related services—programming, network and database development, component design, and a plethora of Internet services—eclipsed computer and electronic manufacturing as the leading high technology growth industry.

The Silicon Valley in the bay area continues to be the world's leading technology center. California's Information Technology exports exceed more than half of the state's total exports, accounting for more than 200,000 people employed in the IT industry in Santa Clara County alone, helping to make San Jose the highest average wage city in the country.

After 40 years of boom and bust in defense, semiconductors, computers

and the dot-coms, the Silicon Valley has steadied itself and is re-emerging as the world headquarters of concepts for gadgets, Web sites and consumer products. Although total venture capital investment in the United States has dropped from its bubble peak, the valley still gets more than 25 cents of every dollar. Unmistakable examples of the region's vitality include Google, whose success has followed its Web predecessors Yahoo and eBay, not to mention valley stalwarts like Intel and Hewlett-Packard. The valley's growing importance in the biotechnology industry and the emergence of nanotechnology expertise in places like NASA-Ames Research Center reaffirm the continual emergence of the area as a leader in the field. California companies lead the world in developing and using information technology to do business better.

©Robert Landau

©Robert Landau

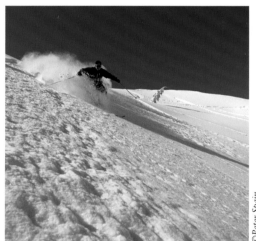

©Peter Spain

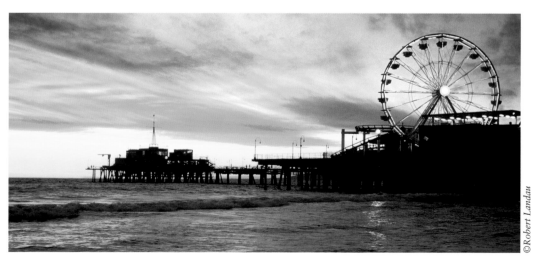

©Robert Landau

©George Lepp

TOURISM

©Rob Perry

Tourism is the 5th leading industry in California in terms of monetary input. Over 318 million domestic and international travelers visit the state each year with expenditures on travel and tourism exceeding $80 billion annually, generating close to $5 billion in tax revenues, and providing jobs for more than 1 million Californians. With its major metro areas, diverse landscapes and cultures, and major attractions that include miles of coastline, major mountain ranges, excellent golf courses, beaches, Disneyland, Hollywood, Palm Springs, Lake Tahoe, the San Francisco Bay area, and the wine country of the Napa and Sonoma valleys, locals and visitors are surrounded with an infinite scenario of travel opportunity. The state maintains a system of more than 250 parks, reserves, historic parks, and recreation areas with Yosemite and Sequoia national parks leading the way.

From Disneyland in Anaheim, Universal Studios in Hollywood, and Sea World in San Diego to Knott's Berry Farm in Buena Park, the boardwalk in Santa Cruz and Legoland in Carlsbad, California's many amusement and theme parks are a constant source of entertainment for both domestic and international visitors. In short, there's plenty to see and do in California. Whether you are the outdoor type or a shopaholic, you'll find more than enough to keep you entertained. Choose from the remote wilderness and magnificent outdoor scenery, beautiful cities along a gorgeous coastline, monster roller coasters, culturally significant landmarks, intriguing exhibitions, and endangered animals... it's all in California.

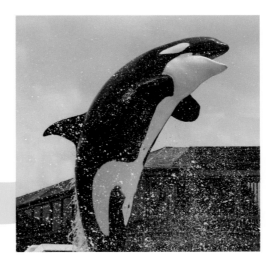

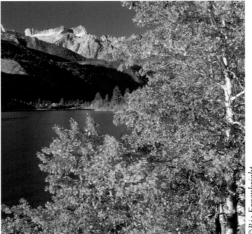

©Ric Ergenbright

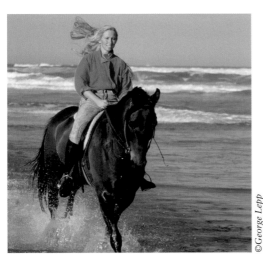

©George Lepp

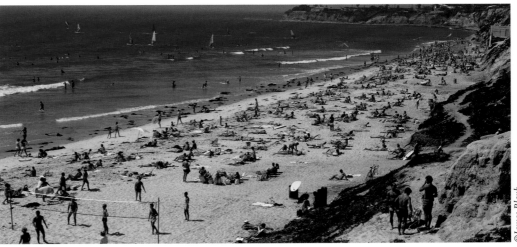

©James Blank

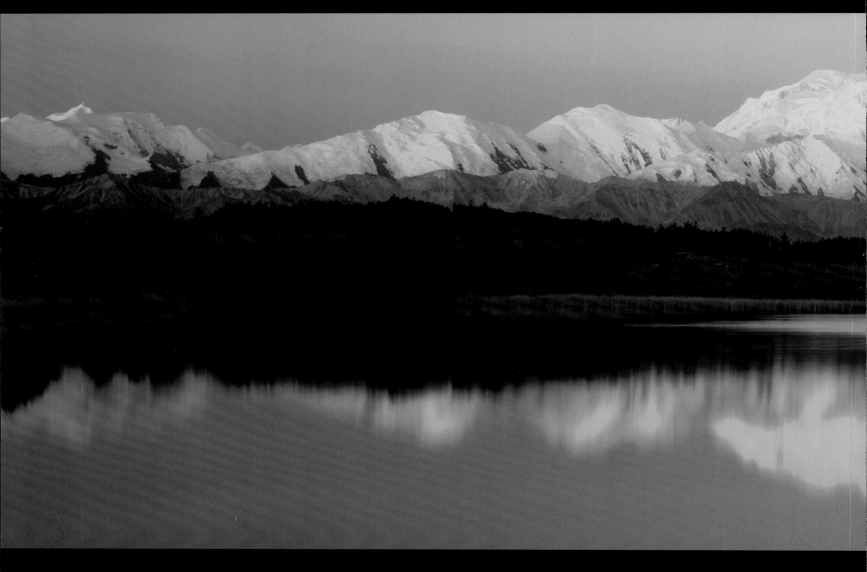

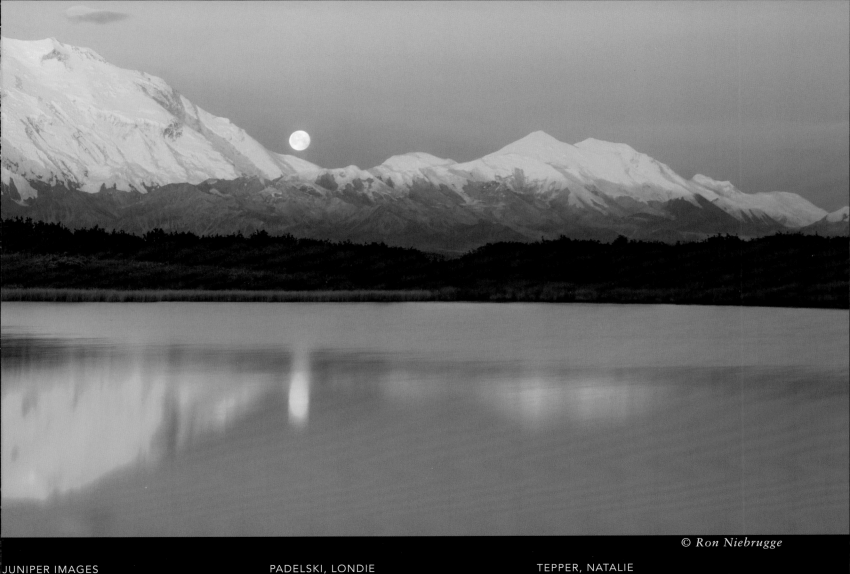

© Ron Niebrugge

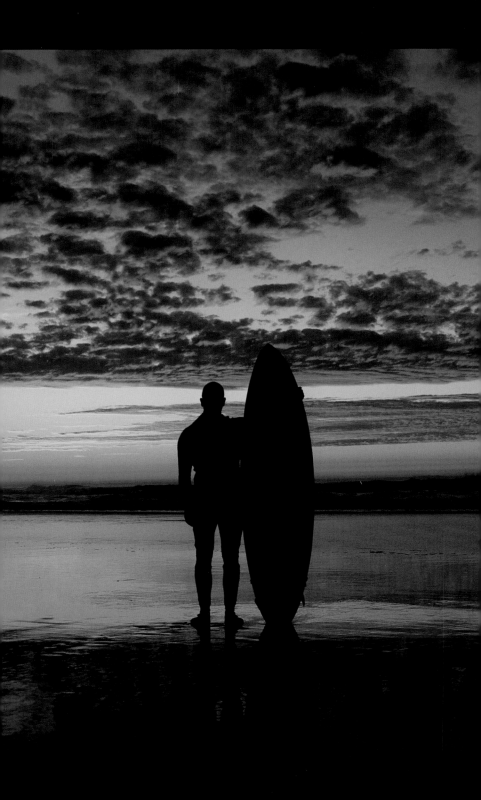

"Now I've joined the surfin' nation and so
I'll take a permanent vacation and go
To the golden shores of 'Frisco Bay
I'll ride 'em all the way to Malibu."

California Calling The Beach Boys - 1985